A DAVID & CHARLES BOOK
David & Charles is a subsidiary of F+W (UK) Ltd.,
an F+W Publications Inc. Company

First published in the UK in 2004
Reprinted 2004

Distributed in North America
by F&W Publications, Inc.
4700 East Galbraith Road
Cincinnati, OH 45236
1-800-289-0963

A catalogue record for this book is
available from the British Library.

ISBN 0 7153 1904 3

Collated & edited by
Dillon Bryden, Tim Bishop,
Neil Turner, Eddie Mulholland,
Jeff Moore, Helen Atkinson
and Peter Macdiarmid

Design by SMITH
Victoria Forrest, Allon Kaye

Printed in Italy by EBS, Verona

for David & Charles
Brunel House, Newton Abbot, Devon

Visit our website at
www.davidandcharles.co.uk

David & Charles books are available
from all good bookshops;
alternatively you can contact our
Orderline on (0)1626 334555 or
write to us at FREEPOST EX2 110,
David & Charles Direct, Newton Abbot,
TQ12 4ZZ (no stamp
required UK mainland).

FIVE THOUSAND DAYS

PRESS PHOTOGRAPHY IN A CHANGING WORLD

FOREWORD BY HAROLD EVANS

PHOTOGRAPHS BY MEMBERS OF
THE BRITISH PRESS PHOTOGRAPHERS' ASSOCIATION

David and Charles

How press photography has changed in the last five thousand days! Not only have newspapers moved from black and white to colour, but also the cameras we use have changed beyond recognition. Digital cameras can store hundreds of images on a single card; we are no longer limited by 36 exposures at a time, with the inherent dangers of choosing when to reload. Today's images can be sent back to the office via a mobile phones from anywhere in the world, or from the pavement beneath our ladders. Happily, the need for us to process film in blacked-out hotel rooms whilst struggling to find a clear telephone line are a distant memory for some of us and mere folklore for others.

There are even more dramatic changes in our industry, not just in camera technology. Changes spearheaded by a fresh generation of picture editors, many of whom are former press photographers, coming into the newsroom and slowly replacing the demoralised picture gatherers, hunched over budget sheets, terrified of the editor, knowing little of photography. Who knows? Perhaps newspapers are beginning to appreciate the press photographer.

Building the BPPA was the dream of a small group of press photographers, lead by John Downing, who were determined to promote the best of press photography both within and outside the profession. Set up in 1984 in the basement of the Duffers Club off Fleet Street, within two years the Association had started a programme of annual exhibitions and books. In 1989 the Association was rocked by the tragic death of member Ian Parry on assignment covering the fall of communism in Romania. The following year, we held a fund-raising dinner, and together with support from the *Sunday Times* and Nikon, launched The Ian Parry Memorial Fund. Since then an annual award has been made to the most promising young photographers to help kick-start their careers.

Reformed last year thanks to the determination and vision of Suresh Karadia, we remain a fully independent, not-for-profit association, above all run by press photographers for press photographers. All this is no mean achievement, for a profession that judges success not by being a friendly, share all, work together little community, but by intense rivalry, struggling to find the unique, the new perspective, the exclusive and special vantage point, trying to work alone. The best press photographer is rated by getting something that everyone else missed. Not an easy group of people to form into an association, but the pages that follow demonstrate the achievement of *Five Thousand Days* and I believe that together we have produced something extraordinary.

The BPPA is proud to publish this book covering many historical, sporting and everyday events from the end of 1989 until the spring of 2004. Every member of the Association was invited to submit twenty of their best pictures which were then edited down, not by picture editors, but by an elected committee of members. These images are not necessarily the pictures that made the front page, though many did, some are not even the pictures that made the paper that day, or any other. Some of the members here risked their lives to take these pictures; others simply rose above the mundane nature of their assignment, to record something memorable, or even humorous. It is a selection of the members' work chosen by their peers.

The project has been nine months in the making and the membership owe a huge vote of thanks to Dillon Bryden, whose vision made us aim high and whose sheer dedication to realizing this ambitious project virtually forced him to put his own photography on hold. Dillon, together with the book committee, Peter Macdiarmid, Helen Atkinson, Eddie Mulholland, Jeff Moore and I had a massive task! Chasing sponsorship, Sam Barcroft rang more numbers and knocked on more doors that the average newsroom hack. After returning from assignments, night after night, Neil Turner sat up through the small hours working on all the image files to make deadlines for submission to our printers. Many thanks to our designer Stuart Smith, for his patience, his commitment to the project and above all his loyalty to the photographs

Sir Harold Evans must take a bow too, for he, as valued friend and supporter of the Association since its inception, somehow managed to fit writing our foreword into his demanding schedule. The BPPA is very grateful to our main sponsors: Graham Smith at Canon Cameras, and John and Mike Selby at Rex Features. Last but not least we must thank Neil Baber from David & Charles for saying yes once and then never saying no after that.

As Giles Coren joked in *The Times*, the first of many first rules of journalism is never to have a photographer on a story. Why? Because the case-study your editor asked for might just have to exist. I suspect that their ability to render a writer's copy redundant may have something to do with it as well.

Tim Bishop
Secretary BPPA

Probably the most potent photographs of the year 2004, indeed of the decade, were taken by amateur snappers, the self-incriminating yobs in the US Army who thought the folks back home would just love to giggle at pictures of naked Iraqis at the Abu Ghraib prison. Stories of the abuses at the prison had been in circulation in print, but only when images reached the newspapers did the world sit up and take notice. It was all proof yet again – as is this book – of the enduring vitality of the still and monochromatic image. Of course, the context mattered. The earlier stills from Fallujah of four murdered American contractors, incinerated and hung from a bridge, with grinning Iraqis in the foreground, were intrinsically more horrific, so horrific that many thought they were too grotesque for publication, too grievous for the families of the dead. But that was a mob scene. The shock of the less violent prison pictures lay in our legitimate expectations of a higher standard of conduct from Americans and from the American Army. In any event, neither set of images will be easy to forget. So it is with many of the photographs on the following pages. They are by professionals, but in the news photographs here one is conscious less of artifice than an honesty of style shared with the amateur snappers. So this is just how it was when the Russians went into Grozny, and the Serbs into Srebrenica and Kosovo, and the Arab militants into the southern Sudan, and the Real IRA into Omagh and the Lord's Resistance Army into Uganda's villages: the documentation of quotidian cruelty is stark, unadorned and provocative. Had the onset of killings in Rwanda been properly photographed and published, it would have been hard for governments and the UN to stand aside as they did while a million people were butchered.

Thirty years ago when in *Pictures on a Page* I first advanced the argument for the longevity of the still, we were in the early stages of infatuation with the moving pictures on television. It was the common presumption that television would kill photojournalism, witness the collapse and suspension of *Life* magazine from a 1969 circulation of eight and one-half million copies and the closure of *Look*. There is no doubt of the commercial effect; television's advertising pull was damaging to those pages whose pages were relatively expensive, but John Szarkowski, when guru of photography at the Museum of Modern Art, suggested that even before television the magazines had failed on creative grounds. They no longer fulfilled their reason for being: to marry consistently superior photography and vivid writing to transform each other and so produce a new means of expression, the 'third effect' in the phrase of Wilson Hicks, one that would offset television's superior speed. There was little as memorable as the series of photo essays by such as Margaret Bourke-White, Alfred Eisenstadt, and Eugene Smith; they did not depend on their immediacy but their intelligence. The long run of *Life* and *Look* was ended by a conjunction of commerce and cowardice: it was always a mistake to presume that their passing marked the death of photojournalism. On its best days under the art direction of Michael Rand, with a succession of able editors and spectacular photographers, *The Sunday Times* magazine launched around this time by Sir Denis Hamilton (amid much scepticism) took up where the American magazines left off – and other newspapers, having scoffed, duly imitated with their own magazines. (And now in 2004 the editorial sage of *Time Inc*, Norman Pearlstine, is reviving *Life* magazine for

distribution through newspapers to achieve a total weekly circulation of 14 million, nearly double its monthly heyday. Some death!)

British newspapers at the time of the suspension of *Life*, were hardly distinguished in the use of photography, though the *Daily Express* and *Daily Mirror* could excel. Today, a generation later, the run of British newspapers both national and provincial has finally come to appreciate the photograph on its own merits, rather than as an illustration, a half-tone decoration of grey text. One can have misgivings. There are in the popular press too many miserable examples of unjustified invasions of privacy and harassment; photojournalism's credibility is newly vulnerable to the kind of Photoshop doctoring manifest in those yachting pictures of the Princess of Wales who was moved closer to Dodi Fayed; and of course atrocity stories always invite outright faking: the *Daily Mirror* on the ill-treatment of Iraqi prisoners was but a modern victim. Still, photographers and picture editors seem to me to have seized with energy and imagination the opportunities provided by space denied to their predecessors. Yes, some pictures are too vacuous to merit the space they get, but that is a lesser ill than the old attitude that a big news photograph somehow diminished a serious newspaper: I still recall the readers' protests I received in 1981 when I ran on the front page of *The Times* a vertical sequence of the shooting of President Reagan, three pictures across six broadsheet columns. It was 'unfitting' for *The Times*, I was told, by Disgruntled, Tonbridge, and others, as if the newspaper of record, aspiring to greatness, should forswear one of the most potent forms of communication.

This book does not attempt to produce the classic third effect of photojournalism. Other than succinct captions, there is no text. Each photograph, moreover, stands on its own, rather than as a paragraph of narrative in a photo essay. (The few instances of grouped photographs are collection rather than essays.) The collection is as random as the accidental art of a succession of pages in a daily newspaper. The effect, though, is cumulative. Whose bodies are these? It almost ceases to matter. One is stunned by the ubiquity of grief and inhumanity (and grateful for glimpses of normal life). Yet there is no sense of intrusion here. The great Eugene Smith set the standard: 'Photographic journalism, because of the tremendous audience reached by publications using it, has more influence on public thinking and opinion than any other branch of photography. For these reasons, it is important that the photographer-journalist has (beside the essential mastery of his tools) a strong sense of integrity, and the intelligence to understand and present his subject matter accordingly.'

The opening photograph by Brian Harris of *The Independent* fulfills the mandate. When Soviet tanks crushed the spring revolution in Czechoslovakia in 1968, the new masters called on the population to mass in Wenceslas Square as a demonstration of their support for their puppet government. Josef Koudelka, the legendary Czech photographer, made an image of the Czech peoples' response: the great square was utterly empty of people, a silent rebuke. In 1989, when the Berlin Wall fell and Communism ended in a whimper, Harris took himself to the same spot where Koudelka had made his picture, looking down on the statue of King Wenceslas. For nearly a week the square was packed every night with 500,000 people celebrating their Velvet Revolution. In Harris' photograph, the heroic King on horseback to the foreground, off centre, seems to be leading the Czechs to a new destiny. Photographed among the crowds from the

LEFT TO RIGHT
Jon Jones p.51
Alex MacNaughton p.64
Jeremy Nicholl p.38
Philip Coburn p.48
Dan Chung p.107
Lewis Whyld p.128
Tony Bartholomew p.235
Nils Jorgensen p.204

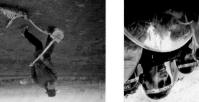

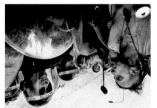

front, the good king would have been seen merely as bringing up the rearguard of a rabble. Here is a splendid example of what I defined in *Pictures on a Page* as a symbolic moment – when an iconic image encapsulates an event or an attitude and does it more effectively than shots of yelling crowds.

A symbolic moment may be very simple as Paul Lowe's presentation of bloodied footprints in the snow (page 32) following a Russian attack on a car, or Leon Neal's shocking portrait of schizophrenia (page 141). No doubt he obscured the face out of respect for her privacy, but it is all the stronger for concentrating on the scars.

It must remain an aspiration of photojournalism to match a meaningful image, whether a symbolic or a news moment, with the visual moment in which the interior geometry energizes the whole and directs the eye. I have called this happy and rare conjunction of substance and shape a decisive moment, an adaptation and refinement of Henri Cartier-Bresson's term where he was thinking only of the visual organization within a photographic frame and not at all of the inherent news. Tom Stoddart's poignant photograph of a tearful mother sending her child out of Sarajevo (page 24) qualifies. It is a relatively minor news moment, but it combines with a graphic visual in the tears of the mother and the bewilderment of the child. Similarly, Graham Barclay's study in black of the funeral of Charles Kray in the East End of London makes its disturbing effect by the juxtaposition of billiard-ball craniums and eyes concealed by shades (page 144).

These are achievements of technique beyond the normal amateur snapper. Jon Jones' heart-stopping photograph (page 36) of Croat soldiers in Mostar opening fire in house to

house fighting is the news moment; the blur of the action is a visual moment, emphasizing a life and death urgency. On page 51, Jones has effectively epitomized starvation and abandonment in Sudan by framing a small boy alone in the middle of what was once a buzzing classroom. Simon Grosset in the two smaller pictures on page 16 captures the fear in Bucharest in the instant that civilians cringe during an exchange of fire with secret police snipers. The significance of the event is reinforced; we cringe with them. The smallest detail can enhance or change meaning. Alex MacNaughton's picture of a confrontation in Park Lane, London, between police and protesters (page 64) is a case in point. The fact of the protest is the news; the visual moment is the jet of beer spittle directed at a policeman in riot gear – who seems to be receiving it with a smile. Without that smile, if such it is, the picture spells anger; with it, the picture spells tolerance under provocation, though MacNaughton's caption tells us the police came in swinging truncheons and the rioter smeared blood over a police shield.

There are many photographs in the book which are just simple news moments where the information, alone and unambiguously, sustains the impact; Paul Lowe documenting the burials of victims in Bosnia (page 22); Jeremy Nicholls' grim depiction of a Chechen villager burying the skeleton of a Russian soldier (page 38); Philip Coburn's prosaic bulldozer (page 48) scooping up corpses in Zaire; Terry Richards at Mazar-e-Sharif in Afghanistan when Taliban fighters, including Abdul Hamid, alias the American John Walker Lindh, are dragged by Northern Alliance soldiers from the underground bunker where they had been a week in hiding (page 90); Dan Chung recording the terror of a child in Baghdad (page 107). In all these and other instances, the viewer leafing through the

daily newspaper should pause sometimes to reflect on how the photographer got into the position to take the picture.

These digital days, getting the picture back to the newspaper for publication is not the nightmare it used to be, while the risks in taking a picture at all have multiplied. All journalists are at risk in an era of terrorist murder and hostage-taking, but none more than the photographer who inescapably has to walk towards the sounds of gunfire. He cannot move in the shadows, anonymous and observant, as can the reporter. The tools of his trade advertise his presence; where he photographs victims, he is also by definition within the reach of the persecutors who are well aware that the camera lens is an instrument of indictment. When he photographs military scenes, he may be accused of espionage, a risk intensified by the outrageous use of 'journalist' as cover for real spies. Scores of photographers have paid for their profession with their lives. The wars in Indochina claimed 45 reporters – and 135 photographers of different nations. In the invasion of Iraq, about ten photographers and TV cameramen were killed. In the actual invasion, before the insurgencies against occupation, journalists of one kind or another were statistically nearly ten times more liable to die than the fighting men.

The lengths to which a photographer may go to get his picture has a happier illustration. Everybody was ready for the last flight of Concorde, so the question for Lewis Whyld was how he could mark the occasion with more than a routine shot of, say, a wave from the captain or a galaxy of flight attendants. He had the idea of photographing Concorde in flight on its way to its birthplace and final resting place at Filton Airfield when it would pass over the elegant Clifton Suspension Bridge in Bristol, a visual marriage for a moment of engineering triumphs of the 19th and 20th centuries (page 128). But how to do that? Concorde would be gone in a flash. He could stand on the ground with the crowds and shoot through the frames of the Suspension Bridge, but that would emphasize the bridge at the expense of the star of the show. The best thing would be to take the picture from above, but as everyone knows who has tried, the results of taking a photograph of one aircraft through the window of another are rarely satisfactory. Lewis went up in a helicopter and stood on the skids in the open air at 3,000 feet ... and waited for the dot that would become a jet roaring beneath him for a few seconds. It was, as he remarks, unnerving: 'My legs and hands were numb from the cold and the roar of the blades above my head was deafening. Don't overexpose the plane, don't focus on the background, did I even have the right lens on? My camera was too slow for a burst so I panned with the plane and made the shot to include the crowd and the bridge.'

This was a decisive moment, combining news and art. But purely visual moments are among the delights of this book. Tony Bartholomew has fun with the wave dodgers on the front at Scarborough (page 235). The antic comedy of Nils Jorgensen's picture of London bobbies caught in a squall on the Thames is straight out of an Ealing comedy (page 204). Something is happening in these pictures, but in others the visual moments are simply a product of fertile imaginations. Signalling a Harrier jet out of its hangar in Kuwait could well have been very ordinary, but Russell Boyce (page 96) makes poetry out of it with a brilliant use of space and clever cropping so that only the beak of the bird intrudes. Tim Smith drew the unexciting assignment of photographing the decline of the textile industry but made a telling image by

LEFT TO RIGHT
Tim Smith p.153
Tom Pilston p.127
Neil Turner p.253
Kieran Doherty p.318
Tom Jenkins p.274
Shaun Botterell p.282
Michael Crabtree p.196
Stewart Cook p.240

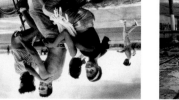
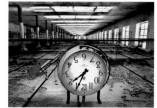

much life the photographers have managed to invest in the
What is most impressive about sports photographs is how
team's victory over Australia in the world cup (page 318)?
sharp focus of the winning drop goal in the English rugby
what might happen. How did Kieran Doherty manage such a
consistency requires knowledge of the sport, anticipating
more of critical moments; sometimes luck helps out, but
grimace expressions. Timing is obviously critical to make
Inevitably, many sports images tend to be the hackneyed grin or
something fresh about the excitement of athletic effort.

Sport is full of drama, but it is not easy to capture
(page 253).
Iris Murdoch when she was in the later stages of Alzheimer's
of Neil Turner's much simpler picture of John Bayley and
space it can get (page 195). I was also moved by the sensitivity
environmental portrait thoroughly deserving of whatever
at her home in Chatsworth Hall, is a fine example of an
formal study of the Duchess of Devonshire, Deborah Mitford,
the page editor is willing to yield. That said, David Sandison's
photographer has, or the subject is willing to give, or space
more time to fuss with lighting and opportunity than the
of Alfried Krupp, lit to emphasize the grotesque, often takes
devastatingly effective as, say, Arnold Newman's photograph
reasons. To take an interesting or revealing portrait as
in the press are merely identifiers, for understandable
press photography, sport one of the stronger. Many portraits
Portraiture seems to me one of the weaker sections of
Pilston's joyous photograph (page 127).
for the dullest caption of the year, but just look at Tom
'Cyclists in Cuba', again, sounds like an entry in a competition
the machines used to be in Bradford's biggest mill (page 153).
focusing on a stopped clock and the sunbeams marking where

routine. Hundreds of button pushers took pictures of the
Commonwealth Games in Manchester in 2002, but I will bet a
pair of my best sweaty sneakers nobody managed something
as witty as *The Guardian's* Tom Jenkins who has Kanukai
Jackson suspended in space for all eternity: he must be,
because there is nowhere for him to land (page 274). The
grouping of the audience in soft focus along a diagonal and the
sheer blackness of the space into which Jackson has plunged
himself all add to a splendid visual moment (it matters not
whether it was a winning vault). Shaun Botterell brings
sophisticated geometry to two swimming events (page 282)
and Scott Barbour to André Agassi's serve (page 295).

Finally, social documentation. This is an area of
photojournalism that has tended to decline in the face of the
more obviously dramatic, so it is good to have included here
two manifestations of the art that are of real merit. They will
both survive for scrutiny by future historians for what they say
about life at the turn of the century. On the one hand, we have
Michael Crabtree's observation of the minutiae of a British
family on holiday in a hut on the beach at Southwold. Call it
'Tea Time' (page 196). On the other, there is Stewart Cook's
attendance at the ceremony where the actress Nicole Kidman
received her star on a Hollywood pavement (page 240). Call it
'Celebrity'. Instead of going for a close-up, Cook took in the
whole scene, Kidman circled by a pack of photographers. Both
these images imprint themselves on the memory in a way that
only a still photograph can. Which is where we came in...

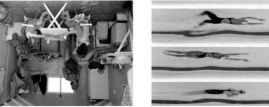
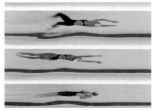
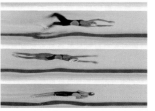
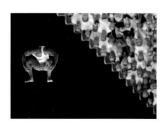

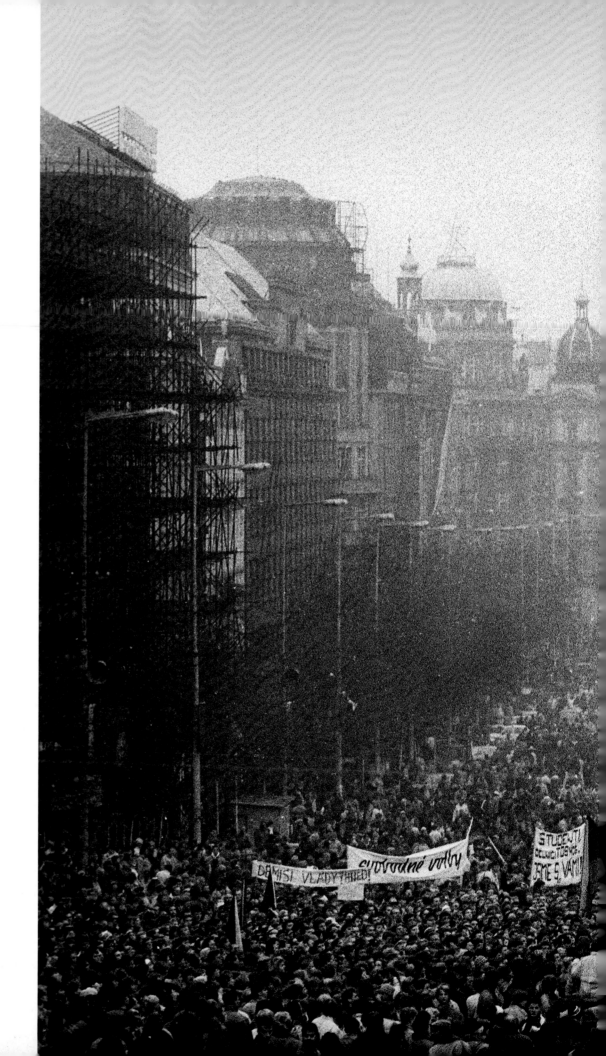

Brian Harris THE INDEPENDENT

The Velvet Revolution, Wenceslas
Square, Prague.
 This was the real end of the World
War II. Every evening for nearly
a week there were up to 500,000
people in the square. In 1968 the great
Czech photographer Josef Koudelka
made an image from this very spot
of an empty square as the population
defied a decree to show themselves
in mass support of the then Soviet-
backed regime. This image was made
in honour of Koudelka and all his
fellow countrymen and women.
November 1989.

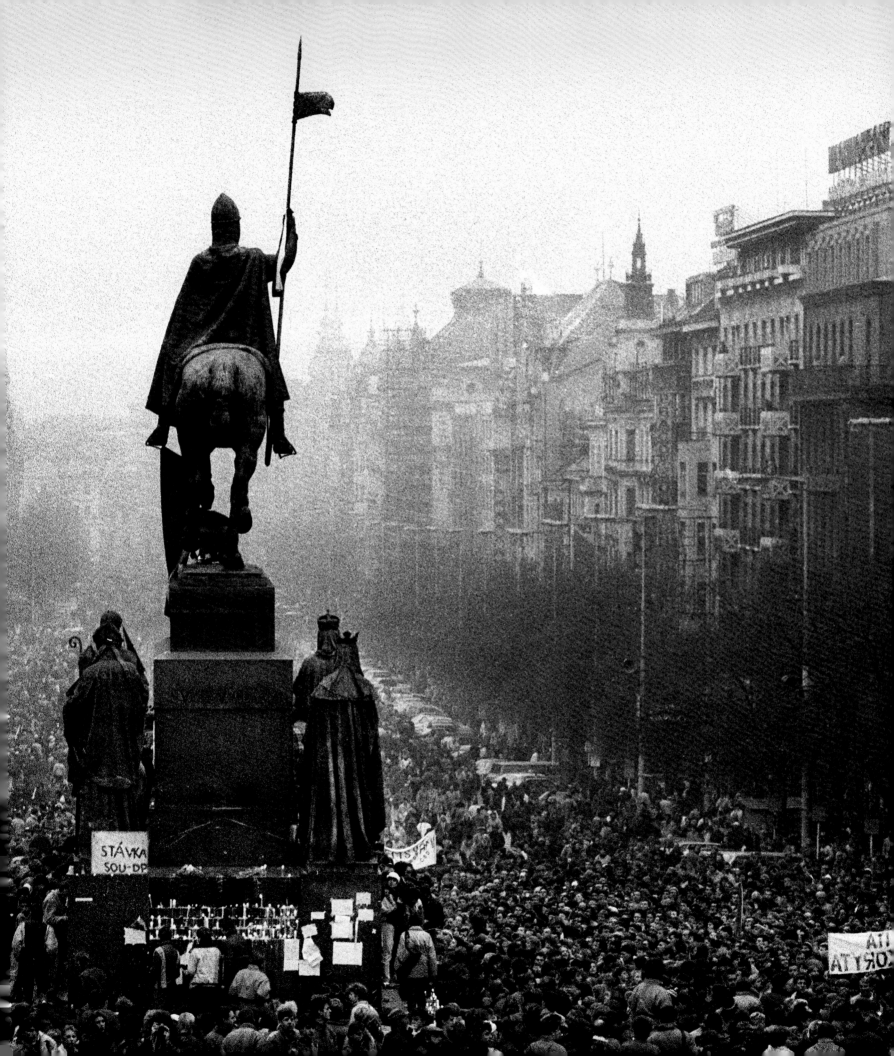

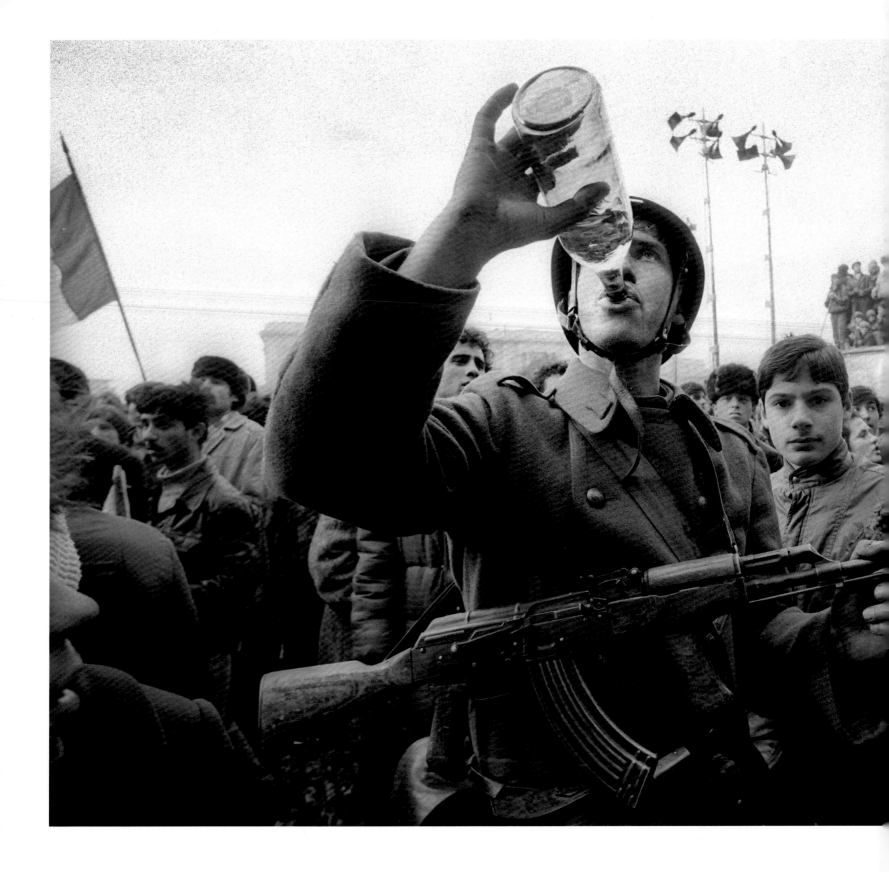

Simon Grosset THE DAILY TELEGRAPH

A soldier drinking water with his
finger over the barrel of his gun
as army and civilians join forces
to overthrow the government of
Ceausescu in Bucharest, Romania.
24 December 1989.

Simon Grosset THE DAILY TELEGRAPH

Soldiers firing back against snipers
from the secret police (*Securitate*),
Bucharest, Romania.
24 December 1989

Simon Grosset THE DAILY TELEGRAPH

Ducking for cover as soldiers fire
back at snipers from the secret
police. Bucharest, Romania.
24 December 1989.

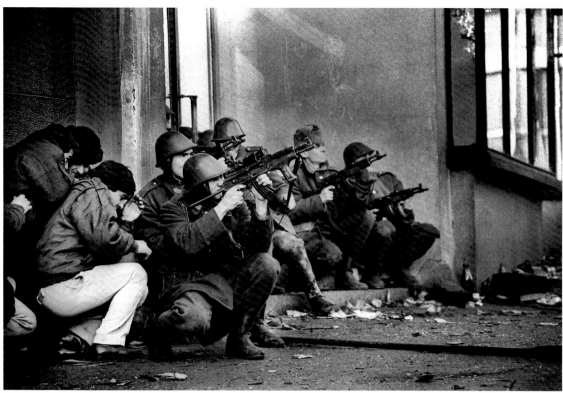

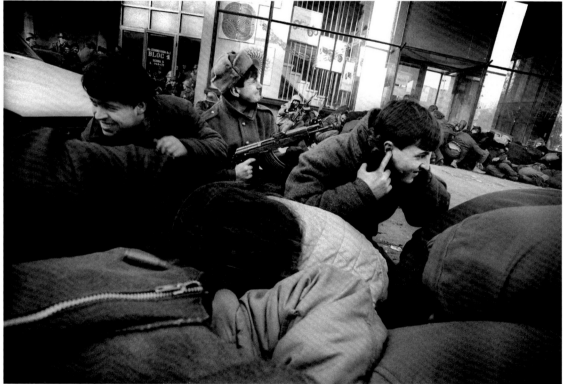

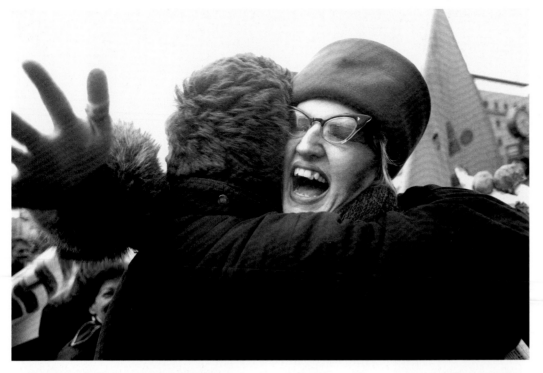

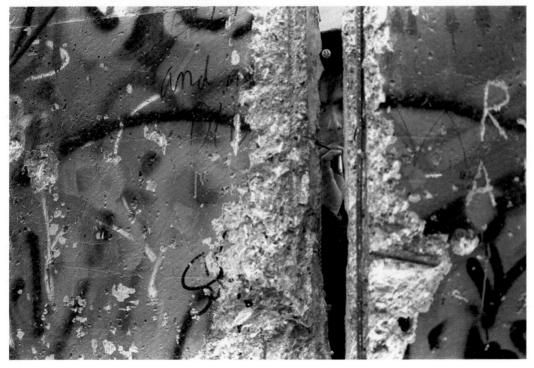

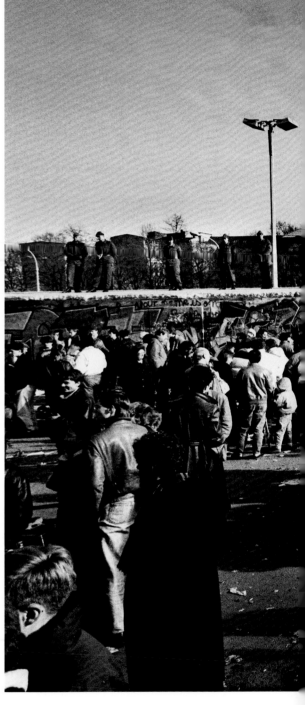

John Angerson

Fellow Berliners embrace during a demonstration near the Berlin wall. September 1989.

Joel Chant

An East German border patrol guard with a Western cigarette which he had exchanged through a hole in the Berlin Wall for badges off his uniform. November 1989.

Brian Harris THE INDEPENDENT

Watched over by East German border guards standing on the wall, West Berliners flock to the wall at the Brandenberg Gate on a sunny Sunday morning. November 1989.

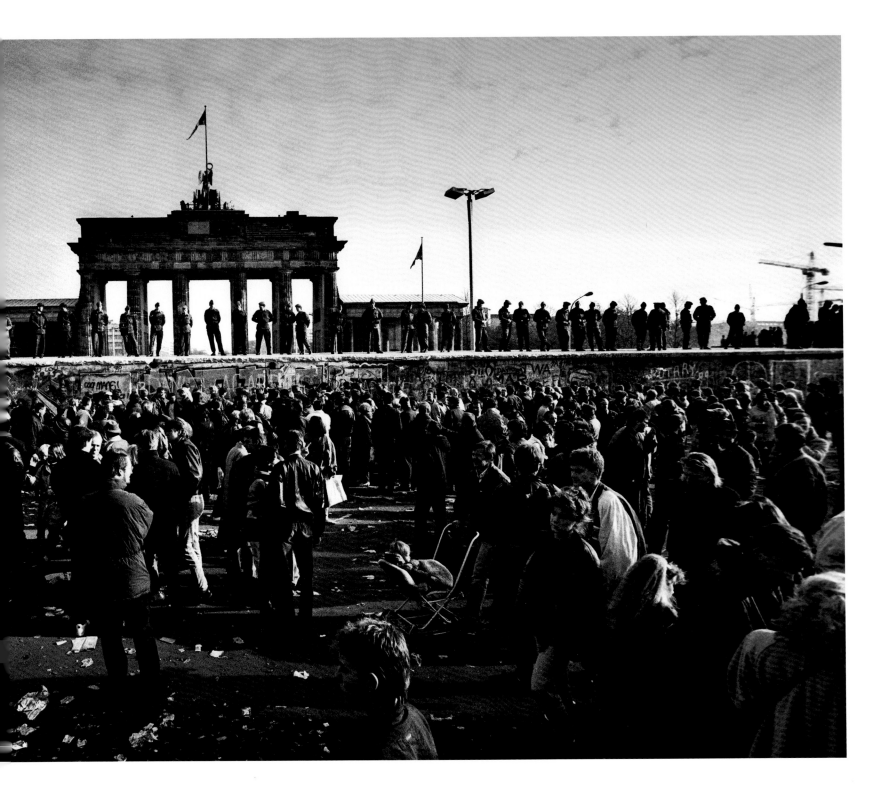

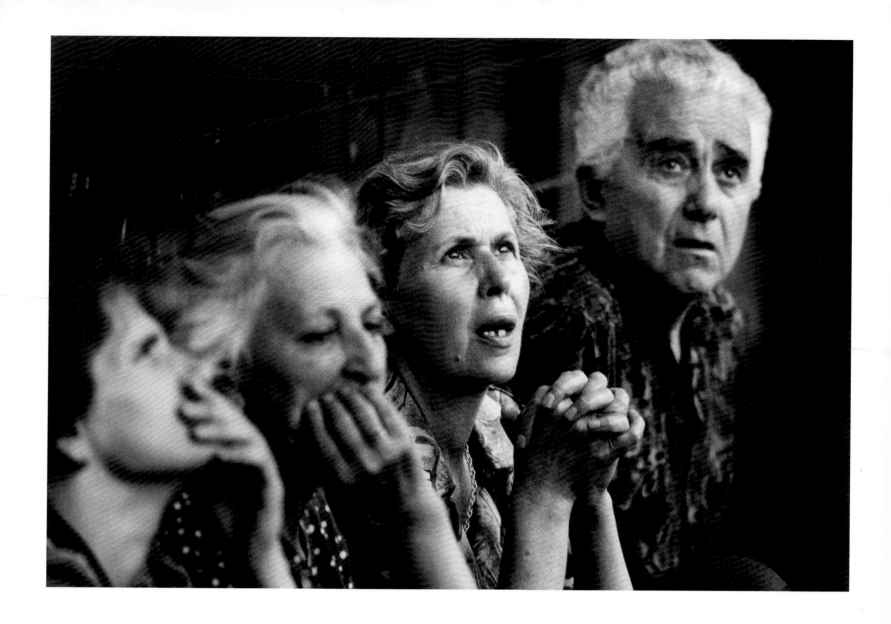

Tom Pilston THE INDEPENDENT

People queuing for water cower at the
sound of Serbian snipers during the
siege of Sarajevo, Bosnia. August 1993.

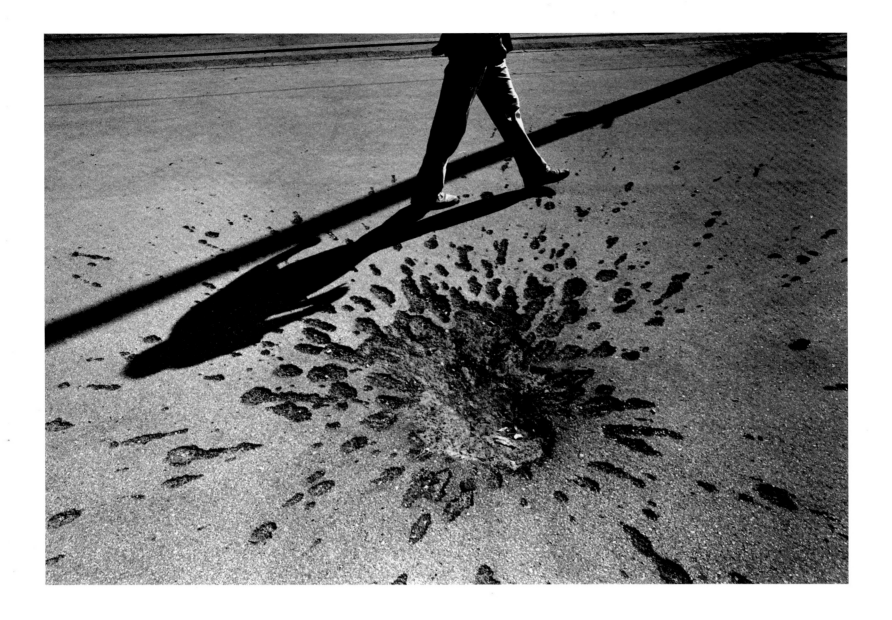

Sean Smith THE GUARDIAN

Mortar shell impact crater on a road
in the centre of Sarajevo, Bosnia
during the siege. October 1991.

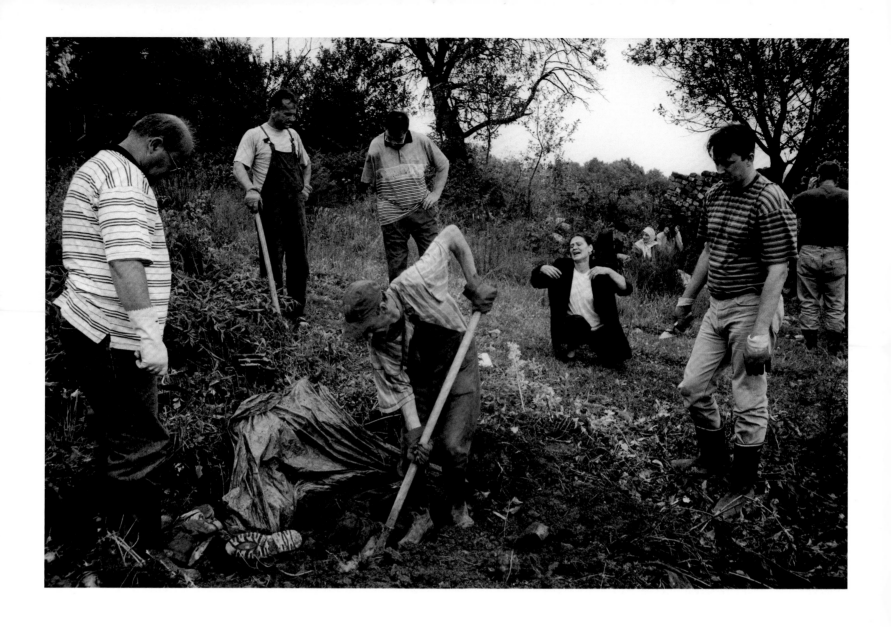

Paul Lowe PANOS PICTURES

Survivors of the Huric family watch as the bodies of their menfolk, Zuhdija (28), Bego (40) and Camil (63) are exhumed. They were shot on their doorsteps by Serbs from the next village at the beginning of the war in 1992. The survivors then went to Srebrenica, where they spent the war until the massacre of 1995. They are now trying to return to their village to live again. Up to seven thousand men and boys were massacred by the Serb forces after the failure of the UN troops to provide adequate protection. June 2000.

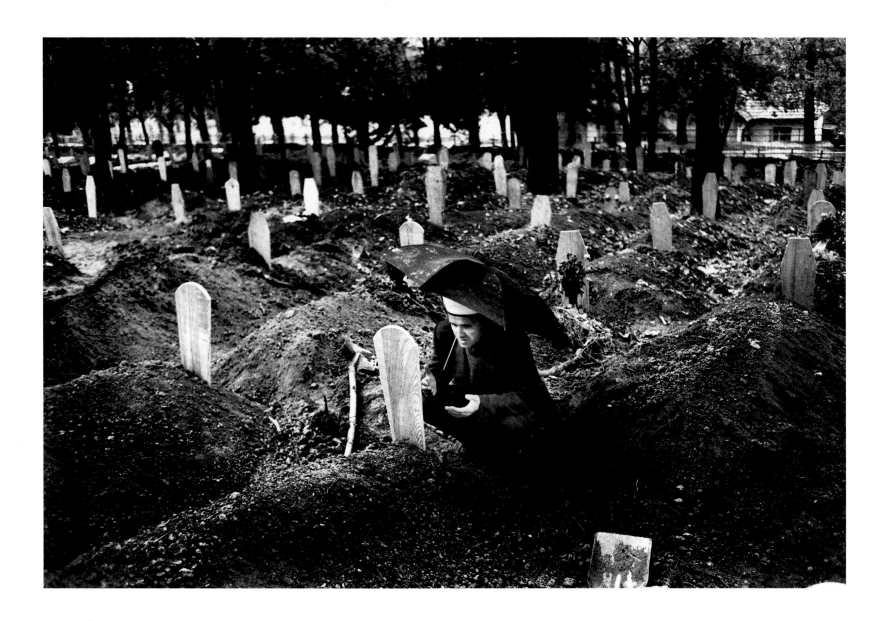

Sean Smith THE GUARDIAN

A Muslim prays at the side of a grave
in a public park in Sarajevo which,
along with a neighbouring football
pitch, had become a cemetery due
to the overwhelming number of
casualties. October 1991.

HARD NEWS

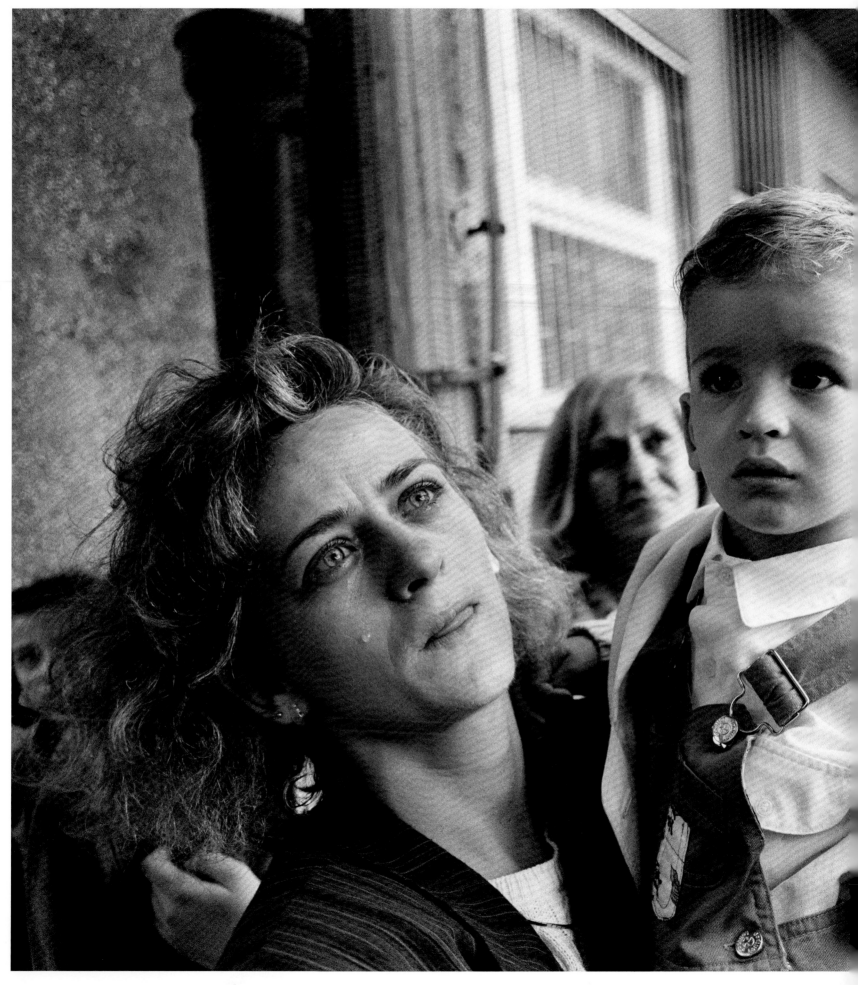

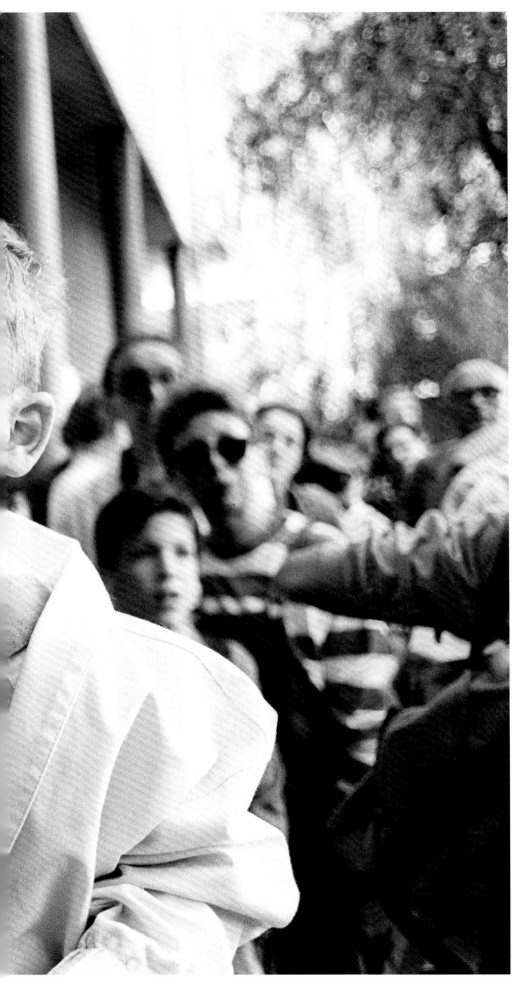

Tom Stoddart IPG

Tears of anguish for a Sarajevo mother as she prepares to send her confused child out of the city on a bus promised safe passage by the surrounding Serb forces. During the 47-month-long siege, many families were torn apart as they evacuated their children to safety outside Bosnia. July 1992.

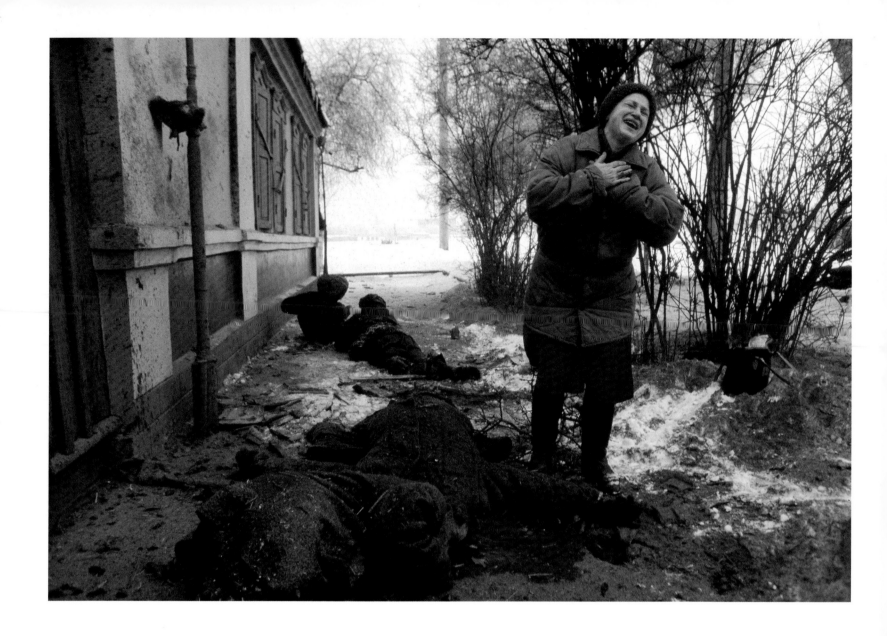

Jon Jones SYGMA

A woman cries in anguish as her friends and relatives lie dead and wounded on a street in Grozny. The Russian army had shelled the civilian area as the people were waiting for bread. January 1995.

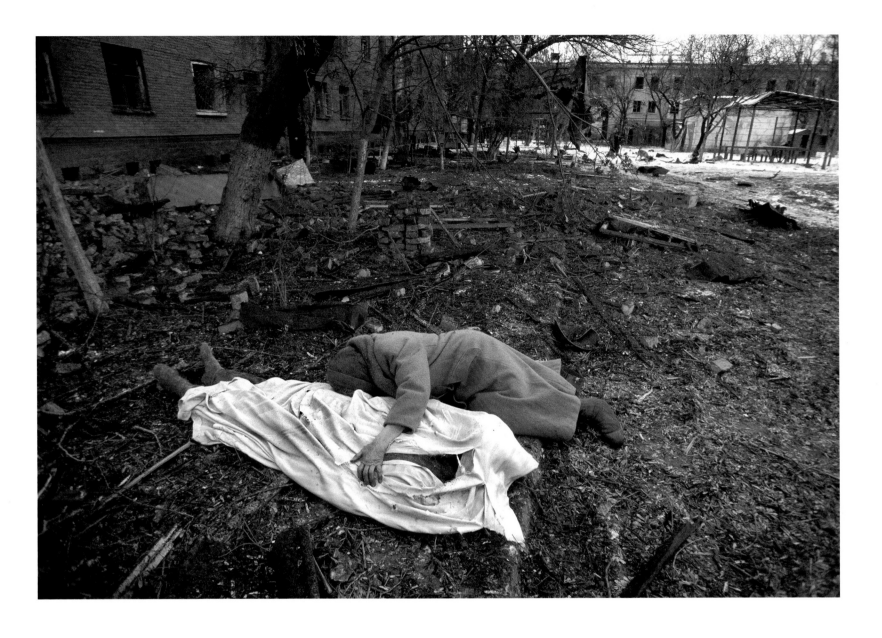

Paul Lowe PANOS PICTURES

A Russian grandmother cries over the
body of her husband. Her daughter
and granddaughter were also killed.

In December 1994 Russian troops
entered Chechnya in an attempt to
quash the country's independence
movement. Early promises of a
quick victory were soon silenced as
the Chechens put up fierce resistance
to the Russian assault and the death
toll mounted. Up to 100,000 people
– many of them civilians – are
estimated to have been killed in the
twenty-month war that followed.
December 1994.

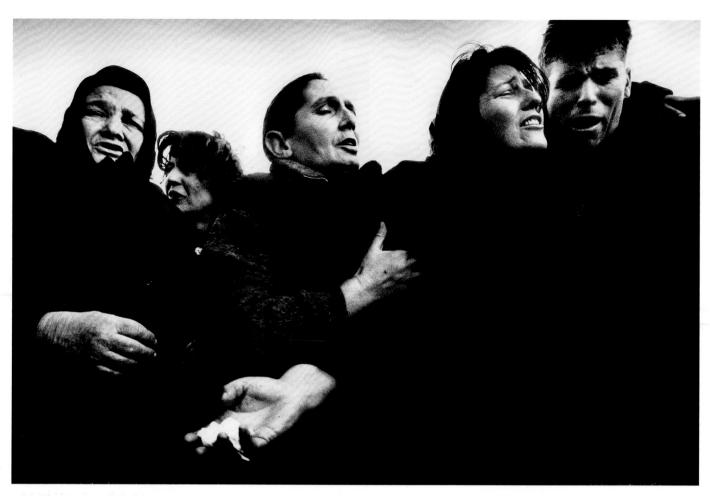

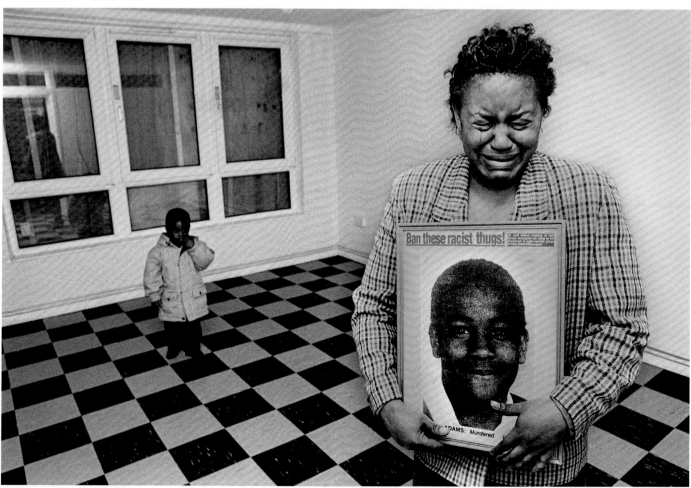

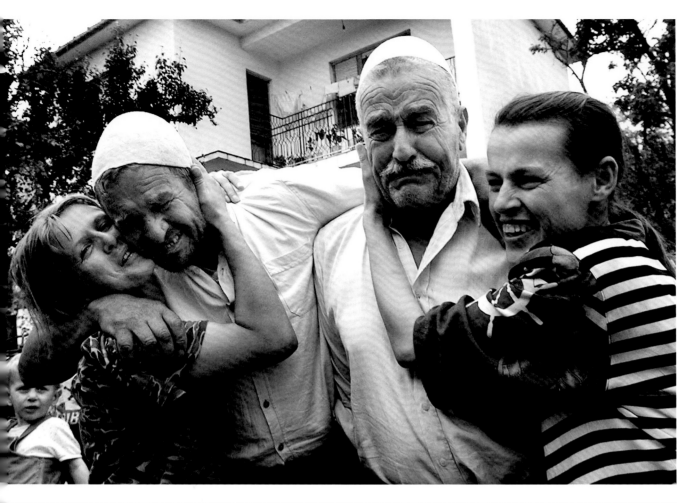

OPPOSITE PAGE
David Rose THE INDEPENDENT

A family mourns the death of a son, a Serbian policeman in Goradevic, a town in a Serbian enclave of Kosovo. March 1998.

Peter Jordan

Lorna Blackwood holds a picture of her murdered son Rolan Adams who was stabbed to death in a racist attack in Thamesmead, south-east London in 1991. Lorna was moved into temporary accommodation and all her belongings put in storage whilst her flat in Brixton was being renovated by Lambeth Borough Council. During this time, the council took everything in storage including all her mementoes of her dead son except the photo she is holding and dumped them in a landfill site. I went to photograph her back in her Brixton Hill flat with her other son Adon to show what the council had done to her and what belongings she had left. 7 June 1994.

THIS PAGE
Eddie Mulholland THE DAILY TELEGRAPH

Rafiz Gashi (left) is greeted by members of his family after their return in June 1999 to the village of Begrace, Kosovo from Macedonia where they had been sent by Rafiz to escape the fighting.

To get this story, reporter Sally Pook and I had to wait at the border till we found a likely subject, then get a taxi to follow the returning family to their village. The taxi driver was not impressed by the drive down dirt tracks which everyone at the time thought had been heavily mined by Serbian troops. We made sure the car we were following was well ahead of us for the dodgiest-looking parts of the route. 18 June 1999.

David White

Funeral for Kursk submariners who died on 12 August 2000, Serafimskoe Cemetery, St. Petersburg, Russia. Wives and families grieve by the graveside of a sailor as his body is lowered into the ground, 18 months after the submarine exploded, killing all 118 men on board. The delay in burial was due to botched rescue attempts and governmental worry about the disclosure of naval secrets. March 2002.

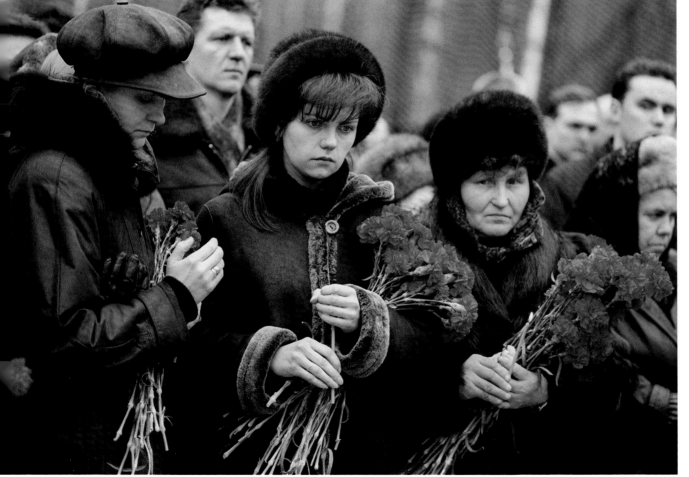

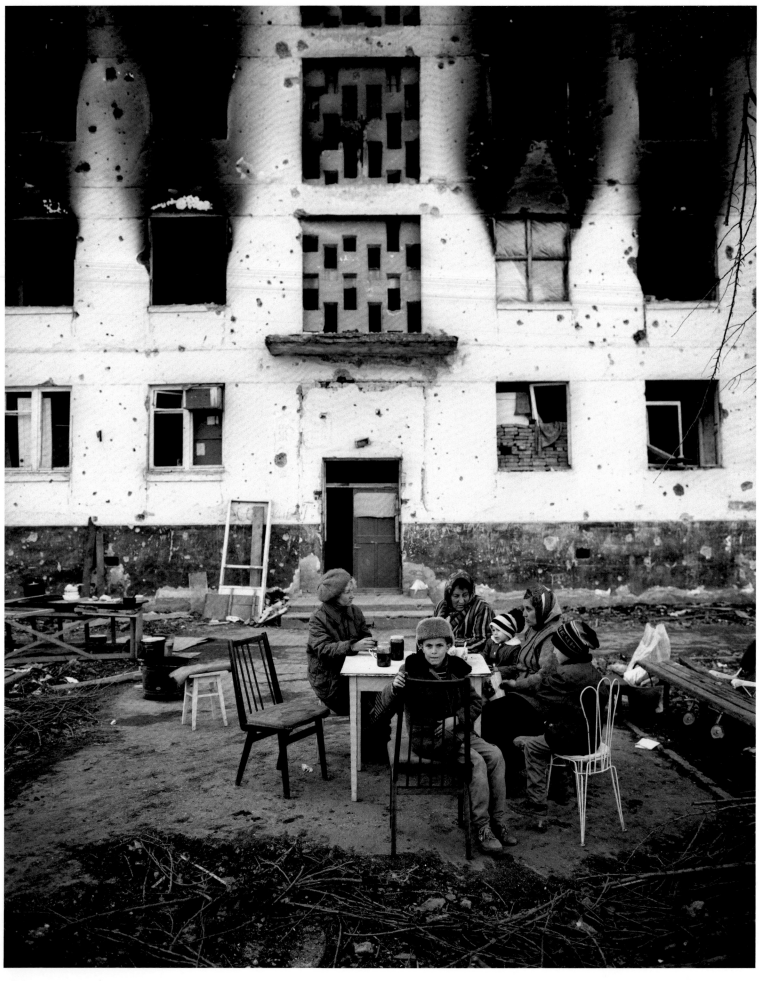

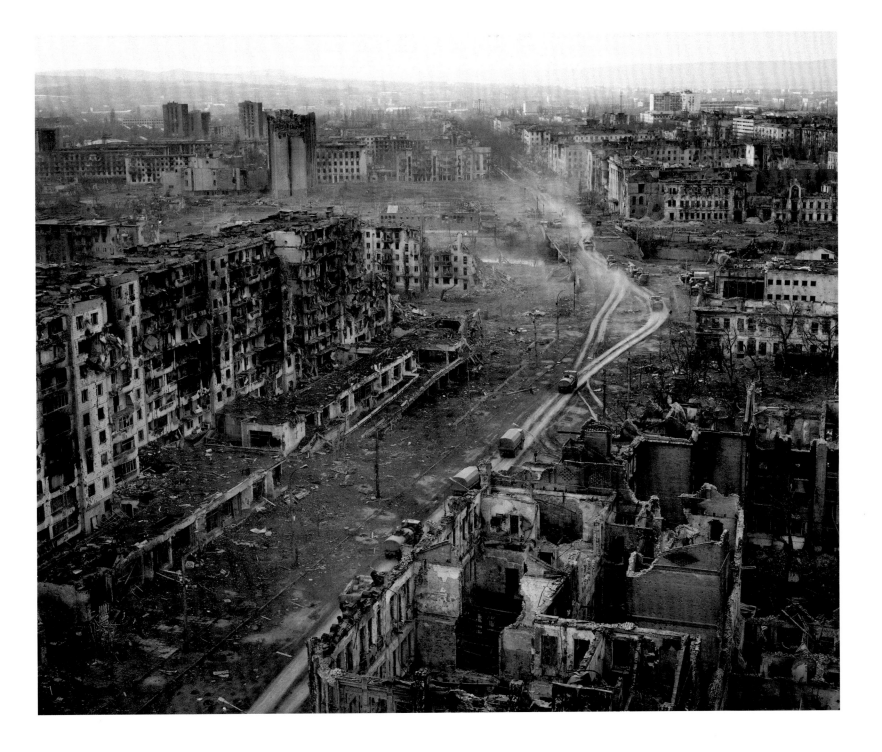

Jeremy Nicholl

A family eats lunch outside their
ruined apartment block after rebel
forces retreated from the city in the
face of a Russian bombardment which
killed tens of thousands of people.
Grozny, Chechnya. March 1995.

Jeremy Nicholl

A Russian military column makes its
way through the ruined city centre
after Chechen rebels retreated in the
face of a bombardment that killed
many thousands of people.
March 1995.

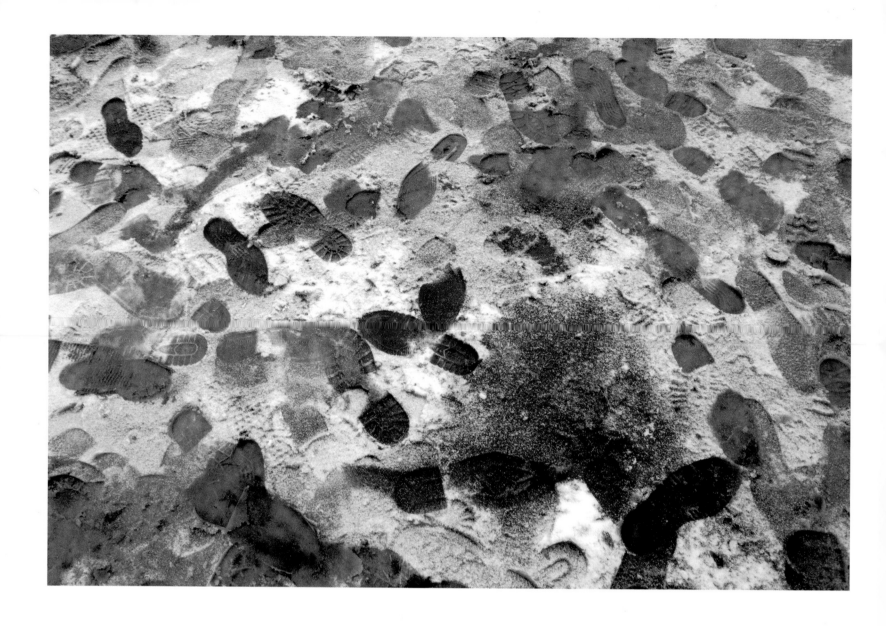

Paul Lowe PANOS PICTURES

Bloody footprints in the snow
following a Russian attack which
killed the civilian driver of a car
in Grozny. December 1994.

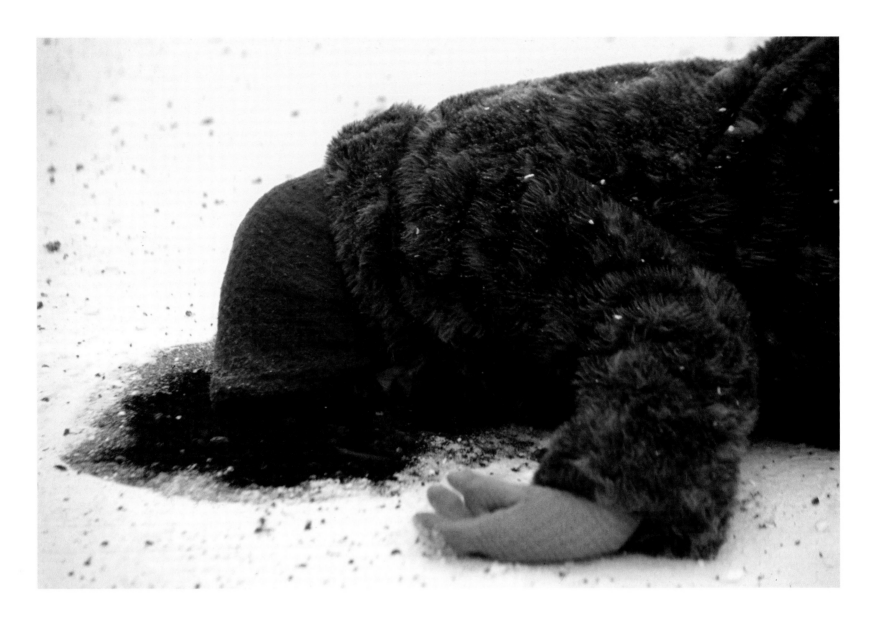

Jon Jones SYGMA

An old woman lies dead on the streets
of Grozny after the Russian army had
shelled the civilian area. January 1995.

HARD NEWS

Justin Sutcliffe SUNDAY TELEGRAPH

A hostage, stunned by gas, slumps
against the window of a bus after
Russian special forces stormed the
Nord Osk Theatre in Moscow ending
a siege by Chechen terrorists.
October 2002.

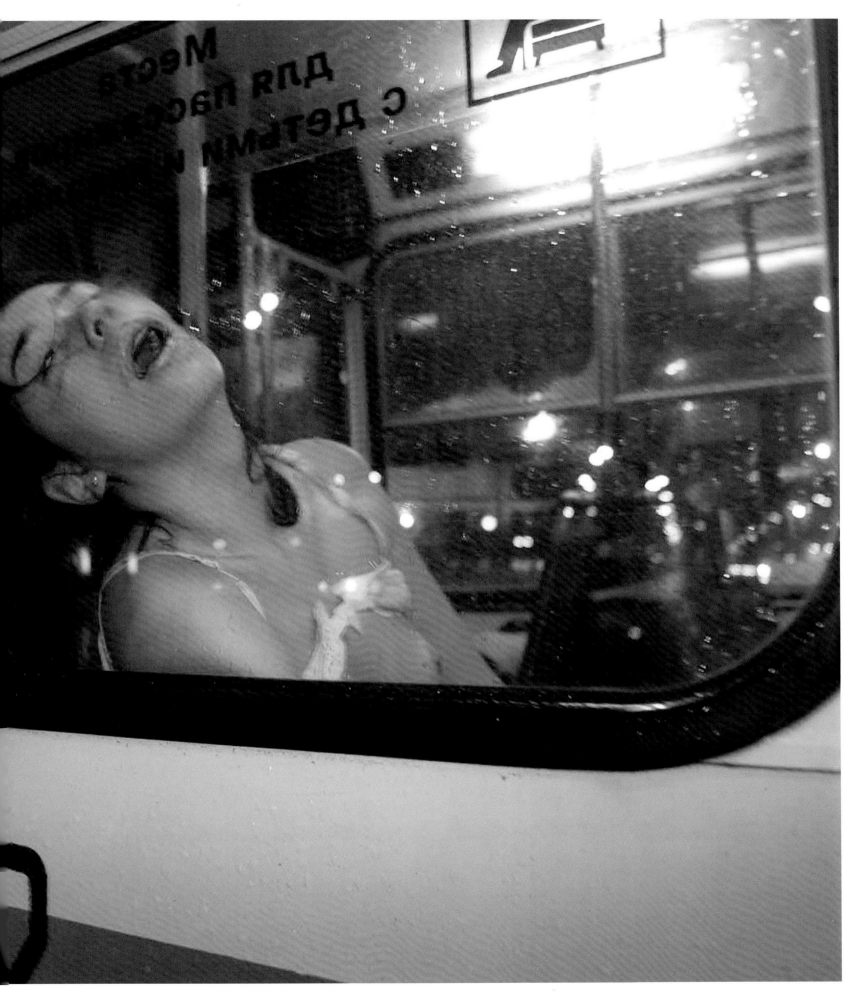

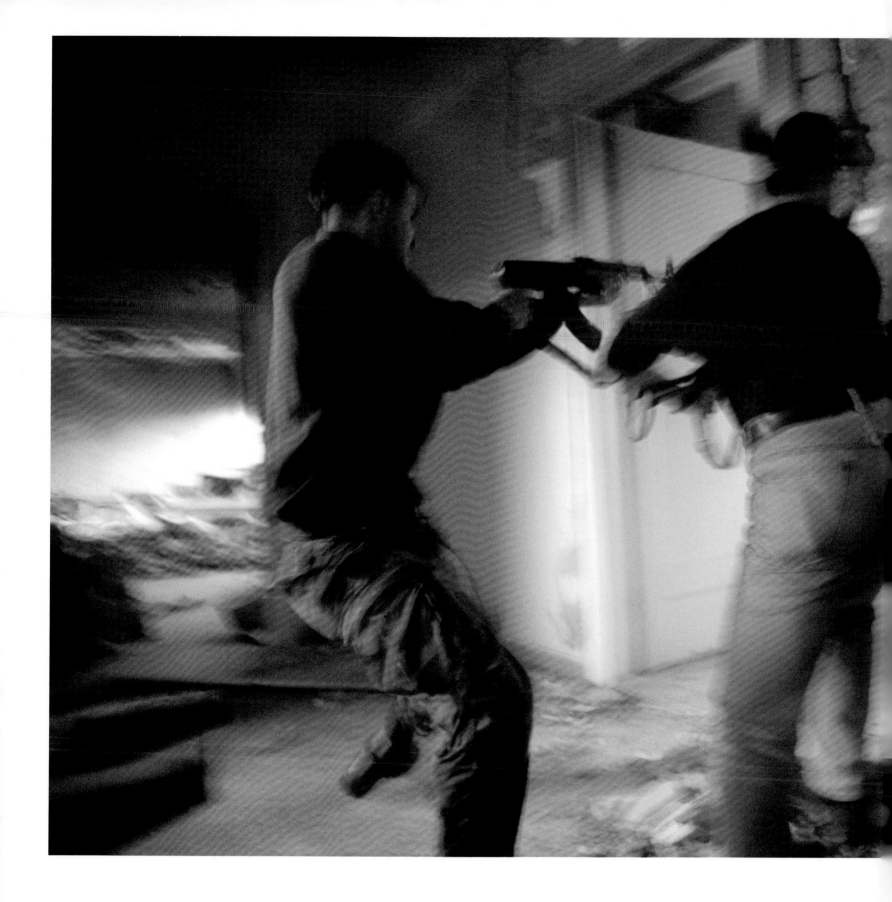

Jon Jones SYGMA

Croat soldiers house-to-house fighting in Mostar during the Bosnian war. May 1993.

Jeremy Nicholl TIME MAGAZINE

A Chechen fighter prays near the front line as Chechen rebels and Russian forces fight for control of Grozny, the capital city, after the Russian republic declared independence. January 1995.

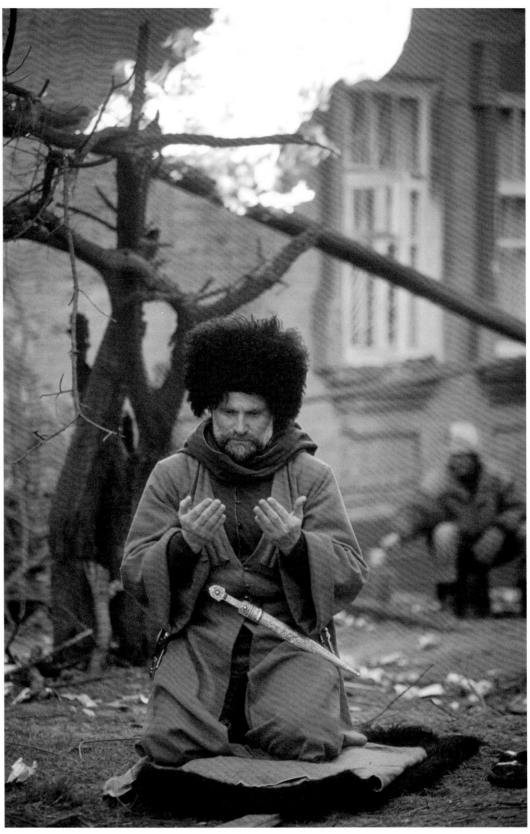

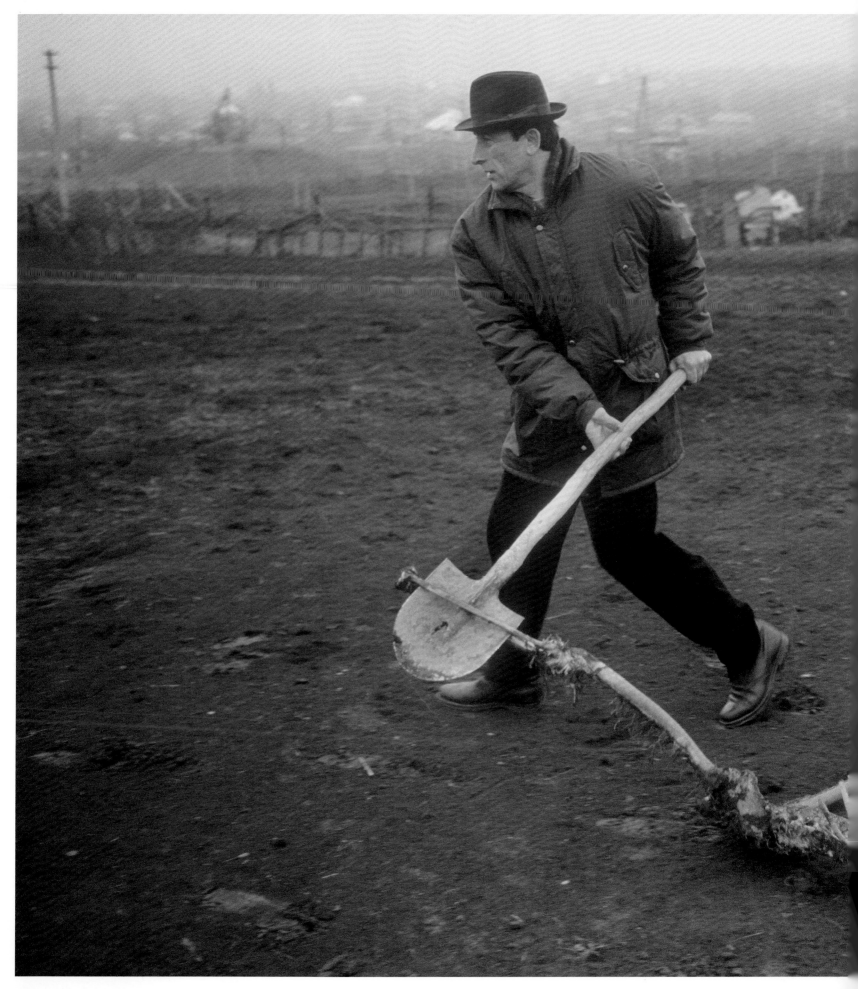

Jeremy Nicholl TIME MAGAZINE

A Chechen villager buries the remains of a Russian soldier whose body was eaten by stray dogs. He was killed in battle on the outskirts of Grozny as Chechen rebels and Russian forces fought for control of the capital city after the Russian republic declared independence. January 1995.

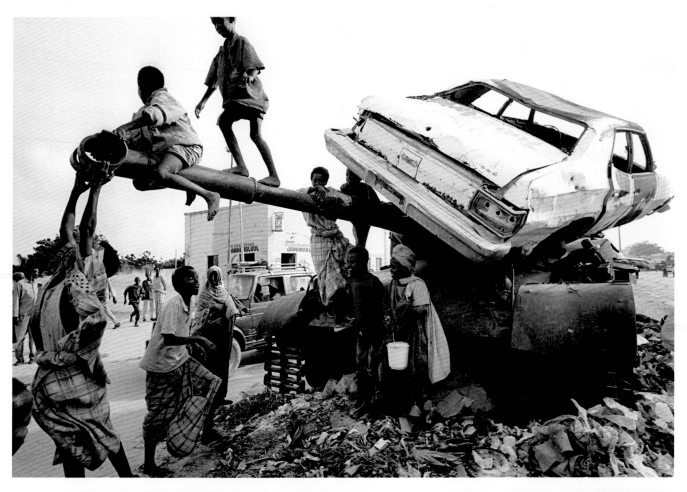

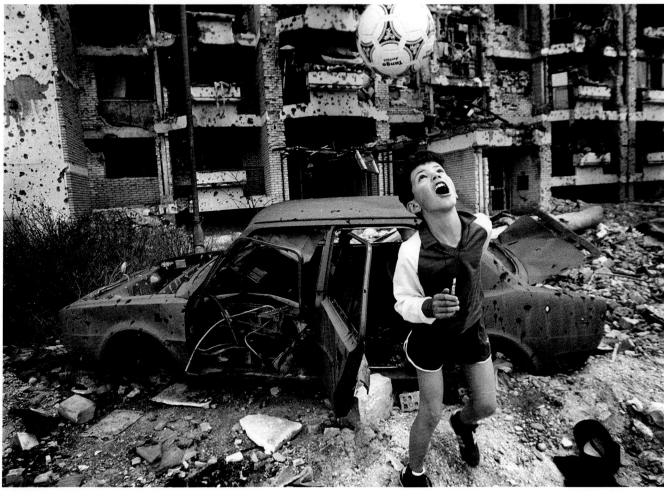

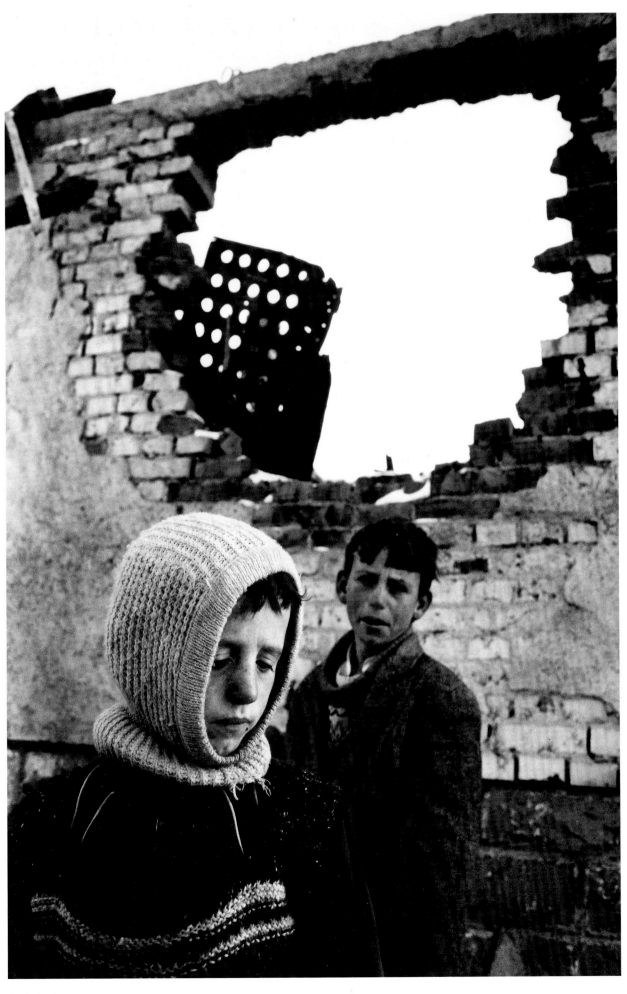

OPPOSITE PAGE
Paul Lowe PANOS PICTURES

In 1991 Somalia's President Barre
was overthrown by opposing
clans, but they failed to agree on
a replacement and plunged the
country into lawlessness and clan
warfare. In December 1992 US
Marines landed near Mogadishu
ahead of a UN peacekeeping force
sent to restore order and safeguard
relief supplies. The US forces
withdrew in 1993 following the
debacle of the infamous 'Black
Hawk Down' battle. August 1992

Mike Moore THE DAILY MIRROR

A young boy plays in the streets
of war-torn Sarajevo. March 1997.

THIS PAGE
Andy Hall

A Kosovan-Albanian boy stands
outside his former home, which
was shelled by Serbian forces in
the Drenica Valley, Kosovo.
December 1998.

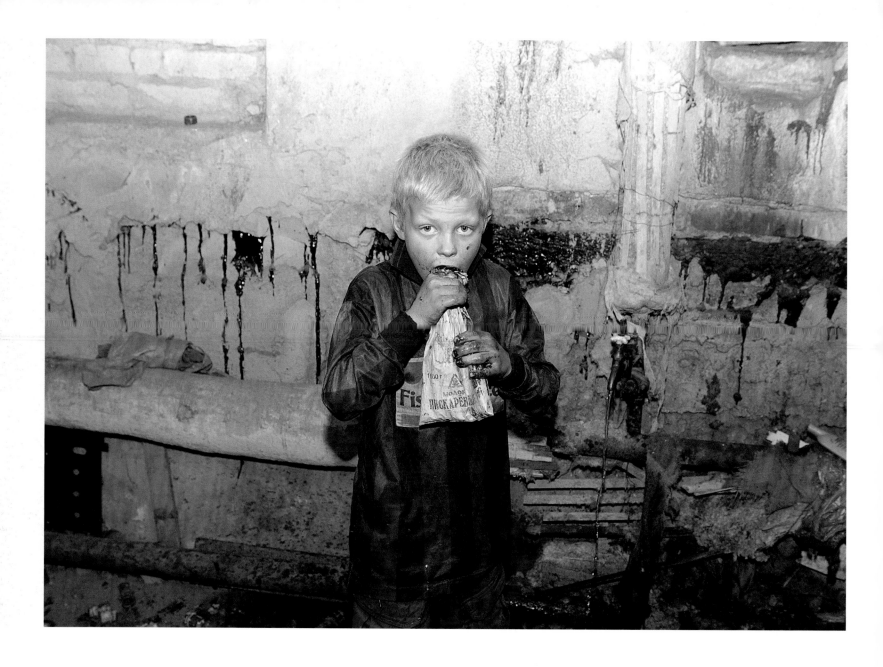

Mark Stewart CAMERA PRESS

A nine-year-old street child sniffing glue in his fume-filled cellar home in St. Petersburg, Russia. The photograph was taken while covering a trip taken by Sarah, Duchess of York and her daughter Princess Beatrice to see the work undertaken by her charity, Children in Crisis. 11 July 2002.

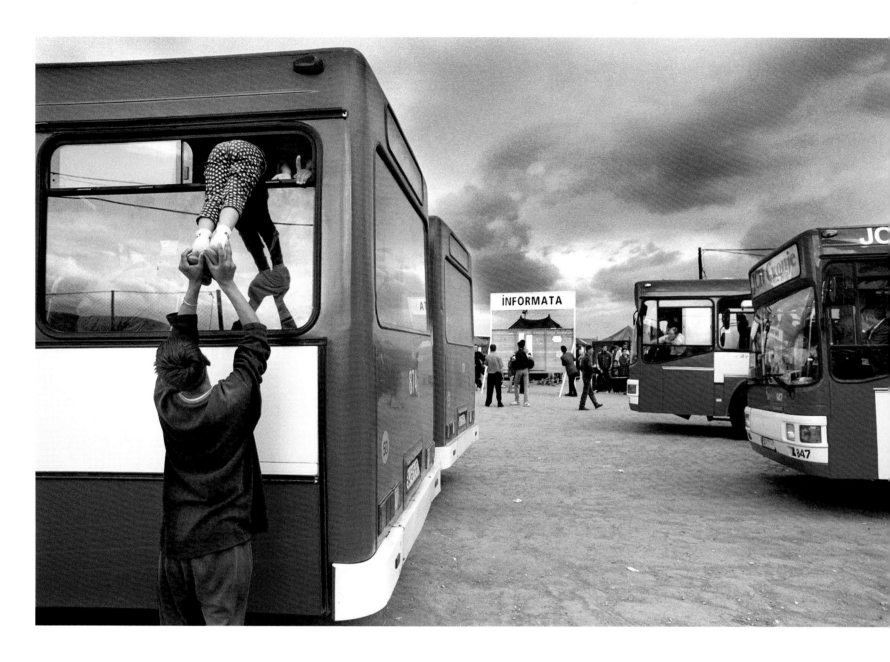

Ben Gurr THE TIMES

A child is given a helping hand to get
an early hug from her relatives, newly
arrived in another convoy of buses full
of Kosovan refugees at Brazde Refugee
Camp in Northern Macedonia.
24 May 1999.

HARD NEWS

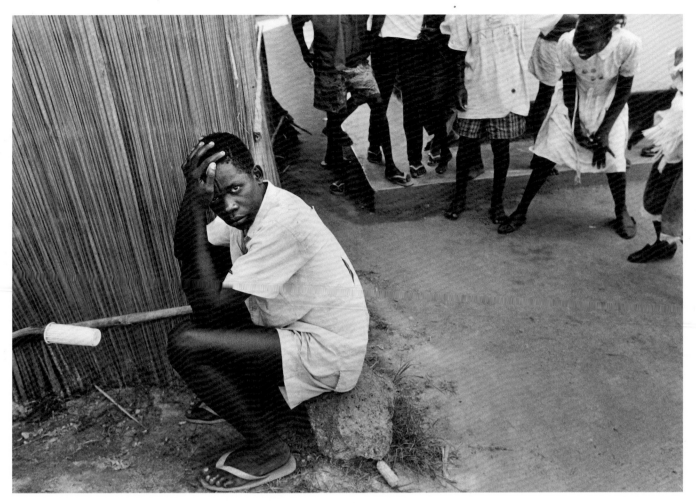

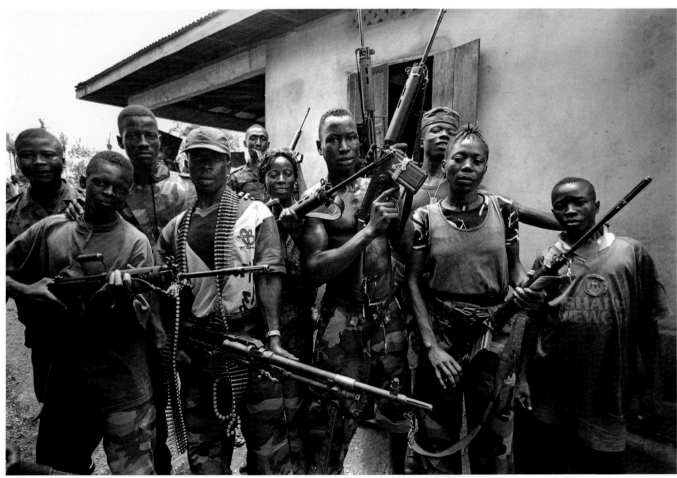

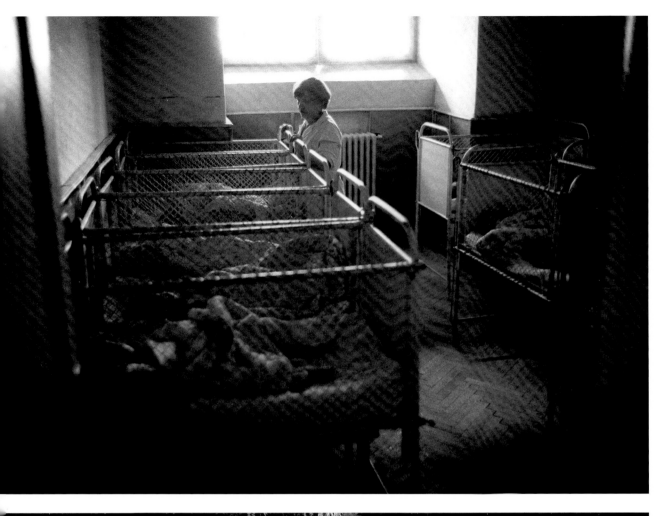

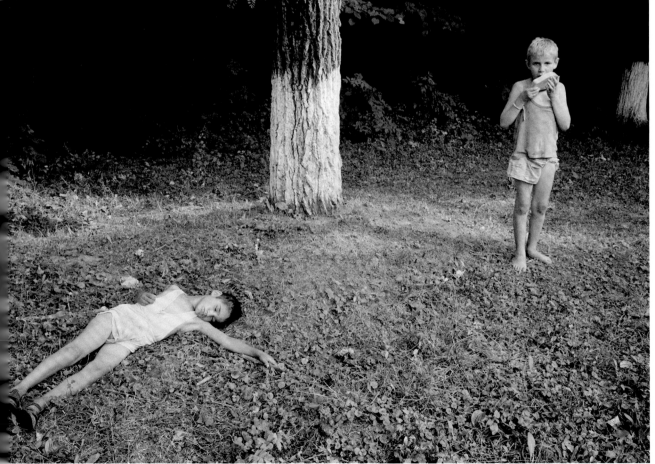

OPPOSITE PAGE
Stuart Freedman NETWORK PHOTOGRAPHERS

Gulu, Uganda. 'Edward', 16, is so deeply traumatized by what he has done and witnessed as a soldier for the Lord's Resistance Army that he is unable to mix with other children. At night, like many of his contemporaries, he wets the bed and recounts his experiences as he sleeps. August 1997.

David Rose THE INDEPENDENT

Fighters belonging to one of the many militias in Sierra Leone. The 'West Side Boys' were fighting for control of the town of Lunsar. June 2000.

THIS PAGE
Nobby Clark

A Romanian orphanage. April 1990.

John Angerson

Tatarai Hospital, Romania. Under the brutal regime of Ceausescu, children's institutions were often found in secret locations. Local maps were altered to such an extent that nearby villagers were completely unaware of the existence of the buildings. Children of all ages and a range of disabilities were sent here. They lived a life of hopeless despair with little or no care and very basic levels of hygiene. November 1990.

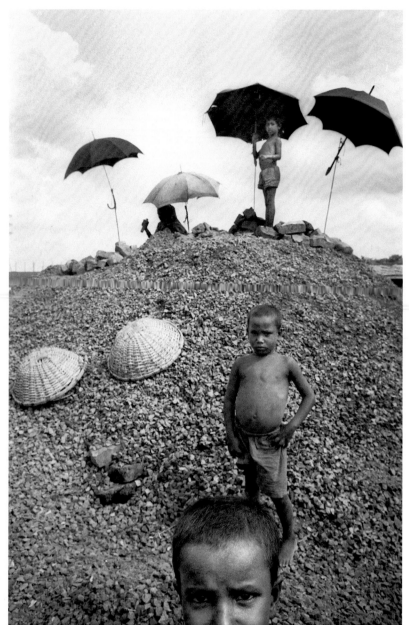

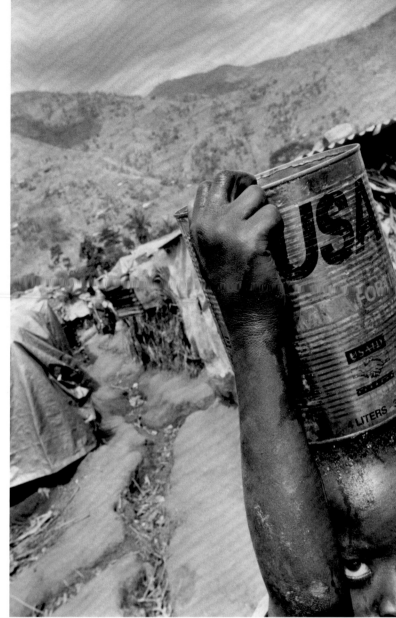

Sean Smith THE GUARDIAN

Child labourers in Dhaka, Bangladesh
breaking stones into gravel for the
construction industry.
September 1997.

Stuart Freedman NETWORK PHOTOGRAPHERS

A child carries water to Buhinga
regroupment camp in Burundi, where
his family have been forced to live.
June 2000.

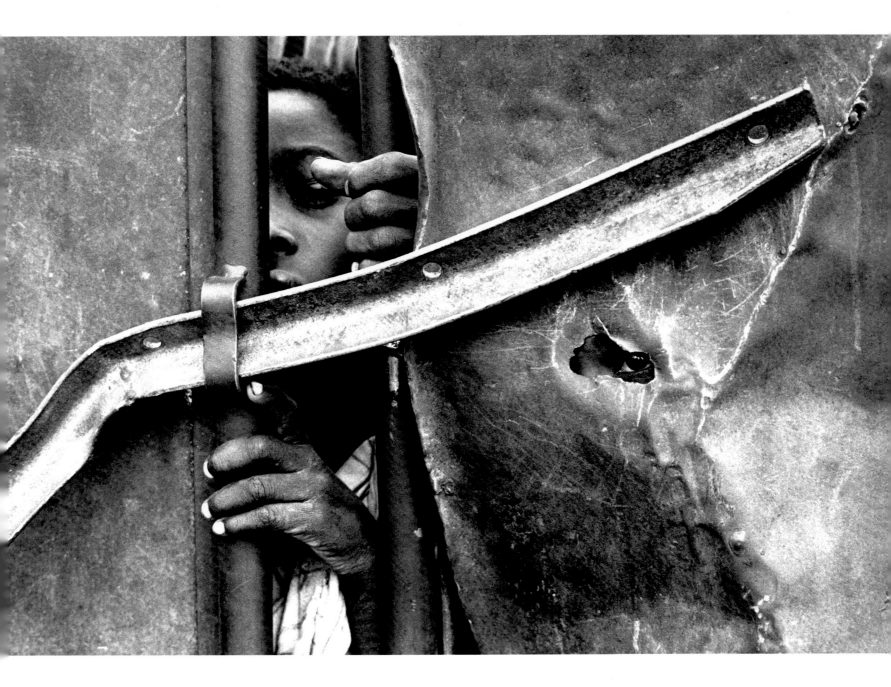

Paul Lowe PANOS PICTURES

Starving children looking through the
gates of a feeding centre in Somalia.
August 1992.

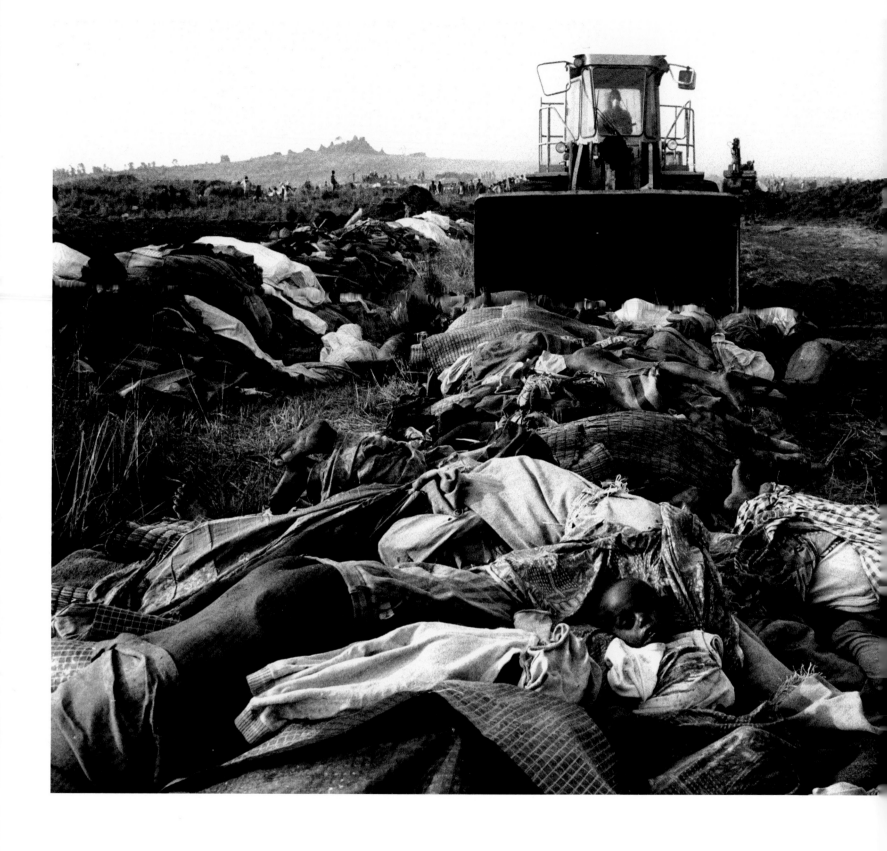

Philip Coburn

Mass burial of Rwandan refugees at Kubumba camp, Goma, Zaire. The displaced Rwandans thought that the camps were places of safety, but disease spread like wildfire. The people in this picture died of cholera:

it is estimated that 30,000 refugees succumbed to the epidemic in three or four weeks. I was shooting almost exclusively on colour film but began to feel that what I was taking was too lurid. On the day I took this picture I

felt that black and white would be more appropriate for the horror of the subject, so I borrowed a roll. Back in England, however, I forgot about it and this picture lay in a drawer for ten years unprinted. August 1994.

Philip Coburn

Camp for Rwandan refugees who had fled the mass killings and civil war, Goma, Zaire. August 1994.

Jon Jones SYGMA

Refugees on the road, returning from Zaire to Rwanda after years of exile. November 1997.

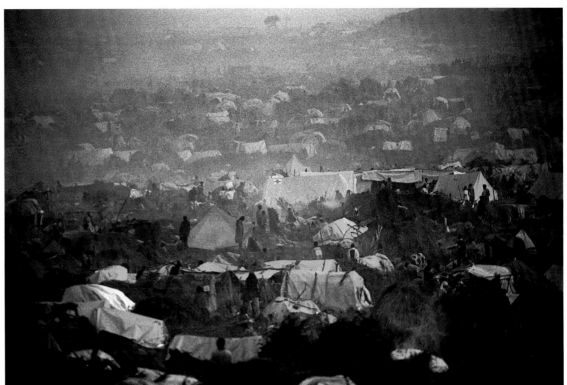

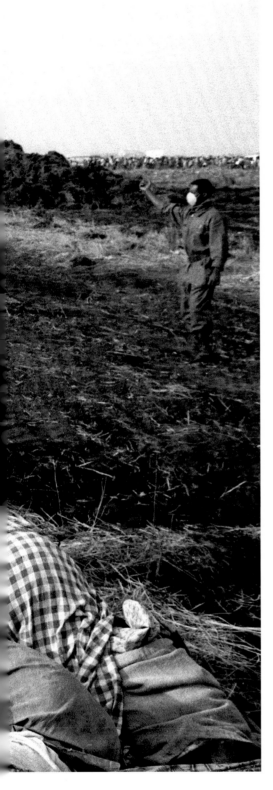

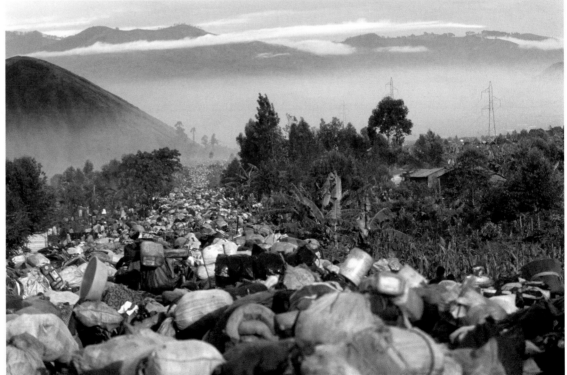

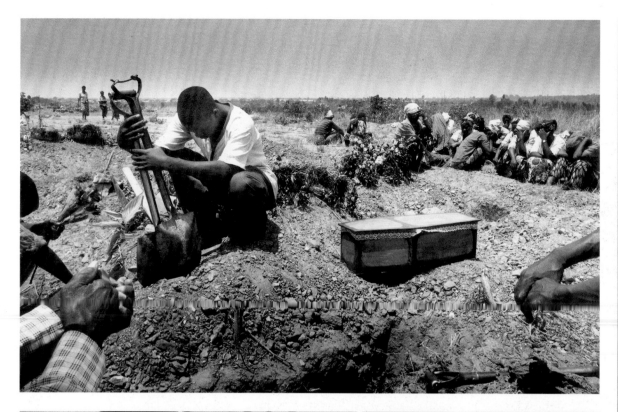

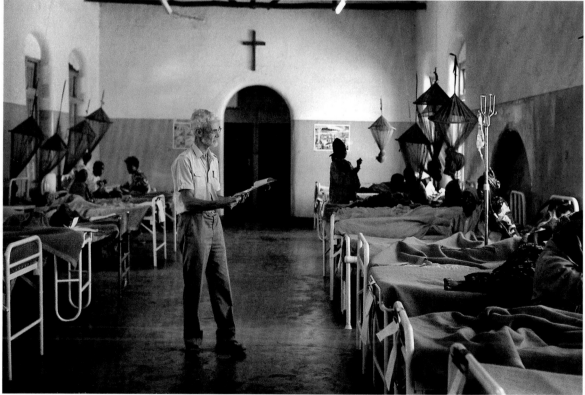

Tom Pilston THE INDEPENDENT

Zambia. Prayers at the funeral of another of Africa's children killed by AIDS. November 1999.

David Sandison THE INDEPENDENT

Sandie Logie, a Scottish doctor, returns to the ward in St. Francis Mission Hospital in Zambia where six years before a slip of the hand left him infected with HIV. More than 80% of patients in the hospital have AIDS.

He had returned to Africa to highlight the difference between first world and third world medicine. September 1999.

Jon Jones SYGMA

A boy tries to eat in an abandoned classroom during the Sudan famine. March 1993.

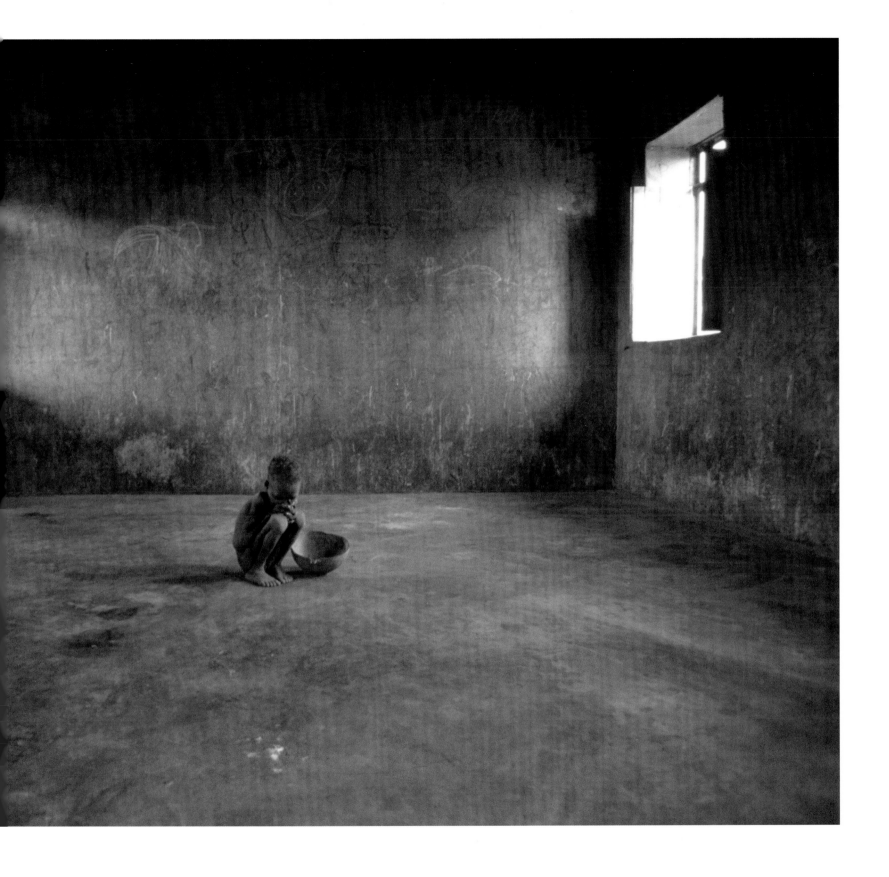

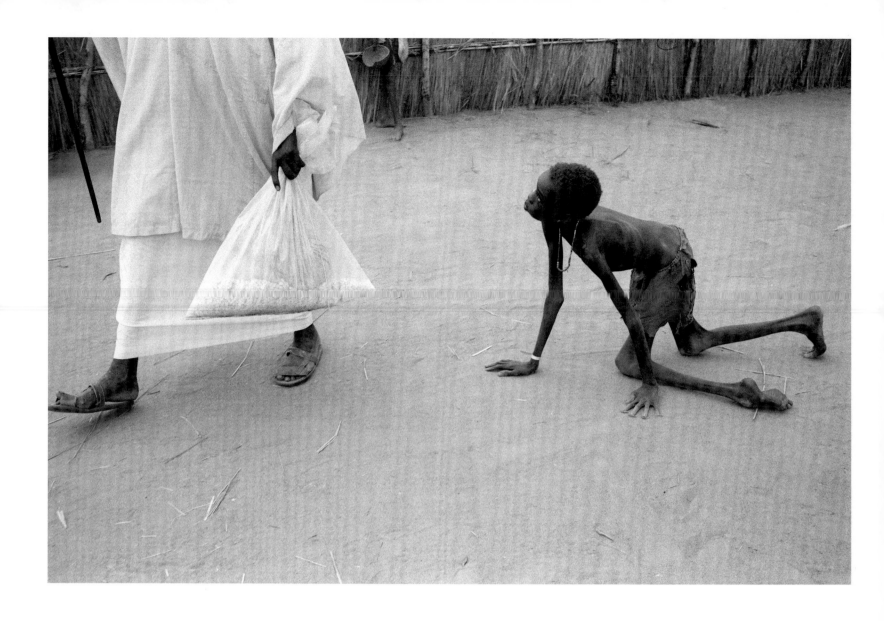

Tom Stoddart IPG

A child looks on pitifully as a
relatively rich local man walks off
with a precious bag of maize that he
had spent hours waiting for at the
emergency feeding centre, Ajiep,
Sudan. July 1998.

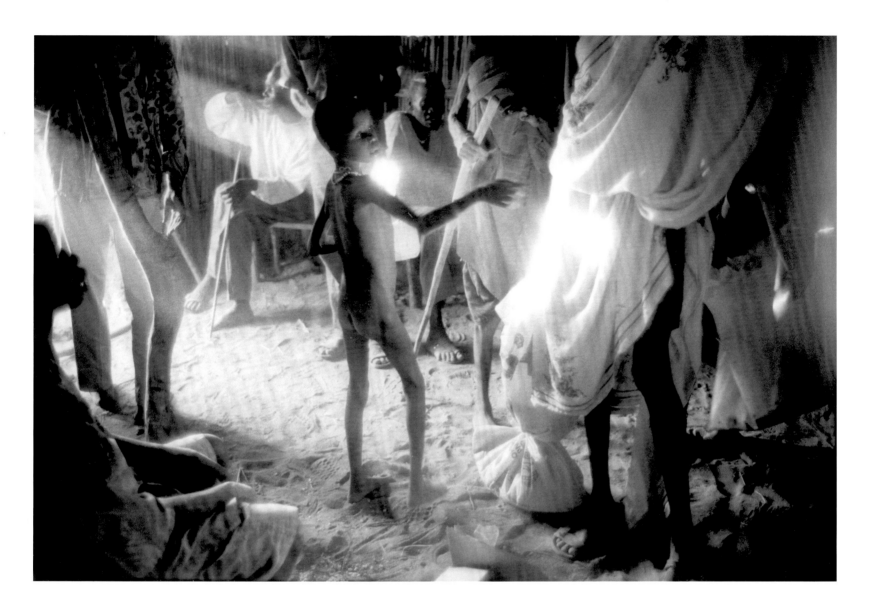

Stuart Freedman NETWORK PHOTOGRAPHERS

A starving child waits for food at
the MSF feeding centre, Ajiep, Sudan.
August 1998.

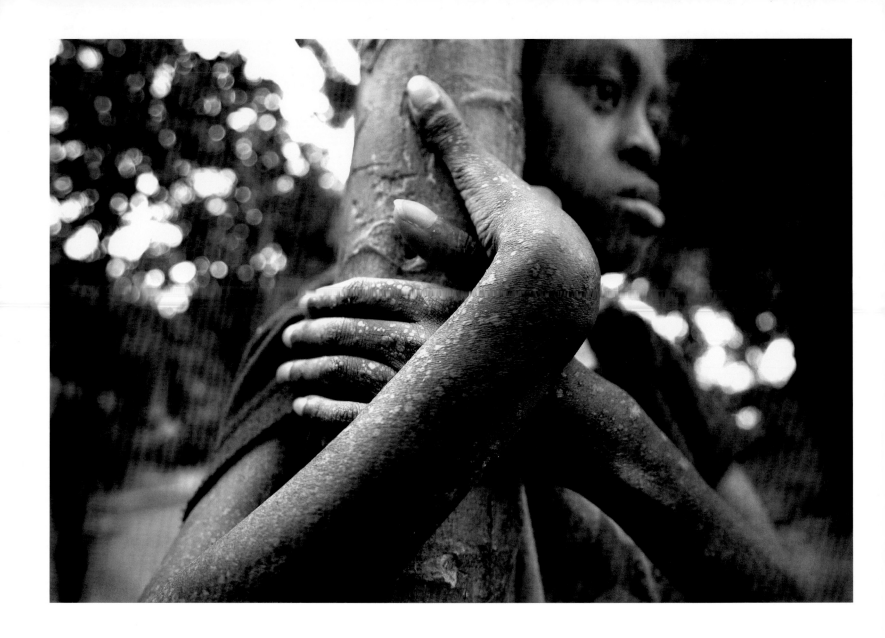

Abbie Trayler-Smith

Twelve-year-old AIDS victim
Mutiendie Amon. His parents have
died from AIDS and he is now looked
after by his grandmother in Sironko
district, Mbale, Uganda.
November 2002.

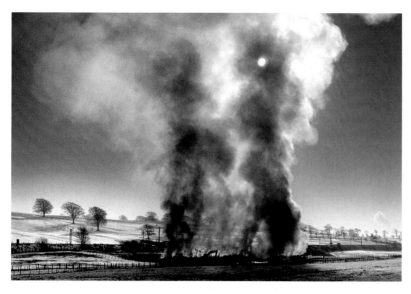

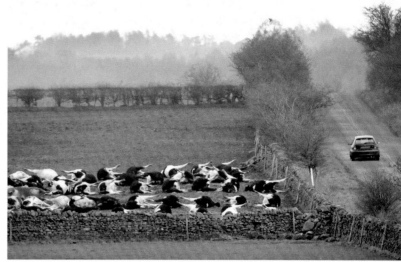

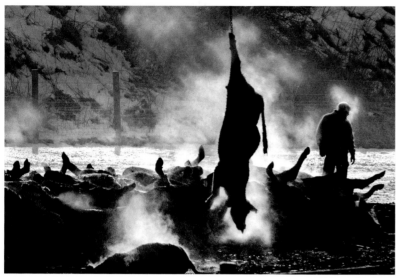

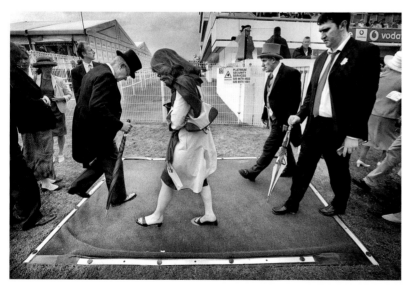

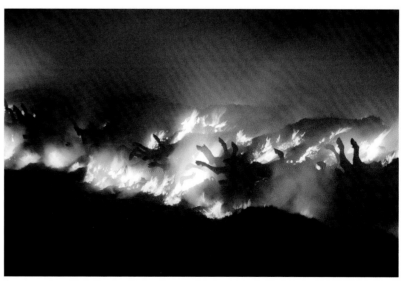

TOP ROW LEFT TO RIGHT
Jeff J. Mitchell REUTERS

Smoke fills the sky as cows and sheep are destroyed by an incinerator at Netherplace Farm in Lockerbie, Scotland. 4 March 2001.

Adrian Dennis AGENCE FRANCE PRESSE

Cattle lie in a field beside a road after being slaughtered in North Dykes, near Penrith. The cows had been killed earlier in the week after being diagnosed with foot-and-mouth but had yet to be burnt. April 2001.

MIDDLE ROW
Dave Cheskin PRESS ASSOCIATION

The burning pit at Netherplace Farm, Lockerbie, Scotland. March 2001.

The gate of Mossburn Animal Centre, a refuge whose rescued animals are due to be slaughtered. March 2001.

BOTTOM ROW
Timothy Allen THE INDEPENDENT

Visitors to the Epsom Derby are required to walk across a disinfectant mat to kerb the spread of foot-and-mouth disease. 9 June 2001.

Mark Pinder

Cattle being burnt at a farm near Wreay, Cumbria. 1 April 2001.

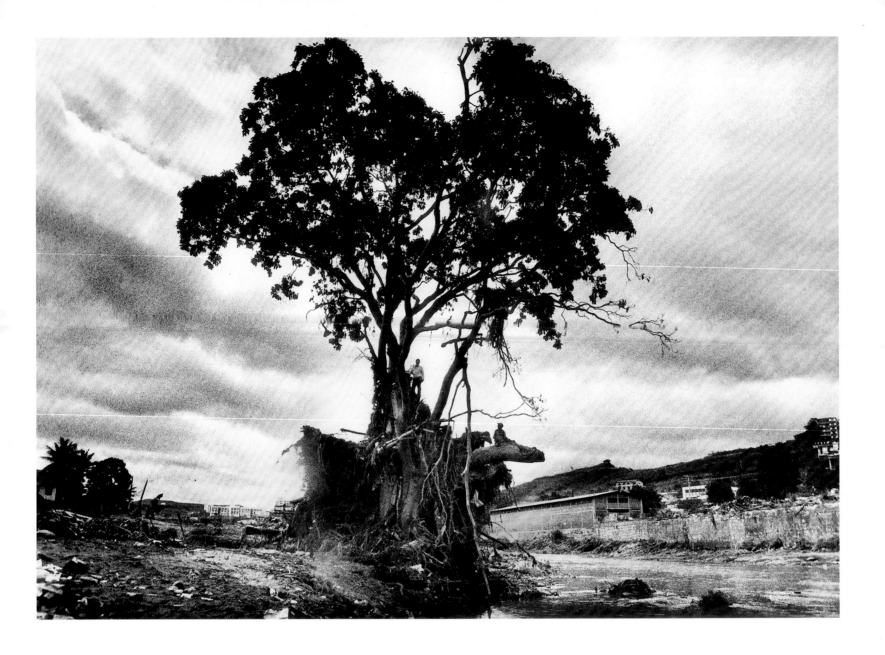

David Rose THE INDEPENDENT

A lone tree is all that remains of a riverbank after the deluge of water stirred up by Hurricane Mitch completely devastated a vast part of Tegucigulpa, Honduras. November 1997.

HARD NEWS

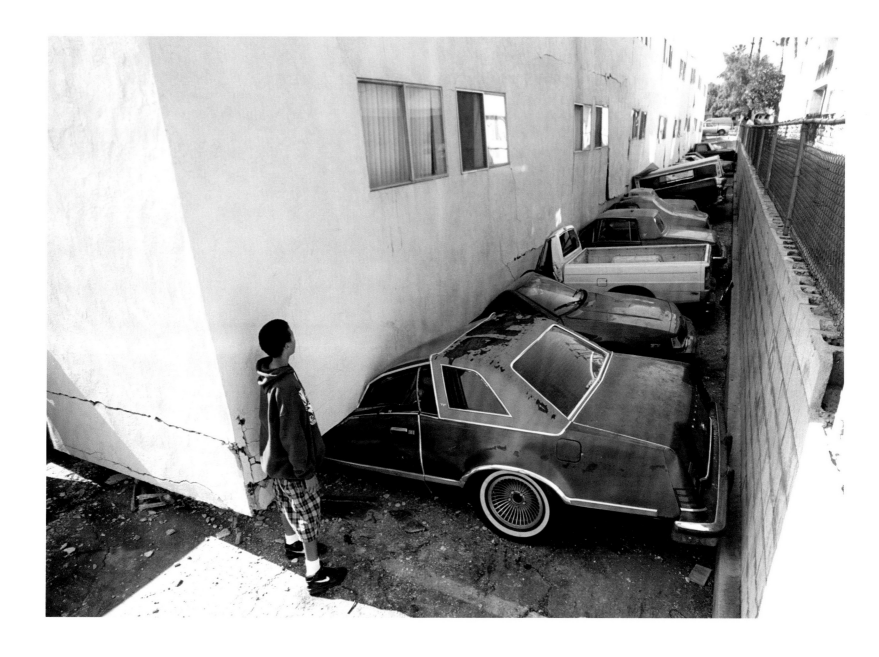

Michael Powell

A Los Angeles apartment block crushes parked cars belonging to residents, the first storey effectively becoming the ground floor. The earthquake was one of the most expensive natural disasters in American history, the total damage estimated at $15 billion. The death toll was 58. January 1994.

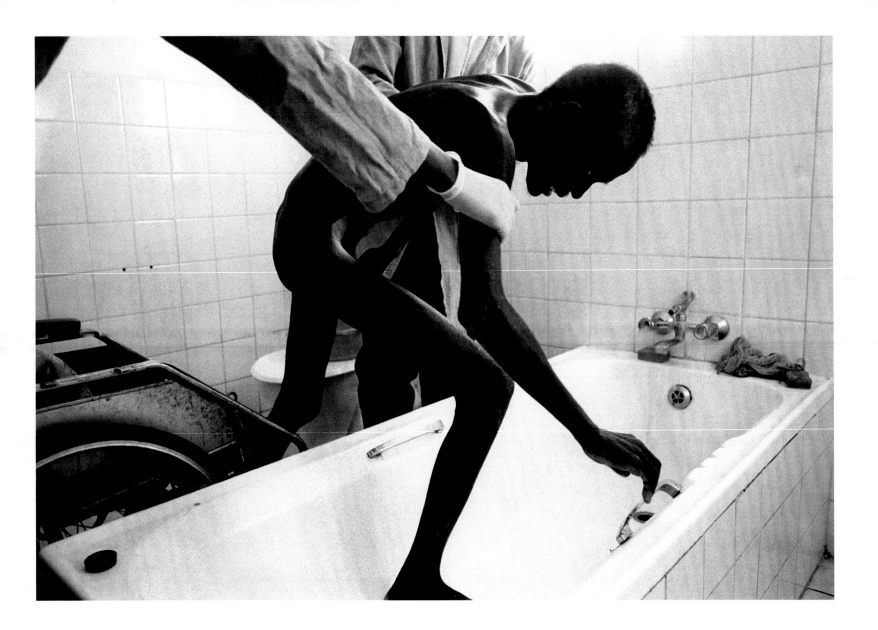

Tom Stoddart IPG

His body wracked by AIDS, Kelvin
Kalasha (30) is helped to bathe at the
Mother of Mercy Hospice in Chilanga,
Zambia. August 2002.

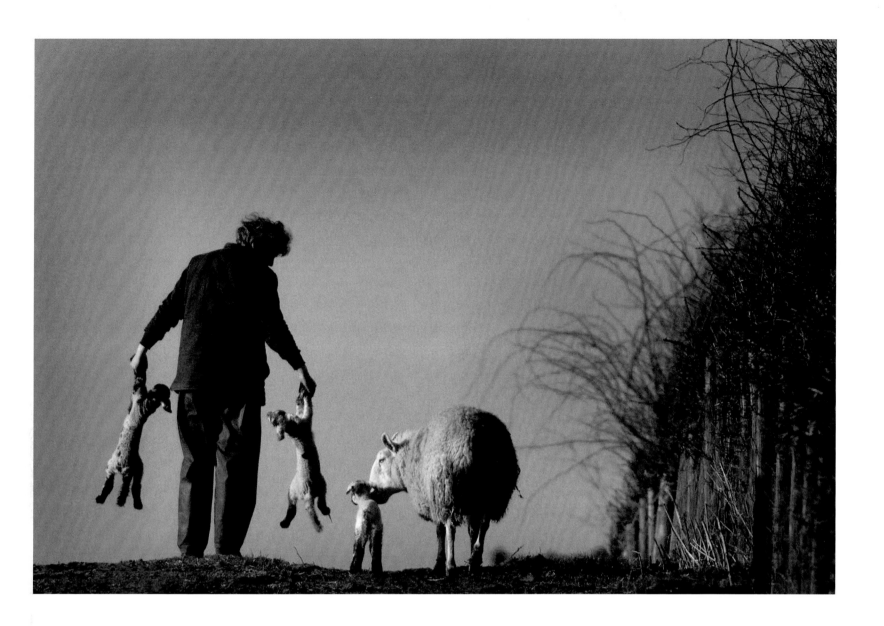

Jeff J. Mitchell REUTERS

A farmer carries two of his new-born
lambs which are affected by foot-and-
mouth disease, to be culled on his
farm in Wigton, Cumbria.
19 March 2001.

HARD NEWS

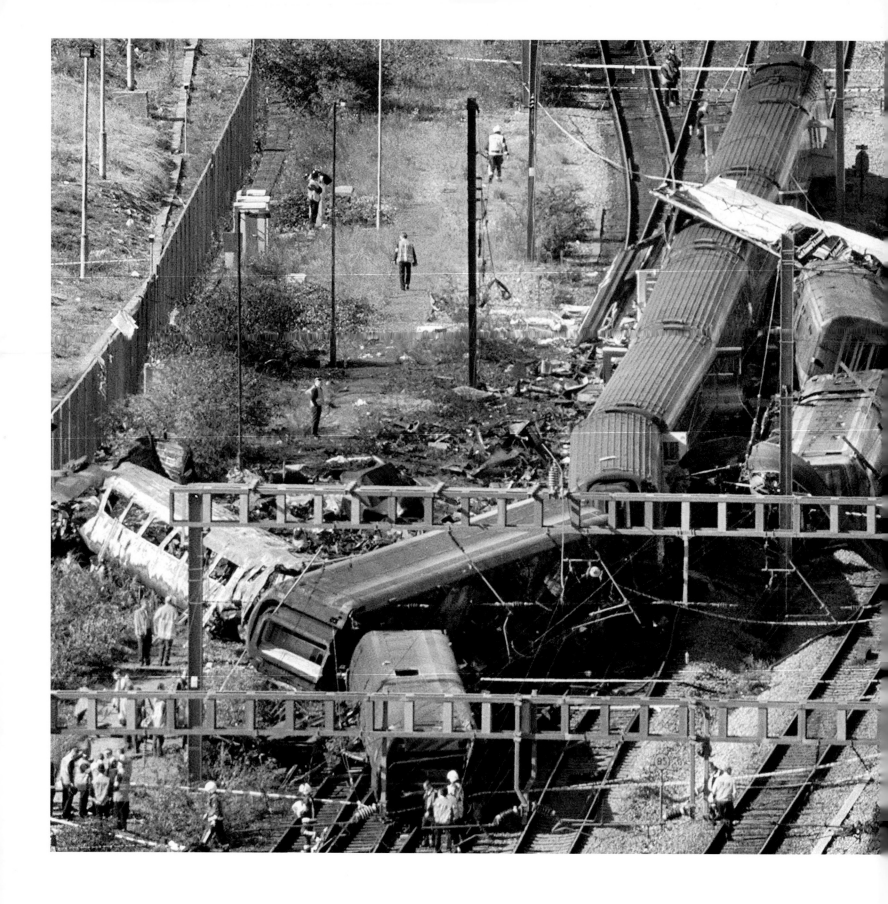

Peter Macdiarmid THE INDEPENDENT

The aftermath of the train crash at
Ladbroke Grove in West London. Two
trains collided during the morning
rush hour killing 31 people.
5 October 1999.

Jonathan Evans THE INDEPENDENT

Train crash at Potters Bar. The 12.45
from King's Cross to King's Lynn
derailed at nearly 100mph mounting
the platform and killing seven people.
A further 70 were wounded.
10 May 2002.

John Taylor INS NEWS

The train carriage that caused
devastation at Potters Bar station is
finally lifted off the platform, to be
put on to a low-loader and taken
away for examination. 14 May 2002.

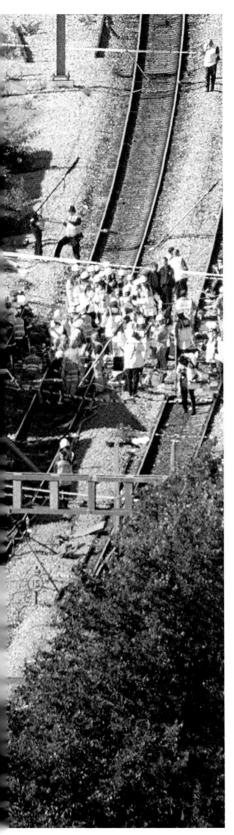

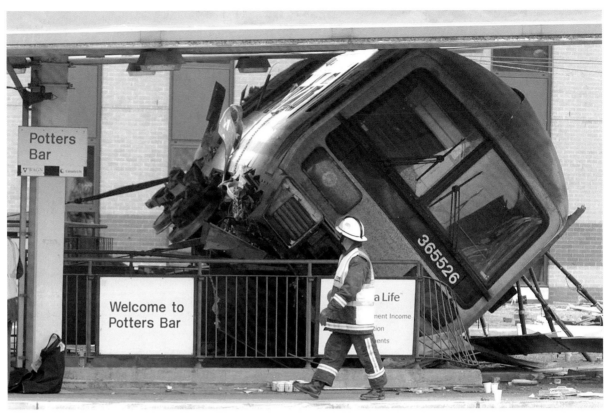

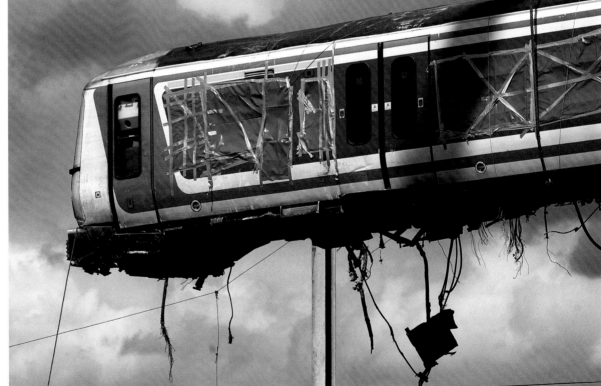

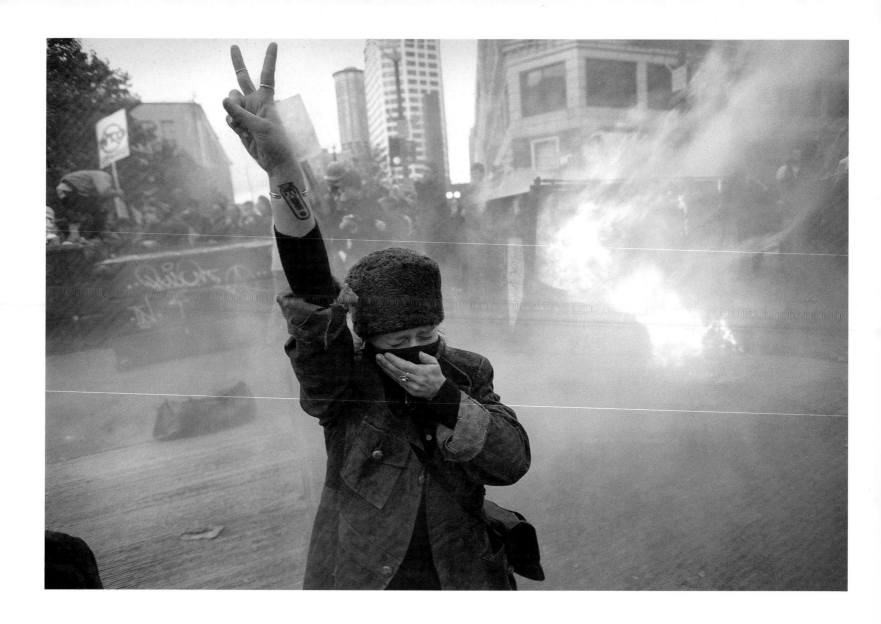

Sion Touhig

Environmental campaigners, trade unionists and anti-globalization campaigners demonstrate in Seattle before the World Trade Organization summit. It was the biggest US civil disobedience protest since the Vietnam War. This woman had just finished reciting the Lord's Prayer and kneeled making the peace sign in front of a charging line of armoured riot police who fired gas grenades and rubber bullets into a line of peaceful protestors. The Seattle Police had used military-grade tear gas which is banned for use in urban areas. The day after the protests finished, the Chief of Police resigned in disgrace. 30 November 1999.

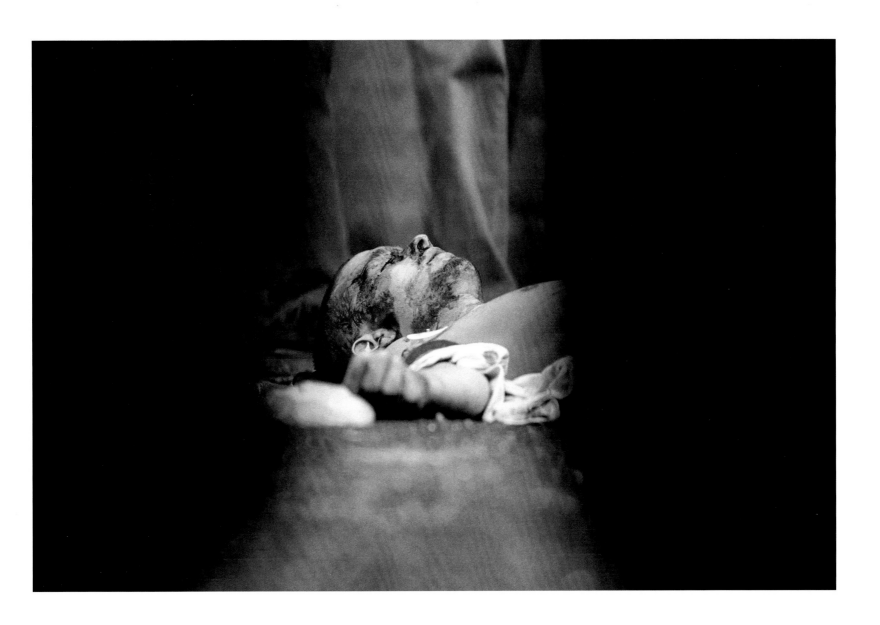

Jess Hurd REPORTDIGITAL.CO.UK

During the Genoa G8 Summit of
world leaders, Italian protester Carlo
Giuliani, 23, was shot dead and run
over twice by Italian riot police.

Police officers formed a secure ring
around Carlo's body to try and stop

photographers recording the event,
and threatened any media that came
too close. I crawled on the ground and
snatched this picture on a long lens as
I was threatened with a police baton.
Most pictures of Carlo Giuliani

showed him as a masked anarchist
rioter. I feel this picture gives an
alternative view of a young local lad
who died alone. July 2001.

HARD NEWS

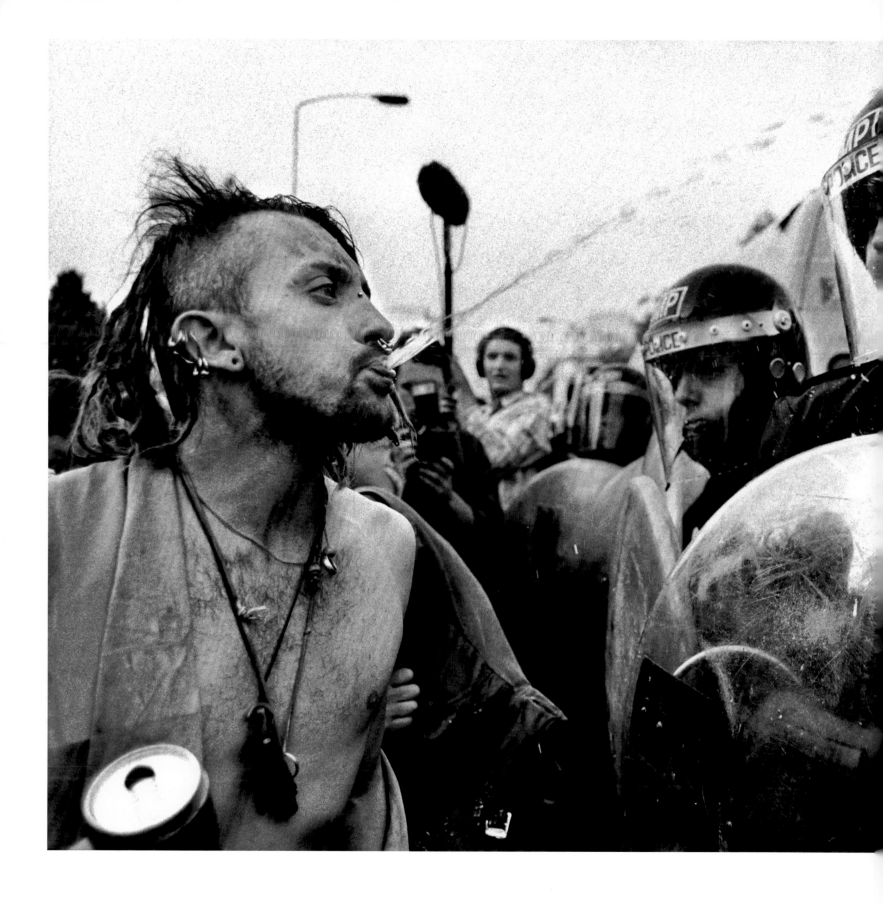

Alex MacNaughton

An anti-Criminal Justice Bill protester spitting beer at a policeman in Park Lane, London. The Conservative government's new Criminal Justice Bill changed a number of civil matters into criminal offences. Included among these were trespass and squatting. These changes were designed to curtail the growing rave and anti-road movement of the time.

At the very end of the march, the police tried to stop a van entering Hyde Park. A lot of pushing and shoving started, followed by the throwing of bottles and cans and the riot police came in swinging truncheons. A man came out of the crowd and started to taunt the police. He was bleeding from a cut on his head and smeared blood over one of the riot shields. He then took a swig of beer and spat at the police.
9 October 1994.

Alex MacNaughton

A demonstrator astride the gates across the end of Downing Street, taunting the police. The gates were badly damaged by the action and replaced by stronger ones.
25 July 1994.

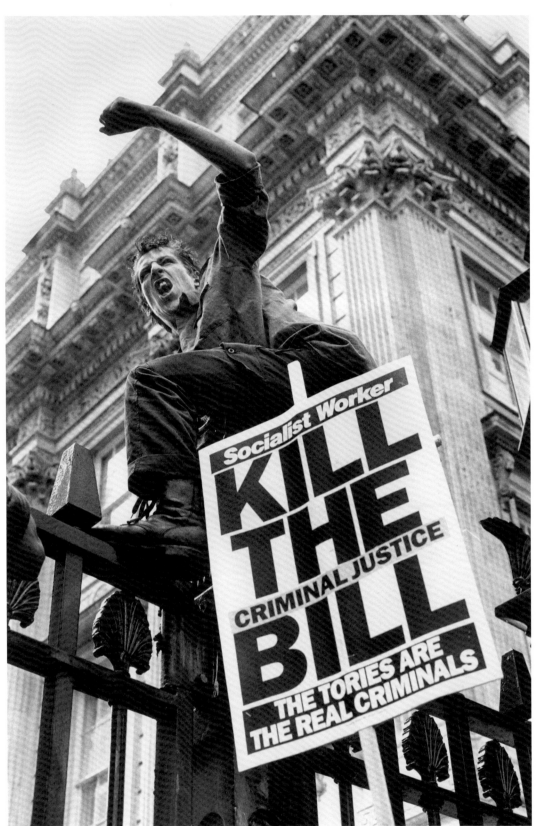

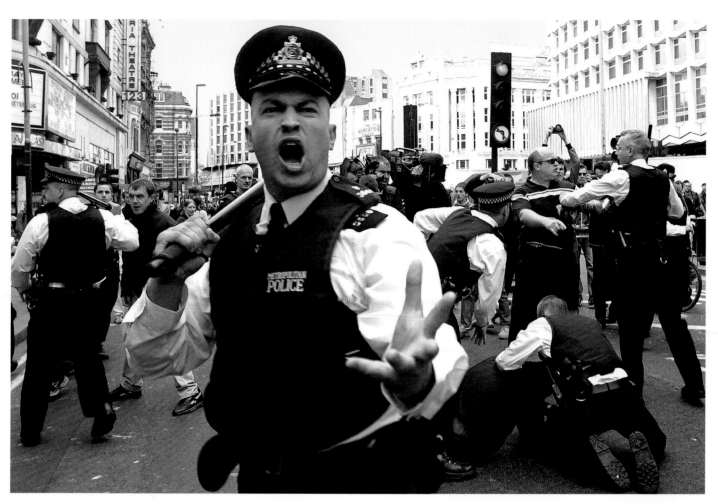

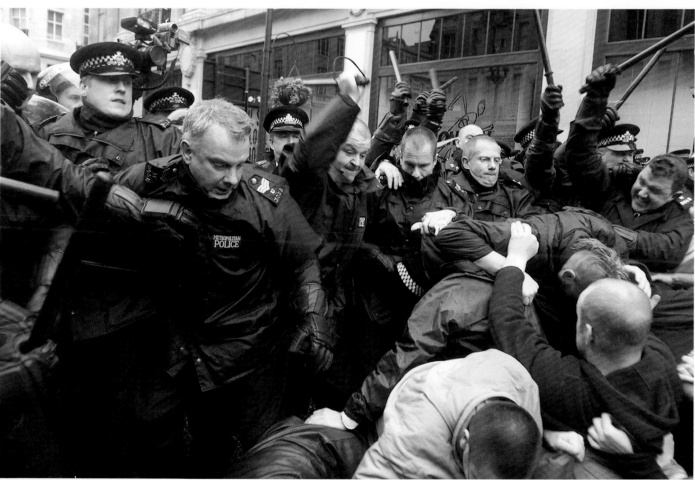

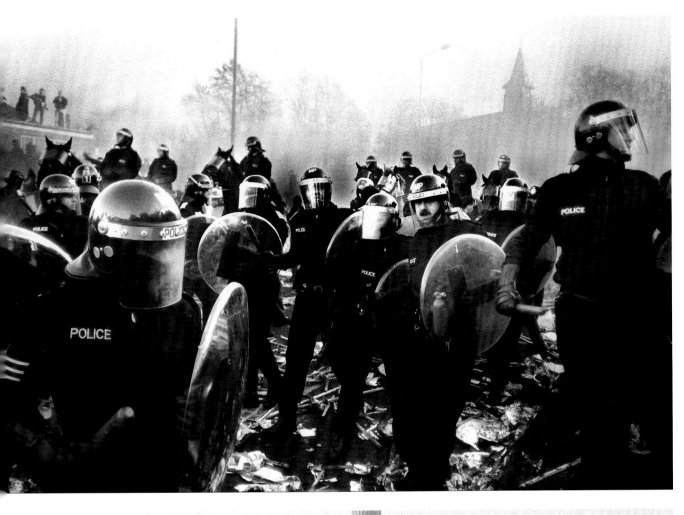

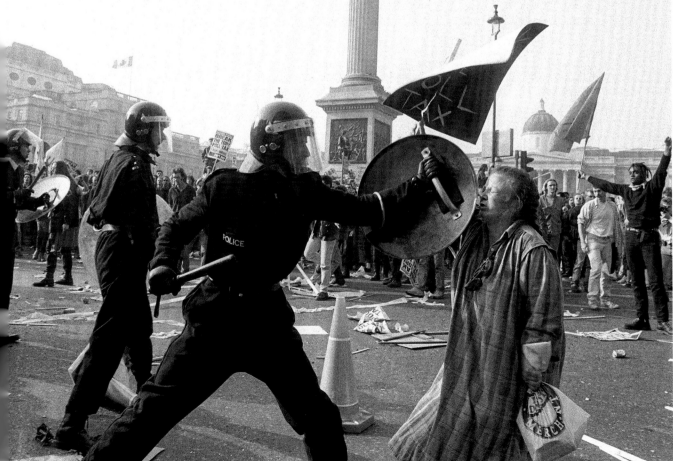

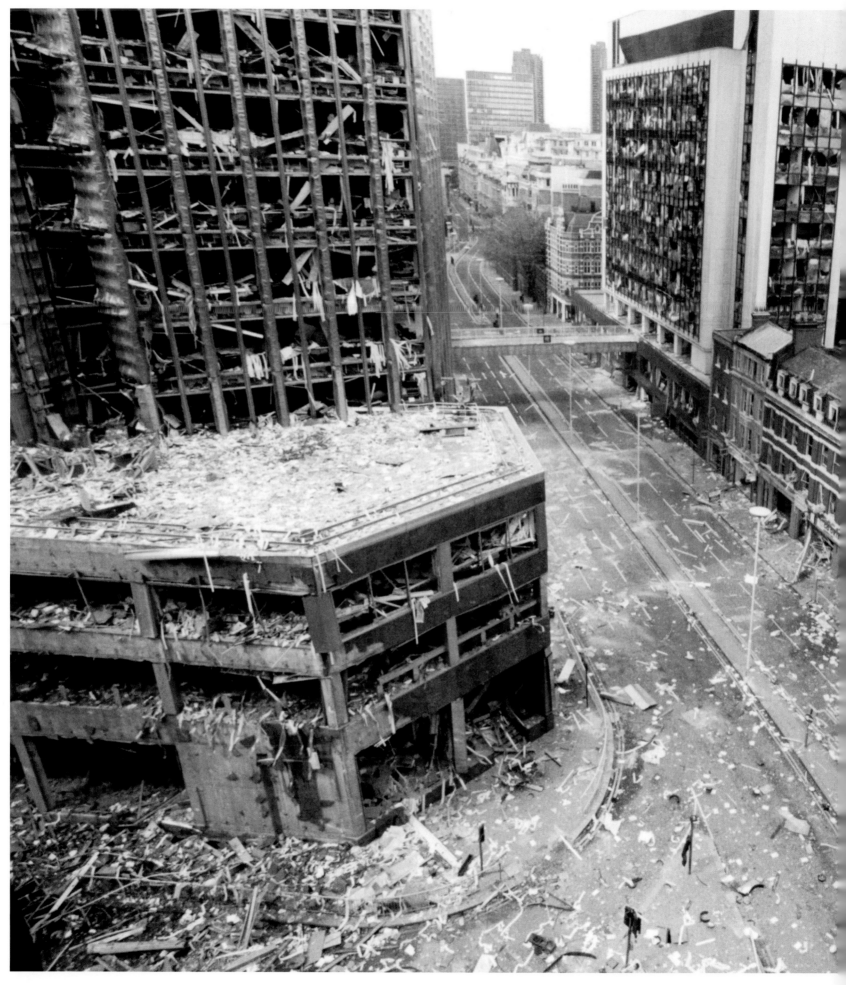

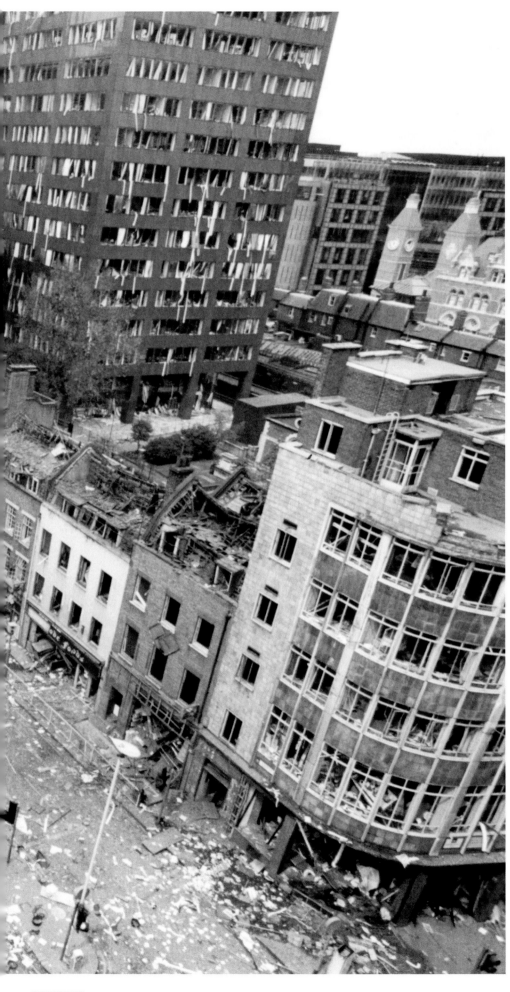

Andre Camara

Bishopsgate in the City of London less than an hour after the IRA detonated a massive bomb. One person was killed and 40 injured in the explosion that shook buildings and shattered hundreds of windows, sending glass showering down into the streets below. Repairs were estimated at a cost of more than £1 billion. April 1993.

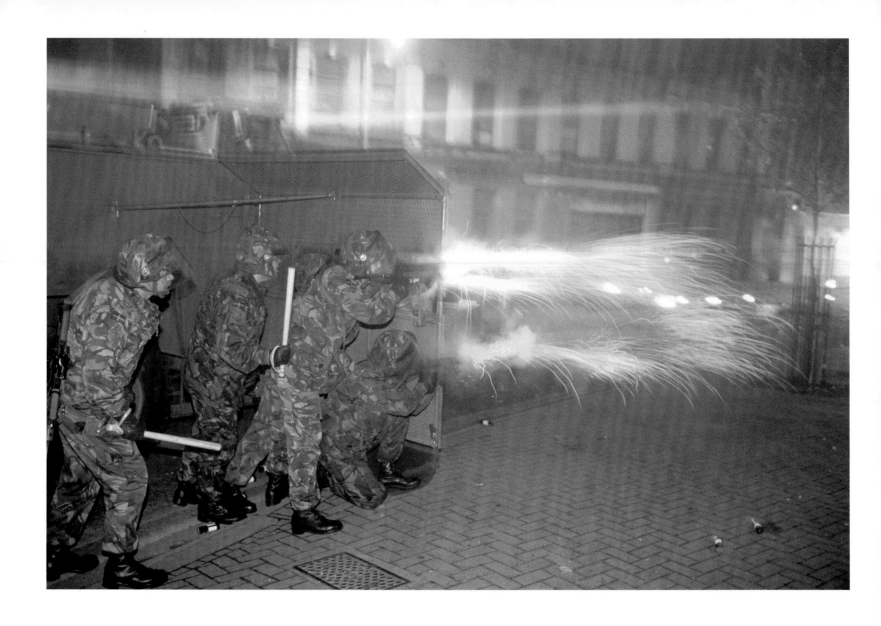

Jez Coulson INSIGHT VISUAL UK

British soldiers fire baton rounds at
Republican rioters in Derry following
the decision to allow the Drumcree
March. Belfast, Northern Ireland.
July 1997.

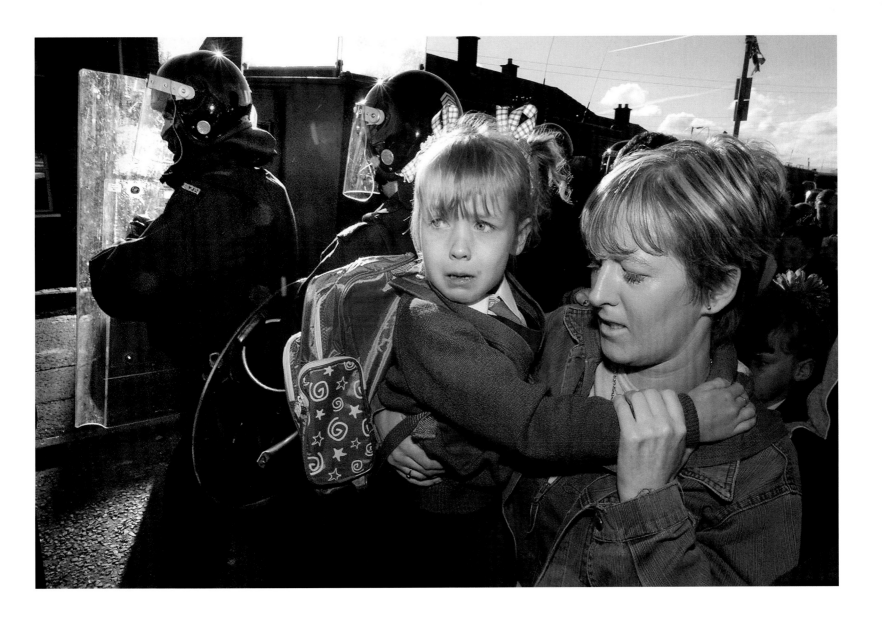

Dan Chung REUTERS

Children from a mainly Catholic estate are escorted by police and soldiers to the Holy Cross Primary School in the Ardoyne area of Belfast. The girls were shouted at by Protestant residents along the route to the school for a second day. 4 September 2001.

HARD NEWS

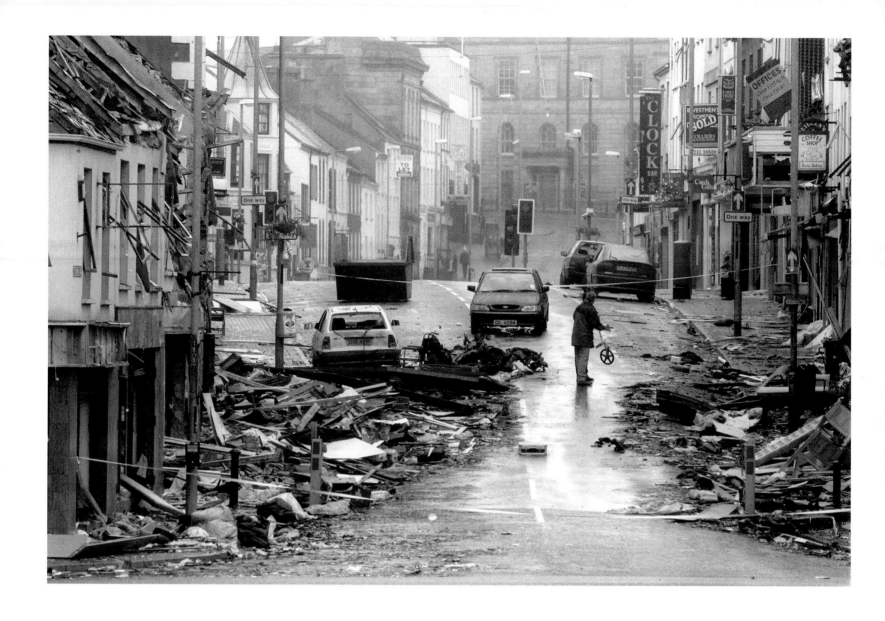

Andrew Shaw

Devastation on Market Street in
Omagh after the Real IRA planted a
500lb bomb in a Vauxhall Cavalier
car. The bomb killed 28, including
two babies, five other children and
15 women. 16 August 1998.

Peter Macdiarmid

A man with a child passes by the remains of a burnt-out shop in the aftermath of riots in Derry, Northern Ireland. 15 August 1999.

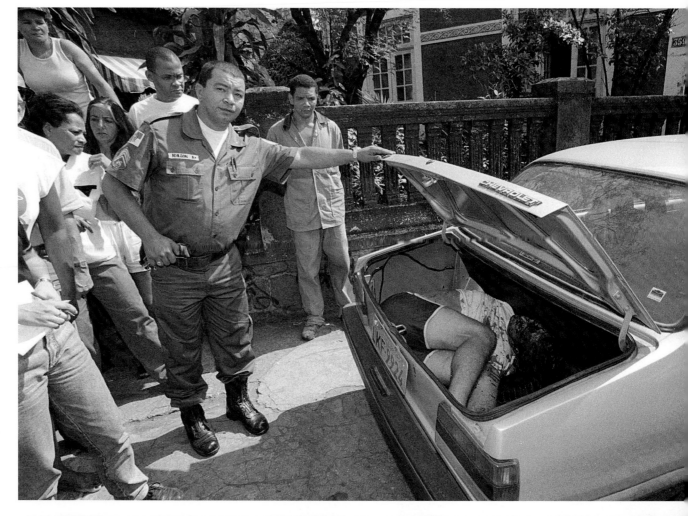

Roger Allen THE DAILY MIRROR

I was sent to Rio to cover a story
about the illegal police death squads
clearing the streets of 'street children'
prior to an election. The way it
worked was: one policeman would
steal a car and drive, another would
grab the kid and another would kill
it; the last man in the chain would
dispose of the body. After days of
visiting the mothers of dead children
and doing pictures of living street
kids, we still had not taken a good
hard picture. We had fallen in with a
local reporter who had a call that a car
with a body inside had been reported
on the outskirts of the city. When we
arrived there was a small crowd
round the car and one well armed
policeman.
 'Where's the body?' we asked.
 'In the boot.'
 'Can we see?'
 'Wait till military police arrive.'
August 1998.

Sion Touhig

An Albanian secret policeman is
executed by a mob after killing a
17-year-old student protester in Vlore,
Albania. In post-communist Albania,
government-backed financial
pyramid schemes collapsed, leaving
the citizens of Europe's poorest
nation destitute. Widespread
demonstrations ensued, and the
students of Vlore University went on
hunger strike. President Sali Berisha
sent his dreaded SHIK secret police
to Vlore to crush the rebellion and
kill the students. The citizens of
Vlore marched on the university at
midnight to defend them and in the
darkness and confusion three SHIK
secret policemen stabbed the boy
to death. The crowd went berserk,
dragged the policemen into the
university foyer and set upon them
in a frenzy, killing two of them with
knives, boots and fists. February 1997.

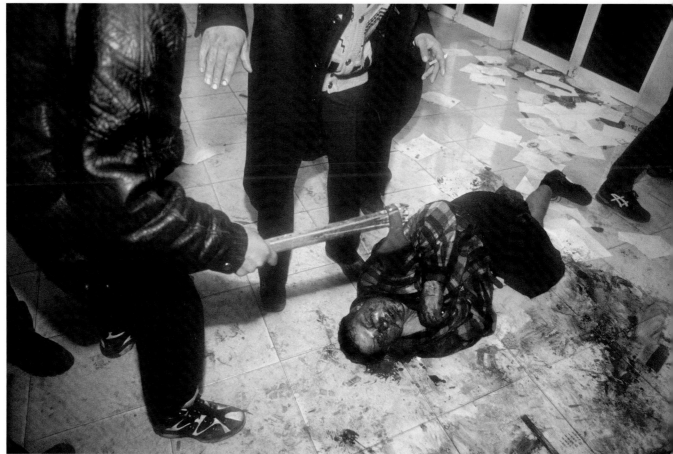

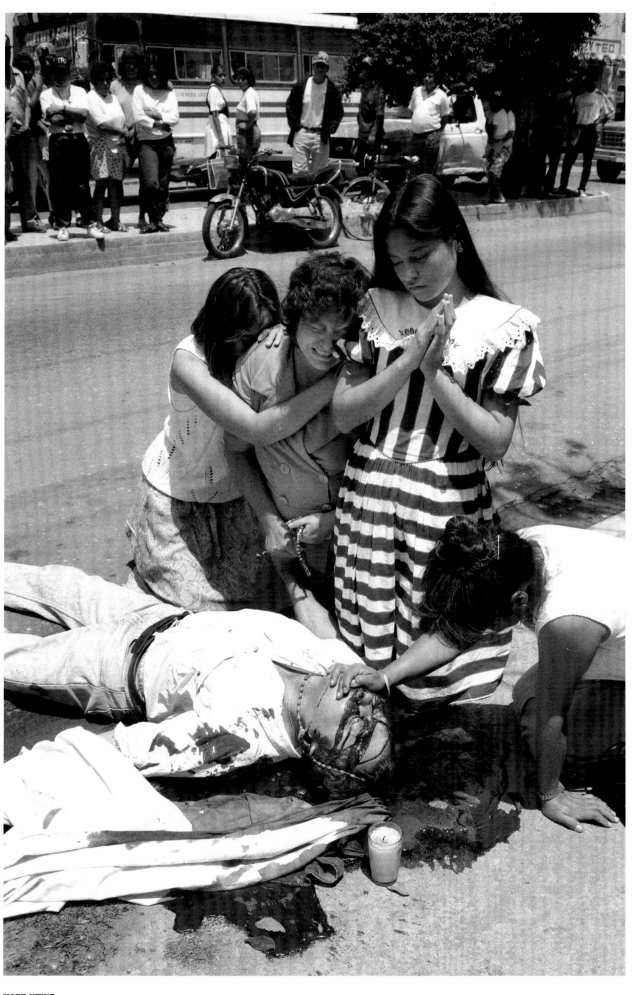

Jacky Chapman

I was in Mexico photographing street children and had decided to take a break and photograph some street scenes. A pair of feet stuck out from a blood-covered sheet. I approached cautiously with my camera slung over my shoulder. Only police and a few bystanders had gathered. I made eye contact with the police and they nodded. I started to photograph the body. As I looked through the viewfinder someone pulled away the cloth. I was shocked. With shaking hands I carried on taking pictures. The victim had been shot in the head. By now a crowd had gathered, more police and a pick-up truck. I looked up and in the distance I saw three people running towards me, screaming hysterically. It was the man's family. Eventually a group of men picked up the body and put it into the back of the pick up truck. As I turned around back to where the body had been I saw the women on their knees mixing the blood up with the dirt and mud from the gutter. A candle had been lit. Together they scooped the dirt and blood into a small box with the candle. This they took home with them. A policeman told me that he thought it was a gang murder, since the man's wallet was still on him. April 1996.

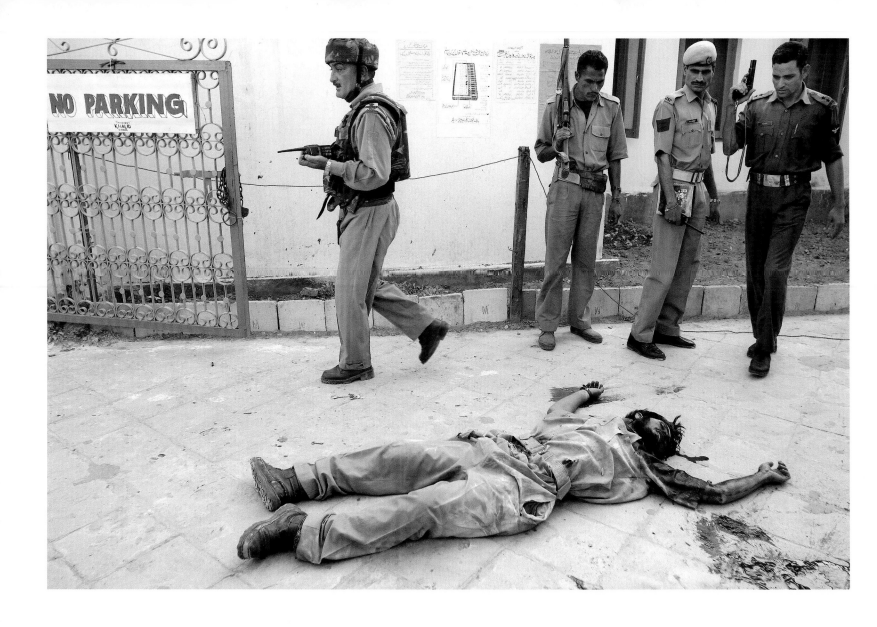

Findlay Kember POLARIS IMAGES

The body of an alleged Islamic
militant is watched by members of
the Indian security forces as it lies
inside the gates of an election polling
station in Doda, Kashmir, India. The
militant, along with two members of
the Indian security forces died in an
early morning gun battle at the
polling station which opened for
voters to cast their votes in the final
stages of the State Elections of Jammu
and Kashmir. 8 October 2002.

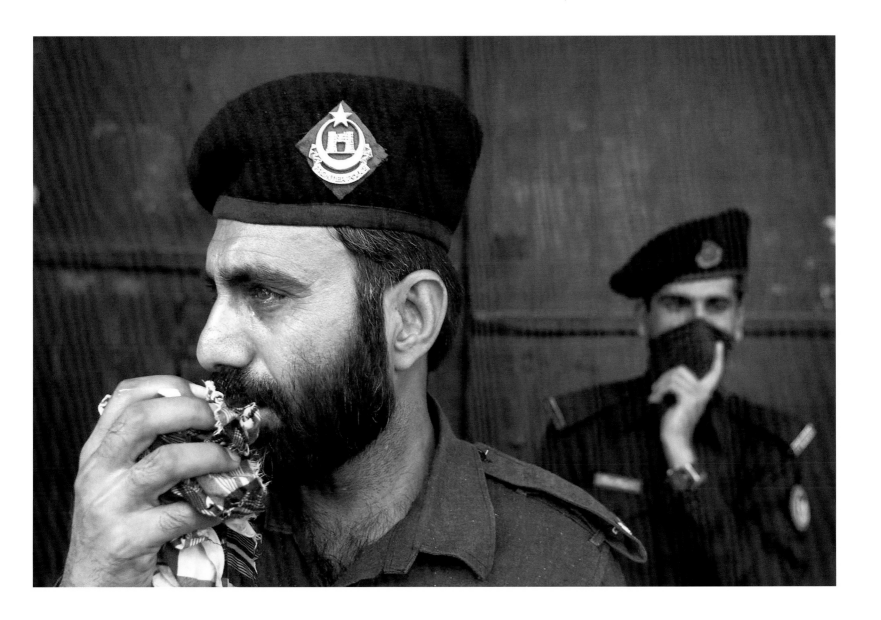

Findlay Kember CAMERA PRESS

An unidentified member of Pakistan's North-West Frontier police force cries as he and a colleague suffer the effects of tear gas during an anti-US demonstration in Peshawar, Pakistan. The demonstrations, which were staged by Islamic fundamentalists, followed the bombing of suspected terrorist training camps in Afghanistan by the US Air Force. 8 October 2001.

HARD NEWS

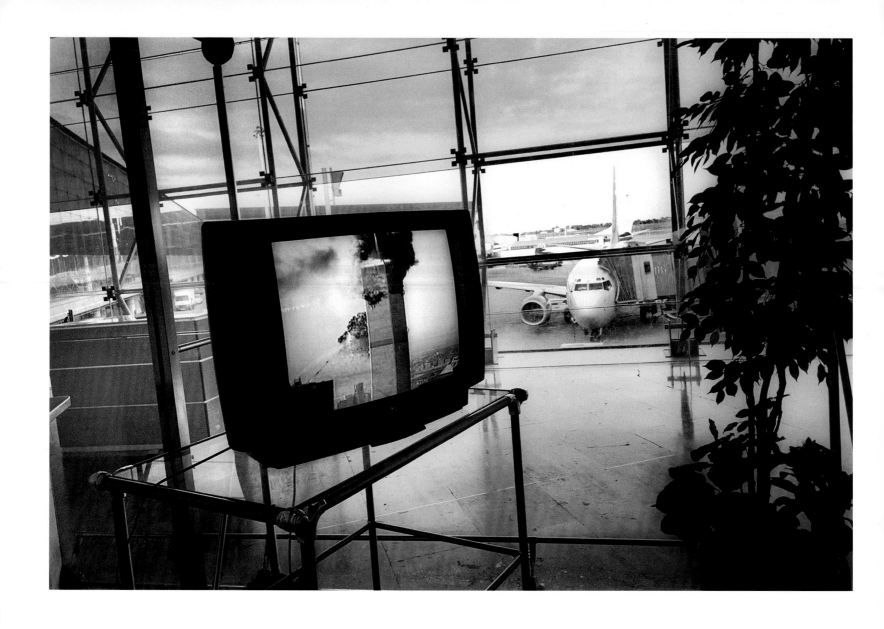

Timothy Allen THE INDEPENDENT

The departures' lounge at Barcelona
airport. The last flight back into
British airspace as events unfold
in New York. 11 September 2001.

John Angerson

Pedestrians in Leeds stop in the street
to watch the events of September 11
unfold on television screens in a shop
window. 11 September 2001.

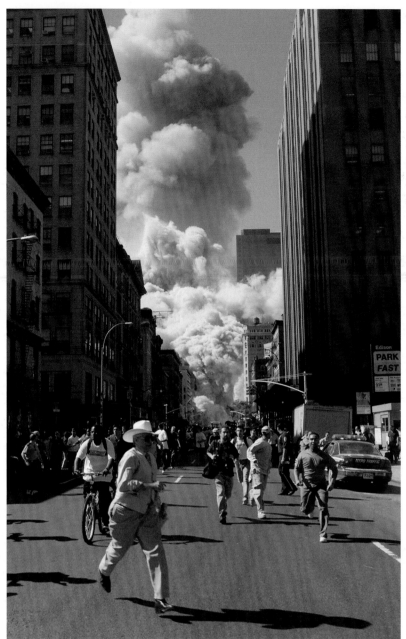

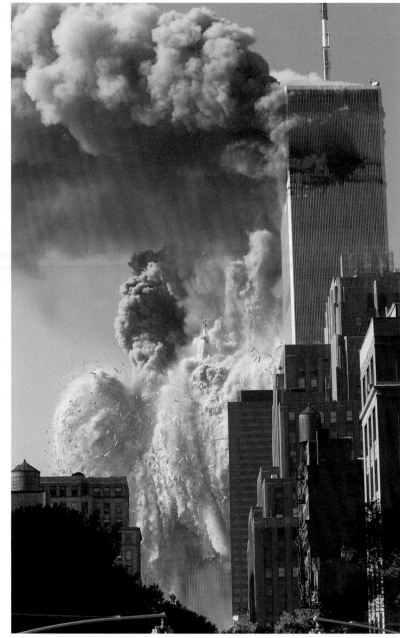

Cavan Pawson THE EVENING STANDARD

New Yorkers flee from the pursuing
cloud of dust and rubble as the World
Trade Center collapses.
11 September 2001.

Cavan Pawson THE EVENING STANDARD

The first of the World Trade Center's
two towers collapses.
11 September 2001.

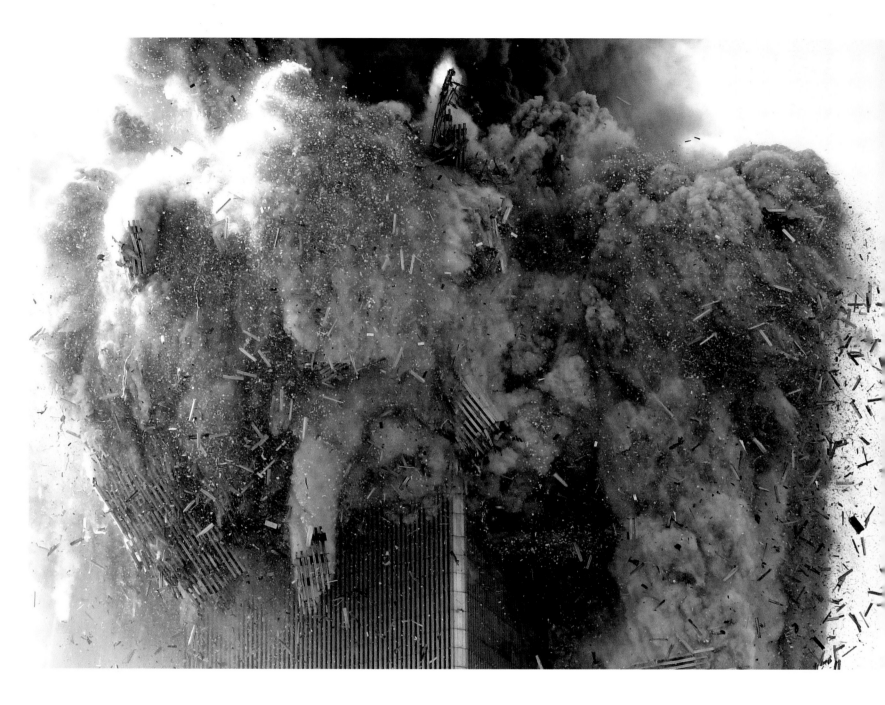

Dan Callister SPLASH NEWS

The north tower of the World Trade
Center begins to collapse.
11 September 2001.

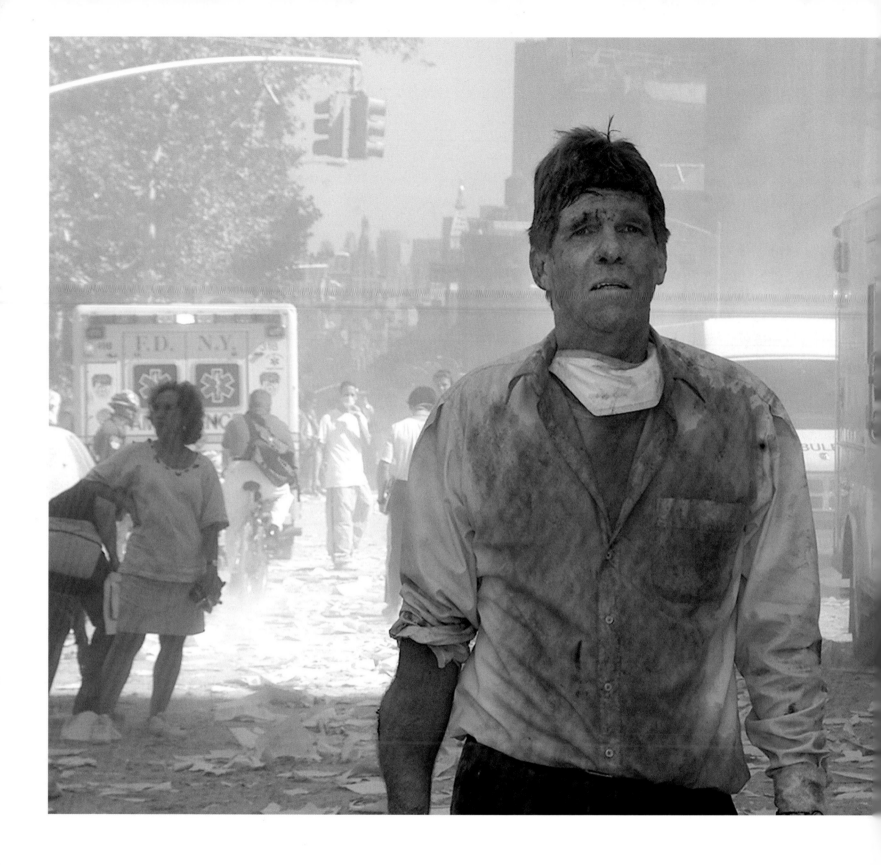

Heathcliff O'Malley THE DAILY TELEGRAPH

In New York to cover Fashion Week I received a call from the London office informing me that an aeroplane had hit one of the World Trade Center towers. Thinking it was probably an accident it wasn't until I arrived at the scene that the terrifying enormity of the event became apparent. After the towers collapsed I stumbled across this dazed and bloodied New Yorker who'd been helping with casualties, whilst trying to bypass police cordons during the confusion to enter the immediate area where the surviving firefighters were still working.
11 September 2001.

Heathcliff O'Malley THE DAILY TELEGRAPH

Firefighters work in the rubble of the World Trade Center in the first few hours after the terrorist attack. Their equipment has been partially crushed by the earlier collapse of the towers.
11 September 2001.

Julian Simmonds THE SUNDAY TELEGRAPH

The Stars and Stripes made from flowers, displayed in Columbus Circle, New York City, a few days after the attack on the World Trade Center.
13 September 2001.

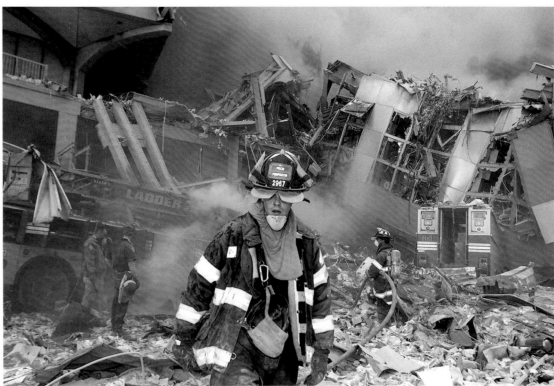

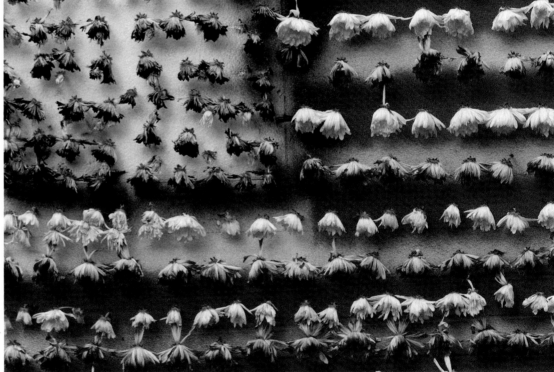

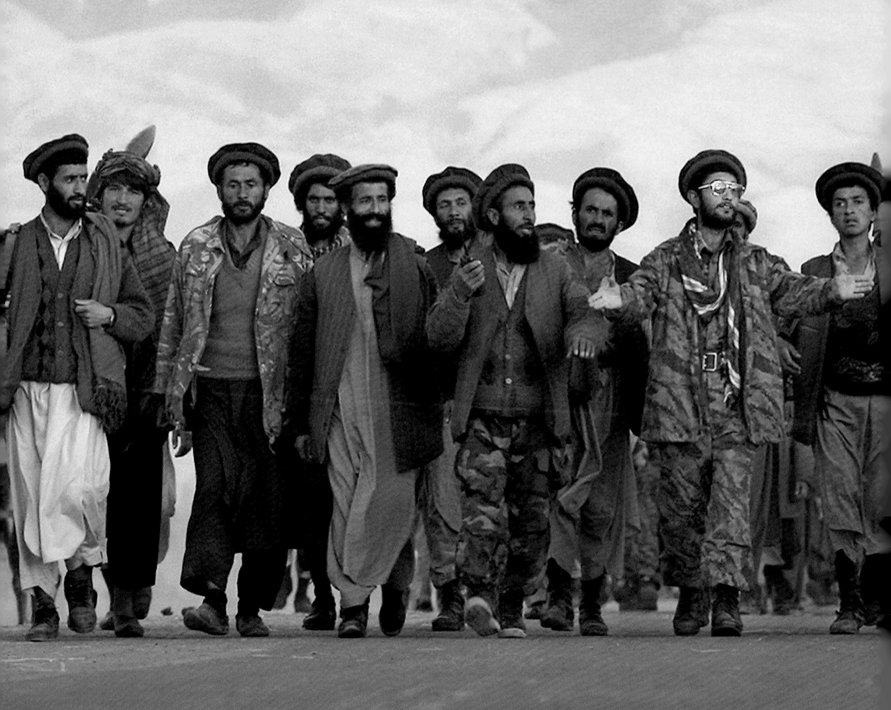

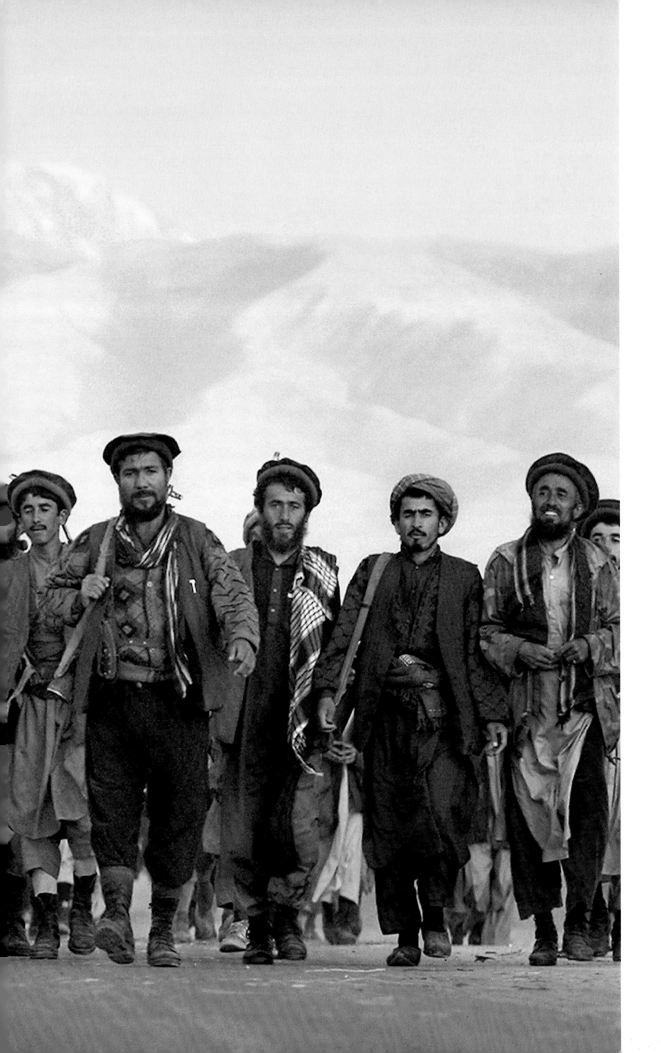

Sion Touhig GETTY IMAGES

Northern Alliance Fighters, Afghanistan.

I was with Northern Alliance fighters advancing on the Taliban stronghold of Kunduz when gunfire and explosions announced some kind of Taliban counter attack – I left the car to see what was going on, just as the entire convoy U-turned and fled, including my driver with all my gear in the back – satphone, laptop, clothes, everything except my cameras. I ran, dodging truck drivers careering across the bridge and smashing into each other. I waded across the river underneath the bridge and staggered up the riverbank.

It was 30 miles to the nearest town and there was no one about except Afghan fighters. Eventually a pick-up truck came out of nowhere and James Hill and Dexter Filkin from the *New York Times* offered me a lift. It was getting dark and we saw these fighters coming up the road. The sun was still on the mountain so I steadied the camera on the ground and shot half-a-dozen frames. 13 November 2001.

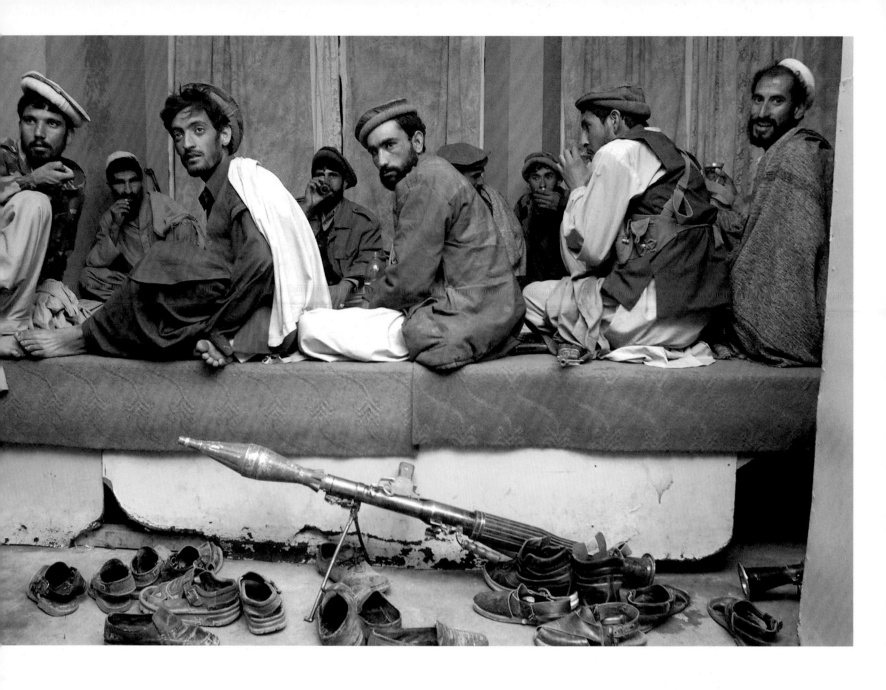

Findlay Kember CAMERA PRESS

Unidentified Afghan fighters loyal to
warlord Haji Qadir, eat dinner at the
'Afghan Hotel and Restaurant',
Jalalabad. 21 November 2001.

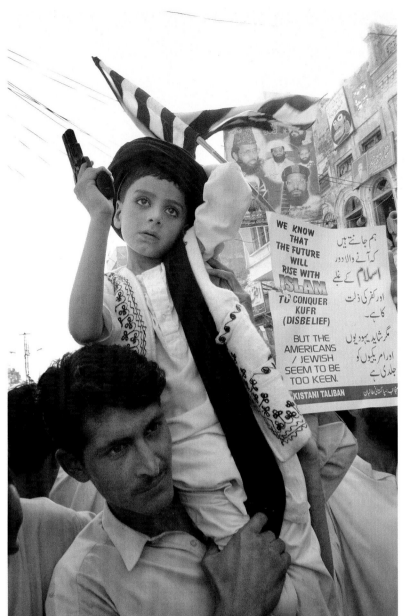

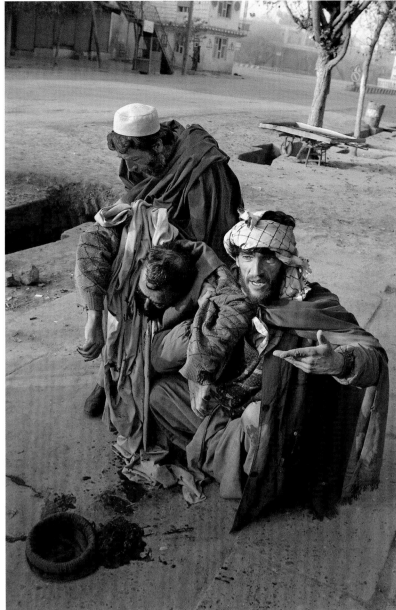

Colin Davey DAILY MAIL

Young boy with a pistol during an
anti-American/British demonstration
in Rawalpindi, Pakistan. October 2001.

Sion Touhig GETTY IMAGES

Northern Alliance fighters drag
away the body of a colleague fatally
wounded by a Taliban sniper, during
fierce street battles in Kunduz,
Afghanistan. November 2001.

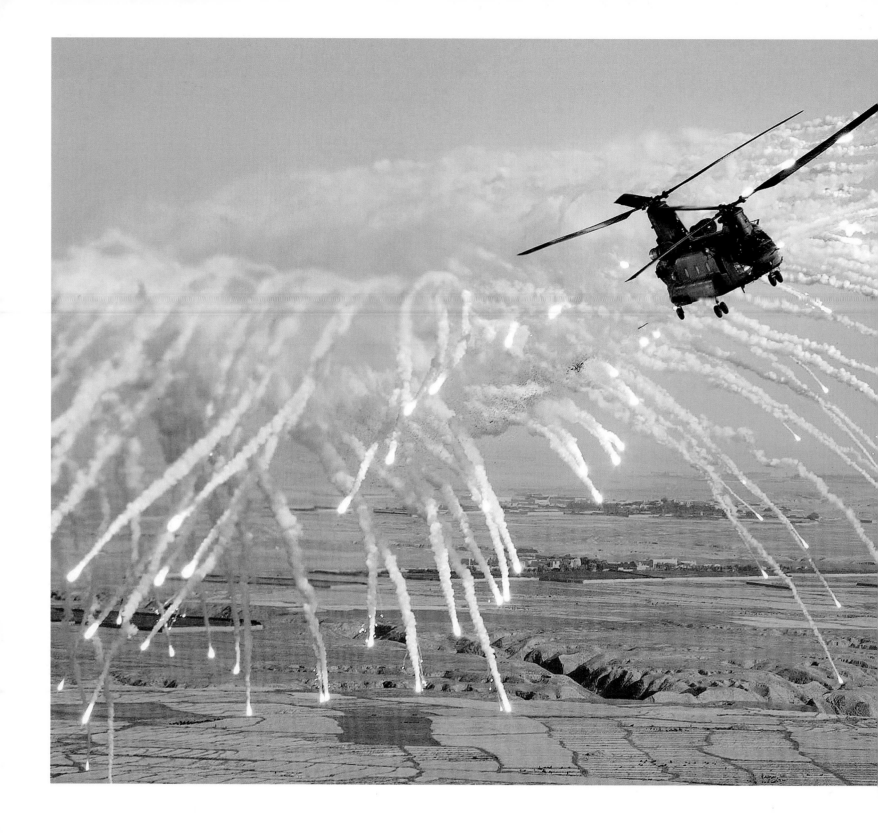

Helen Atkinson

A British Chinook helicopter releasing counter measures during a drill over Afghanistan. July 2002.

Eddie Mulholland THE DAILY TELEGRAPH

A government soldier stands watch on the front line in Kabul, Afghanistan guarding what was left of Darul Amman palace, built to celebrate victory over the British at the end of the Anglo-Afghan War in 1919. The Taliban were surrounding the city but the government forces were emphatic in their belief that they would never conquer the capital. Three weeks later ministers were hanging from lamp-posts in the streets. August 1996.

Julian Simmonds THE SUNDAY TELEGRAPH

A Young Mujahid, with the Northern Alliance, clambers along the barrel of a tank after manoevres at Jabul Seraj, 35 miles north of Kabul, Afghanistan. October 2001.

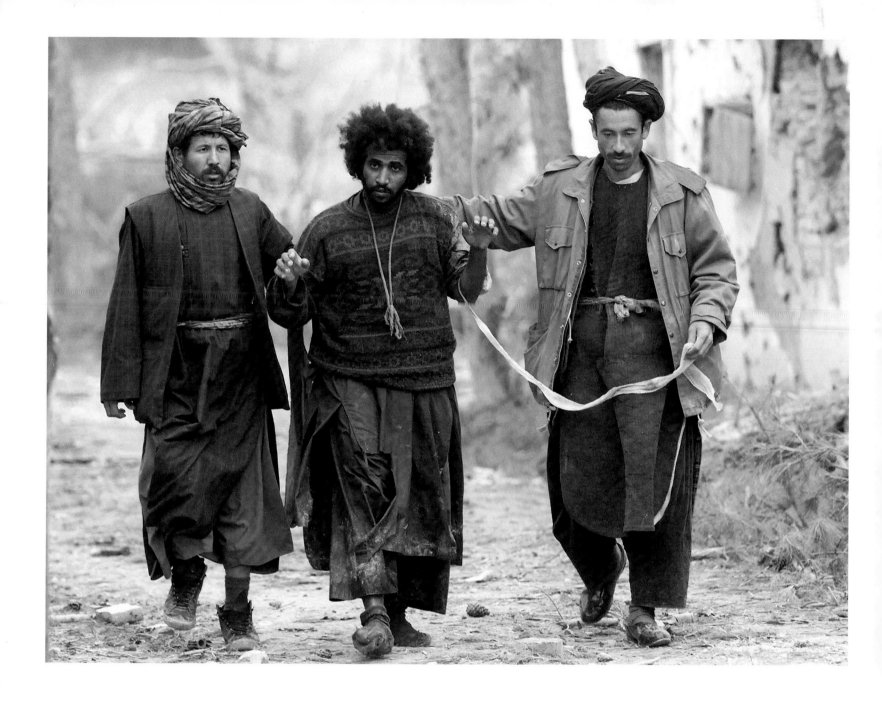

Terry Richards THE SUN

Mazar-e-Sharif, Afghanistan. Taliban prisoners are led one by one from the underground bunker where they had been in hiding for up to six days.

After the siege and fall of Konduz in the north we had heard that there had been a huge battle at the historic fort Qala-i-Janghi. The morning following our arrival we spoke to the head of the Red Cross who was organizing the recovery of all the dead bodies from the battle three days earlier.

He pointed to the entrance of an underground bunker where they thought there were bodies but could still be people alive as well. I went to the entrance and shone my torch into the gloom but decided not to venture any further. As we walked away, shots rang out. Three Afghan body clearers had gone into the bunker and one had been killed, the other two injured. Over the next two days the Northern Alliance used every means in their attempt to get the prisoners to come out. Eventually they surrendered and 83 people emerged, some carrying terrible injuries.
December 2001.

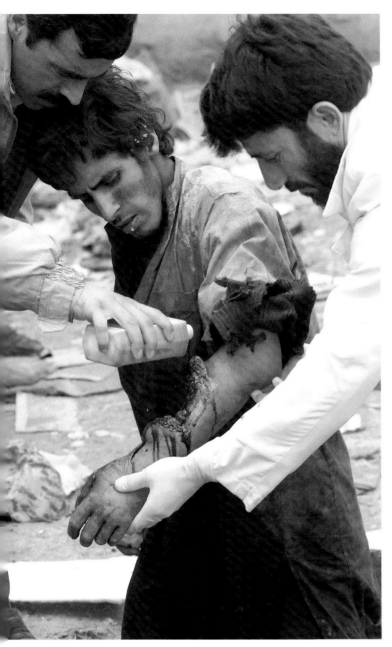

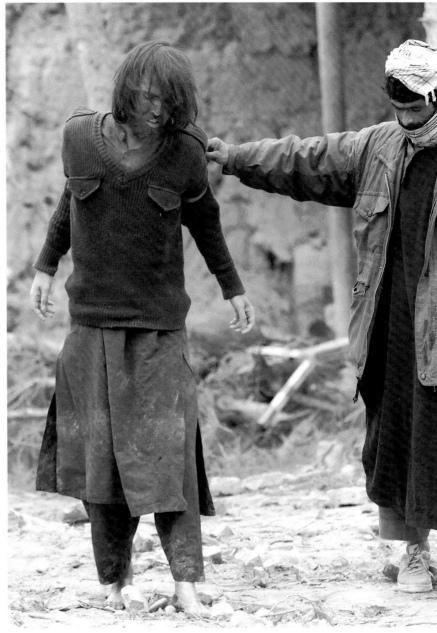

Terry Richards THE SUN

Mazar-e-Sharif, Afghanistan. Red Cross workers give first aid and food to the injured as Taliban prisoners are led from the underground bunker where they had been in hiding. December 2001.

Terry Richards THE SUN

Mazar-e-Sharif, Afghanistan. One of the Taliban prisoners dragged from the underground bunker is an American citizen from Washington, Abdul Hamid, alias John Walker Lindh. December 2001.

Heathcliff O'Malley THE DAILY TELEGRAPH

Iraqi soldiers parade outside the Qaddisiyah Memorial on Iraqi Martyrs' day in Baghdad for the last time before the Allied invasion of Iraq. Every year wreaths were laid by Saddam Hussein or another senior Baath Party member in memory of those who died in the Iran-Iraq war. Being early in the morning only a handful of media were present for what seemed to be such a symbolic moment, certainly one never to be seen again, and I could only feel pity for these soldiers who would soon suffer the force of the American military machine. 15 February 2003.

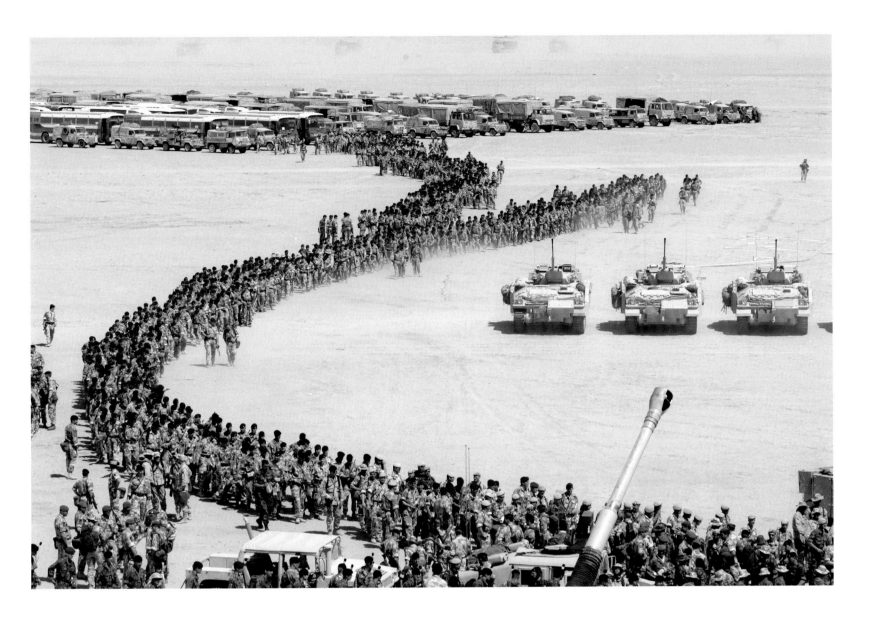

Dan Chung THE GUARDIAN

Tanks and soldiers of the 7th
Armoured Brigade gather in the
Kuwaiti desert for an address by
US Marine General Tommy Franks.
March 2003.

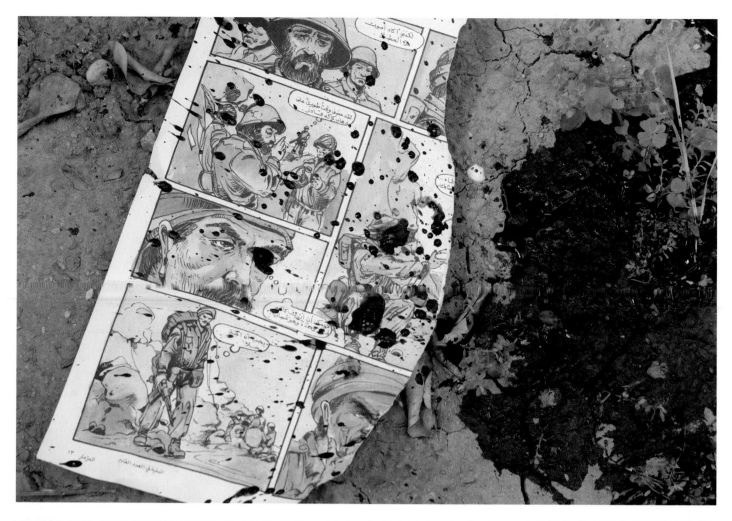

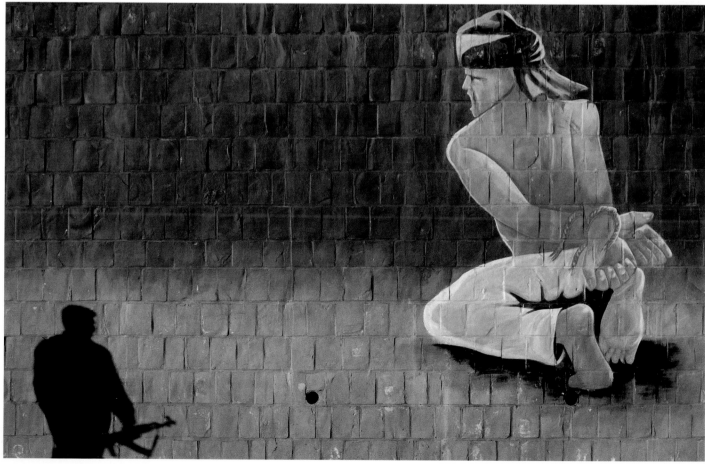

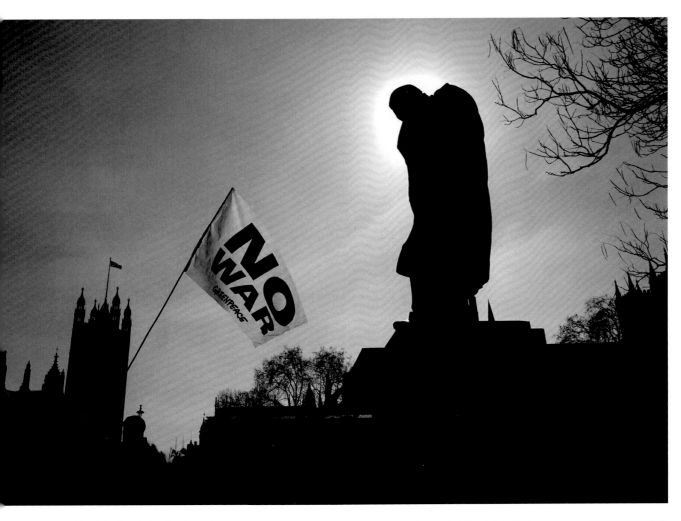

OPPOSITE PAGE
Heathcliff O'Malley THE DAILY TELEGRAPH

The torn page of an Iraqi war comic, splattered with the blood of a freshly slaughtered sheep.

After working in Iraq over the previous four months, and a month before the Allied invasion of 2003, I visited the home of an Iraqi family without a government 'minder' being present. I'd been desperately trying to find a family ritually slaughtering a sheep for the Islamic festival of Eid. After shooting the main set of pictures, I noticed on the ground this torn page from a war comic splattered with the blood of the sheep. To me it seemed almost prophetic of the bloodshed to come in the following months. 10 February 2003.

Paul Rogers THE TIMES

A Kurdish Peshmerga (fighter) walks past a mural on the outskirts of PUK-held Sulaymaniya in Iraqi Kurdistan. The mural commemorates a captured Peshmerga who was caught and executed on this spot by Saddam Hussein's forces following the 1991 uprising. 28 February 2003.

THIS PAGE
Alan Weller

Anti-Gulf War demo at the foot of the statue of Winston Churchill in London. March 2003.

Heathcliff O'Malley DAILY TELEGRAPH

A portrait of Saddam Hussein being removed by a member of staff at the close of an exhibition dedicated to the Iraqi dictator's image at the Saddam Arts Centre in Baghdad. This picture was taken shortly after the October referendum which claimed that Saddam had received 100% of the popular vote, but the manner in which it was being carried out of the exhibition centre perhaps tells another story. 20 October 2002.

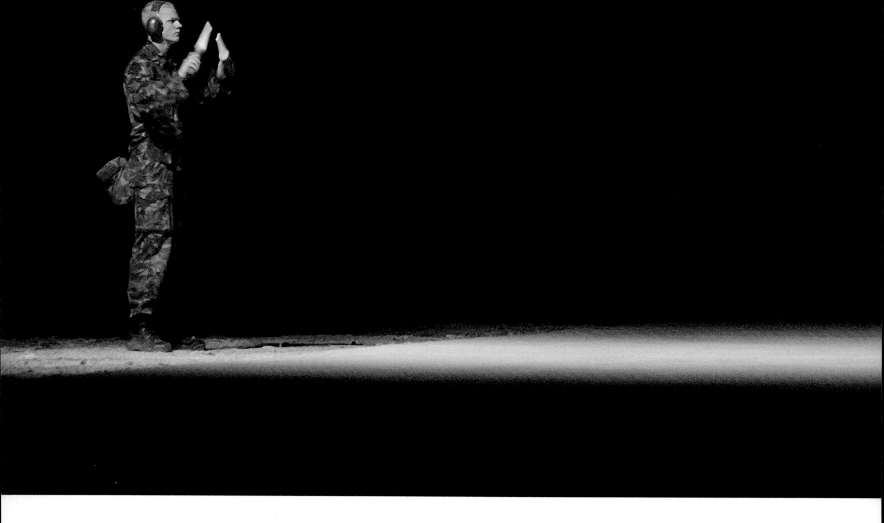

Russell Boyce REUTERS

A British Royal Air Force groundcrew
member marshals out a Harrier GR7
on their base in Kuwait prior to its
mission over Iraq. 29 March 2003.

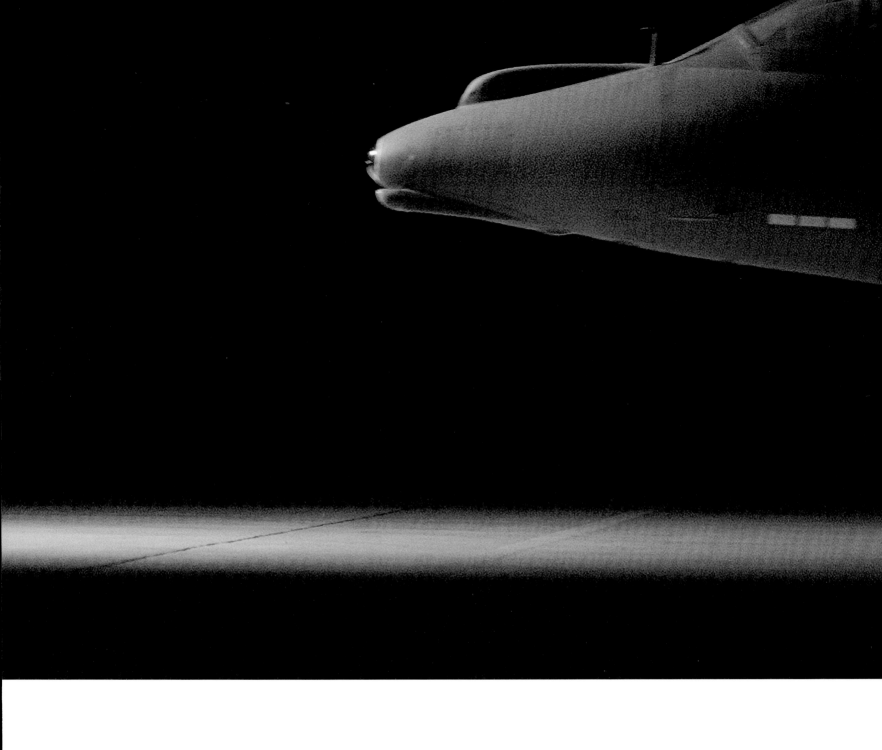

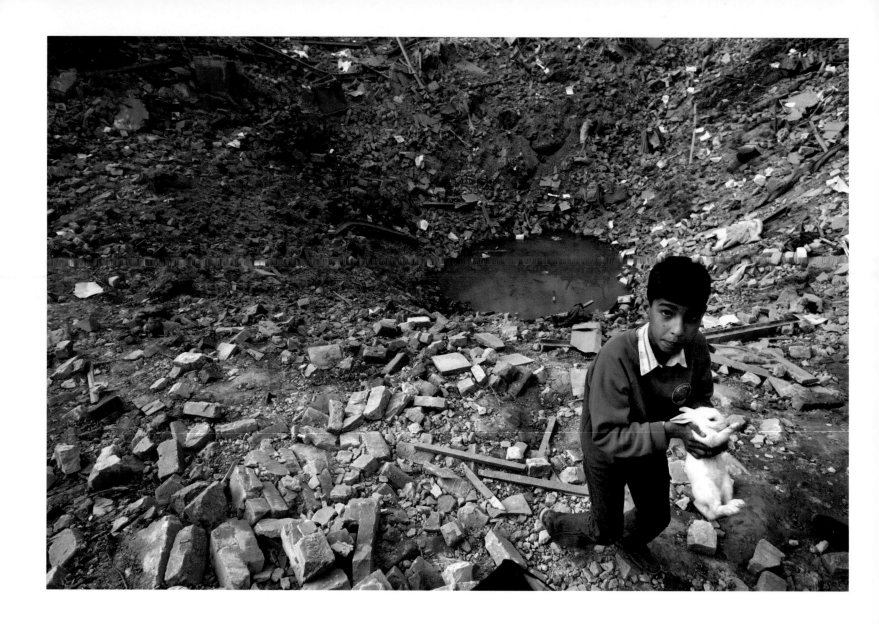

Sean Smith THE GUARDIAN

There had been an enormous missile
hit in a residential area of Baghdad.
Most of the surrounding houses were
damaged or completely demolished.
The owner of one kept pet rabbits and
when he was hospitalized by the

attack some of the local kids rescued
his surviving rabbits. 23 March 2003.

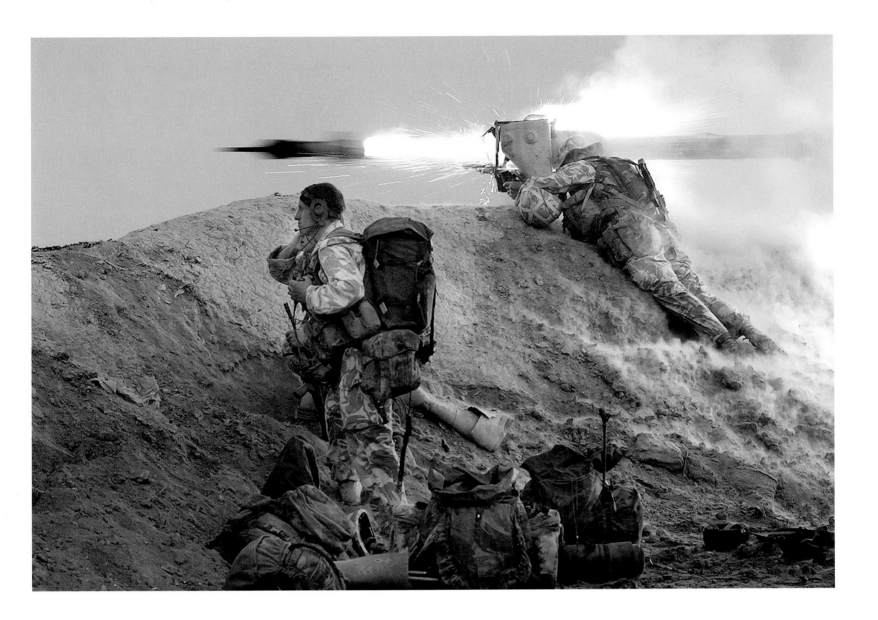

Jon Mills

A British Royal Marine from 42
Commando fires a Milan wire-guided
missile at an Iraqi position on the
Al Faw Peninsular. In the biggest
helicopter invasion since Vietnam,
marines from 40 and 42 Commando
move into southern Iraq to take and
guard Iraq's main oil wells.
21 March 2003.

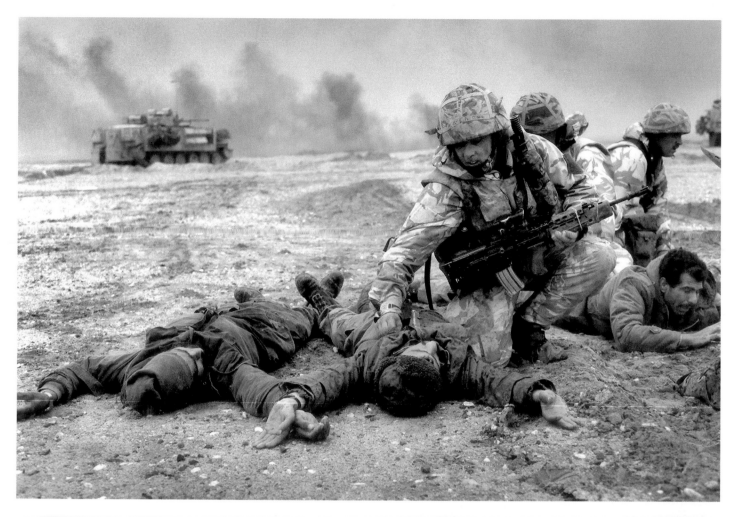

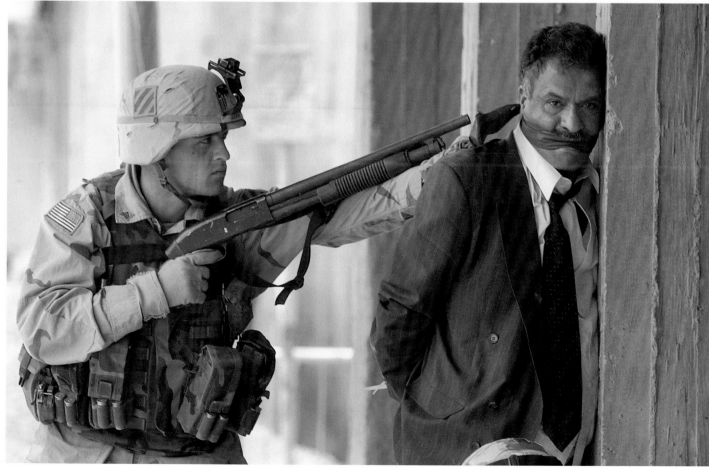

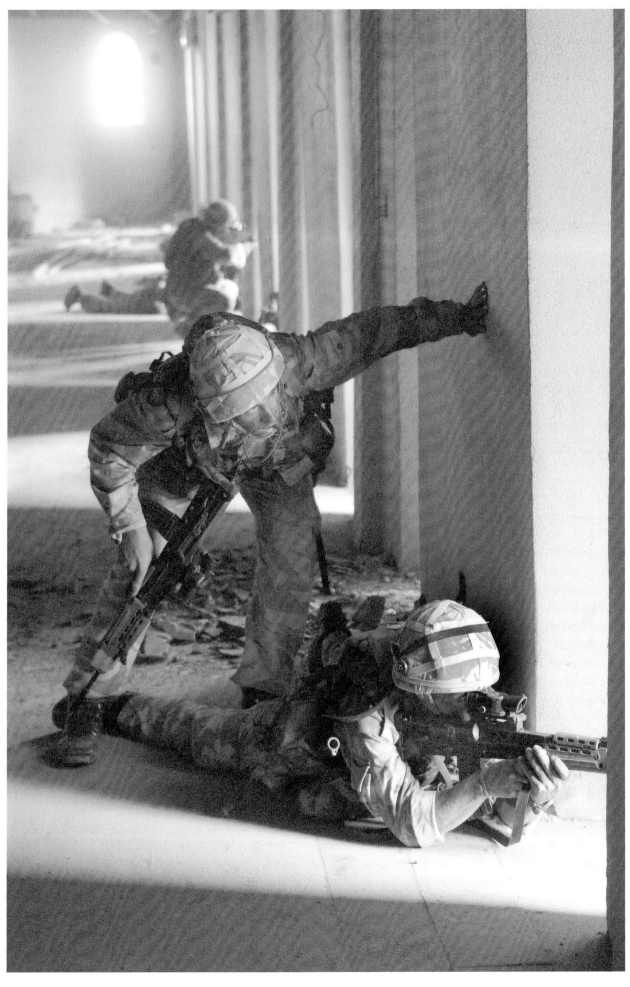

OPPOSITE PAGE
Mike Moore DAILY MIRROR

Sergeant Thomas Gorrian taking the
surrender of the surviving Iraqi forces
during the first Gulf War. One of the
only photographs taken showing
British ground troops in action in
the Iraqi desert during the liberation
of Kuwait. February 1991.

Peter Nicholls THE TIMES

A US soldier arrests a man in the
Karada area of Baghdad. He was
suspected of being an Iraqi
Intelligence officer and of being
involved in an extortion racket.
26 April 2003.

THIS PAGE
Terry Richards THE SUN

Among the first allied troops into Iraq,
Royal Marines 40 Commando take
refuge in an unfinished building while
approaching enemy positions near
the town of Al-Faw. 22 March 2003.

David Cheskin PRESS ASSOCIATION

Troops from the Queen's Lancashire
Regiment on patrol in some of the
areas which came under heavy
bombing in Basra, Iraq during the
second Gulf War. September 2003.

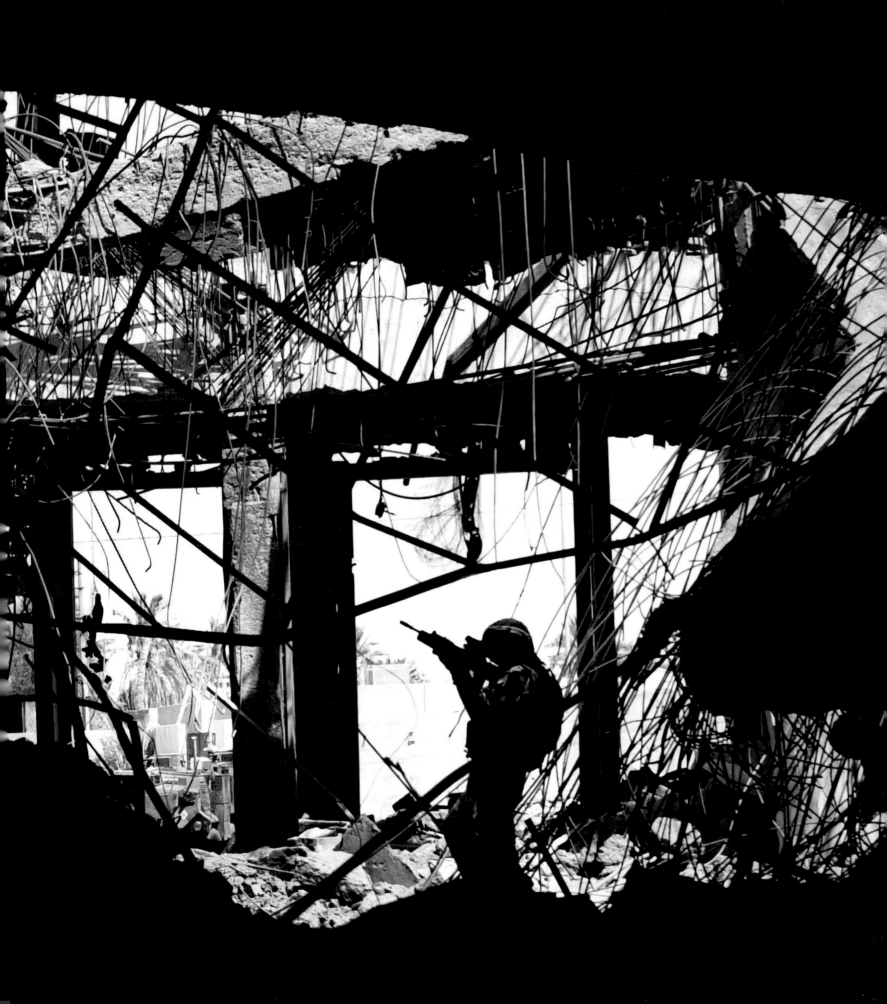

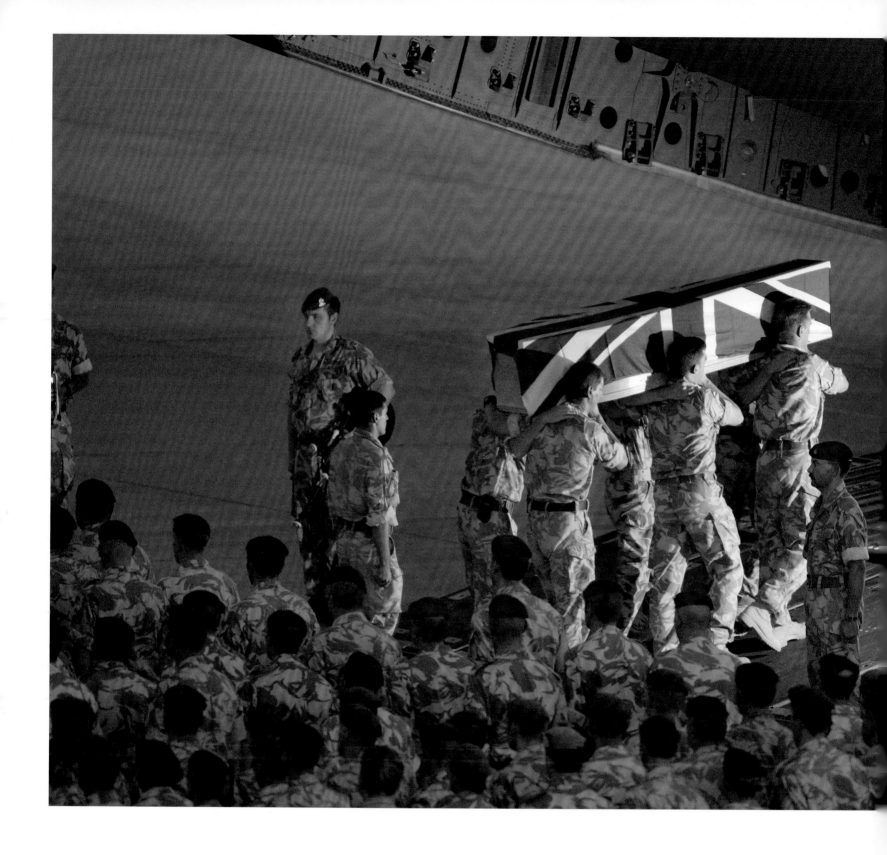

Jamie Wiseman THE DAILY MAIL

The coffins of the six dead British
Military policemen who were
ambushed and killed in the
Southern Iraq town of Major
al-Kabir are and loaded aboard
an RAF C-17 transporter aircraft
for their final journey home.
July 2003.

Sean Smith THE GUARDIAN

Woman soldier on a bed in Uday
Hussein's 'fun house'. Saddam
Hussein's son had used the palace
as a party house with swimming pool,
semi-erotic decorations and lavish
furniture and fittings. 10 March 2003.

Martin Godwin

Kabul, Afghanistan. A woman's new-
born baby dying because there is no
electricity or incubator to keep it
alive. November 2002.

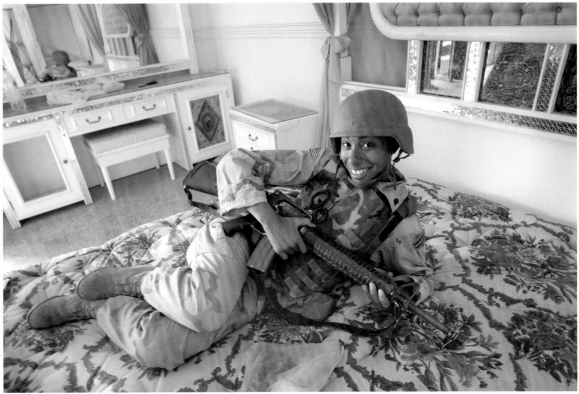

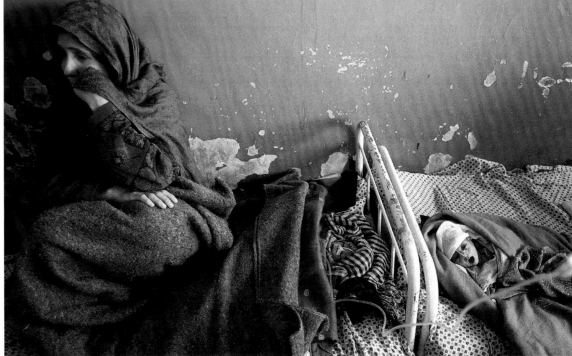

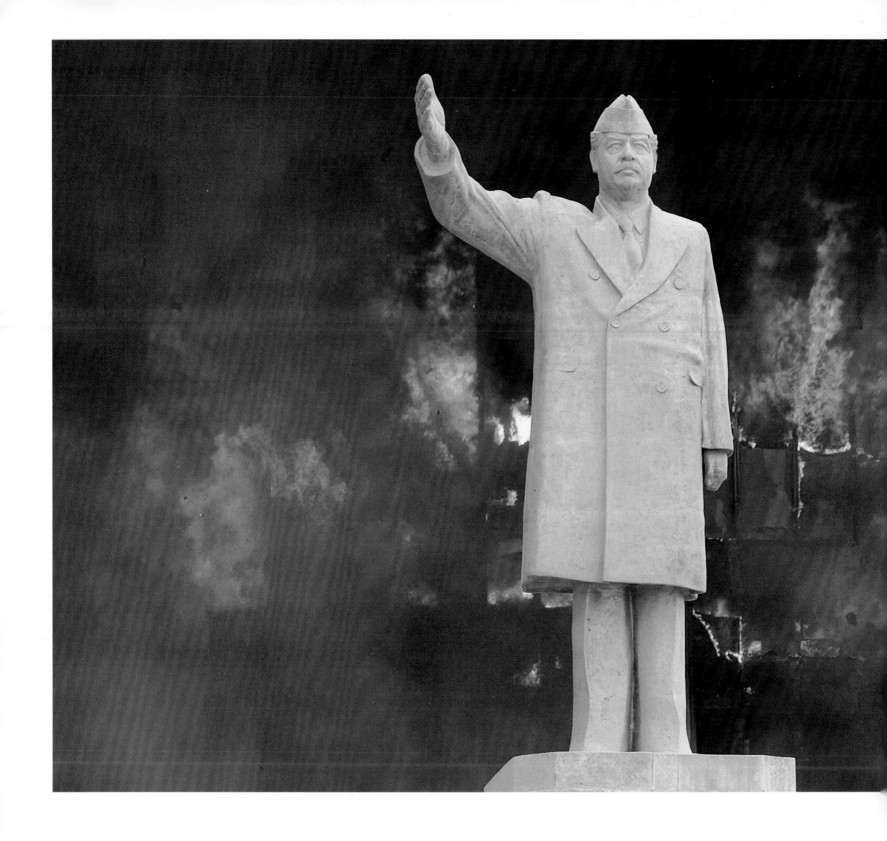

Peter Nicholls THE TIMES

Saddam statue in front of the Iraqi
Olympic Headquarters, after being
set alight by looters as US marines
entered Baghdad. The building was
also the headquarters of Uday
Hussein, Saddam's son. 9 April 2003.

Dan Chung THE GUARDIAN

Families continue to leave Basra in
southern Iraq across one of the town's
bridges, manned by British soldiers.
March 2003.

Mike Moore THE DAILY MIRROR

Baghdad ablaze during the 'Shock and
Awe' allied bombing. Missiles strike
the presidential compound and score
a direct hit through the roof of the
Iraqi Senate building. Seen from
across the Tigris River. March 2003.

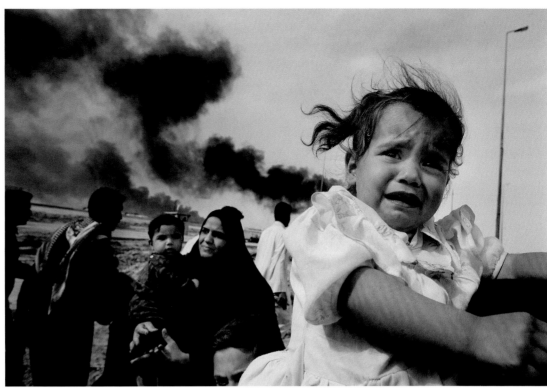

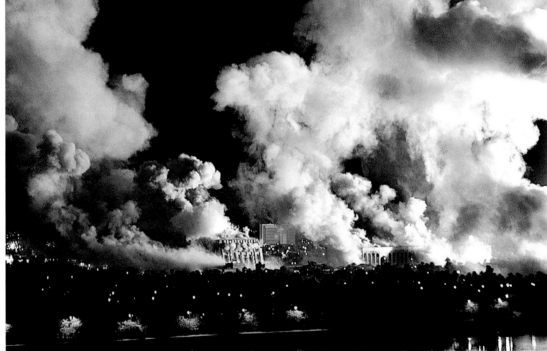

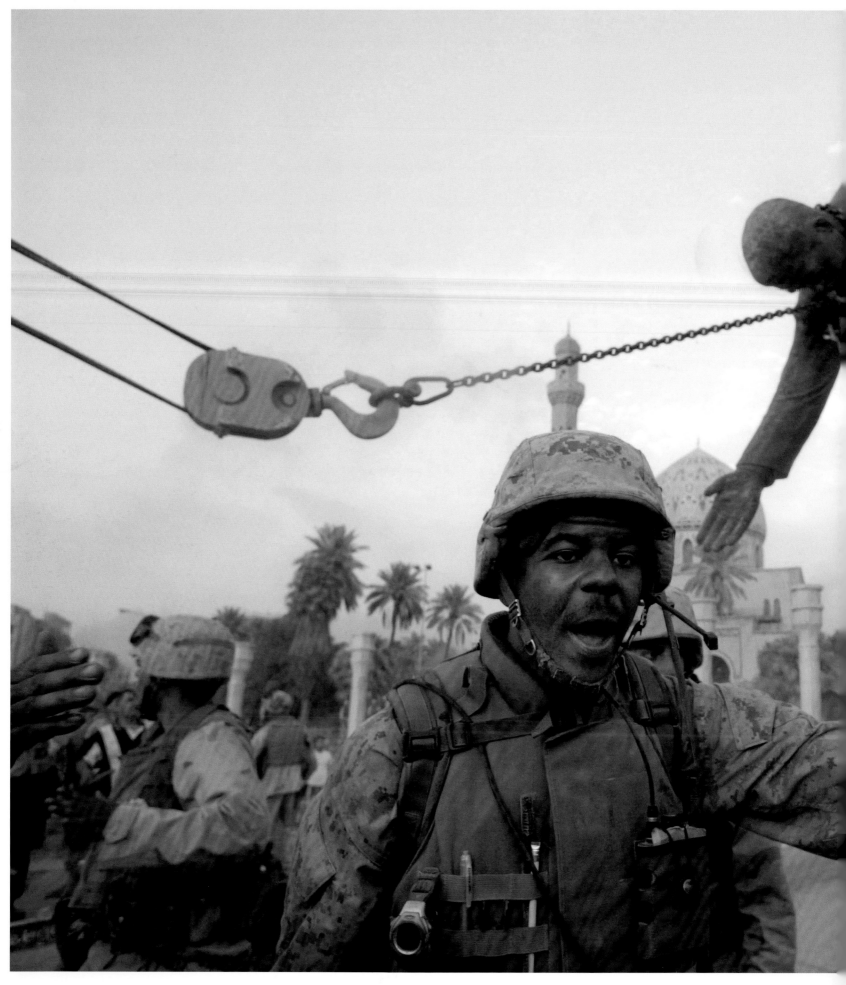

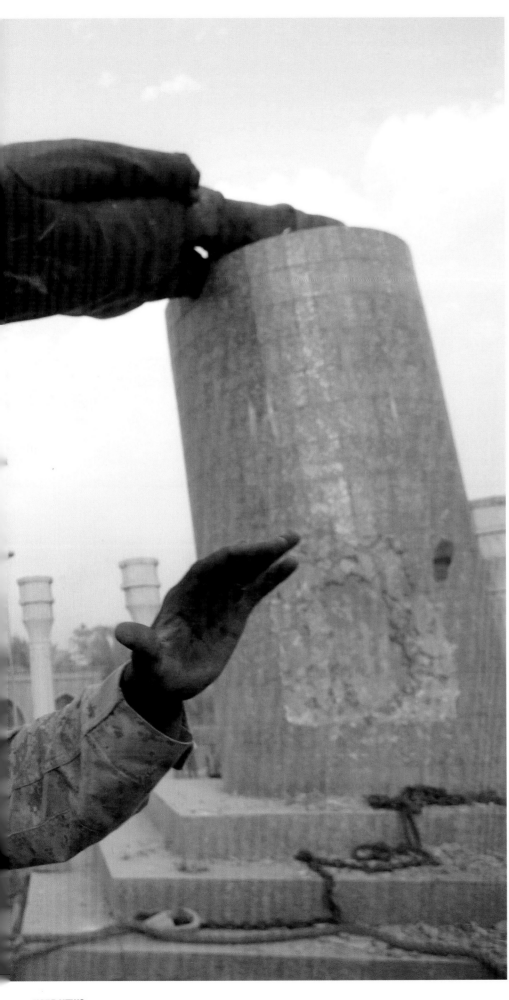

Sean Smith THE GUARDIAN

A statue of Saddam Hussein is pulled
down in Baghdad.
 The event, presented as a defining
moment by news organizations, was
attended by only a couple of hundred
people, not nearly enough to fill the
square, although numbers were
swelled by American soldiers.
The general sentiment across the
disparate groups of Iraqis was that
this was an army of occupation, not
liberation. 9 April 2003.

John Angerson

Astronaut's space suit at the Wet-F
training pool at the Johnson Space
Center, Houston, Texas. The deep pool
is used to simulate weightlessness.
September 1997.

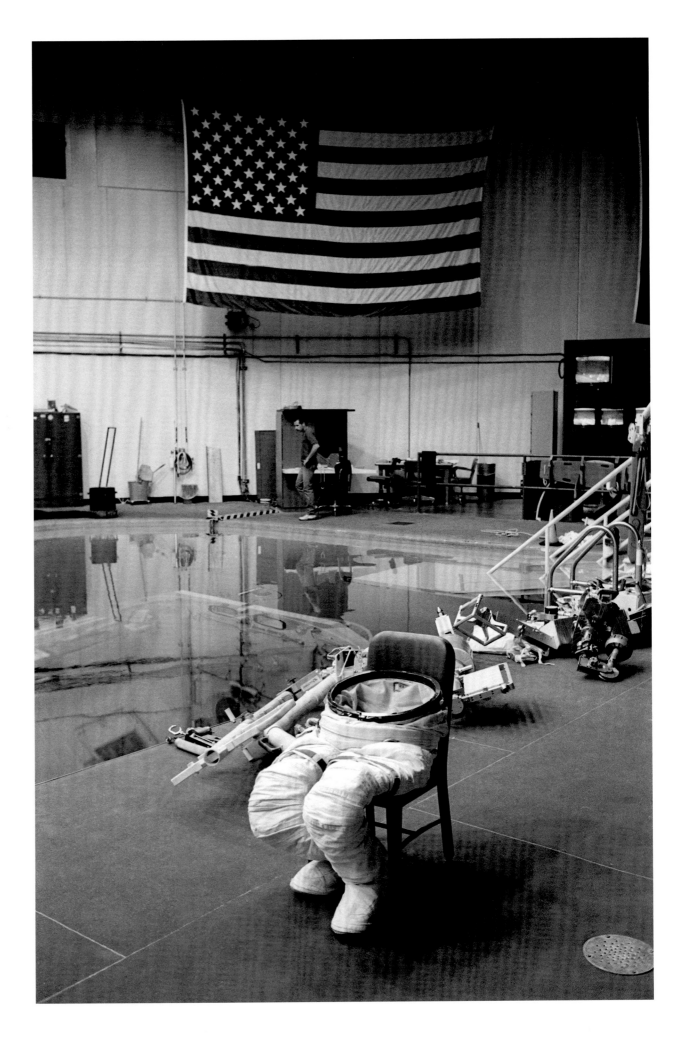

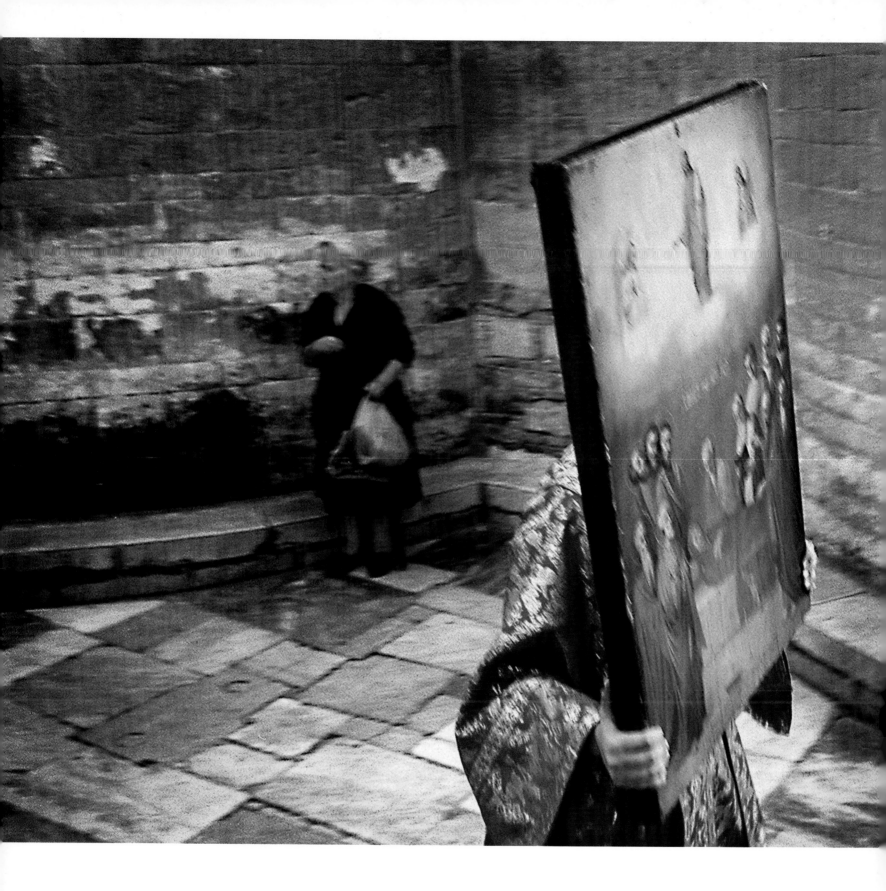

Mykel Nicolaou

Greek Orthodox procession in the
village of Agiassos, on the island
of Lesvos, Greece. August 2000.

Andrew Shaw

Young men play pool on the banks
of the Yangtze River in Chongqing,
China. Chongqing is one of China's
most industrialized cities and lies
on the confluence of the Yangtze
and Jialing rivers. April 1994.

Jonathan Player

Hairdressing competition in
Bucharest, Romania: a sign of a
people emerging from the shadow
of dictatorship. December 1990.

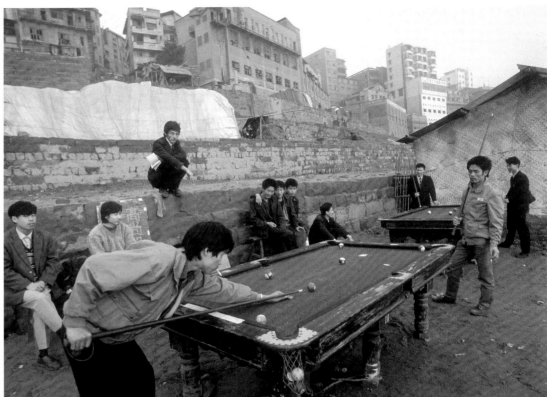

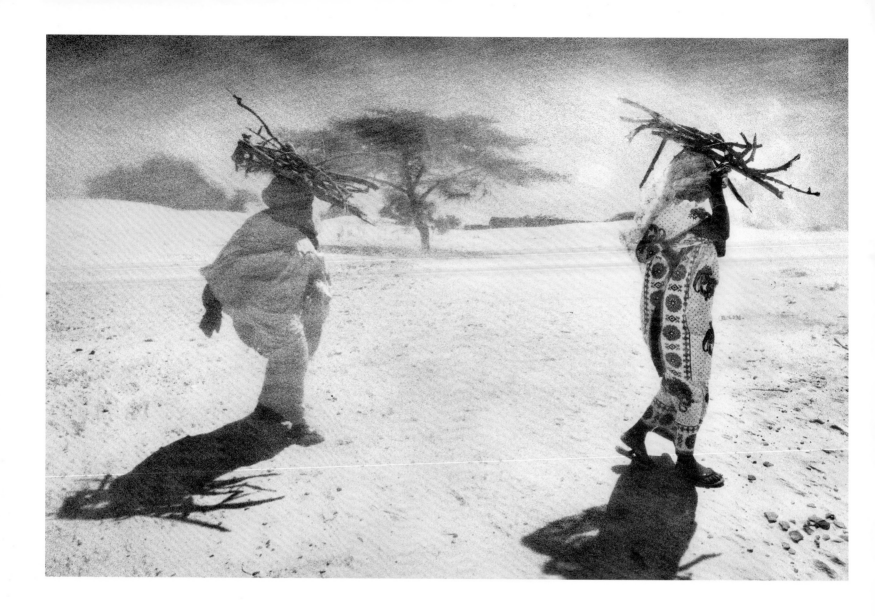

David Rose THE INDEPENDENT

Collecting firewood, Burkina Faso,
Africa. April 1995.

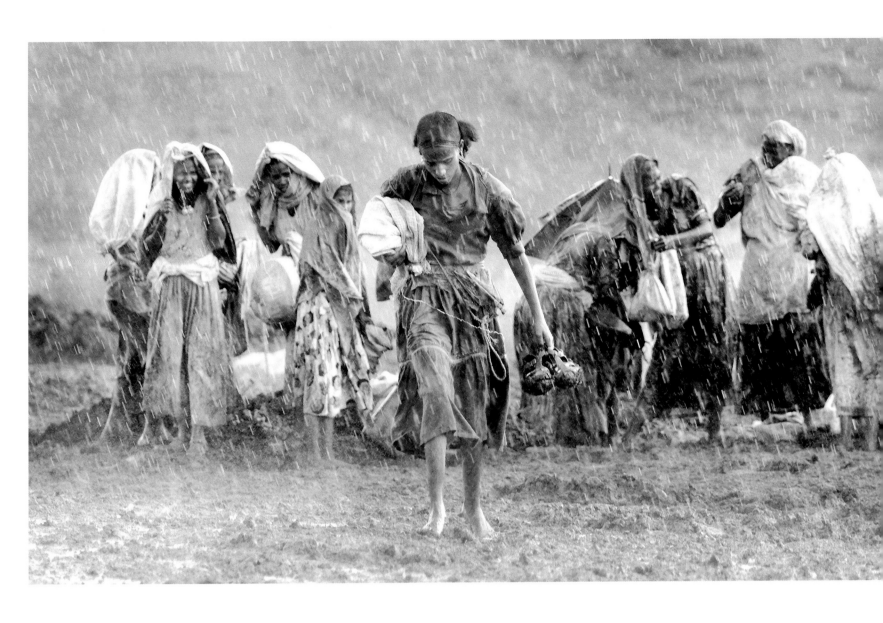

Peter Macdiarmid CHRISTIAN AID

Workers shelter from a surprise burst of rain while building a dam in Central Tigray, Ethiopia. After three years of drought these farmers and their wives are taking part in a 'work for food' scheme run by REST (the Relief Society of Tigray). Although welcome, the rain has come too late to irrigate the long-maturing crops of sorghum and finger millet which are due to be planted now. 20 April 2000.

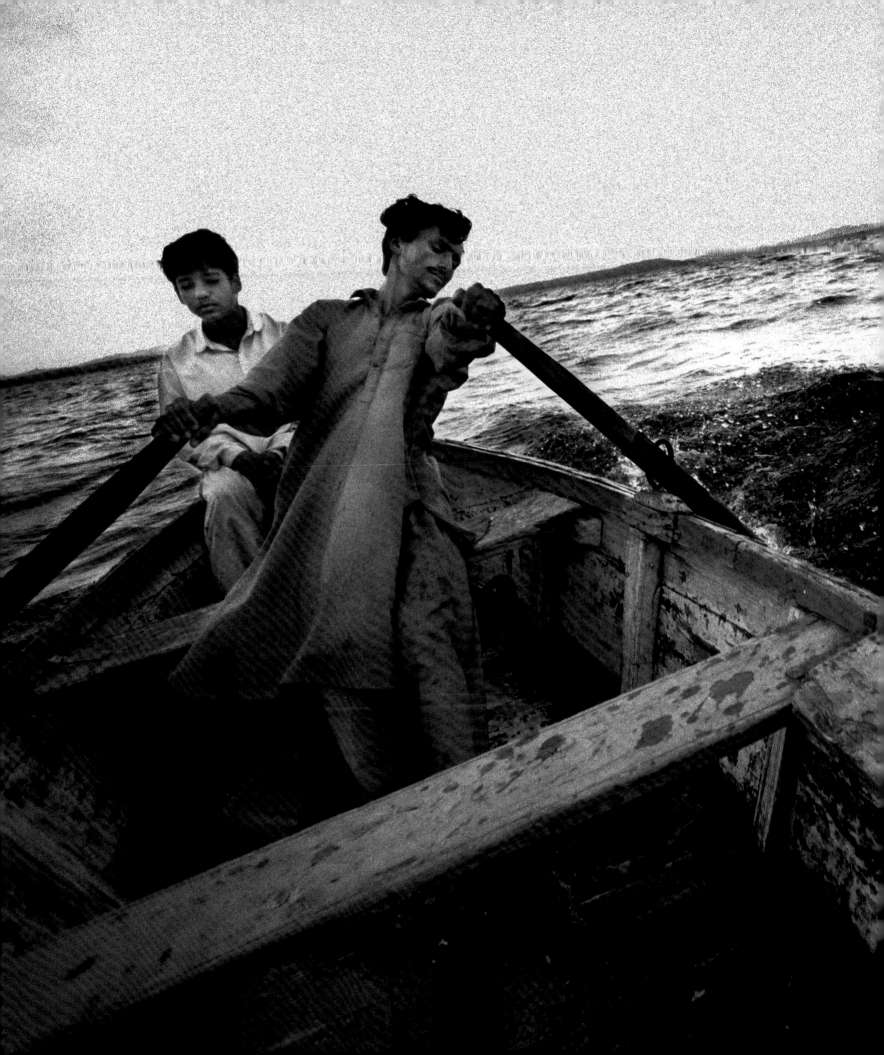

Tim Smith THE OBSERVER

Rowing boat crossing the sunken
city of Mirpur in Pakistan. Only the
top of the Hindu temple can be seen
emerging from the water. In the
1960s, over 100,000 people lost their
homes, their land and their livelihood
when the Mangla Dam was built.
Many came to Britain where Mirpuris
now make up over 75% of the British
Pakistani Community. July 1996.

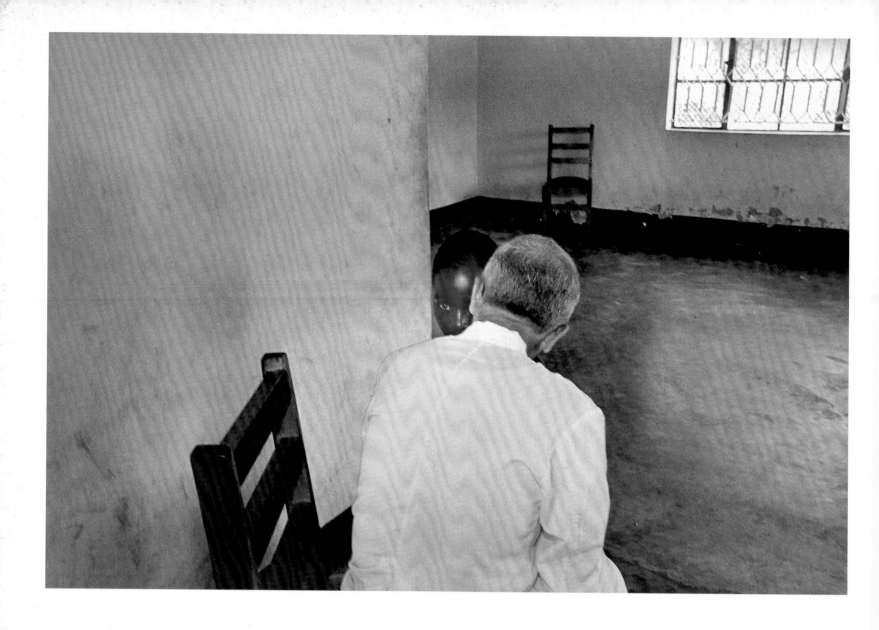

Stuart Freedman NETWORK PHOTOGRAPHERS

A former child combatant for the
Lord's Resistance Army gives
confession to an Italian priest, Father
Guido, Gulu, Uganda. August 1997.

Eddie Mulholland THE DAILY TELEGRAPH

A refugee from the Coalition bombing
of Afghanistan carries her sick child
across the border into Pakistan at the
town of Chaman.
 Most of the people were fleeing
bombing in the Kandahar region and

it was the task of journalists based in
the city of Quetta to cover their plight.
The problem was that Quetta was a
four-hour trip from this crossing point
and getting your name on the list for
trips to the crossing was like winning

the lottery. I was in Quetta for over
three weeks and was allowed only
one trip. October 2001.

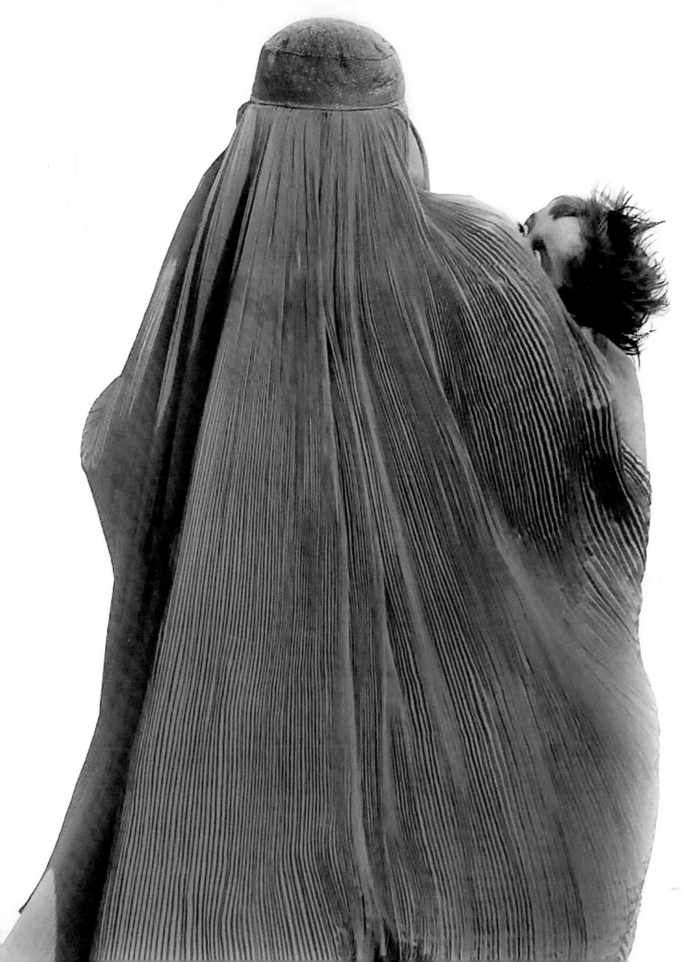

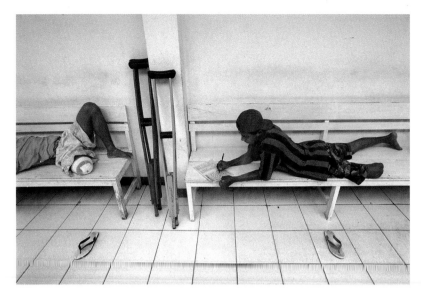

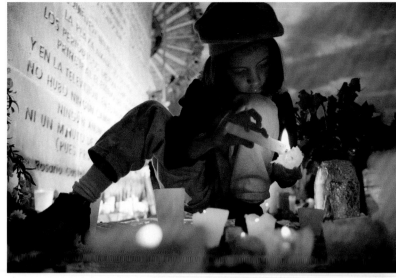

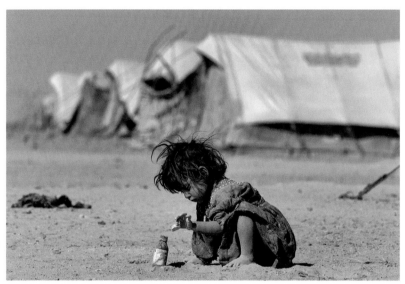

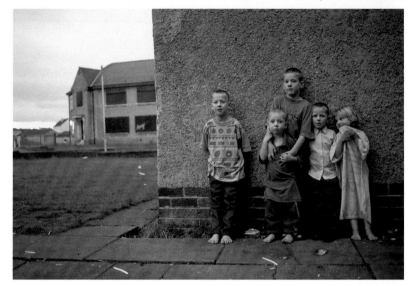

TOP
Timothy Allen THE INDEPENDENT

In a hospital in Ambon, the capital of Maluku in Eastern Indonesia, young victims of Indonesia's religious conflict in the Eastern archepelago of Maluku. November 2000.

Stuart Conway

A girl lights a candle in the Plaza de las Tres Culturas in Tlatelolco, Mexico City during the thirtieth anniversary of the student demonstration that led to hundreds of students being killed by the army. 2 October 1998.

BOTTOM
Richard Pohle

An Afghan child plays in the dirt of the giant Spin Boldak refugee camp in Taliban-controlled southern Afghanistan. 19 November 2001.

Jez Coulson INSIGHT VISUAL UK

Child poverty on the streets of Hamilton, near Glasgow, Scotland. October 1998.

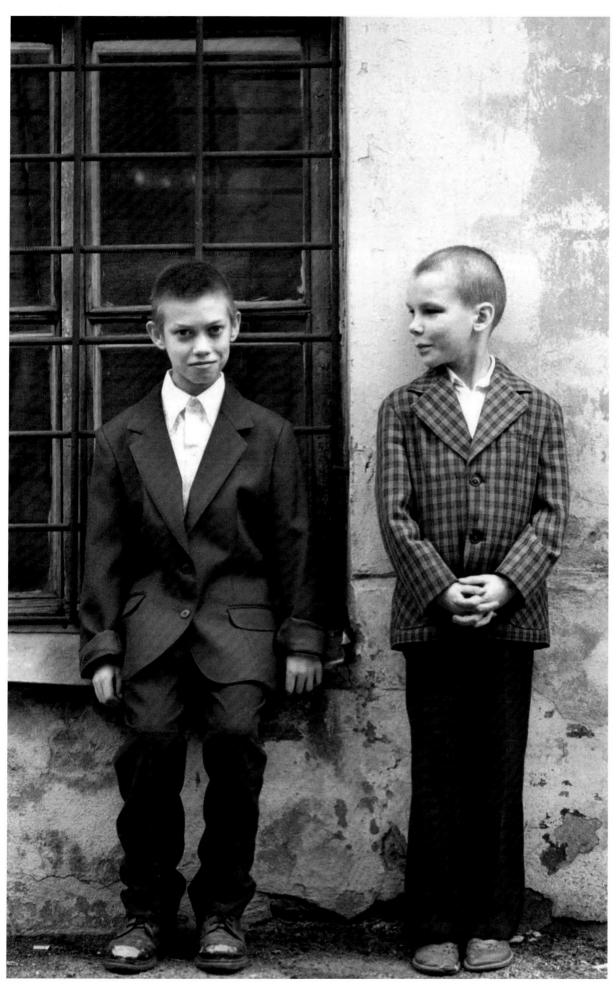

Graeme Hunter EXPRESS NEWSPAPERS

Streetkids Maxim and Andre at
the Mariensky charity canteen in
St Petersburg, Russia. 8 May 1998.

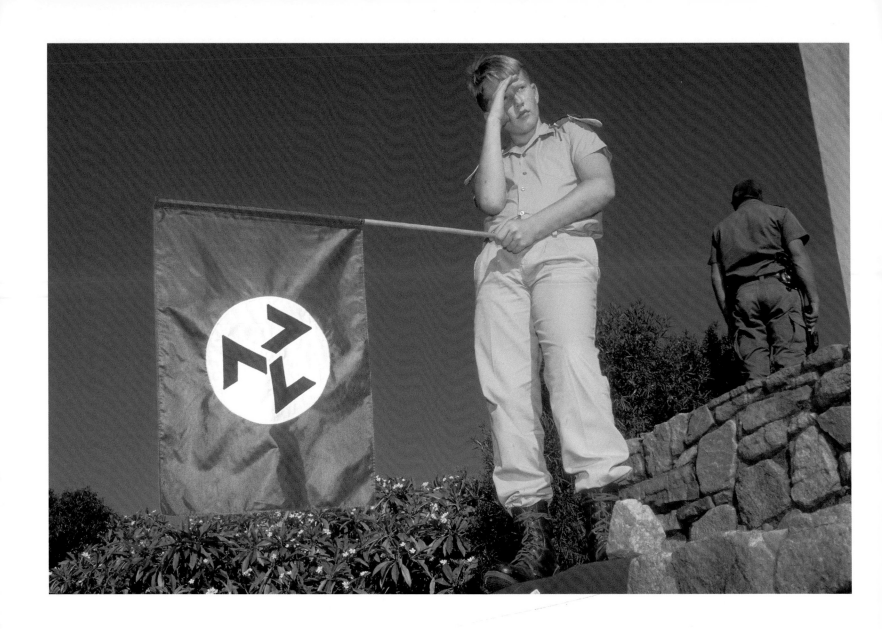

Jez Coulson INSIGHT VISUAL UK

A young AWB supporter at a rally held
by the white supremacist movement
in the run-up to South Africa's first
multi-racial elections. April 1994.

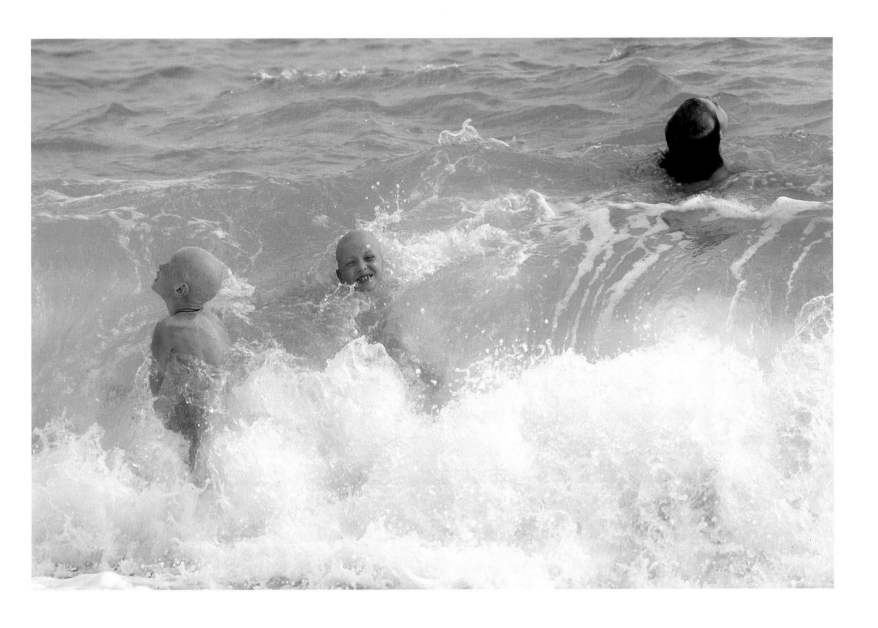

David White

Andrei Morienets (centre) dives through waves at Tarara Beach Camp, outside Havana, Cuba.

On the personal initiative of Fidel Castro, child victims of the Chernobyl nuclear disaster are flown from the Ukraine to Tarara to receive treatment and help their recuperation as much as is possible. Cuba leads the world in the study and treatment of the effects of radiation in humans. Most children at the camp have various cancers, thyroid and skin problems. Since 1990 the camp has performed more than 100 operations, including kidney transplants, heart operations and bone marrow transplants. Tarara is now fighting for survival and there is a chance that the centre will be closed and the bungalows where the children stay turned into expensive tourist chalets. June 1998.

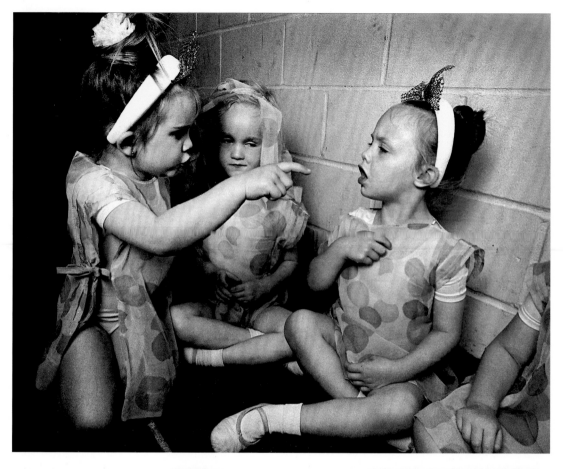

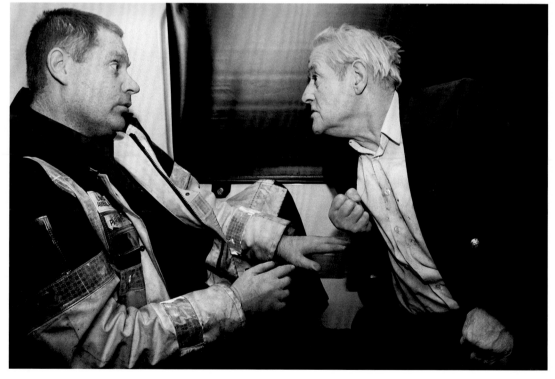

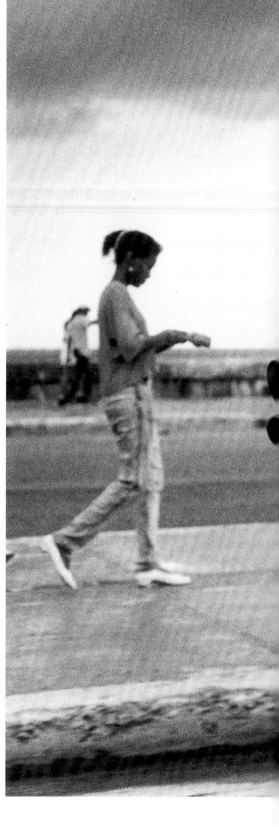

Peter Jordan

Holly Brook (centre) watches as Emily Dowson and Daisy Wootton, all age four, have a few words with each other backstage before the young ballerinas perform Tchaikovsky's *Nutcracker Suite* at the Edward Alleyn Theatre, Dulwich College, south London. The up-and-coming dancers are part of an 80-strong cast from the North Dulwich Ballet School. 14 July 1995.

Teri Pengilley

London Ambulance paramedic Martin Bunford tries to calm Paddy, found lying unconscious on the street in Whitechapel, London and now aggressively demanding a cigarette. 9 February 1999.

Tom Pilston THE INDEPENDENT

People take to their bicycles to beat the fuel shortages in Havana, Cuba, still suffering from a US blockade and without Soviet support since the fall of their Communist allies. June 1995.

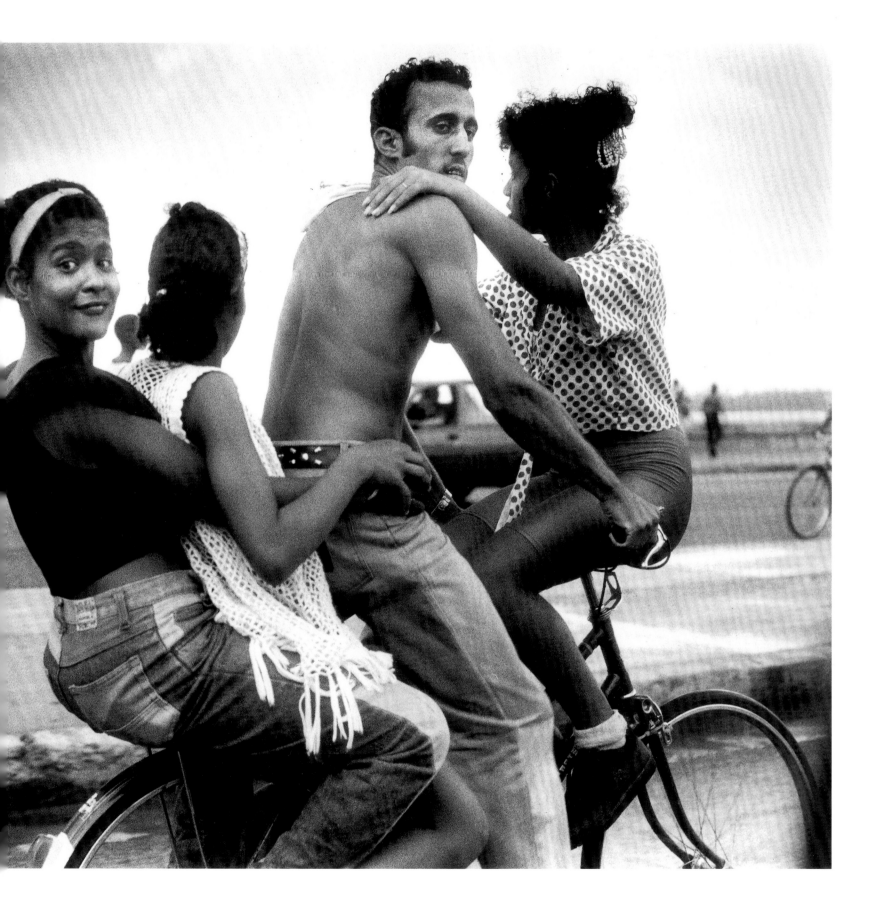

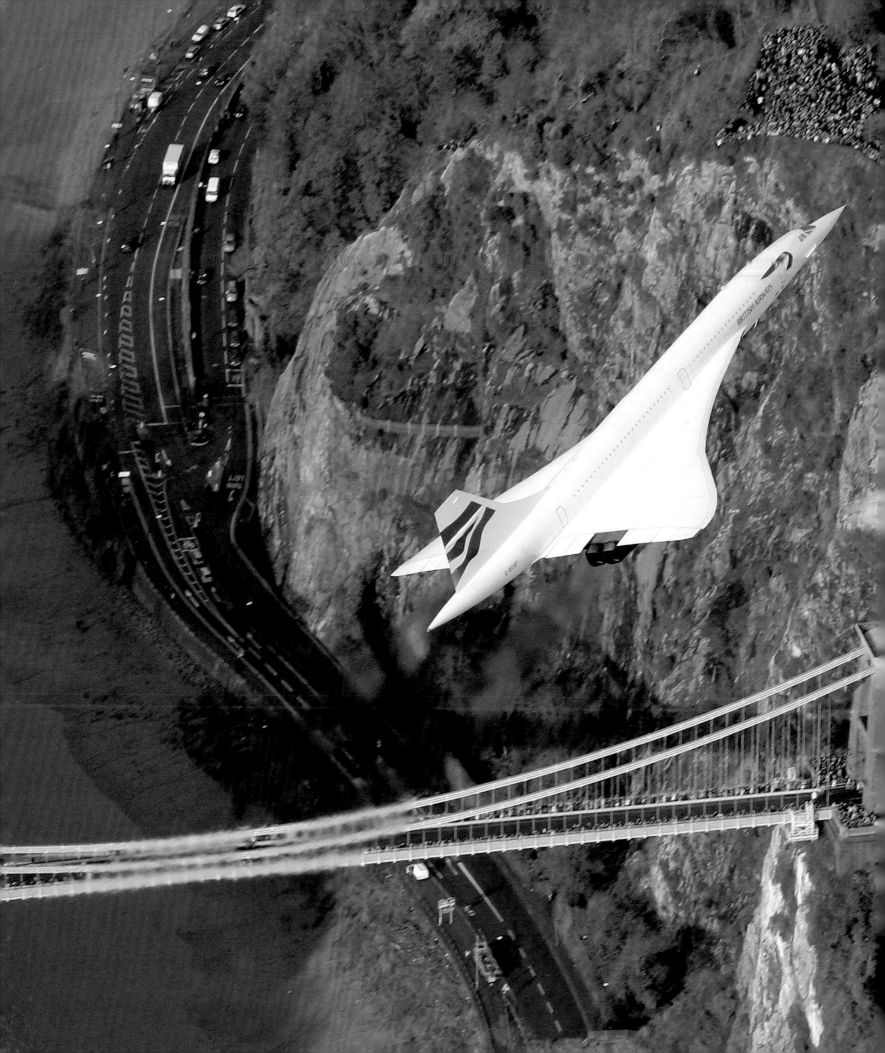

Lewis Whyld SWNS

Crowds of spectators watch Concorde pass over the Clifton Suspension Bridge in Bristol on its final flight, briefly uniting engineering triumphs of the nineteenth and twentieth centuries. The supersonic plane returned to its birthplace at Filton airfield in Bristol where it will remain.

Standing on the skid of a helicopter at 3,000 feet watching for the approaching passenger jet was unnerving. My legs and hands were numb from the cold and the roar of the blades above my head was deafening. Don't overexpose the plane, don't focus on the background, did I even have the right lens on? My camera was too slow for a burst so I panned with the plane and made the shot to include the crowd and the bridge. 26 November 2003.

Paul Stewart

Moss Side, Manchester where, due to the presence of drug gangs, the retail infrastructure had collapsed, leading the area further down the spiral of urban decay. February 1997.

Wattie Cheung

Latvians reading the daily papers
displayed on wooden hoardings in
Riga. September 1993.

Kirsty Wigglesworth PRESS ASSOCIATION

Firefighters at a Westminster fire
station in central London keep warm
around a brazier as they stand on the
picket line at the start of a 48-hour
strike. 1 February 2003.

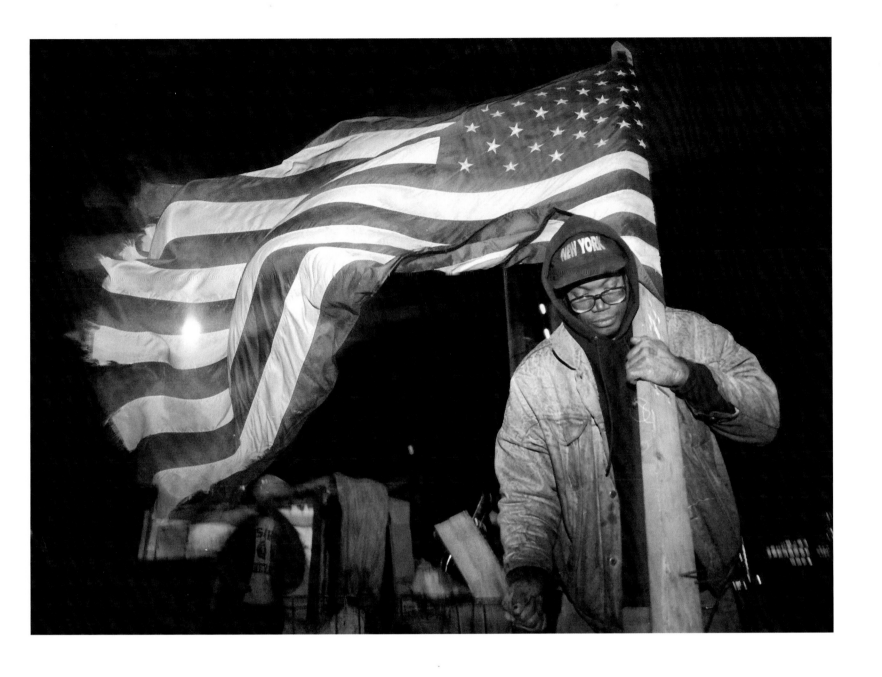

Richard Pohle THE TIMES

A vagrant carries a large American
flag in the cardboard city erected
under Brooklyn Bridge in New York
in protest of alleged harassment by
the authorities to clear such city areas
of down-and-outs. October 1995.

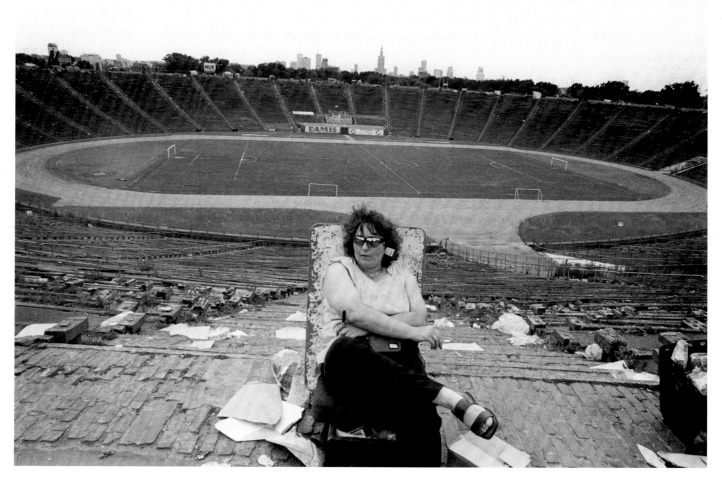

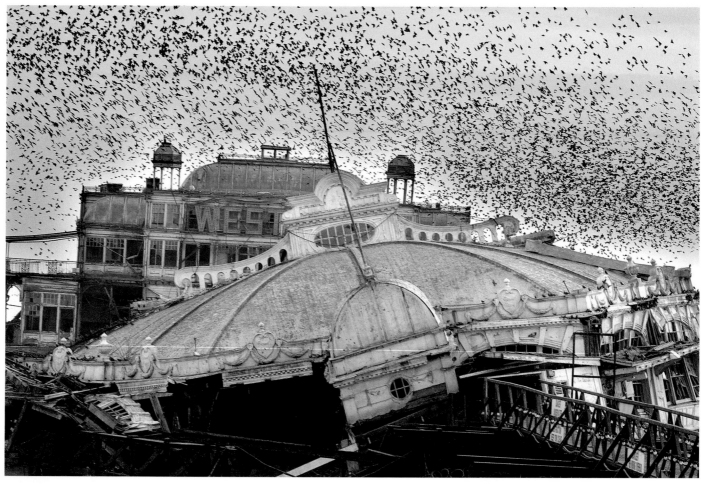

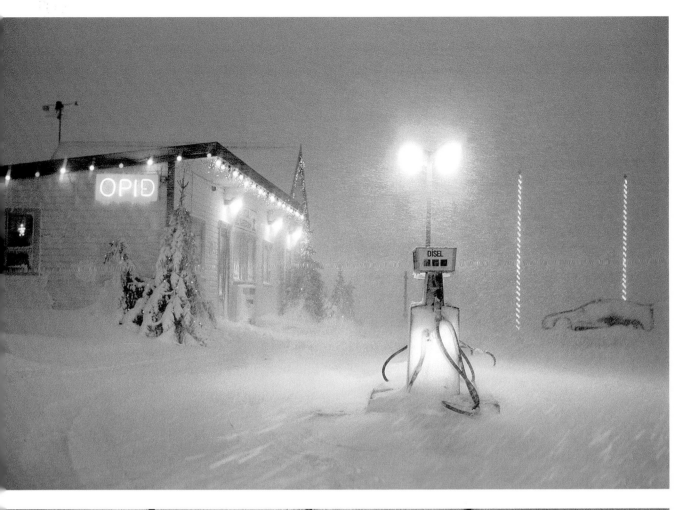

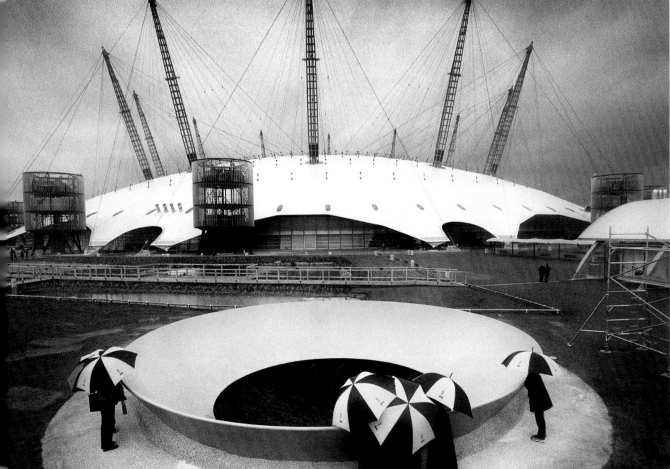

OPPOSITE PAGE
Justin Leighton

French and German soldiers train together near the Maginot Line in the Alsace region of France. These soldiers are to become the core of a new Euro Army. The training included the history of the wars that were waged between the two nations. April 1992.

Jez Coulson INSIGHT VISUAL UK

A Catholic child plays with a toy gun in front of a patrolling British soldier, Belfast, Northern Ireland. July 1998.

THIS PAGE
Max Nash AP

A female Israeli soldier walks up from the beach at Ein Fashka, at the northern end of the Dead Sea with her assault rifle.

Following numerous terrorist actions on Israel's borders, the army recommended that its troops carry their weapons with them at all times. Most Israeli women are called up at the age of 18 to do national service for two years, and although in general they do not see active service, they are armed as men. 27 September 1989

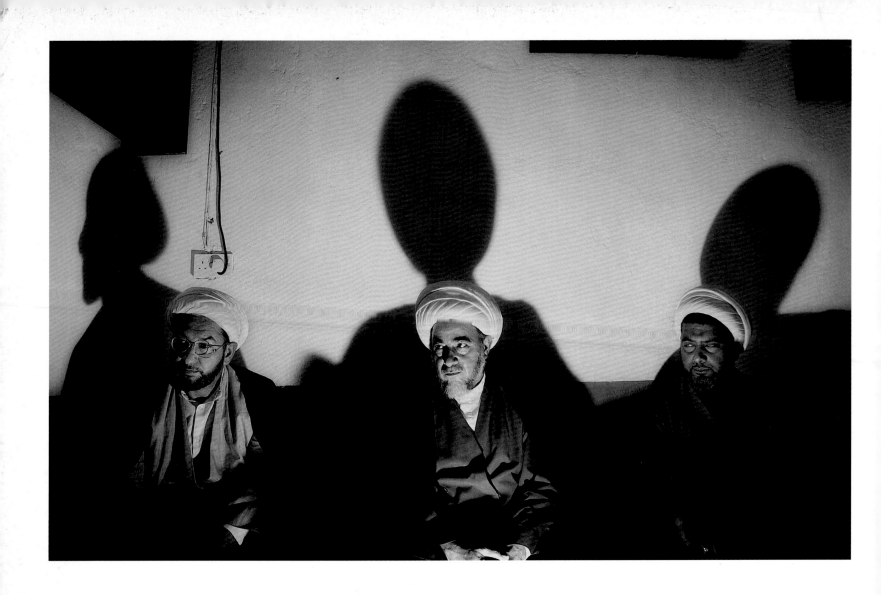

Richard Mills THE TIMES

Shia Hia Cleric Ayatollah Salih Al-Taee,
flanked by two of his followers, gives
an interview on the future of Iraq.
April 2003.

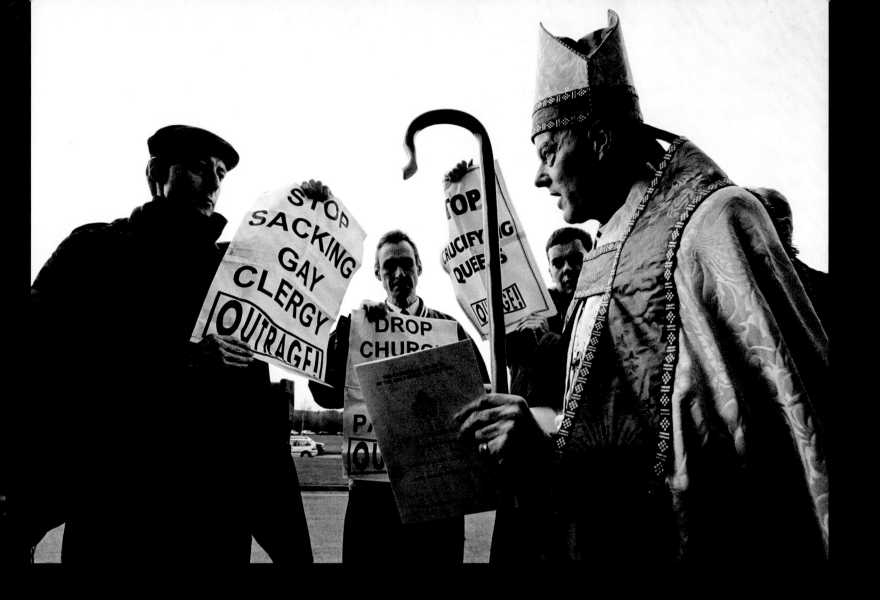

Andrew Wiard REPORTPHOTOS.COM

Peter Tatchell and Outrage gay rights
demonstrators waylay John Gladwin,
Bishop of Guildford, as he arrives for
his enthronement at Guildford
Cathedral. 18 December 1994.

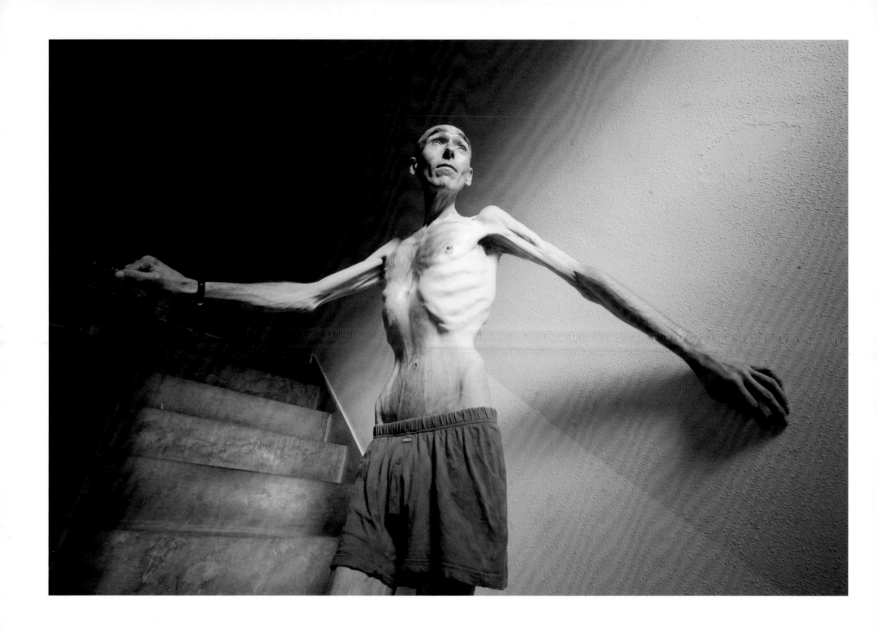

Roger Allen THE DAILY MIRROR

Brian Kane is six foot tall and weighs just 6st 10lb. He has been in hospital many times to try and cure him but he thinks he is fat when he looks in the mirror. Brian lives with his boyfriend in his flat in Birmingham.

When he was in hospital his friend Michelle died just before she was to be released. After the funeral one of the psychiatrists said, 'Let that be a warning to you all'. Brian went and bought a chocolate bar promising to eat it to put on weight. It is still uneaten in his kitchen.
September 2003.

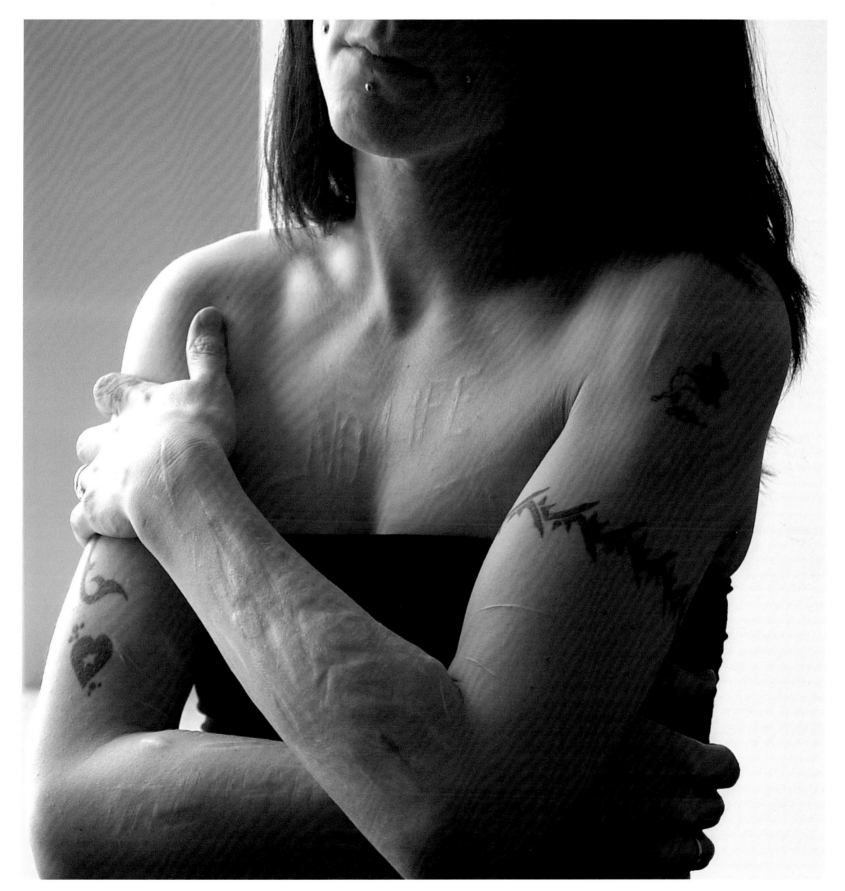

Leon Neal

Beth has suffered with the symptoms
of schizophrenia for several years. The
scars from her episodes of self-harm
are visible on her body. She cut the
words 'No Life' into her chest during a
period of alcoholism. 8 January 2003.

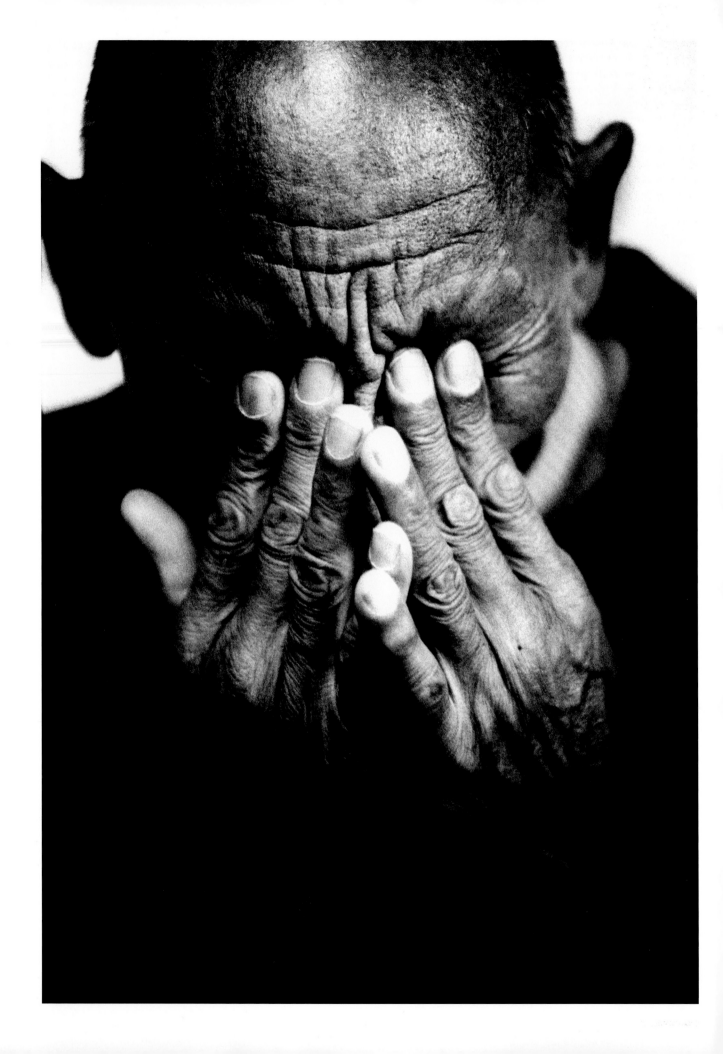

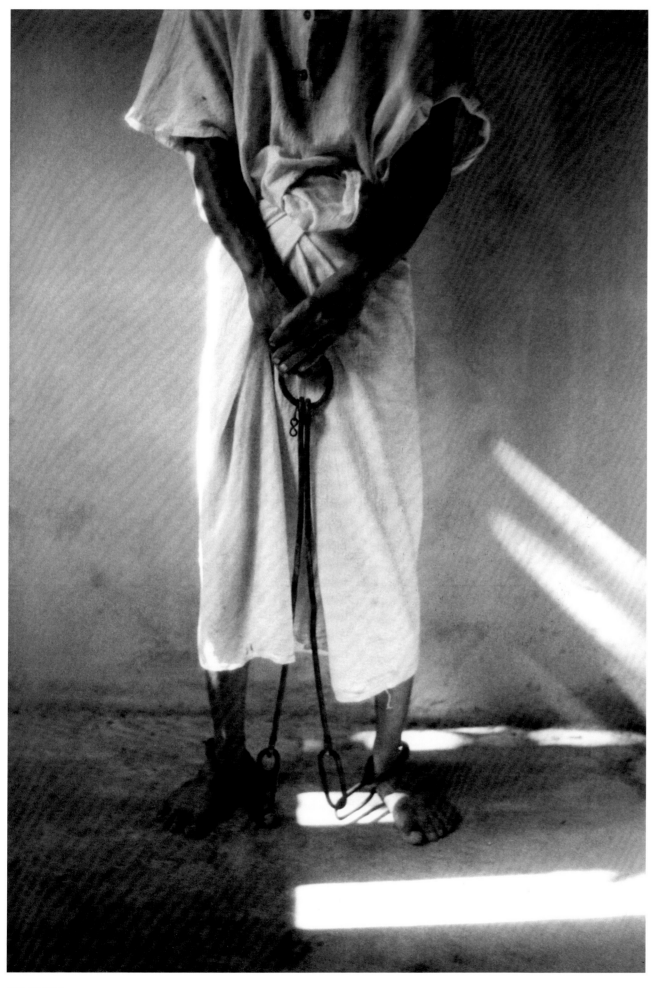

OPPOSITE PAGE
Dillon Bryden THE INDEPENDENT

Palden Gyatso, a Tibetan monk who was imprisoned and tortured by the Chinese authorities, breaks down during a press conference at the House of Commons in London where he had described his ordeal. February 1995.

THIS PAGE
Nic Dunlop

A former political prisoner and student activist demonstrates in a prison uniform and shackles. He fled Burma after spending several years in various prisons before fleeing to exile, Mae Sot, Thailand. January 2002.

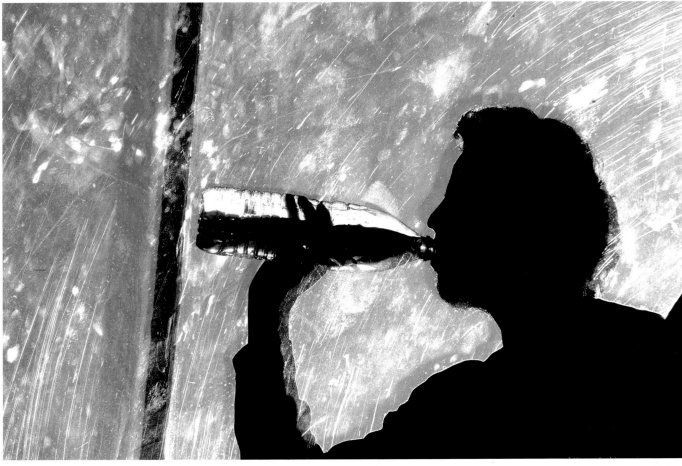

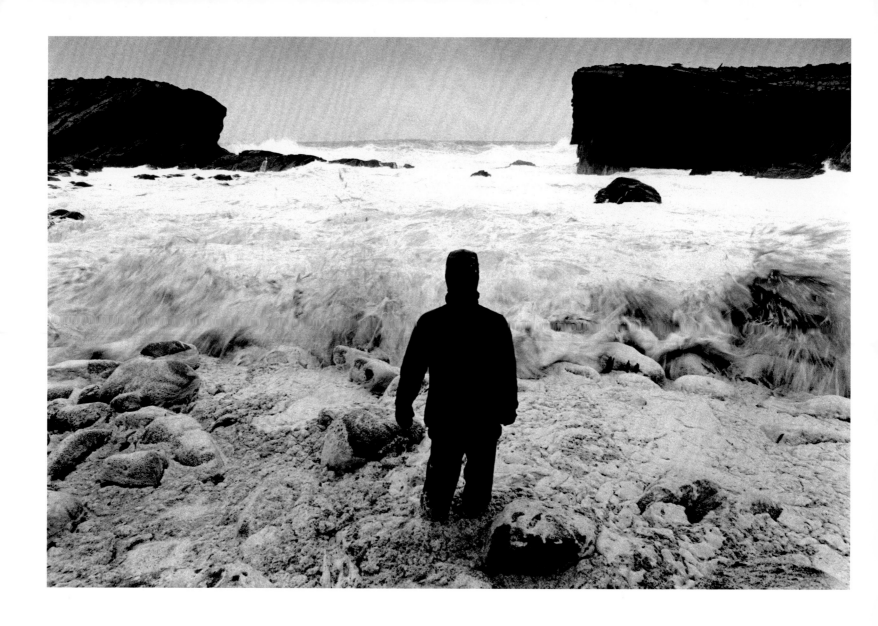

Dillon Bryden

Gary Wright near his home at Scatness,
the most southerly point of the
Shetland Islands, watching the oil-
polluted sea following the spill when
the Braer tanker went aground in
Quendale Bay, Shetland. January 1992.

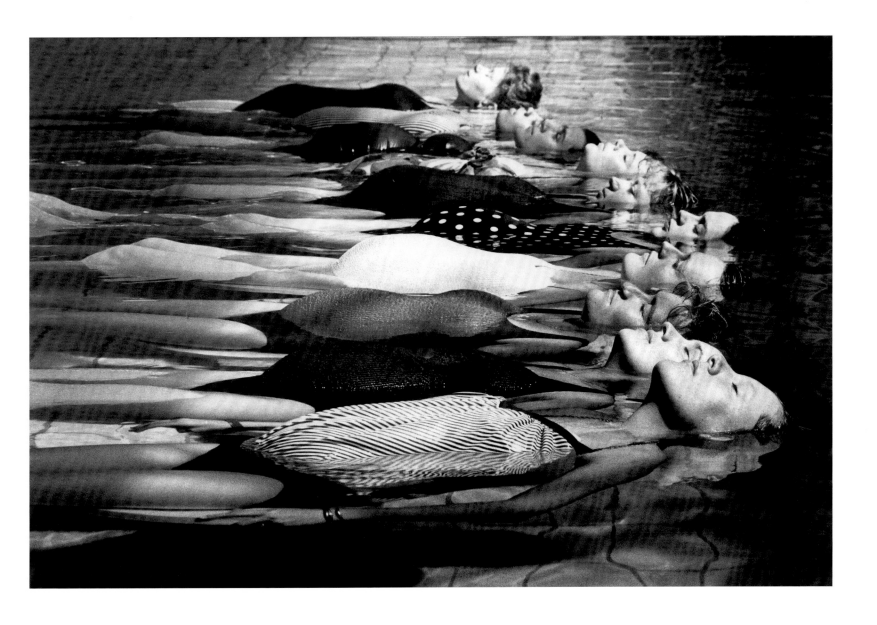

Roger Bamber

Pregnant mothers in Brighton learn
to relax at an ante-natal class in a
swimming pool.

The buoyancy of the water helps
them exercise gently. Sitting in foam-
rubber rings they are able to float

about with just their tummies and
faces visible above the water.
June 1991.

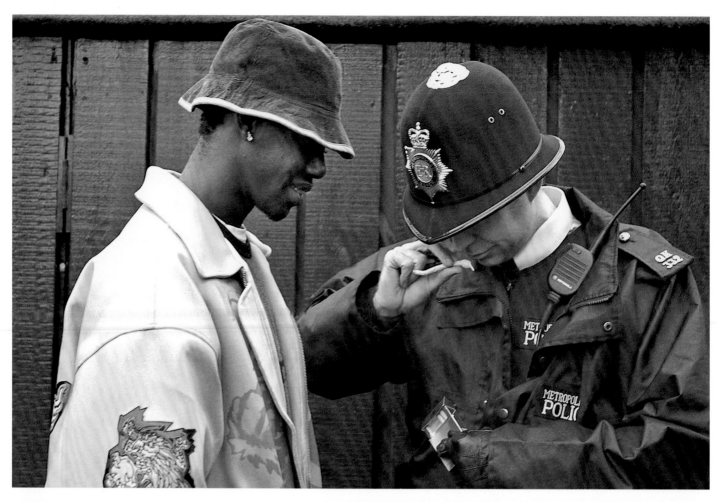

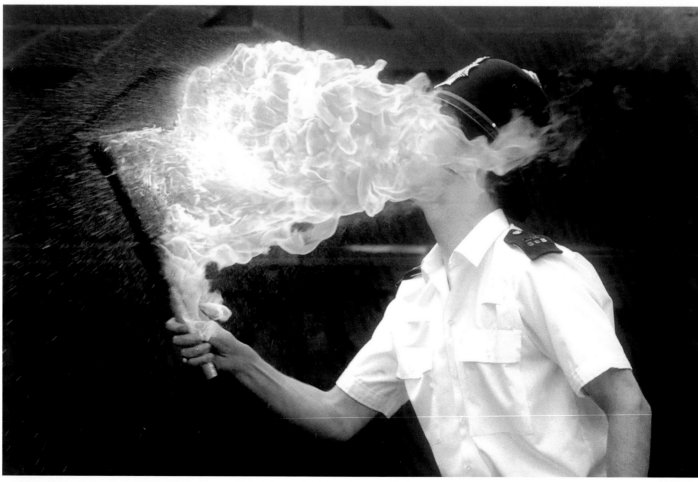

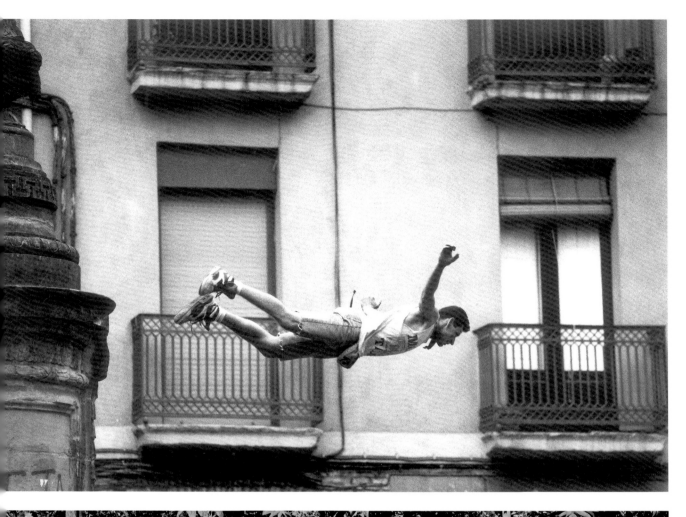

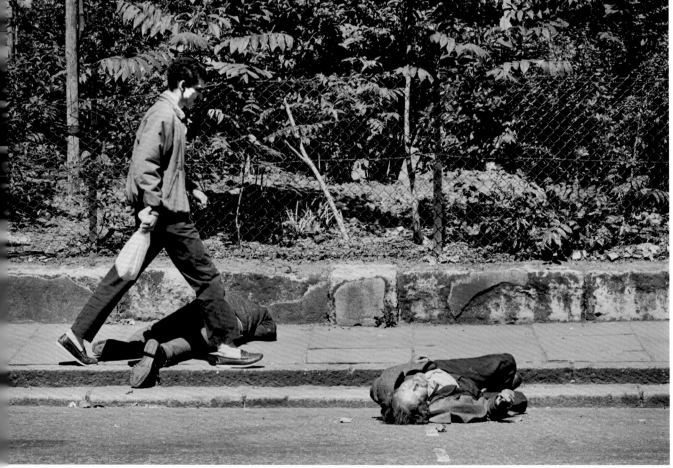

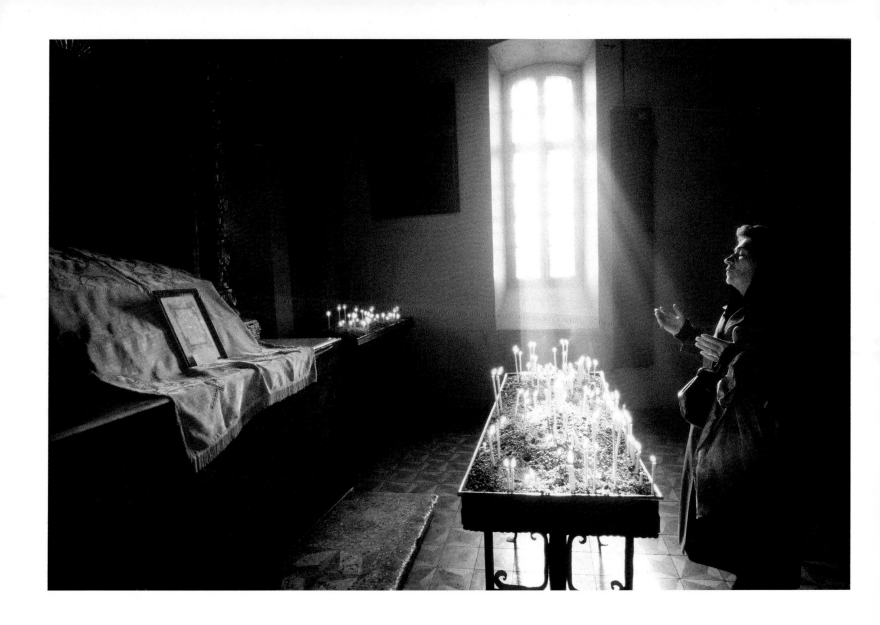

Edmond Terakopian

A woman prays for the souls of her
family whom she lost during the
devasating Armenian earthquake
exactly ten years before.
6 December 1998.

Jack Hill

A little girl waiting to have her portrait taken in a Baghdad photographic studio in the days following the end of the American occupation. With a loss of security, and a limited supply of water and electricity, citizens have little to be cheerful about. June 2003.

Andy Hall THE OBSERVER

Fifteen-year-old author and celebrity
Gil Alicea on the streets of his home
town, New York City. The boy, whose
father is in prison and whose mother
died of AIDS, found fame by writing
a book about his life seen through

the philosophy of basketball.
October 1996.

Tim Smith THE OBSERVER

Empty weaving shed at Bradford's biggest mill, Lister's Manningham Mills. The textile industry in the north of England has collapsed in recent times. There are now fewer than 1,000 people employed in textiles in Bradford, once the woollen textiles capital of the world. June 1992.

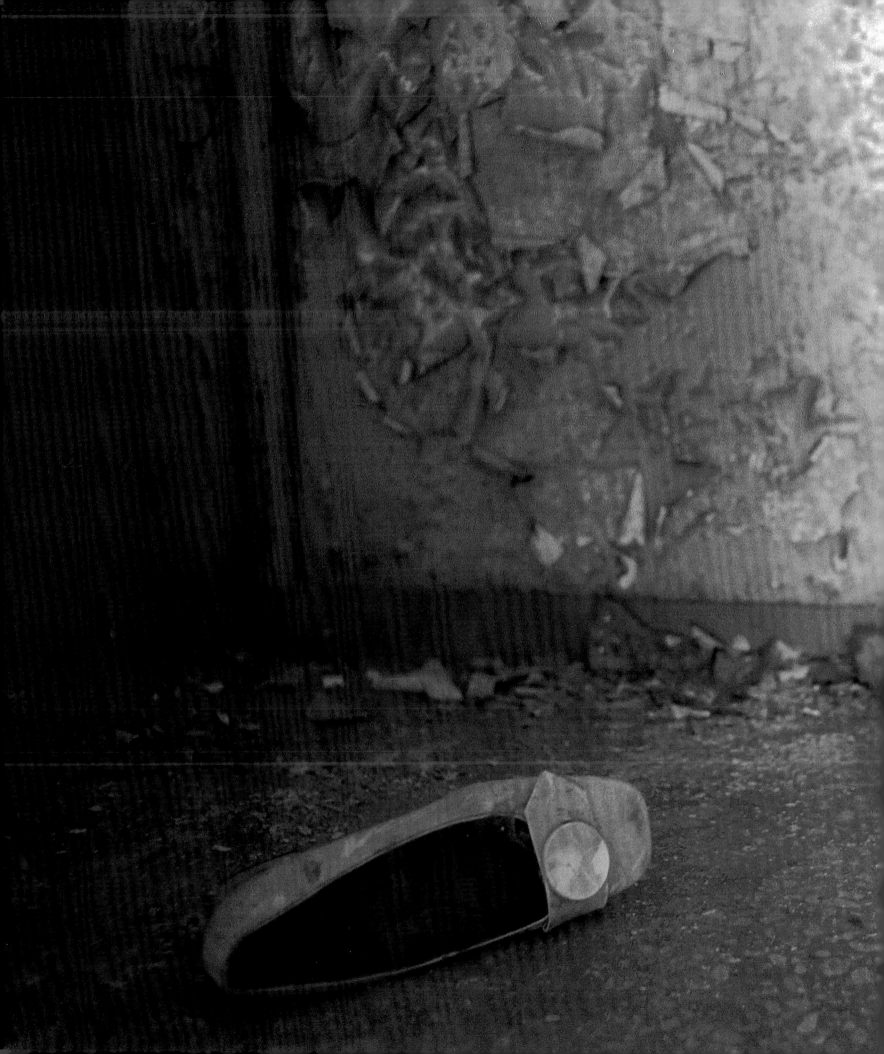

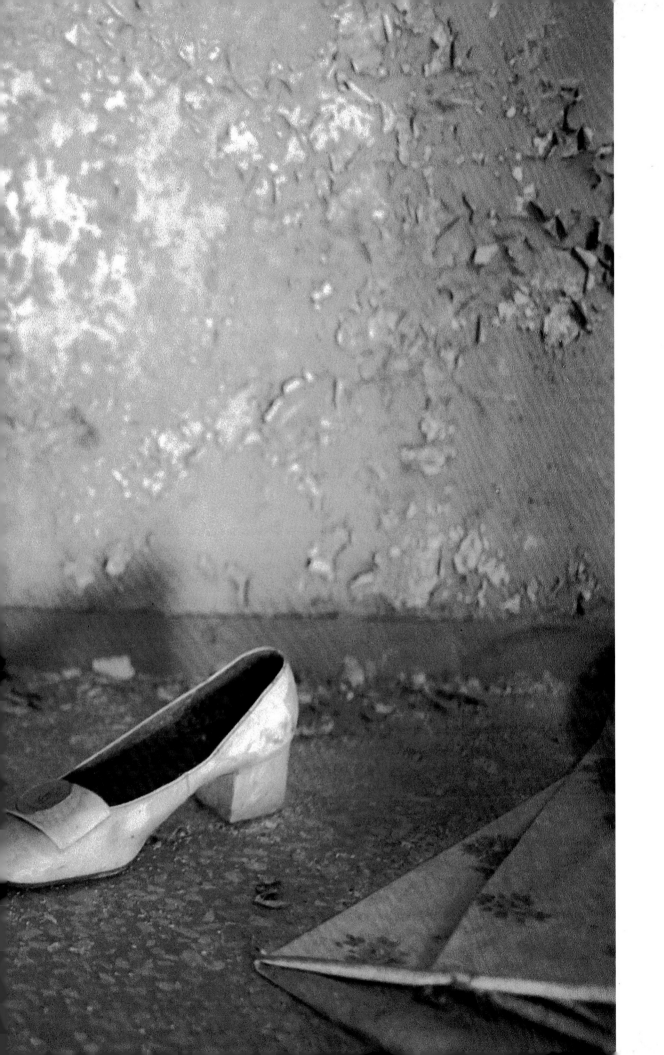

Martin Godwin

A discarded pair of shoes on the landing of an abandoned tower-block in the ghost town of Pripyat, two kilometres from the Chernobyl power plant, site of the world's worst nuclear accident ten years before. November 1995.

The Queen is amused as a swarm of
bees causes concern amongst guests,
prior to the Queen's Company Review
at Windsor Castle. 15 April 2003.

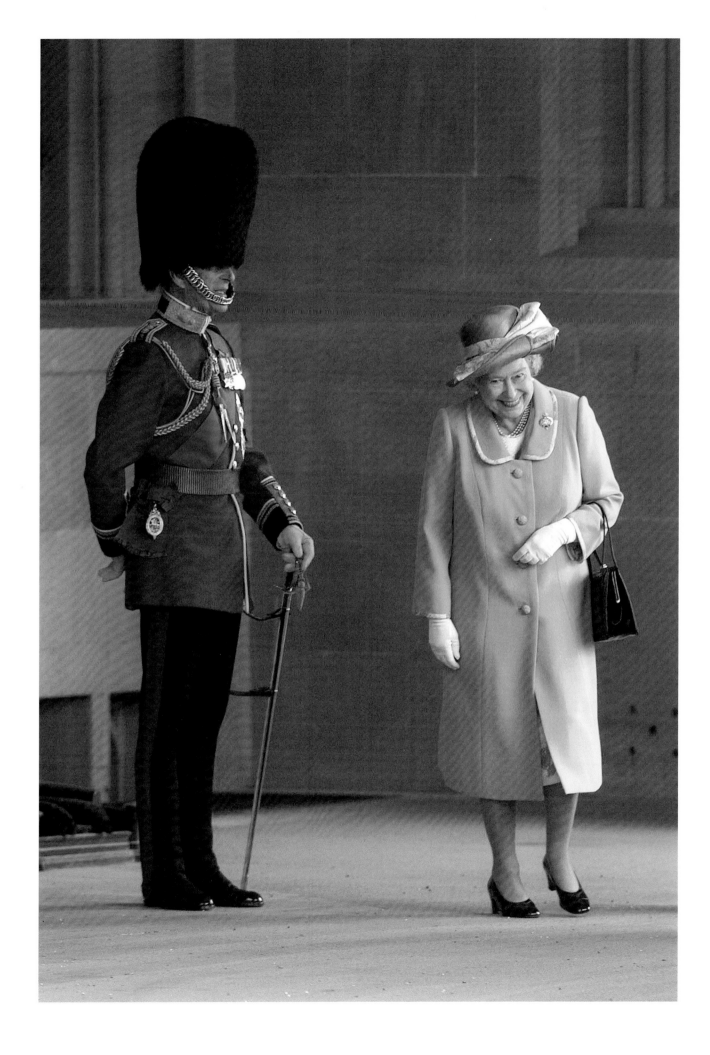

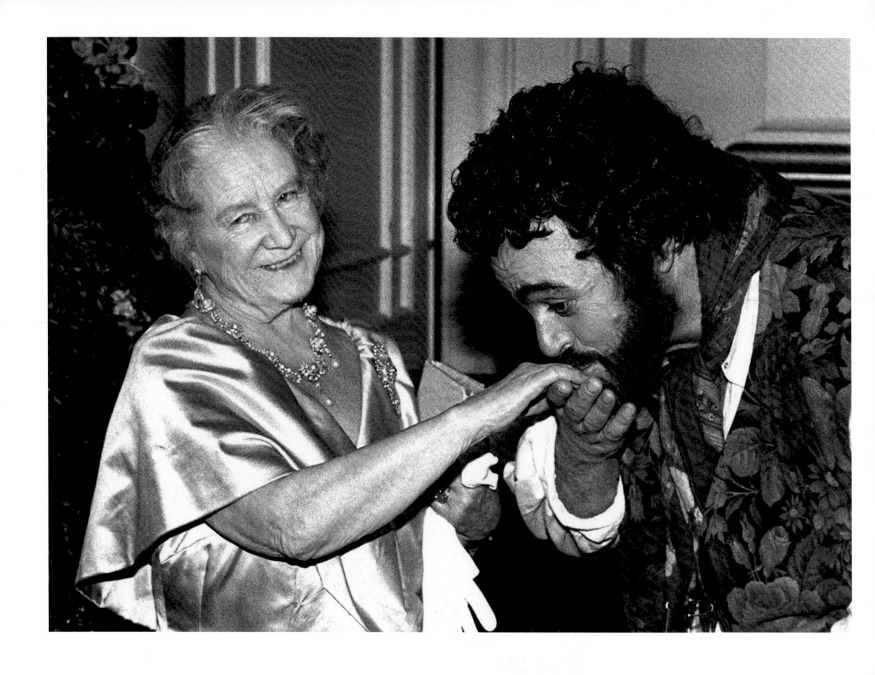

Adam Butler PRESS ASSOCIATION

Pavarotti kisses the hand of the Queen Mother in the Royal Opera House, Covent Garden. March 1990.

OPPOSITE PAGE TOP
Mark Stewart CAMERA PRESS

The Queen at a service for the Order of the British Empire at St Paul's Cathedral, London. 8 May 1996.

Max Nash ASSOCIATED PRESS

The Queen straightens Sophie, Countess of Wessex's hat, whilst they wait to attend the Christmas Day service at the Sandringham Church, Sandringham. 25 December 2002.

BOTTOM
Mark Stewart

The Queen is taken by surprise as she takes tea with Eton schoolboys at Guards Polo Club, Windsor, after a day at Royal Ascot. 18 June 2003.

Kelvin Bruce

The Queen photographing the Duke of Edinburgh as he competes in the dressage section of the carriage driving event at the Royal Windsor Horse Show. 12 May 2000.

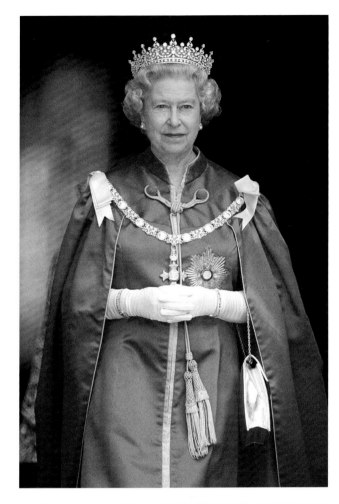

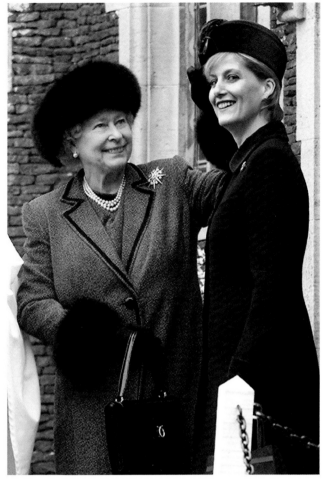

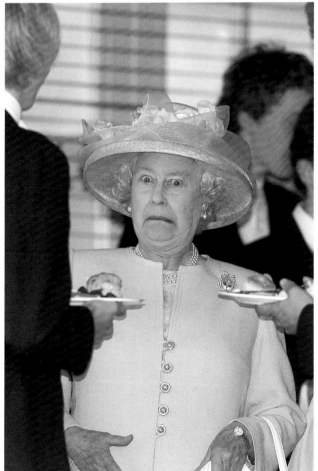

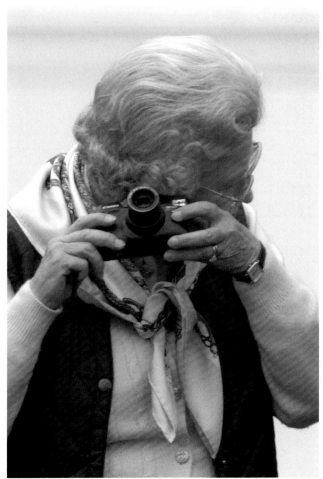

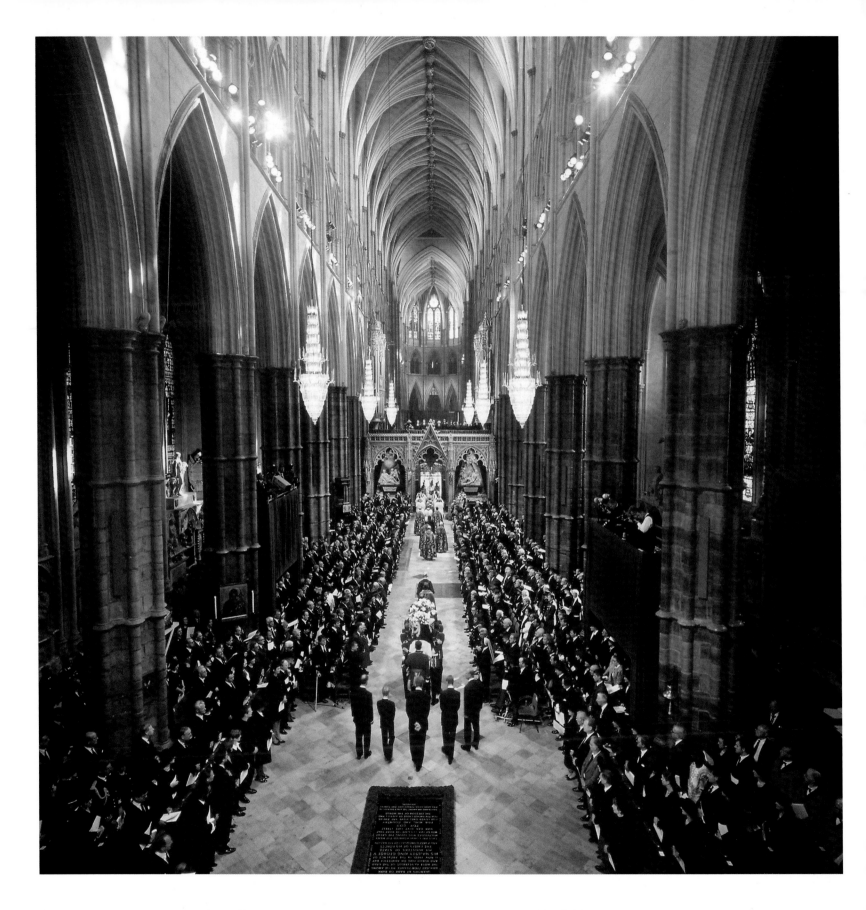

Nils Jorgensen REX FEATURES

The coffin of Diana, Princess of Wales being carried inside Westminster Abbey, London. September 1997.

Sion Touhig GETTY IMAGES

The Queen Mother's funeral, London.
 The official press pen for the Queen Mother's funeral wasn't in a great spot but I noticed a better view from an office overlooking the entrance to Westminster Abbey. The owners agreed to place two photographers in rooms overlooking the site. We were cleared by the authorities on condition that we'd be discreet. April 2002.

Jeff J. Mitchell REUTERS

Prince Charles looks up during the Queen Mother's funeral service at Westminster Abbey, London. April 2002.

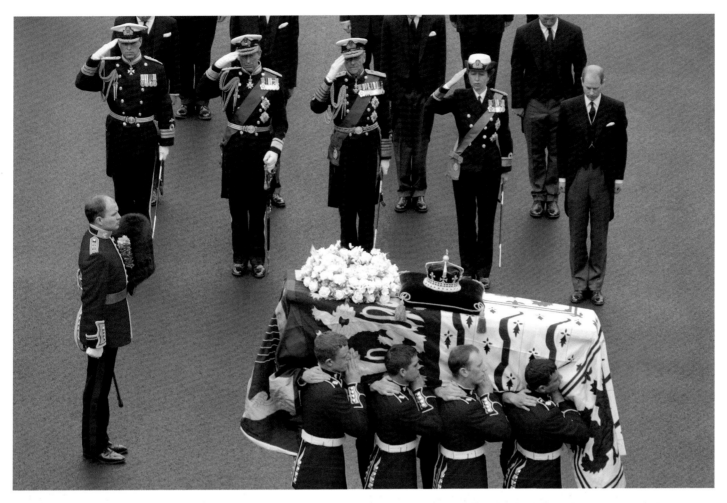

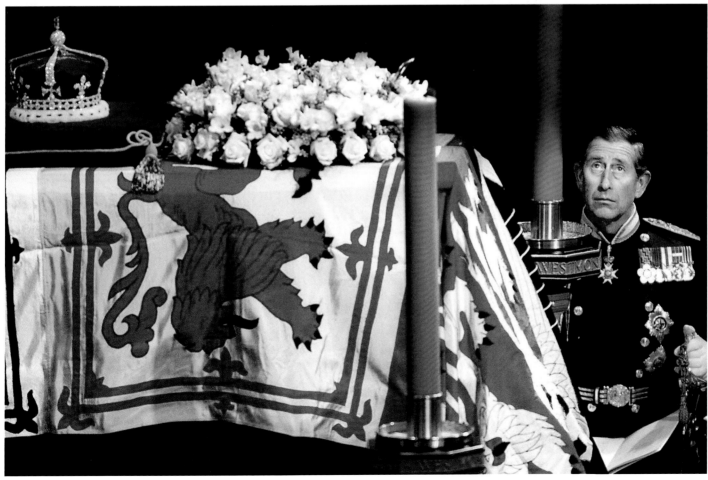

Tim Graham

Princess Diana at the Taj Mahal, India.
February 1992.

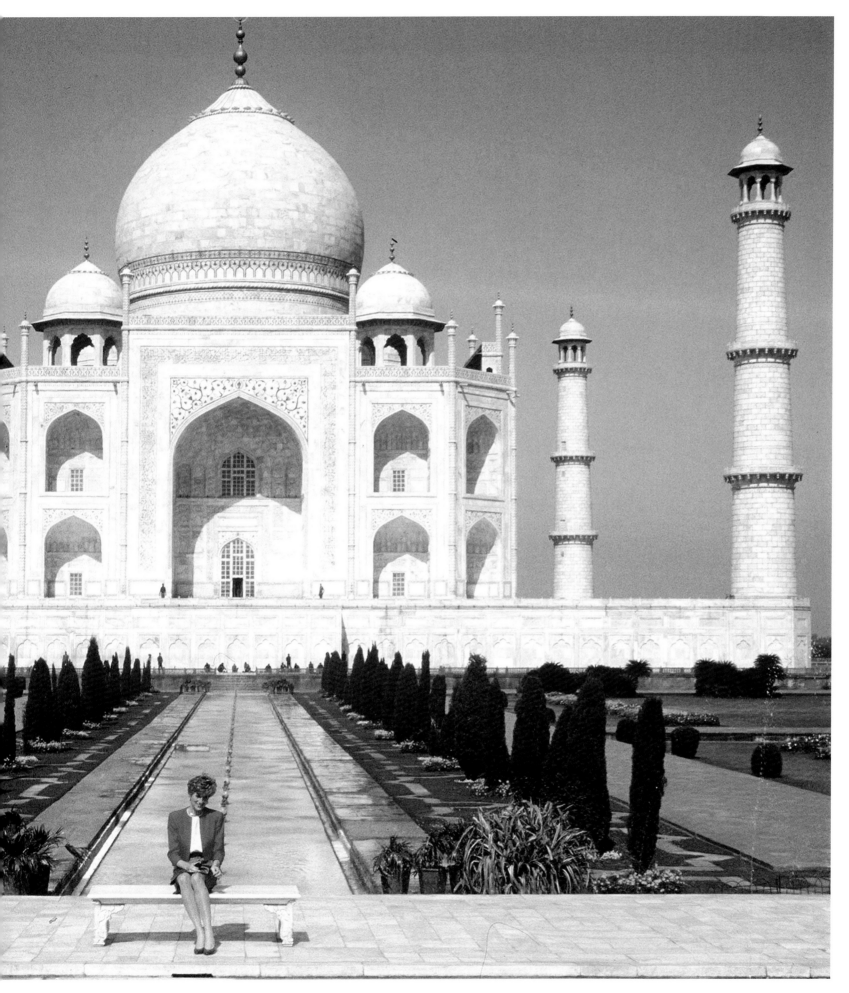

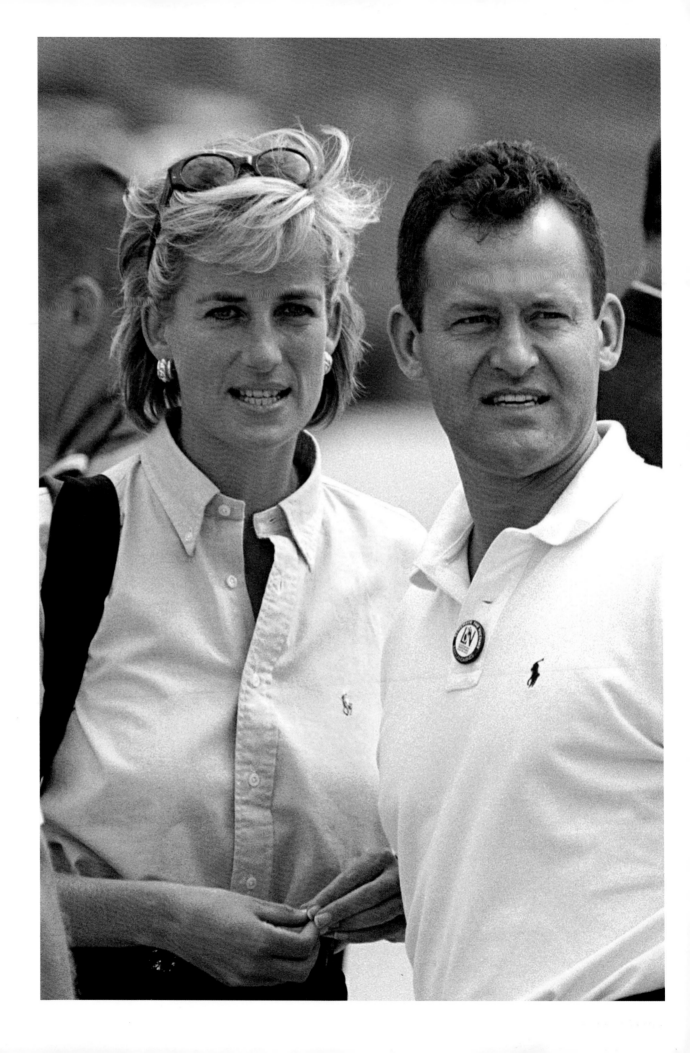

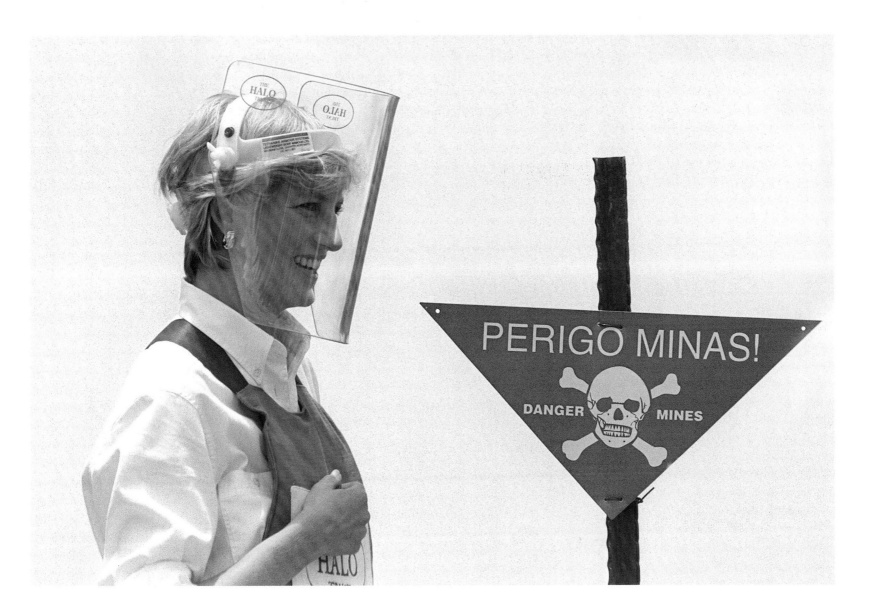

Tim Rooke REX FEATURES

Princess Diana at Sarajevo airport
Bosnia, with Paul Burrell. August 1997.

Tim Rooke REX FEATURES

Princess Diana in Angola as part of
her campaign against land mines.
January 1997.

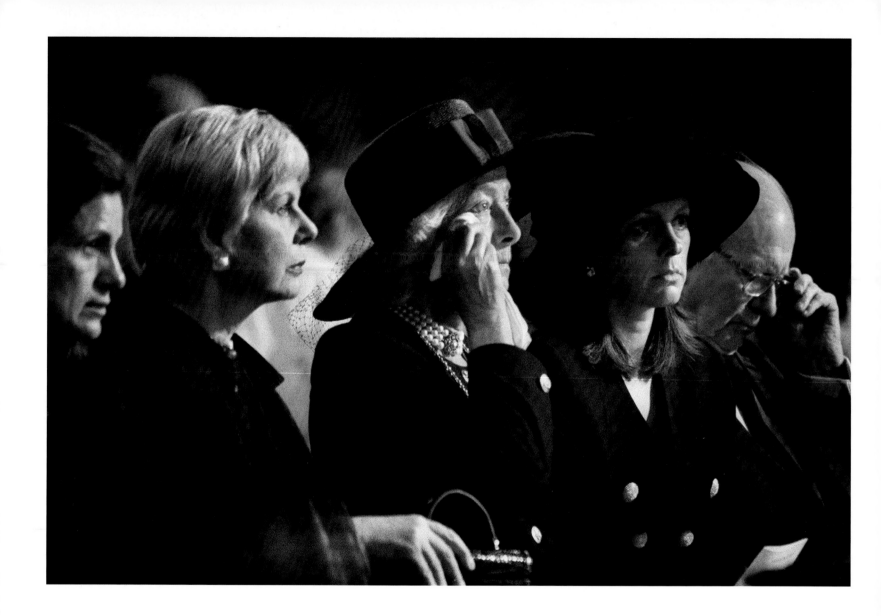

Stuart Conway

Princess Diana's mother Frances
Shand-Kydd sheds a tear during
the Catholic memorial service at
Westminster Abbey on the eve of
Diana's funeral. 6 September 1997.

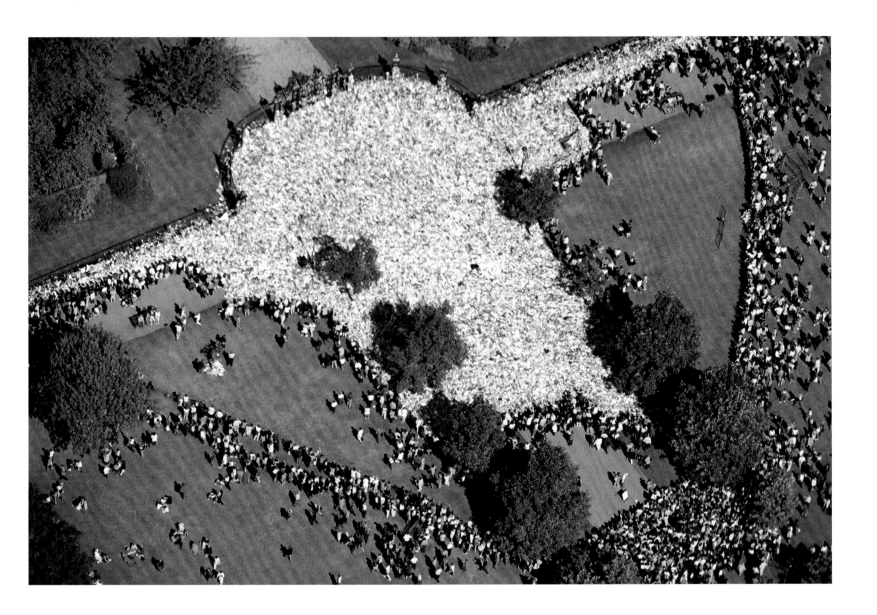

Adrian Dennis AP

Mourners gather around flowers left
at the gates of Kensington Palace after
the death of Diana, Princess of Wales.
September 1997.

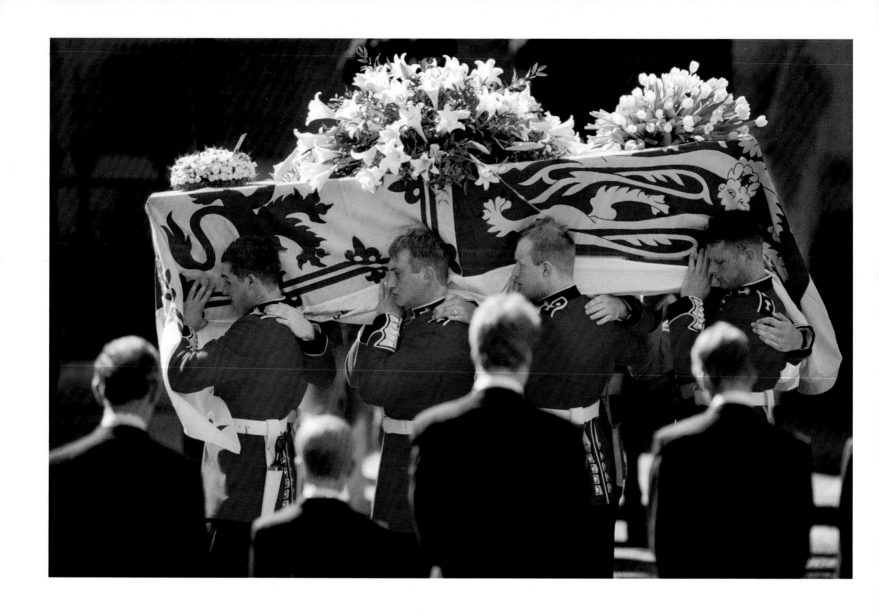

Brian Harris

Prince Charles, Prince Harry,
Viscount Althorp, Diana's brother,
and Prince William watch as the
Princess of Wales's coffin passes
into Westminster Abbey, London.
September 1997.

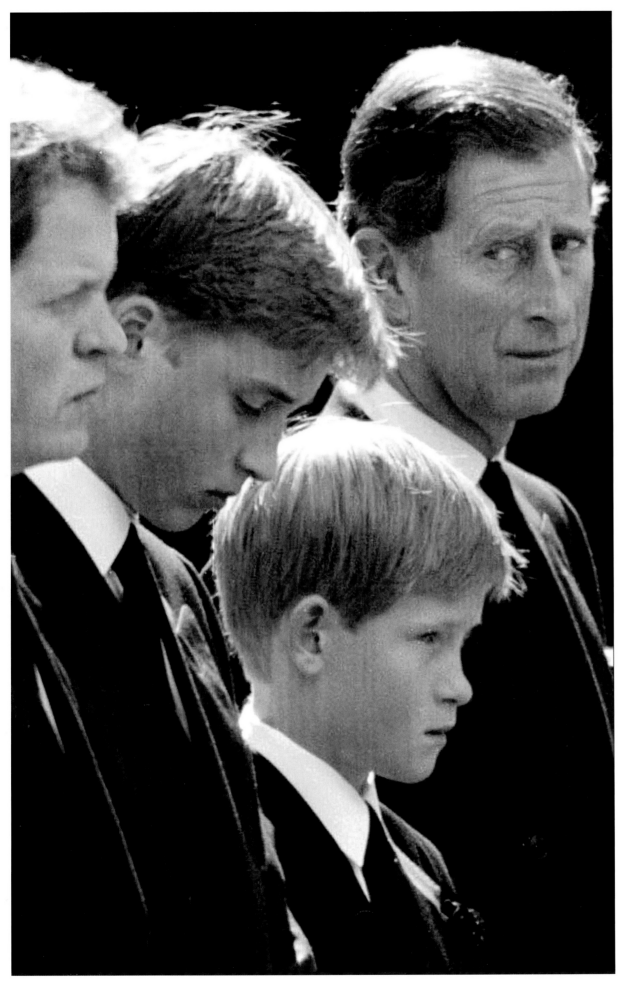

Mike Moore THE DAILY MIRROR

A concerned Prince Charles glancing towards princes William and Harry outside Westminster Abbey as the coffin of Diana, Princess of Wales is loaded into the hearse after her funeral service. September 1997.

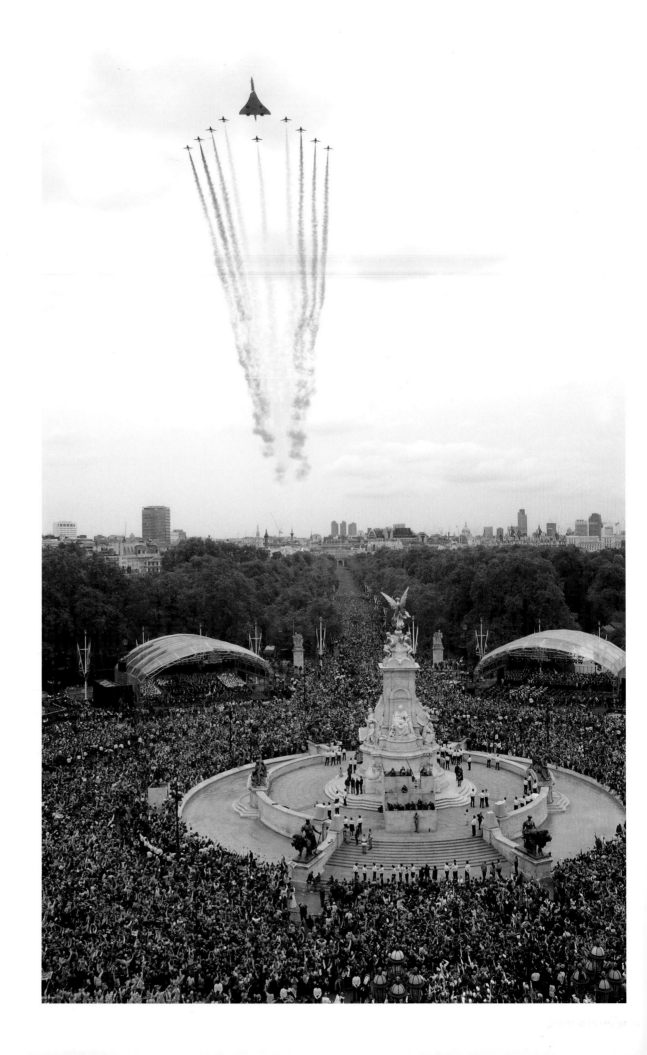

John Cobb THE DAILY TELEGRAPH

Concorde and the Red Arrows fly
over Buckingham Palace during the
Queen's Golden Jubilee celebrations.
5 June 2002.

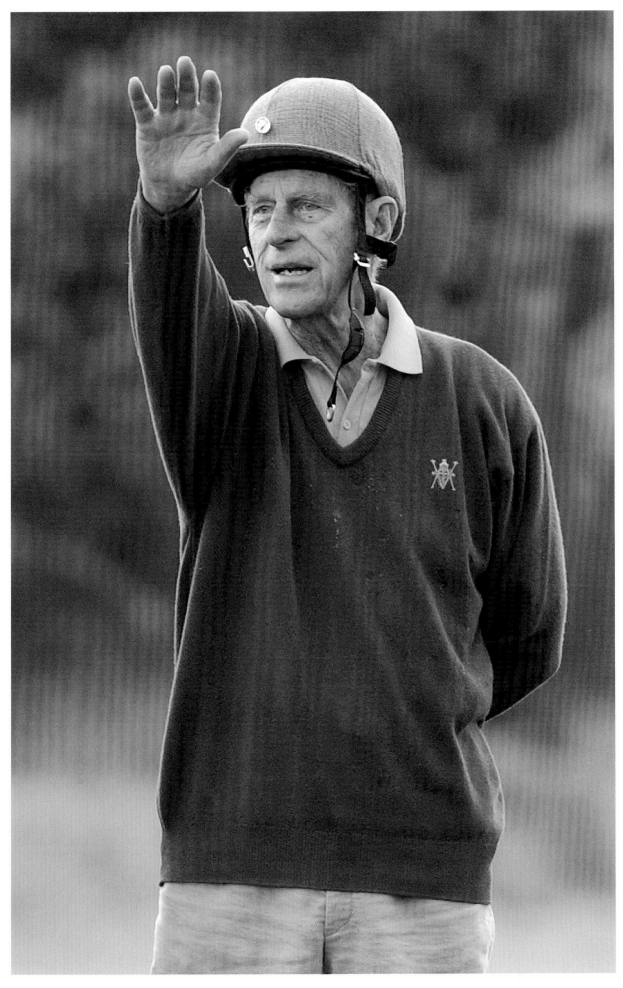

Kelvin Bruce

Prince Phillip makes an unfortunate gesture whilst competing in the carriage driving at the Royal Windsor Horse Show. 17 May 2003.

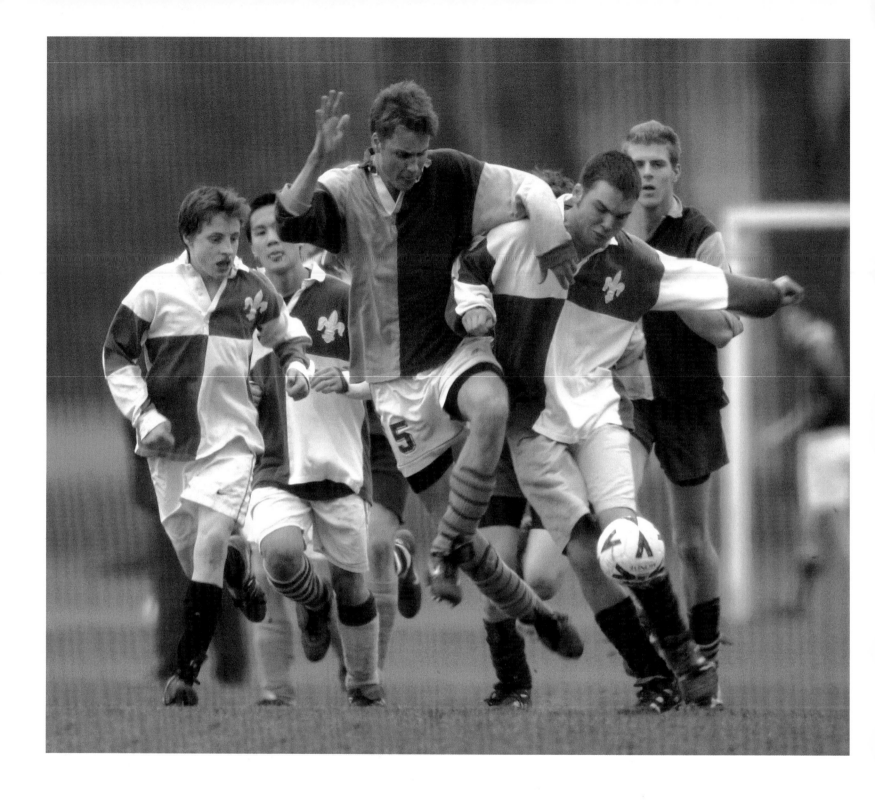

Kelvin Bruce

Prince William playing the Eton 'Field Game'. 11 March 2000.

OPPOSITE PAGE. TOP
Tim Graham

Princes William and Harry on holiday with their father at Balmoral in Scotland a few days before the death of their mother. 16 August 1997.

Doug Seeburg THE SUN

Prince William emerges from the sea after completing the swimming leg for Eton College in the Pembrokeshire Triathlon, Fishguard, Wales. 4 July 1999.

BOTTOM
Mark Stewart CAMERA PRESS

Princess Diana and Prince Harry at the fiftieth anniversary of VJ Day celebrations. August 1995.

Max Mumby

Prince William playing bicycle polo at Tidworth Polo Club, Hampshire. July 2002.

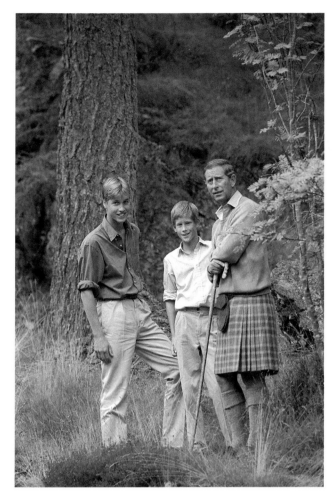

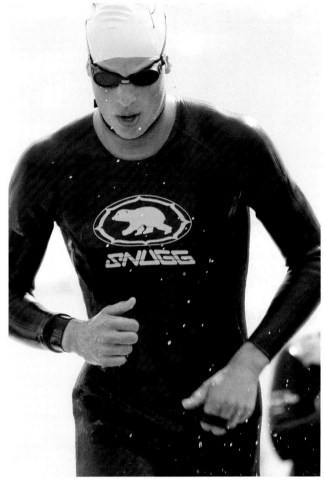

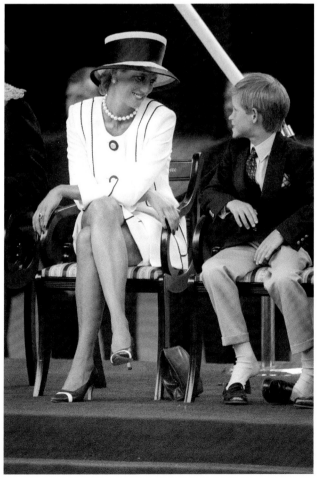

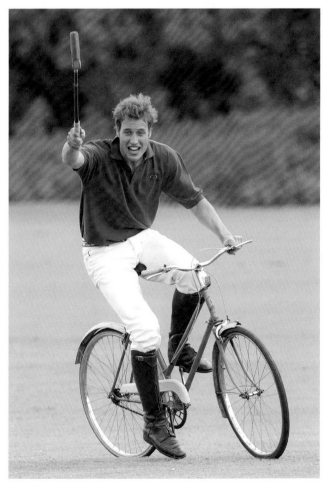

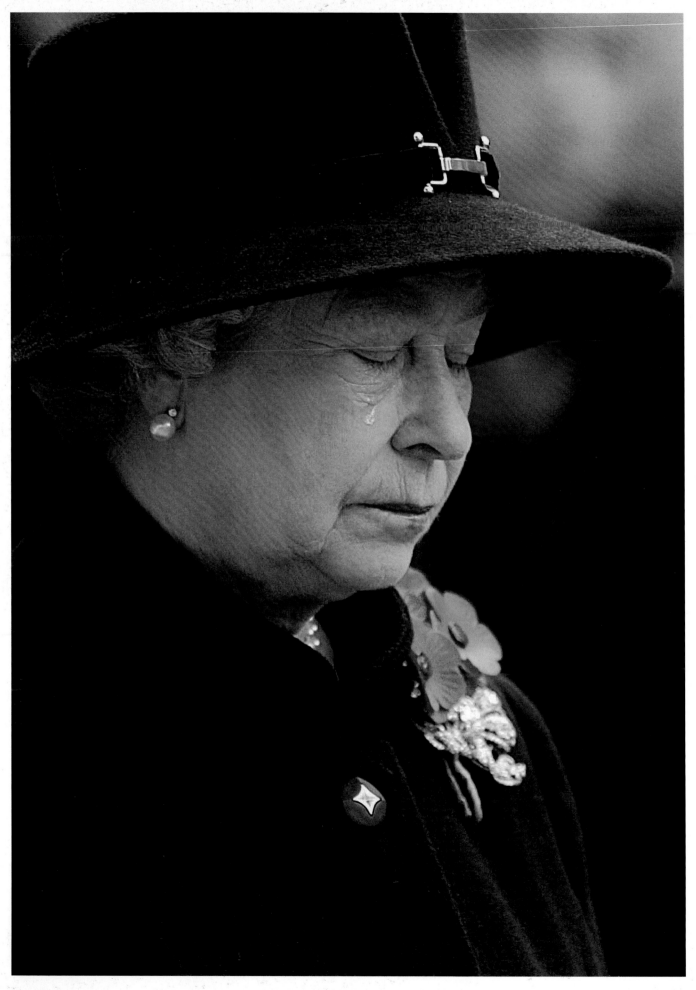

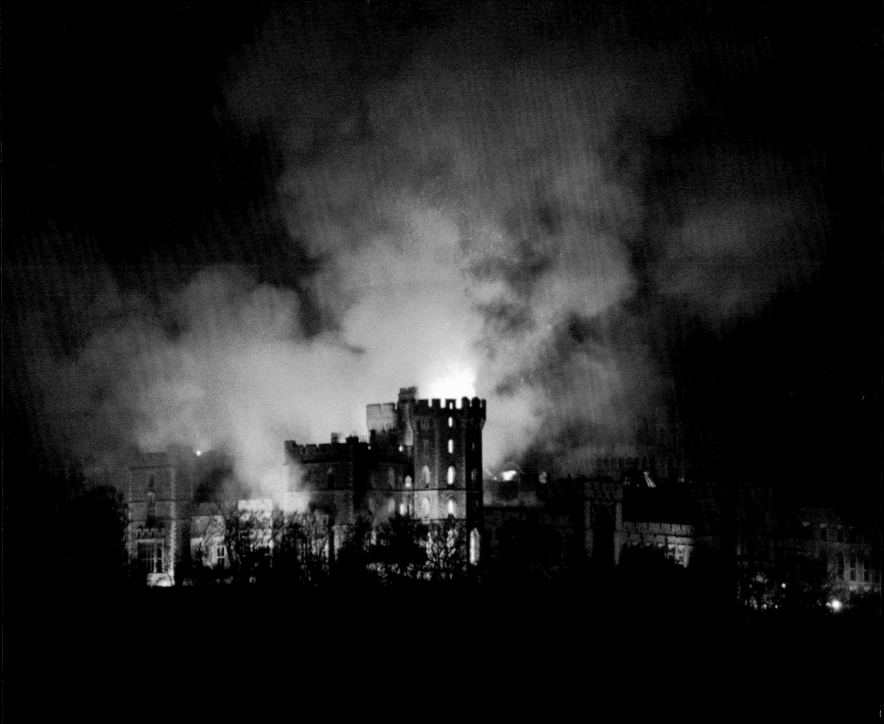

Mark Stewart CAMERA PRESS

The Queen cries at the Field of Remembrance, Westminster Abbey as she planted a poppy in memory of those killed in action. This was the first time she had performed this ceremony as it had always been carried out by the Queen Mother who had died earlier in the year. 8 November 2002.

Martin Beddall THE TIMES

Windsor Castle ablaze. The fire damaged 100 rooms of the royal residence which subsequently required a £40 million restoration.

I was called by *The Times* picture desk early evening to see 'if it was still alight'. I raced over, got the shot on a damaged, wobbly tripod and back to Wapping in time for it to be published on the front page the next day. 20 November 1992.

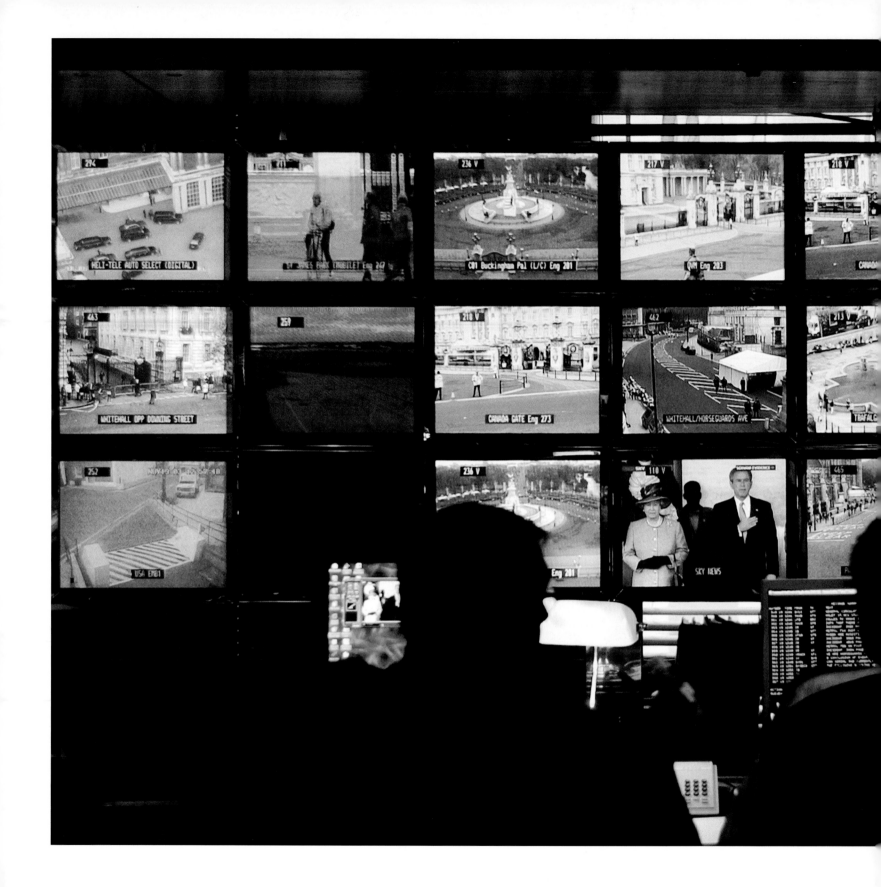

Kirsty Wigglesworth PA

Police officers monitor CCTV screens, showing secure areas of central London, in the control room at New Scotland Yard during the state visit of President George W. Bush. November 2003.

Stewart Cook REX FEATURES

Governor candidate Arnold Schwarzenegger taking part in a 9/11 memorial at The Simon Wiesenthal Centre in Los Angeles. 9 September 2003.

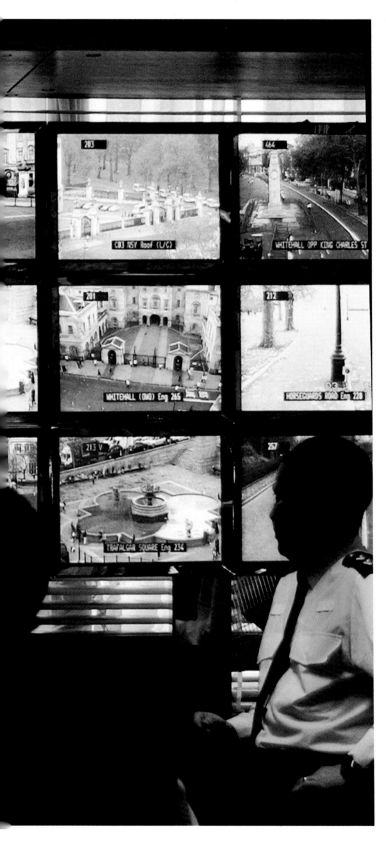
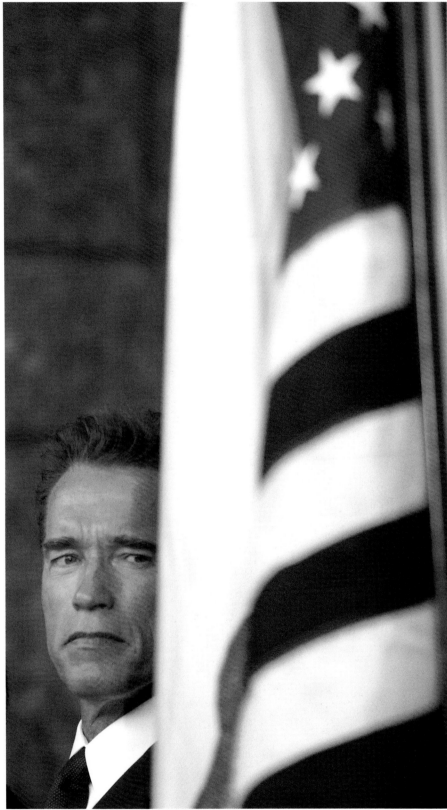

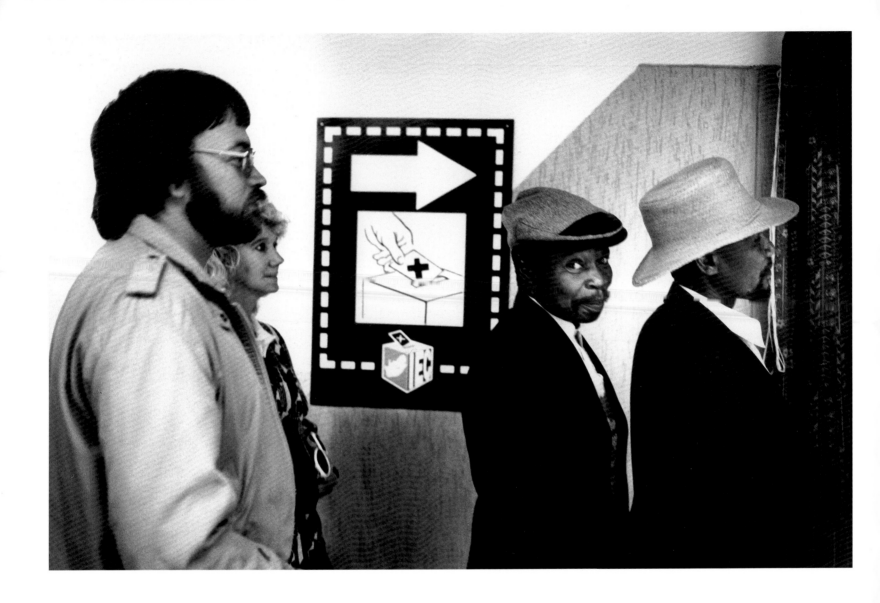

Andy Hall THE OBSERVER

A black South African cannot suppress
his joy whilst waiting in line to vote
during his country's first free and
democratic elections, Boksburg,
South Africa. 27 April 1994.

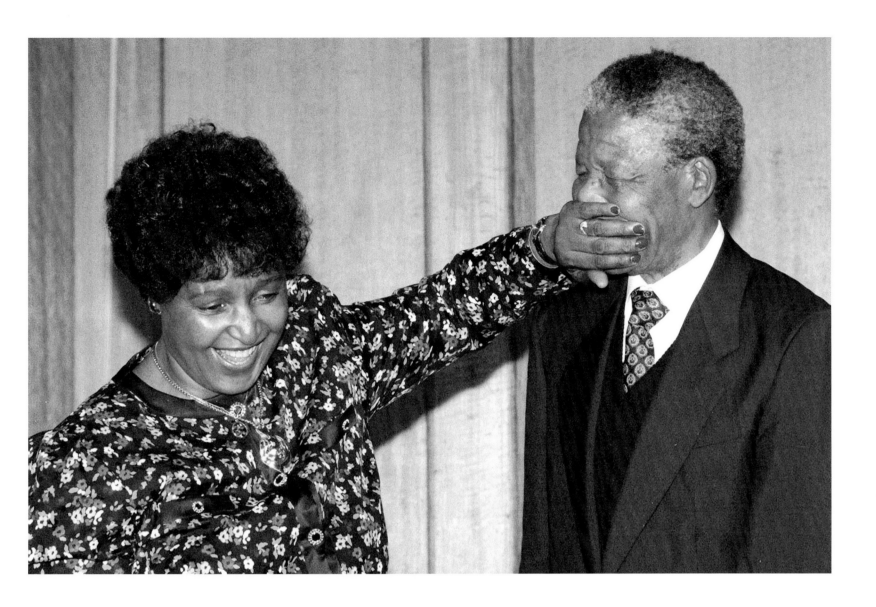

Fiona Hanson PRESS ASSOCIATION

Former South African President
Nelson Mandela is playfully silenced
by his then wife, Winnie, as the
couple leave the stage following a
press conference in London. It was his
first visit to the city after his release

from prison, having served 27 years
for treason as leader of the ANC.
27 April 1994.

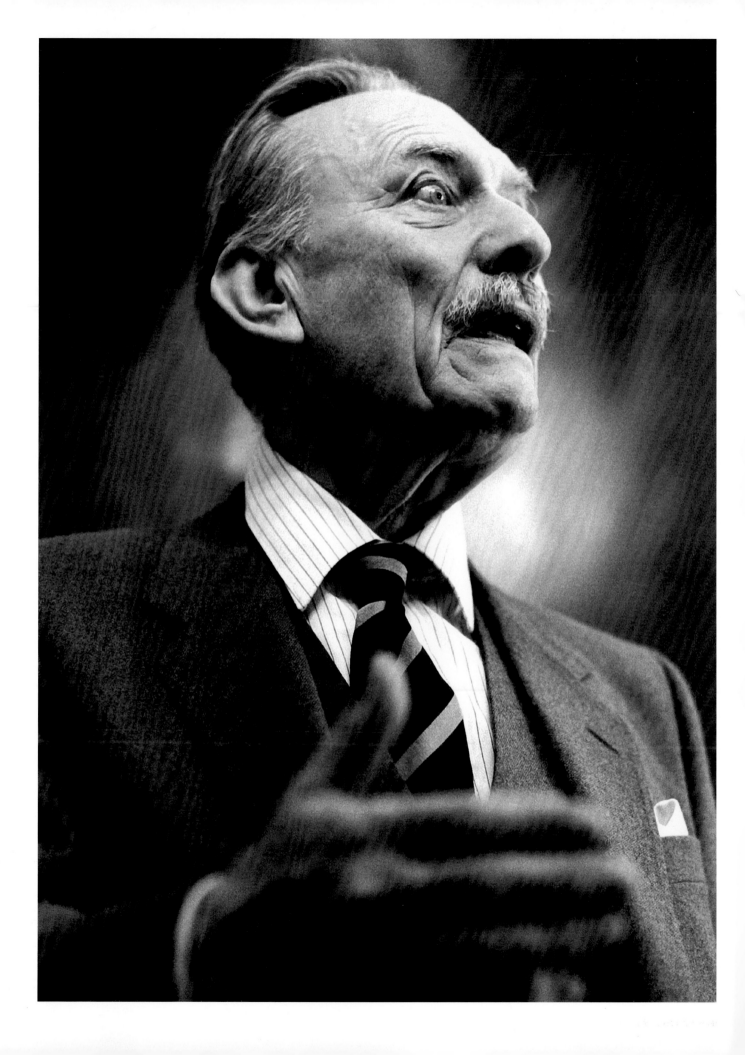

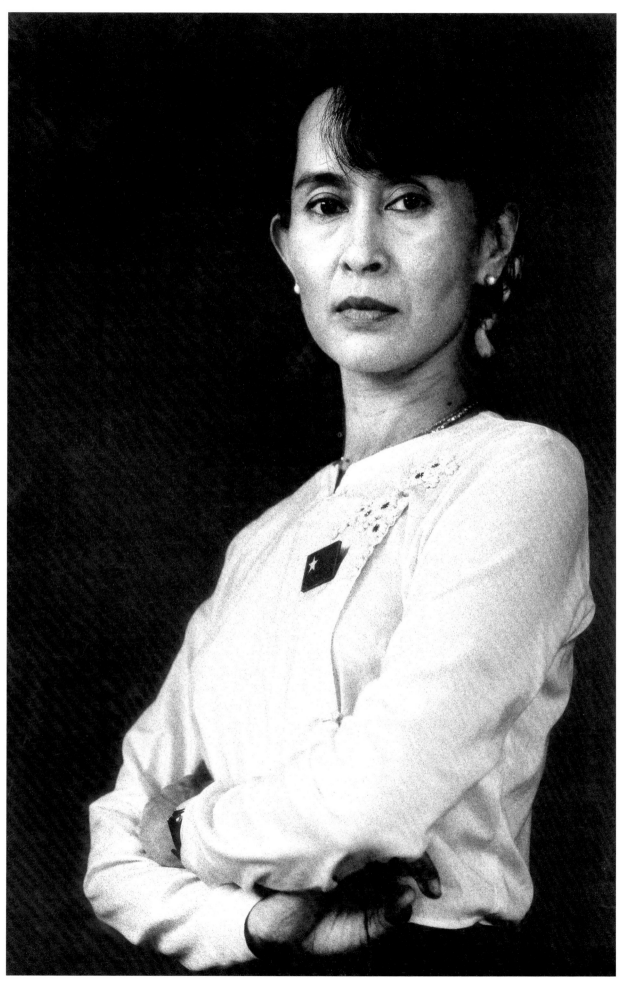

Geraint Lewis

Politician Enoch Powell speaking in London. November 1989.

Nic Dunlop

Aung San Suu Kyi, Nobel laureate and General Secretary of the National League for Democracy, the party that won the Burmese elections of 1990, at her home in Rangoon. Despite the election victory, the ruling military junta imprisoned thousands of her supporters and she has spent much of the past 14 years under house arrest. In May 2003, her cavalcade was attacked by a pro-government mob killing and wounding scores of her party members and supporters. August 1996.

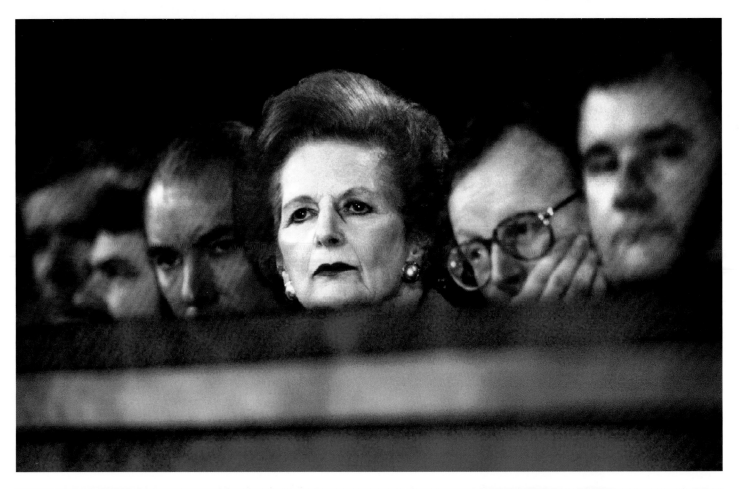

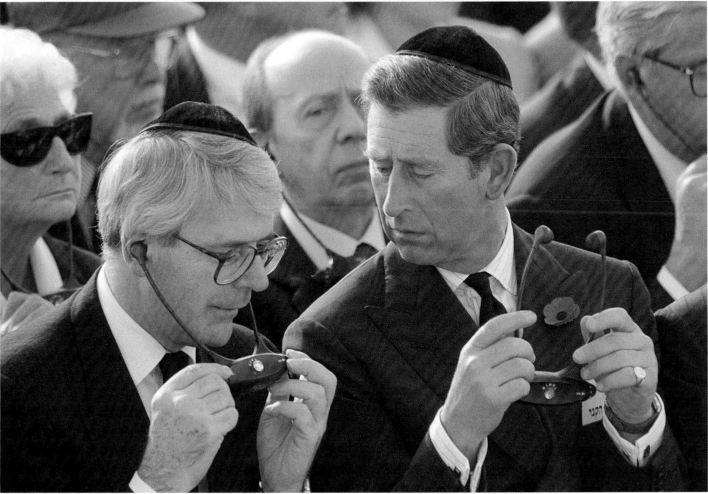

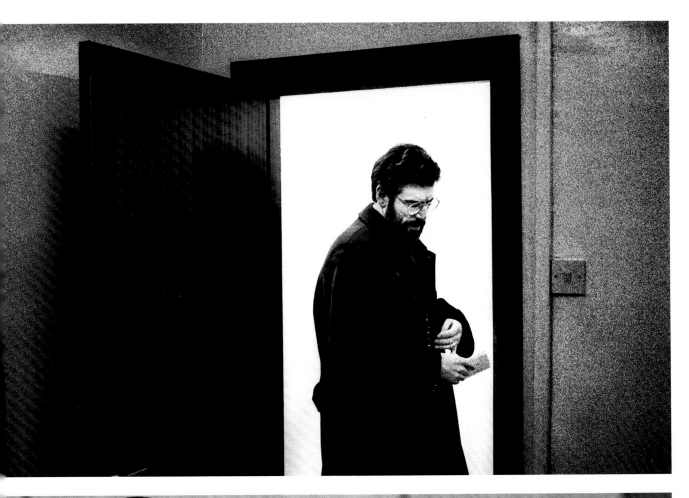

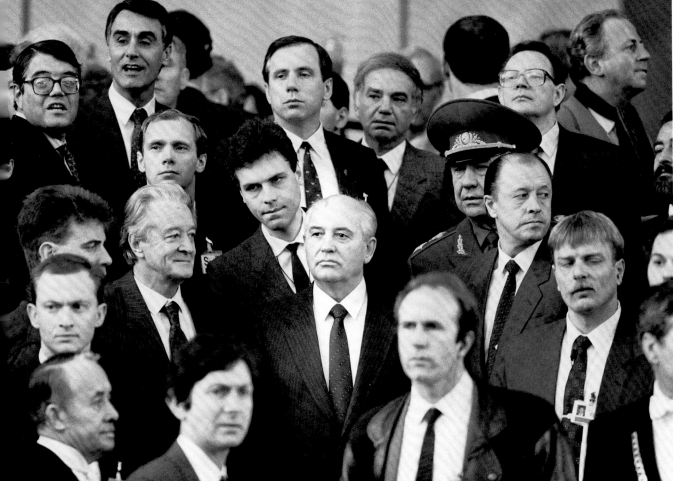

TOP
David Sandison THE INDEPENDENT

Prime Minister Tony Blair has a drink
at his local pub near his home in
Trimdon, Durham. 12 April 2002.

Ian Waldie REUTERS

Prime Minister Tony Blair is seen in
the viewfinder of a television camera
as he gives a speech at Kaimhill
School in Aberdeen.
14 May 2001.

BOTTOM
Peter Jordan

Minister Mo Mowlam and Prime
Minister Tony Blair hold a Town Hall
meeting in Hammersmith, London.
7 July 2000.

Eddie Mulholland THE DAILY TELEGRAPH

Tony and Cherie Blair climb aboard the
election battle bus in Northampton on
the first day of the 1997 election
campaign that was to result in a
landslide victory for the Labour party.
April 1997.

Robert Hallam THE INDEPENDENT

Lord Archer and the snooker player
Ken Doherty celebrate the peer's
appointment as President of the World
Professional Billiards and Snooker
Association across the Thames from the
Houses of Parliament. 9 October 1997.

David Sandison THE INDEPENDENT

Prime Minister Tony Blair relaxes at
his home in Trimdon, near Durham.
12 April 2002.

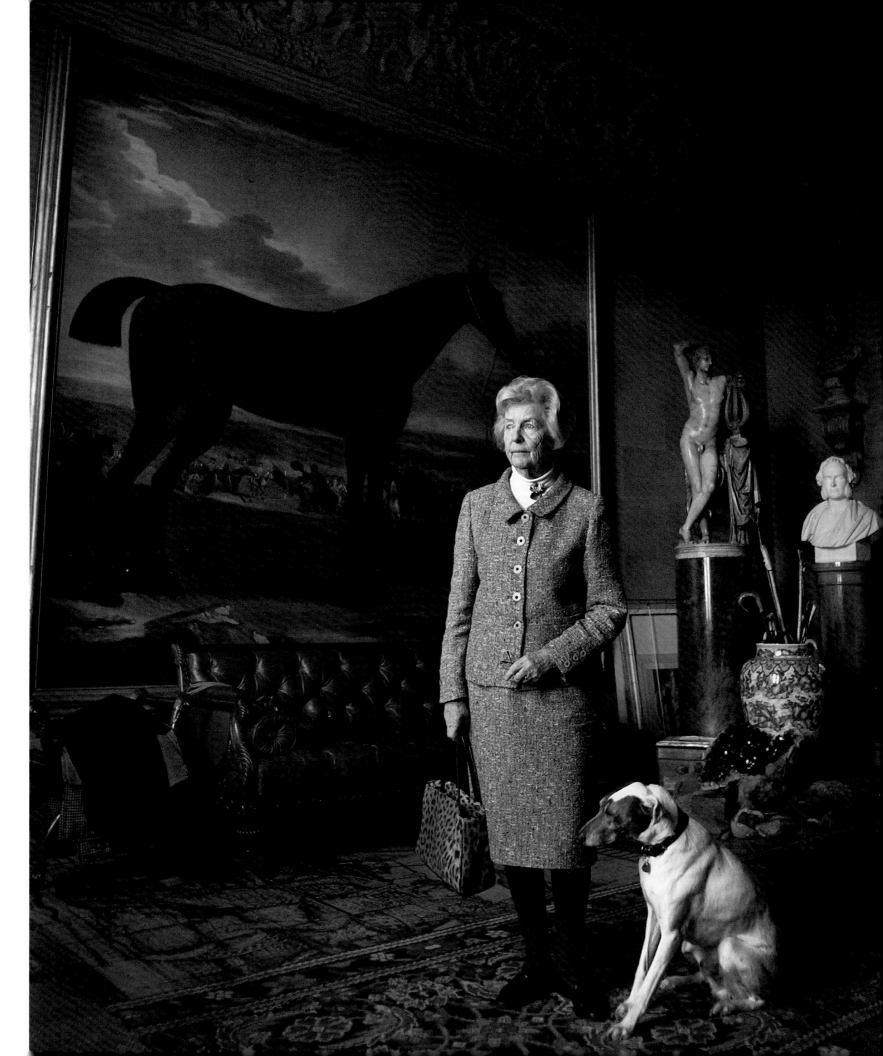

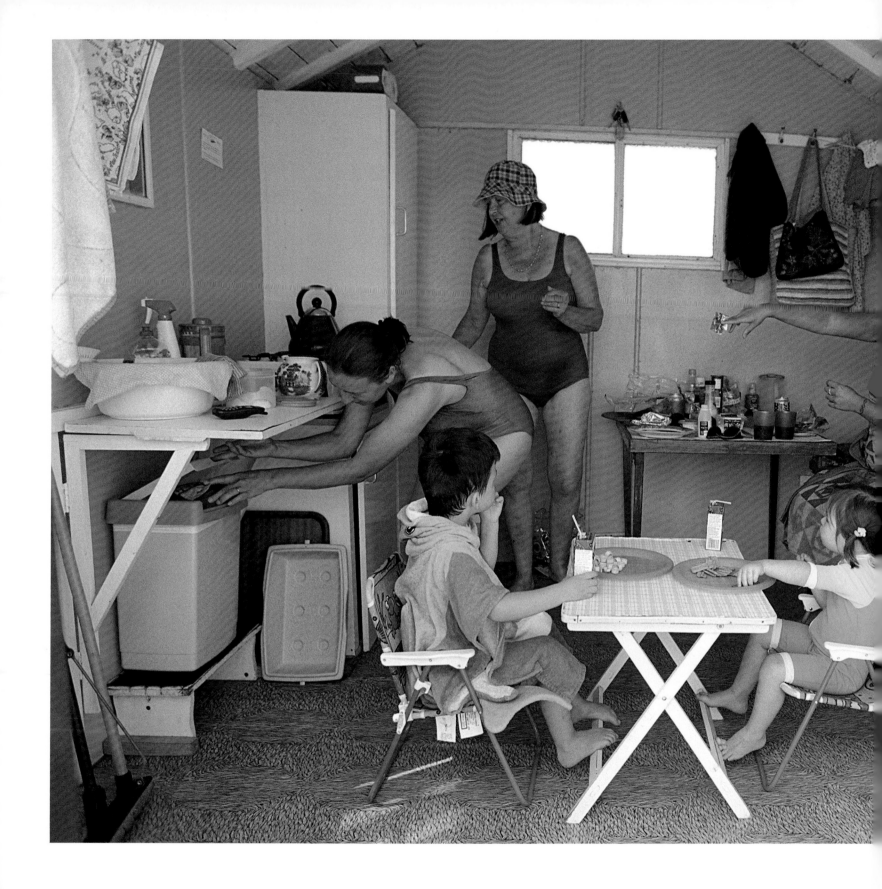

Michael Crabtree TROIKA

Beach huts in Southwold, on the
Suffolk coast provide sanctuary from
the record temperatures hitting
Britain. August 2003.

John Angerson

Caravan enthusiasts enjoy their early
morning breakfast, Hastings, England.
May 1997.

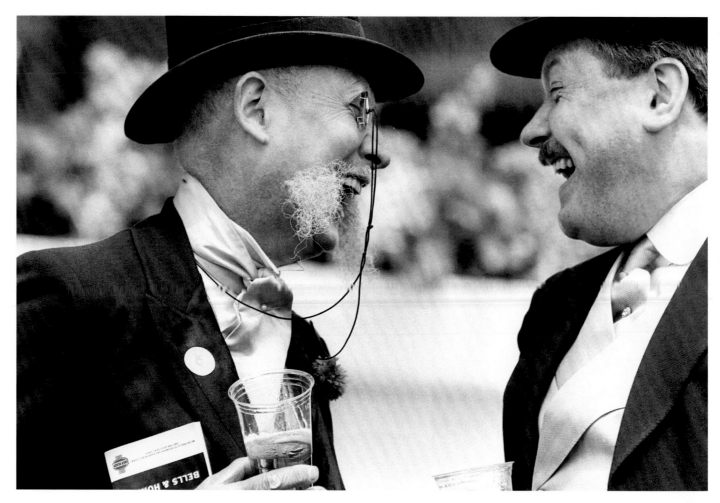

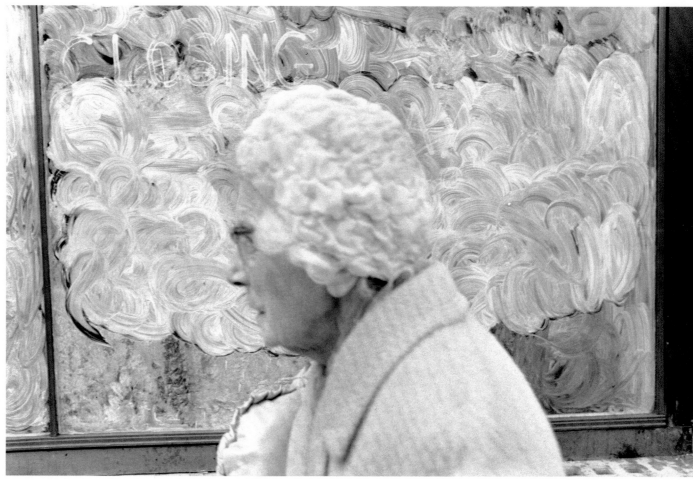

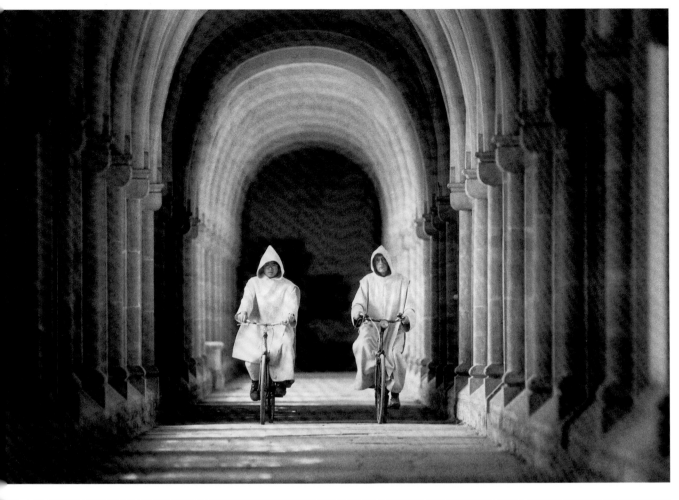

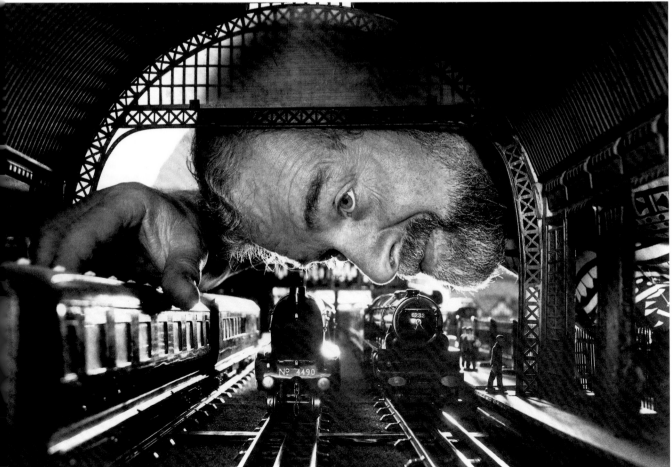

Tom Jenkins THE GUARDIAN

The Royal Enclosure at the Epsom Derby, Surrey. 6 June 1990.

Nils Jorgensen IN-PUBLIC.COM

A lady in a London street. Taken from an ongoing personal project on street photography spanning a period of 25 years, which explores the unusual in the everyday. March 1992.

Roger Bamber

Monks of St Hugh's Charterhouse Monastery in Sussex. Originally built to house 250, the ten-acre monastery is now home to only 19 monks. The cloisters are so long that they have taken to using bicycles to get from their cells to their work and prayers. July 1995.

Roger Bamber

Old vaults under Brighton railway station have been turned into a model railway museum. Curator Chris Littledale arranges 'O' gauge model trains in a tin-plate station just below the platforms of the real thing. August 1991.

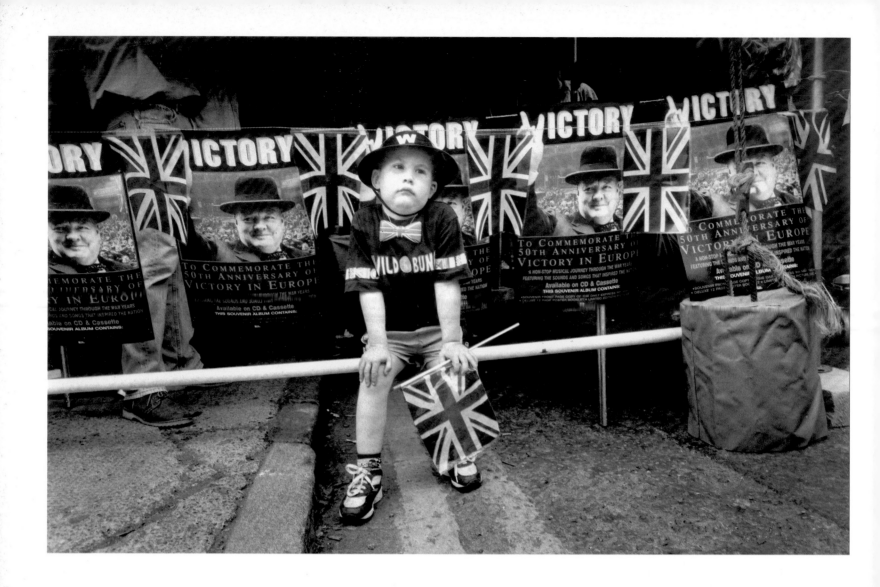

David Sandison THE INDEPENDENT

A street party to celebrate the fiftieth
anniversary of VE (Victory in Europe)
Day near London Bridge in London.
May 1995.

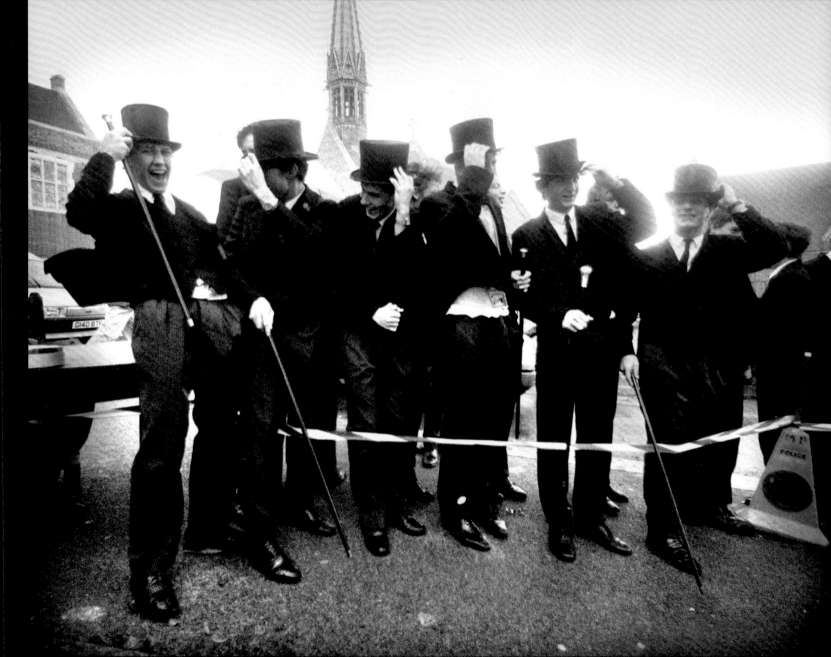

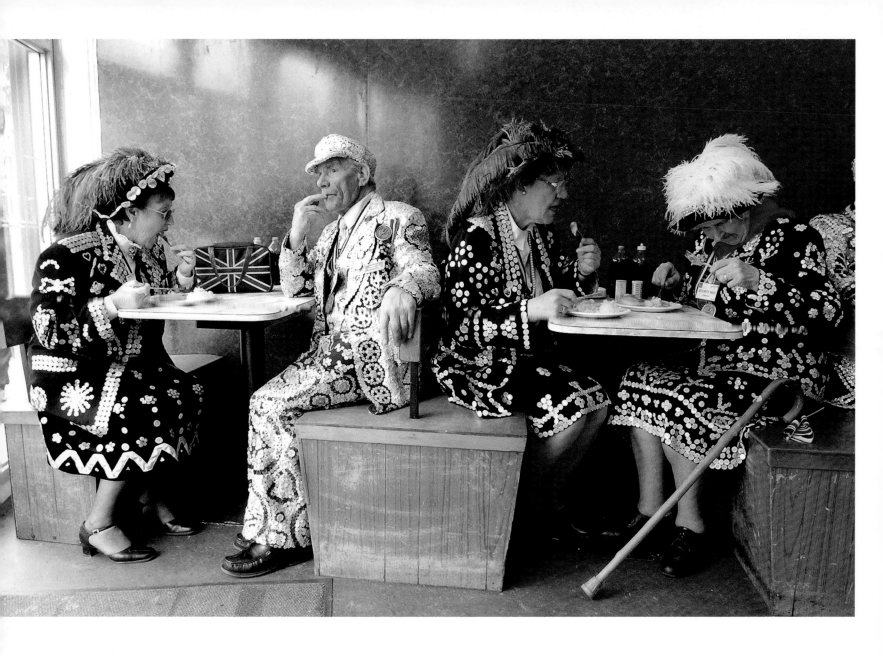

Jeff Moore NATIONAL PICTURES

Pearly kings and queens from
Newham, Blackfriars, Hackney and
Wapping have lunch in Duncan's Pie
and Mash shop after meeting the
Queen in East London. 9 May 2002.

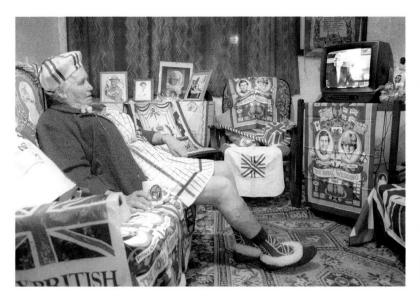

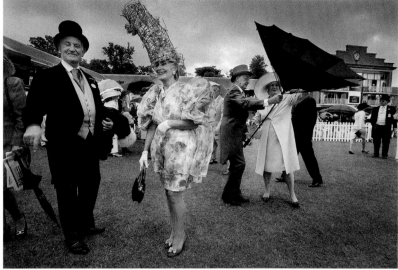

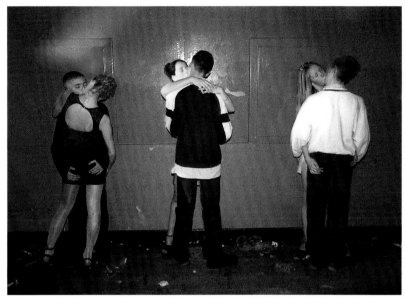

TOP
Rosie Hallam NEWCASTLE EVENING CHRONICLE

Elsie Dixon at home in South Shields
watching the television interview
with Princess Diana during which
she revealed there were 'three people
in the marriage', referring to Camilla
Parker-Bowles. 20 November 1995.

Tom Pilston THE INDEPENDENT

A storm passes across Ascot
racecourse on Ladies Day. June 2000.

BOTTOM
Adrian Dennis AGENCE FRANCE PRESSE

A member of the kitchen staff looks
on as officers of the Yeoman of the
Guard assemble in the Royal Court
before the arrival of the Queen for
the State Opening of Parliament.
20 June 2001.

Terry Kane EYEWITNESS IMAGES

A teenage disco night at the Queen's
Hall, Widnes. April 2000.

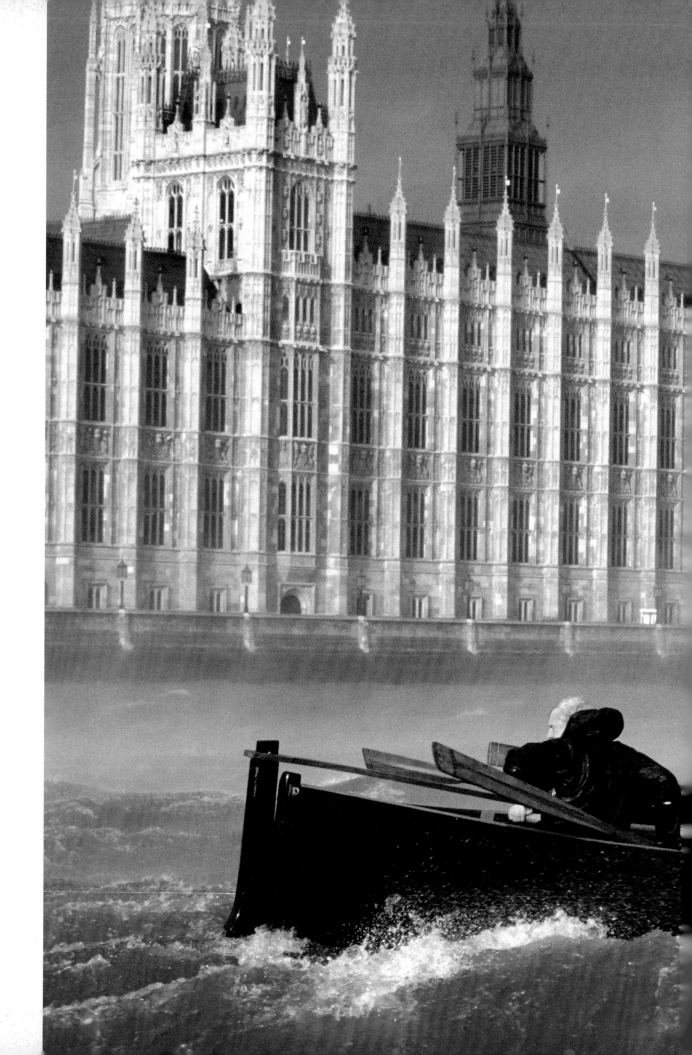

Nils Jorgensen REX FEATURES

A team of London policemen caught in a storm while training for a sponsored row on the River Thames. The event coincided with some of the worst weather to hit England in decades. January 1990.

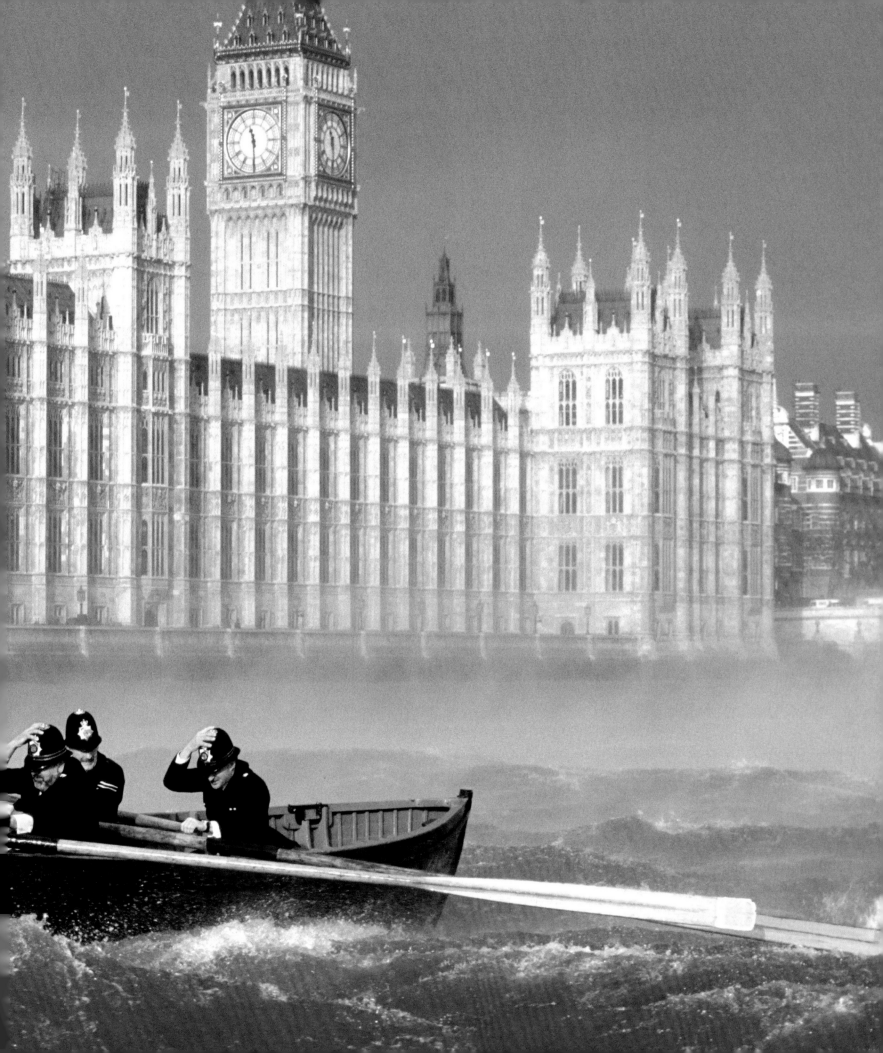

Geraint Lewis

Staten Island Ferry, New York.
January 1999.

Craig Holmes

Diners in a café in the West End of
London. July 2003.

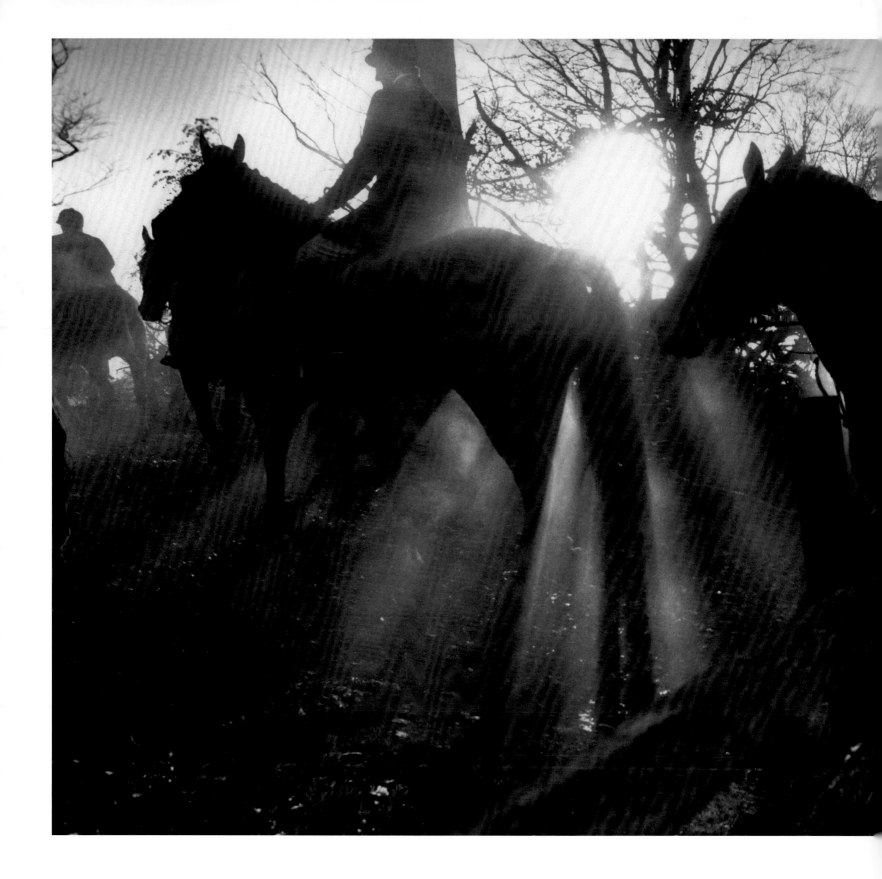

Stuart Conway

Horses' breath condenses on a frosty morning as riders from the Duke of Buccleuch's Hunt in the Scottish Borders pass through a wood. December 1994.

Richard Addison LINCOLNSHIRE ECHO

The Right Reverend David Rossdale, Bishop of Grimsby officially dedicates the new reception area at Frances Olive Anderson Primary School in Lea near Gainsborough, England. April 2002.

Ian Waldie REUTERS

A tourist stands in the rain and
observes the new London Eye from
the South Bank. 30 December 1999.

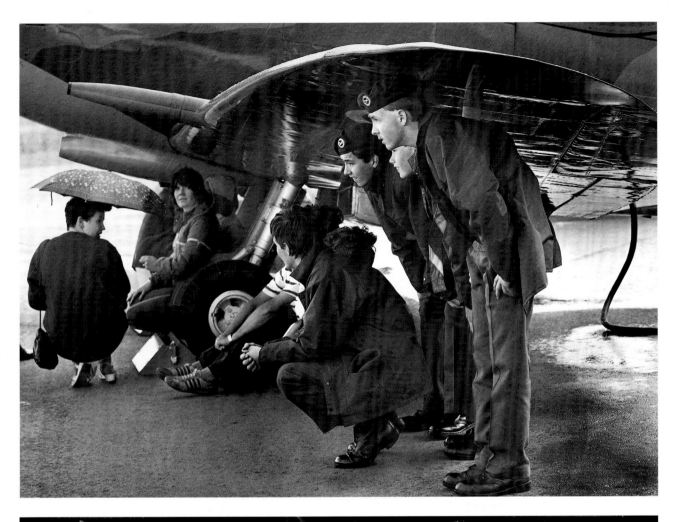

Andy Weekes

RAF cadets shelter from the rain under the wing of a Second World War Spitfire at an air show at RAF Northolt near London. July 1990.

Dillon Bryden THE INDEPENDENT

Willie Williamson of the the London Transport Lost Property Office in Baker Street with a small selection of the thousands of lost umbrellas that pass through his hands every year. November 1993.

Jonathan Evans

Andrea Davies views a Glenn Brown
painting at the Turner Prize preview
at the Tate Britain Gallery, London.
24 October 2000.

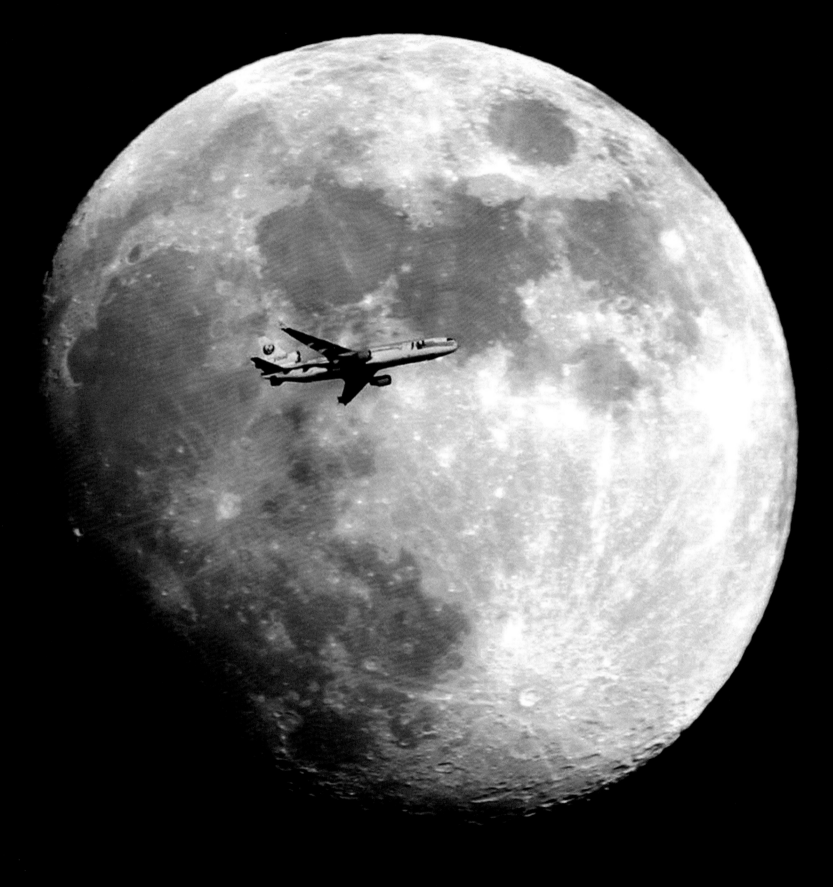

Ian Waldie REUTERS

A JAL airliner passes in front of the
rising moon in Osaka, Japan.
22 June 2002.

Vicki Couchman

Swingers at the 'Swingstock' festival
in the woods in Wisconsin, USA.
20 July 2003.

Martin Beddall THE TIMES

Forty-year-old security officer Tony
Young from Edgbaston, Birmingham
emerges from the entrants tent at the
National Final of the Sun-Pat
American Lookalike Competition held
in Greenwich, England. 9 August 1992.

Jeff Morgan THE GUARDIAN

An old lady with her Jack Russell
terrier encounters a robotic
Triceratops dinosaur on the steps
of the National Museum of Wales,
Cardiff. 10 March 1997.

Mark Lewis SOUTH WALES ARGUS

A fireman plays the theme from
Titanic to cheer up residents whose
house was flooded during storms in
Newport, South Wales. October 2000.

Roger Bamber

Four-year-old Jermaine Briffa provides a small but enthusiastic audience for a Punch and Judy show in Brighton. July 1992.

Tom Pilston THE INDEPENDENT ON SUNDAY

Oxford students celebrate as their crew crosses the finishing line first in the Boat Race. April 1991.

Roger Bamber

Amish children living in Conewango Valley, 300 miles north of New York City. The community were being struck down by a whooping cough epidemic. Shunning modern drugs and vaccines, the children were being treated with lemon juice and honey and three babies had died, becoming the first whooping cough fatalities in America for three years. January 1990

Peter Nicholls THE TIMES

An Afghan woman buys cosmetics on the eve of the Eid celebrations in Kabul. Under the recent Taliban government she would not have been allowed to buy such goods from the bazaar stall. 15 December 2001.

Brian David Stevens

Kim Phaggs from the 'London Reader's Wifes' drag collective prepares for a show at the Vauxhall Tavern, south London. August 2002.

Linda Nylind

The Ace Café in north London.
September 2001.

Jack Hill

Italian Pino Della Grotta, a barber in
south London, approaches retirement
in boisterous spirit after cutting hair
for 50 years. He learnt his trade from
his father in Monte Cassino, Italy.
January 2003.

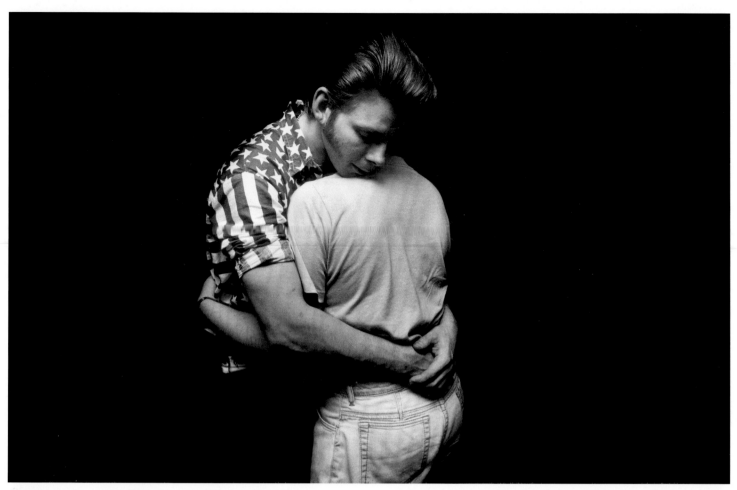

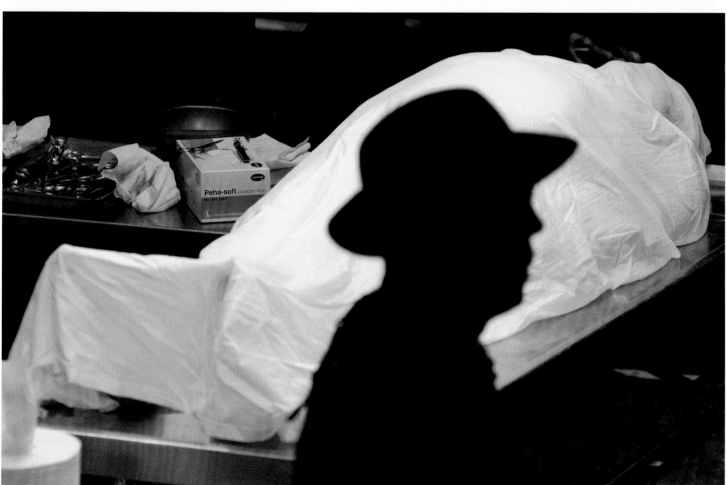

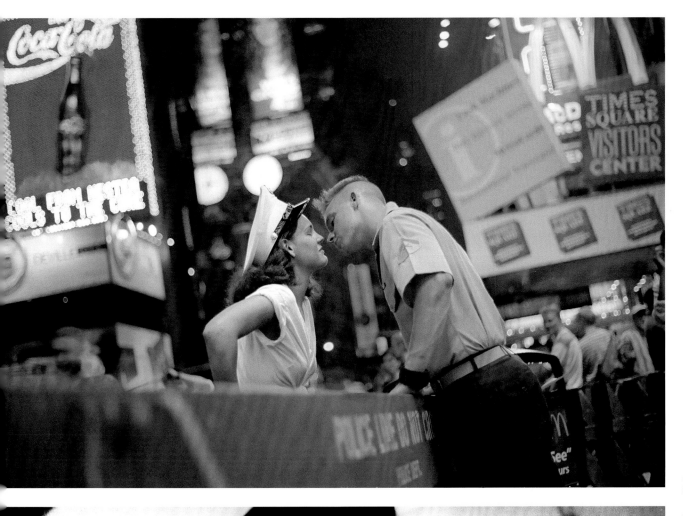

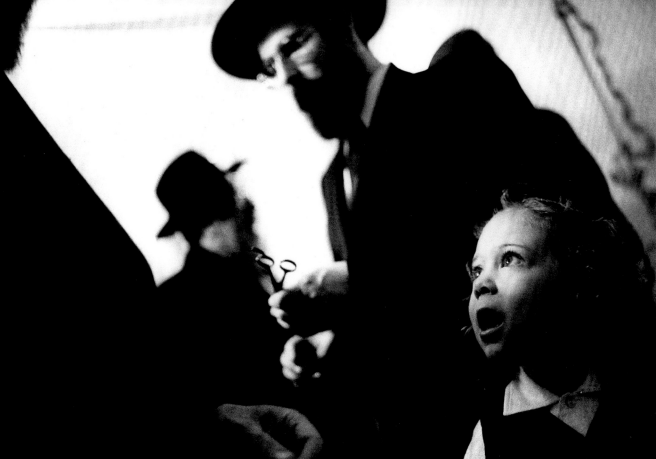

OPPOSITE PAGE
Stuart Freedman NETWORK PHOTOGRAPHERS

A couple hold each other through a slow dance, Blackpool. January 1991.

David Levene

German Professor Gunther von Hagens performs a public autopsy on a 72-year-old man at the Atlantis Gallery in East London. In front of a paying audience Von Hagens carried out the first public post-mortem examination in Great Britain since the 1830s despite being threatened with arrest after Her Majesty's Inspector of Anatomy ruled that he did not have a licence to carry out the autopsy. November 2002.

THIS PAGE
Sion Touhig

Independence Day in Times Square, New York.
 There was a big military stage show in Times Square. It had finished but I hung around as the crowd dispersed to see if I could get a good picture. I saw some off-duty US Marines sightseeing, checking out the bright lights and chatting to a showgirl. When the girl put the Marine's hat on, I crossed the street and framed the shot just as they kissed. 4 July 2000.

David Levene

Opshernish. On his third birthday Menachem, a boy from a Hasidic Jewish family, has his hair cut for the first time. Friends and family are invited to join the 'mitzvah' and each cut a few strands. January 1999.

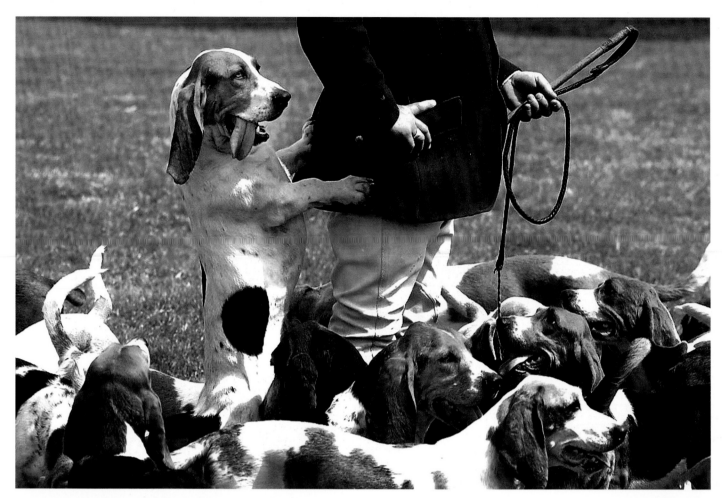

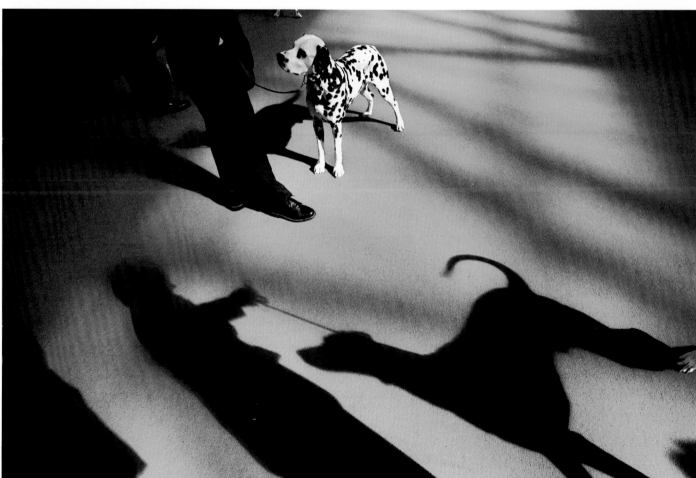

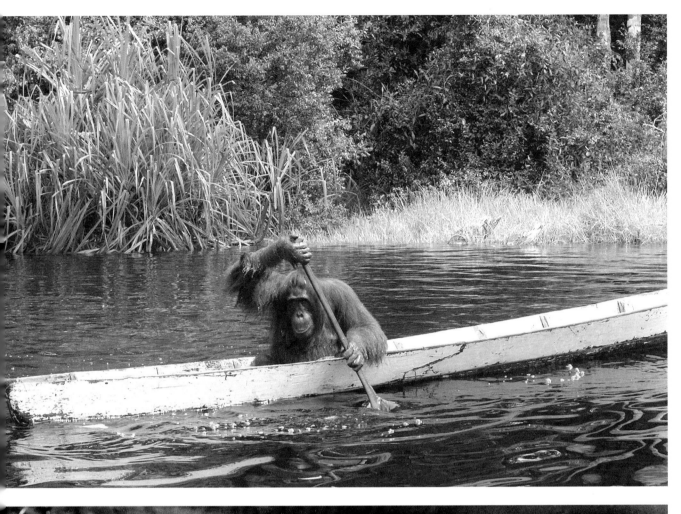

OPPOSITE PAGE
Eddie Mulholland THE DAILY TELEGRAPH

One of the Huckworthy Bassett
Hounds climbs up huntsman Mark
Hicks to get a better view of the pack
at a Game Fair in Hampshire.
July 1998.

Andrew Fox

The Dalmatian judging ring is
illuminated by sunlight at Crufts dog
show, NEC, Birmingham. March 2000.

THIS PAGE
Sam Barcroft

Princess the orangutang paddles
a canoe at Camp Leakey, Tanjung
Puting National Park, Central
Kalimantan, Indonesia. June 2001.

Andy Weekes

Fred the piranha-like quetzal cichlid
indulges in his favourite snack – tangy
and curry-flavoured twiglets.
12 July 1999.

Mark Chilvers

The elephant enclosure at Regent's
Park Zoo, London. July 1999.

Andy Hall THE OBSERVER

Building the Globe Theatre in London
on the site of the Tudor original and
using Tudor building materials.
July 1994.

Les Wilson

The River Thames on Millennium night. The only picture to show all the fireworks going off at midnight, taken from the BT Tower with an exposure time of 20 seconds. 1 January 2000.

Edmond Terakopian

The IFBB British Bodybuilding Grand
Prix, Wembley Conference Centre,
London. 27 October 2002.

Mark Chilvers

A Mexican matador proudly stands at
the entrance of the bullring situated
outside of Valladolid in Mexico.
August 2002.

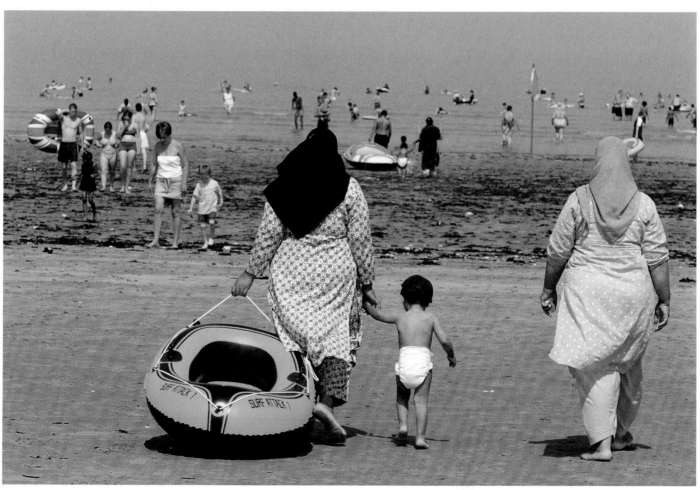

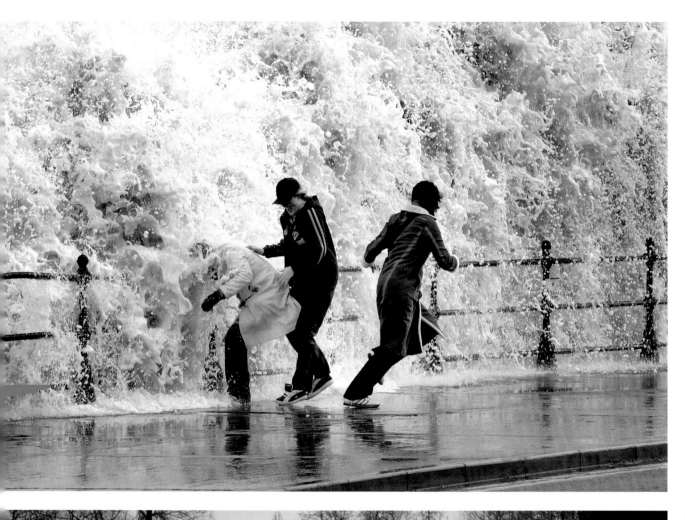

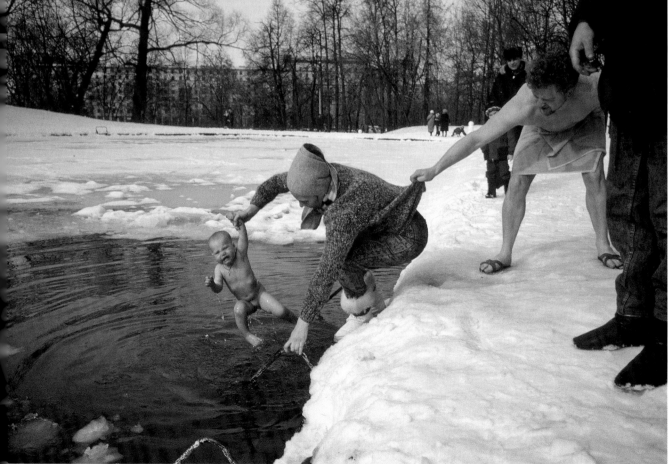

OPPOSITE PAGE
Jeremy Nicholl

A winter ice swimmer, or 'walrus'
greets the New Year with his
daily swim in the River Neva as
temperatures plunged to –35˚C during
an unusually cold holiday period in St.
Petersburg, Russia. 1 January 2003.

Michael Crabtree TROIKA

With record temperatures hitting
Britain, holiday makers enjoy the heat
wave in Margate on the Kent coast.
August 2003.

THIS PAGE
Tony Bartholomew

A group of wave dodgers get a
soaking as they are caught out by
high tides backed by strong winds
lashing the Marine Drive in
Scarborough, North Yorkshire.
 I knew that the combination of
high tides and winds would bring
the waves crashing in and I stayed
focused on these three, getting closer
and closer to the waves, knowing they
would eventually get wet. A wave
return wall is now being built in the
area meaning that this kind of scene
could soon be a thing of the past.
24 February 2002.

Jeremy Nicholl

A group of winter swimmers known
as 'walruses' dip a baby girl in a lake
in temperatures of –18˚C, Gorky Park,
Moscow, Russia. January 2002.

Brian Harris THE INDEPENDENT

The ship *Neptune* moored in the harbour of the old port, Marseilles, France. It had been used in Roman Polanski's film *The Pirate* and had been impounded by the French authorities in lieu of monies owed by the film director while evading extradition back to the United States on charges of rape against a minor. March 1992.

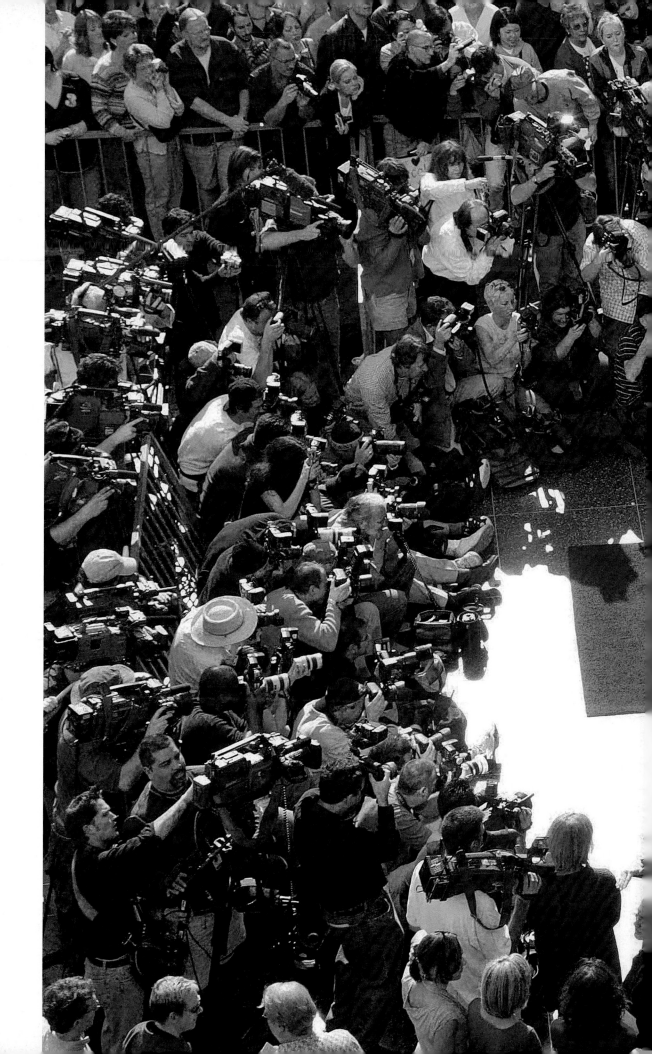

Stewart Cook REX FEATURES

Nicole Kidman, surrounded by a
throng of photographers, receives her
star on the Hollywood walk of fame.
13 January 2003.

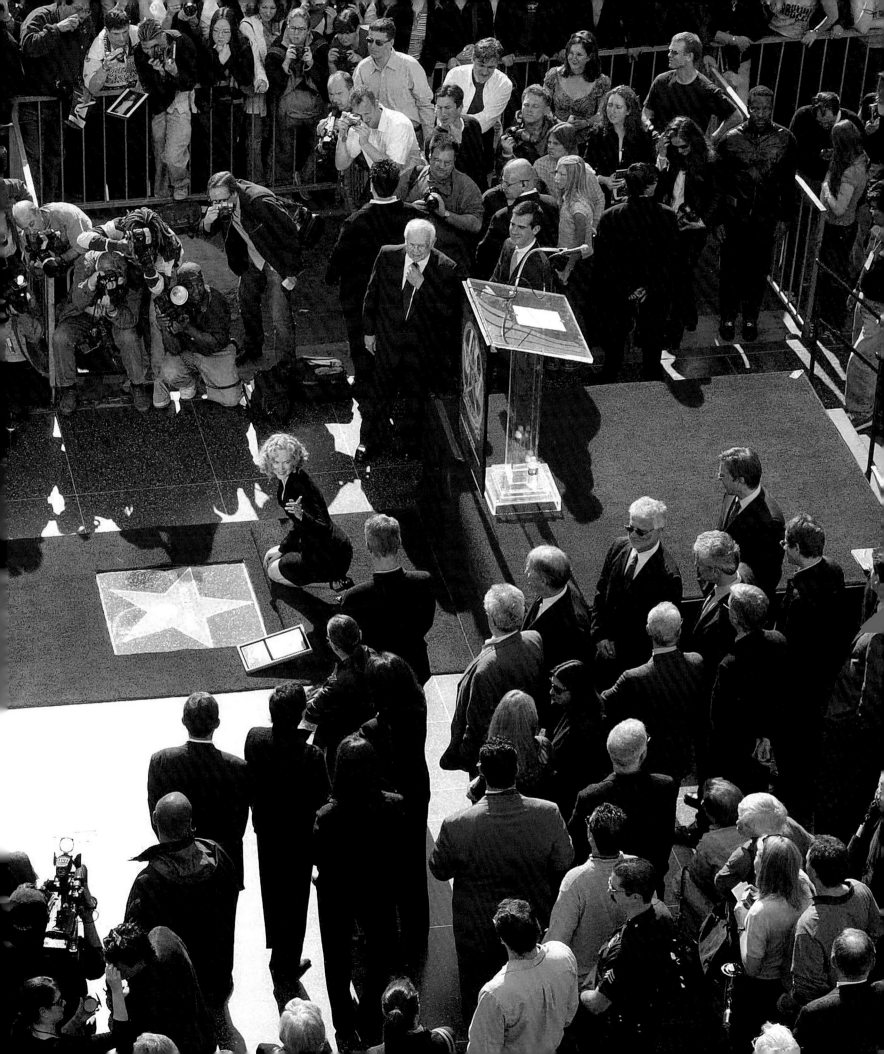

Geraint Lewis

Tilda Swanton taken at the Edinburgh
Film Festival where she was
promoting the film *The Deep End*.
August 2001.

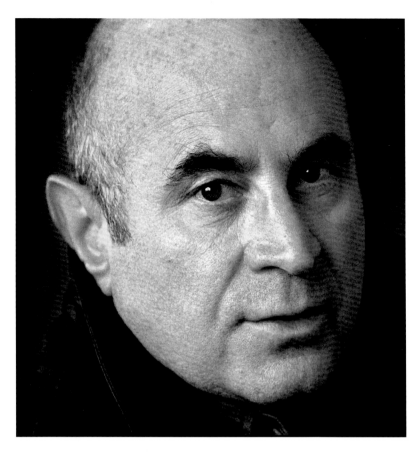

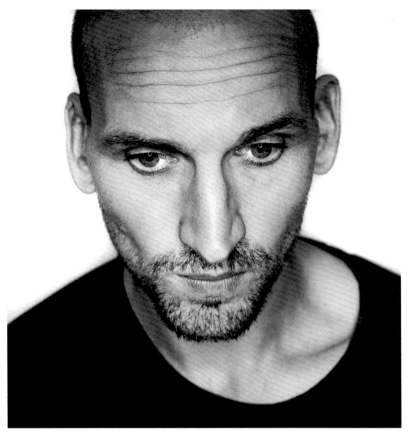

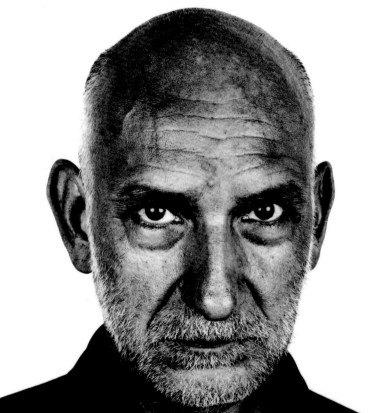

Graham Barclay

Bob Hoskins in his suite at the
Atheneum Hotel, London.
18 March 1998.

John Angerson

Christopher Ecclestone.
July 2001

Geraint Lewis

Ben Kingsley, taken at the Old Vic
Theatre in London where he was
performing in *Waiting For Godot*.
June 1997.

Graham Barclay

John Hurt. May 1998.

Nobby Clark

Steven Berkoff rehearsing *Salome*
at the National Theatre, London.
September 1989.

Mykel Nicolaou

Yehudi Menuhin. September 1996.

TOP
Jim Winslet FINANCIAL TIMES

Artist Maggi Hambling at her
home/studio in Clapham. On the wall
behind her are portraits of Henrietta
Moraes (left) and her father Harry
Hambling. September 2001.

Justin Sutcliffe

Quentin Crisp on the streets of New
York. November 1997.

BOTTOM
Geraint Lewis

Peter Ustinov in his dressing room at
the Theatre Royal, Haymarket where
he was doing his one man show.
March 1994.

Nick Ray THE TIMES

The Hayward Gallery in London
celebrates the centenary of the
National Art Collections Fund.
The exhibition 'Saved' celebrates
the many pieces the fund has saved
for the nation. October 2003.

Sue Adler THE OBSERVER.

American photographer William
Wegman at his exhibition, ICA,
London. Wegman's subject matter is
his dogs, dressed in various outfits
and placed in human situations.
July 1990.

ARTS AND ENTERTAINMENT

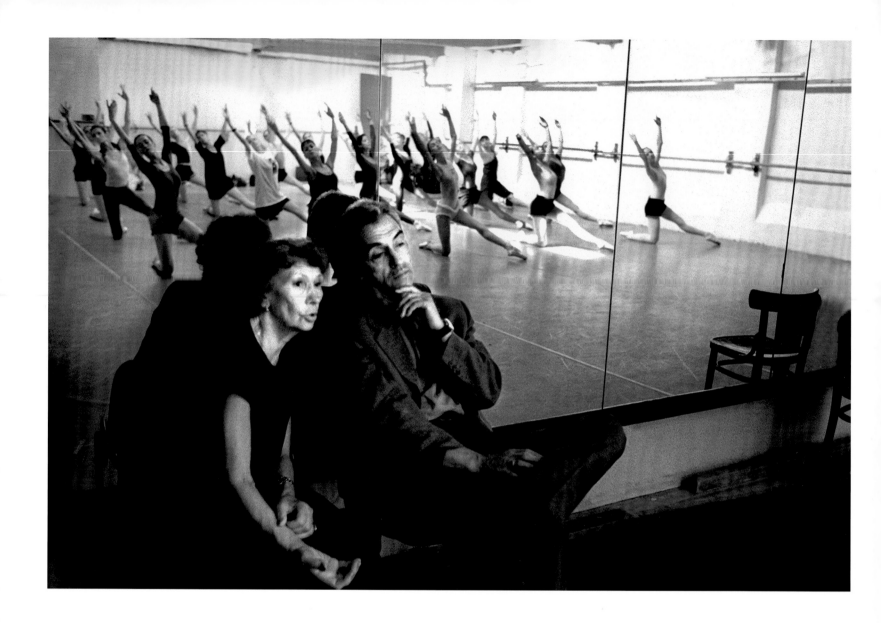

Laurie Lewis

Rimma Karelskaya and Mikhail
Tsivin of the Bolshoi Ballet rehearsing
La Bayadère for the opening of the
season at the London Coliseum.
July 1998.

Laurie Lewis

The Bolshoi Ballet. Backstage at the
London Coliseum. August 1998.

OPPOSITE PAGE
Laurie Lewis

Ballet Nacional de España. The wedding dance from *Medea*, Madrid. July 1992.

Laurie Lewis

Irek Mukhamedov with Anne de Vos in Ashley Page's *Fearful Symmetries* at the Royal Opera House, Covent Garden. June 1994

THIS PAGE
Sue Adler THE OBSERVER

Slava Polunin, the Russian clown, in *Snowshow*, Hackney Empire, London. January 1996.

Sarah Lee

Exhibits from the *Spectacular Bodies* exhibition at the Hayward Gallery, London. December 2000.

Pete Millson

Charlie Watts photographed at Ronnie
Scott's, London. April 2001.

Dillon Bryden THE EVENING STANDARD

Film producer Lew Grade in his office
in Mayfair, London. March 1998.

OPPOSITE PAGE
Tim Smith THE OBSERVER

Julian Bleach as the master of
ceremonies in Improbable Theatre's
production of *Shockheaded Peter* at
the West Yorkshire Playhouse, Leeds.
April 1998.

THIS PAGE
Neil Turner
THE TIMES HIGHER EDUCATION SUPPLEMENT

Professor John Bayley and Dame
Iris Murdoch in the back garden
of their home in Oxford. When this
photograph, one of the last of her,
was taken Dame Iris was in the latter
stages of Alzheimer's Disease; she
was looked after by her husband
who is an author and academic.
9 September 1998.

Chris Moore

Catherine Deneuve congratulating
Yves Saint Laurent after his Haute
Couture show at the Hotel
Intercontinental, Paris. January 1992.

Karl Prouse

Lawrence Steel's Spring/Summer Collection show during Milan Fashion Week. 28 September 2001.

OPPOSITE PAGE
Helen Atkinson

Arkadius's Autumn/Winter 2001
collection. Modelled on the catwalk at
London Fashion Week. February 2001.

THIS PAGE
Peter Macdiarmid

A model stands on the catwalk under
a giant painting wearing an outfit
designed by Christian Lacroix for his
Spring/Summer Collection in Paris.
October 1995.

John D. McHugh

A model shows the work of Jean Paul Gaultier at a retrospective of his designs since 1976 at the Victoria and Albert Museum, London. May 2003.

Chris Moore

Alexander McQueen Autumn/Winter Collection, Paris. March 1993.

Chris Moore

Hussein Chalayan Autumn/Winter Collection, Atlantic Gallery, London. March 1998.

Karl Prouse NATIONAL PICTURES

Model wearing an Alexander
McQueen design from the
Spring/Summer Collection.
26 September 2000.

Jeff Moore

Naomi Campbell backstage at an Antonio Berdi fashion show, London. September 1997.

Andrew Shaw

Elizabeth Hurley leaves a hotel in central London. Hurley's boyfriend, the actor Hugh Grant, was arrested in Los Angeles the previous evening for having sex with the prostitute Divine Brown. 28 June 1995.

Jeff Moore

Uma Thurman with photographers at a photo call for her movie *Kill Bill* at the Dorchester Hotel, London. 2 October 2003.

Dan Chung THE GUARDIAN

Catherine Zeta-Jones and husband Michael Douglas leave the High Court after their legal action against *Hello* magazine. February 2003.

Graeme Hunter

Eminem throws a baby doll in the air from the balcony of Glasgow's Arthouse Hotel in reference to Michael Jackson who had dangled his child from a hotel balcony. 24 June 2003.

Ian Waldie REUTERS

Julia Roberts arrives at the première of *Notting Hill*, London. 27 April 1999.

Richard Chambury GLOBELINKUK

Madonna at the Royal Gala Performance of *Die Another Day*, Royal Albert Hall, London. 18 November 2002.

Graham Barclay

Nicole Kidman on the terrace of the
Dorchester Hotel in London, on the
day her Oscar nomination was
announced. 11 Feb 2003.

Andy Weekes

Christopher Lee at a book-signing in
Nottingham. November 2002.

OPPOSITE PAGE
Les Wilson MAIL ON SUNDAY

Michael Jackson at Exeter City
Football Club. 14 June 2002.

Sarah Lee

Tom Jones. October 2002.

THIS PAGE
Stefan Rousseau PRESS ASSOCIATION

Actors Hugh Grant and Liz Hurley
in the garden of their home in West
Littleton, Bath, following Grant's
indiscretion with prostitute Divine
Brown in Los Angeles. 30 June 1995.

Stuart Boulton THE NORTHERN ECHO

Ronan Keating signing T-shirts at
TFM Radio in Thornaby, Cleveland.
He was visiting the region to promote
his new album and single. The young
girls had been waiting outside since
6am, Keating arrived at 10am.
20 June 2000.

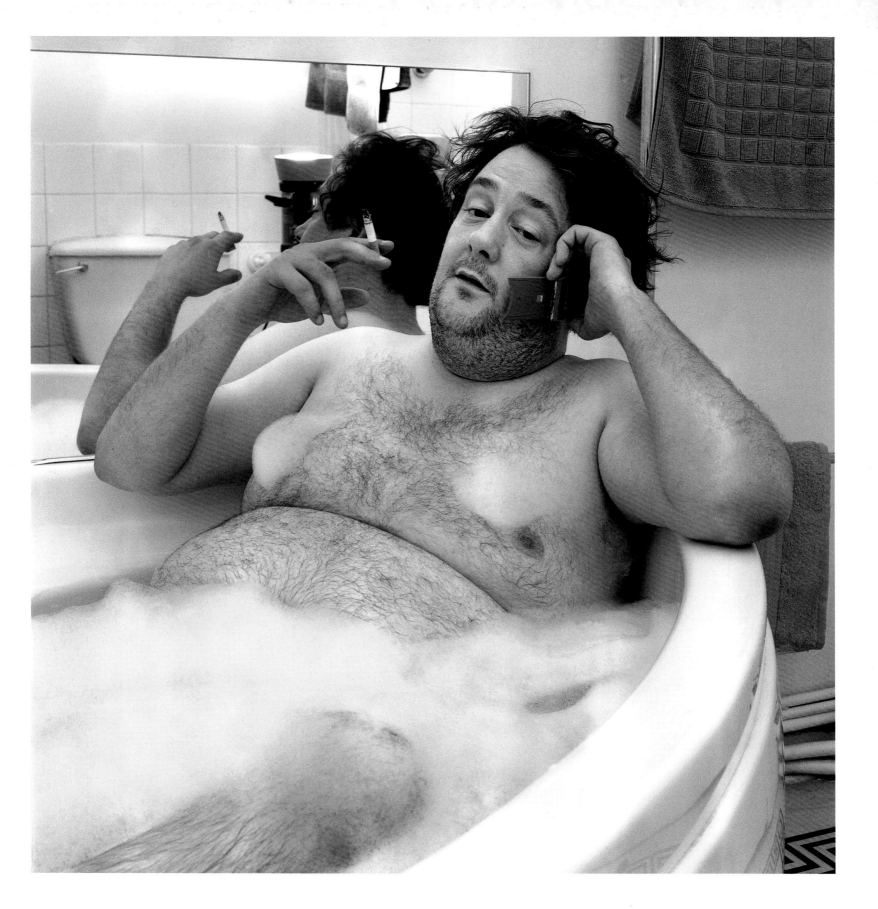

Eddie Mulholland THE DAILY TELEGRAPH

Former Spice Girl Geri Halliwell enjoys her performance at the 'Prince's Trust Party in the Park', Hyde Park, London. July 2001.

Geraint Lewis

Comedian Johnny Vegas in the bath on a Saturday morning during the Edinburgh Festival. August 2001.

Tom Jenkins THE GUARDIAN

Gold medallist Kanukai Jackson of
England competing in the vault at
the Commonwealth Games,
Manchester. July 2002.

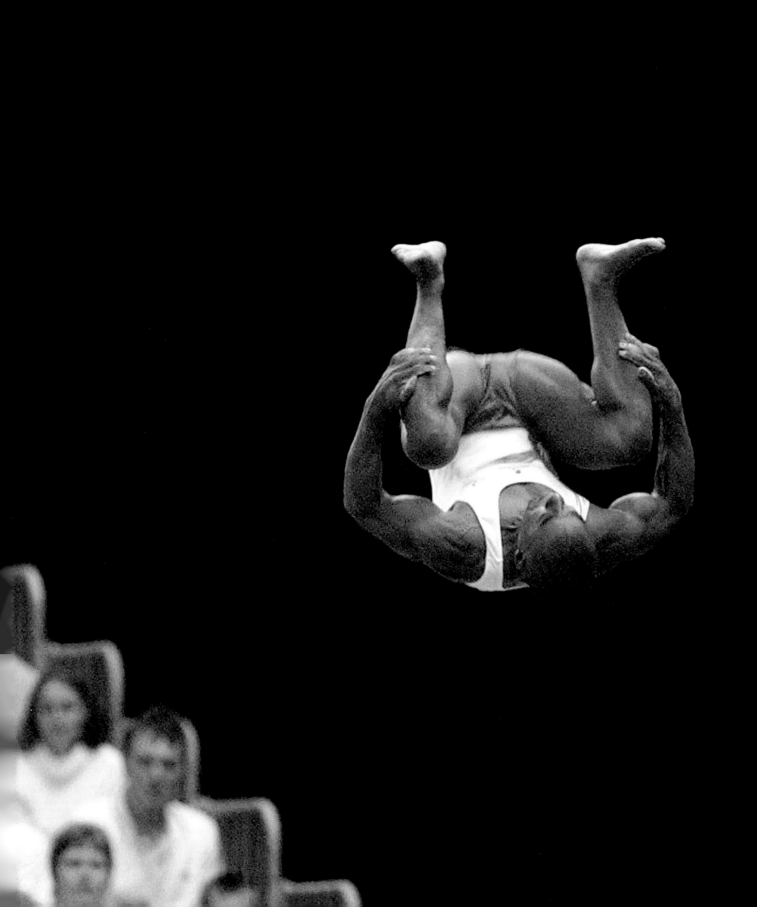

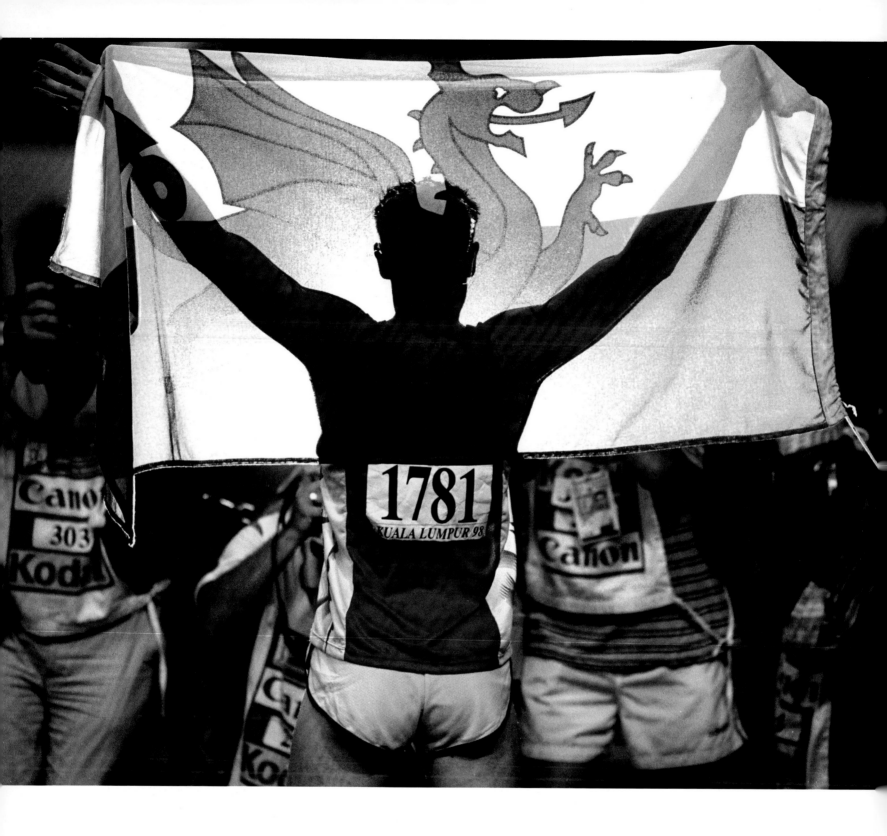

Stu Forster GETTY IMAGES

Iwan Thomas flies the flag for Wales after victory in the 400m during the Commonwealth Games in Kuala Lumpur, Malaysia.

Thanks must go to colleague Alex Livesey who was one of the photographers whose burst of flash from the other side made the picture. 19 September 1998.

Michael Steele ALLSPORT

The start of the 60m at the World Indoor Championships in Lisbon. March 2001.

Clive Brunskill ALLSPORT

Shadows of the competitors splash through the water jump during the 3,000m Steeplechase event at the World Championships held at the Olympic Stadium in Athens. 1 August 1997.

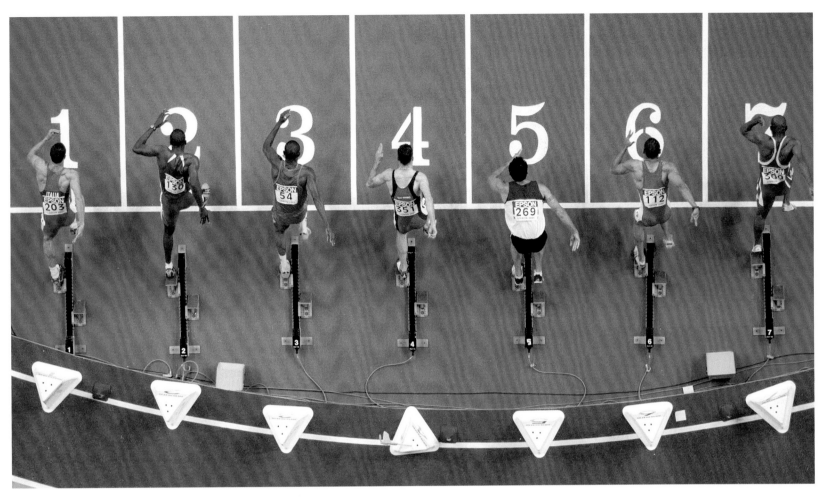

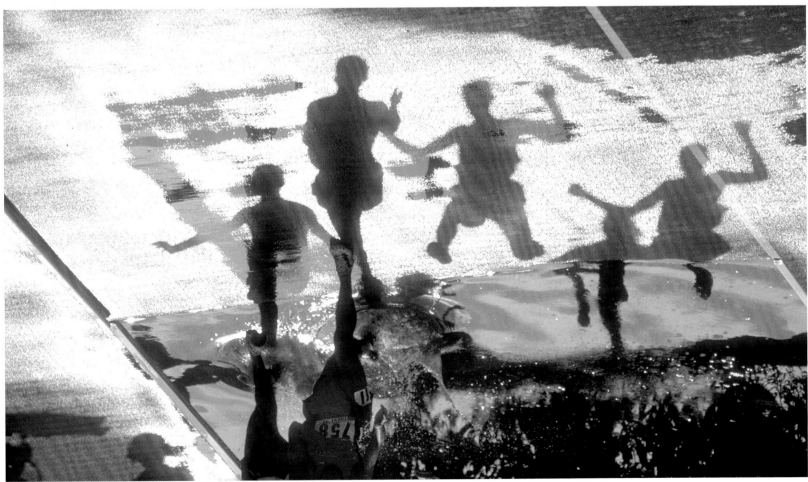

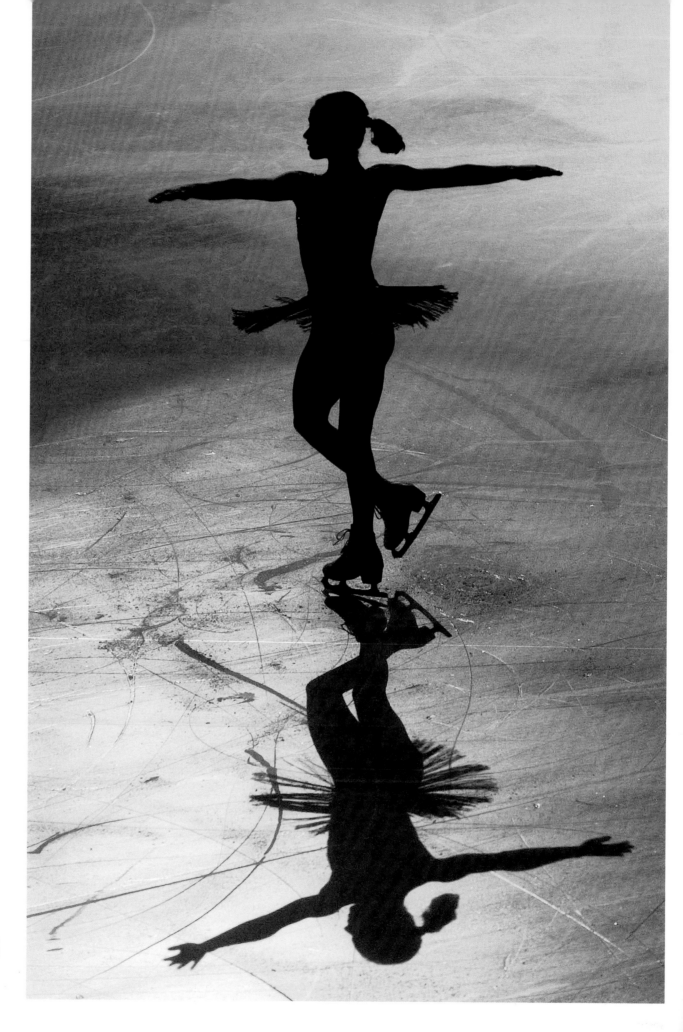

Sasha Cohen of the USA performs in
the figure-skating exhibition during
the Salt Lake City Winter Olympic
Games, Utah. 22 February 2002.

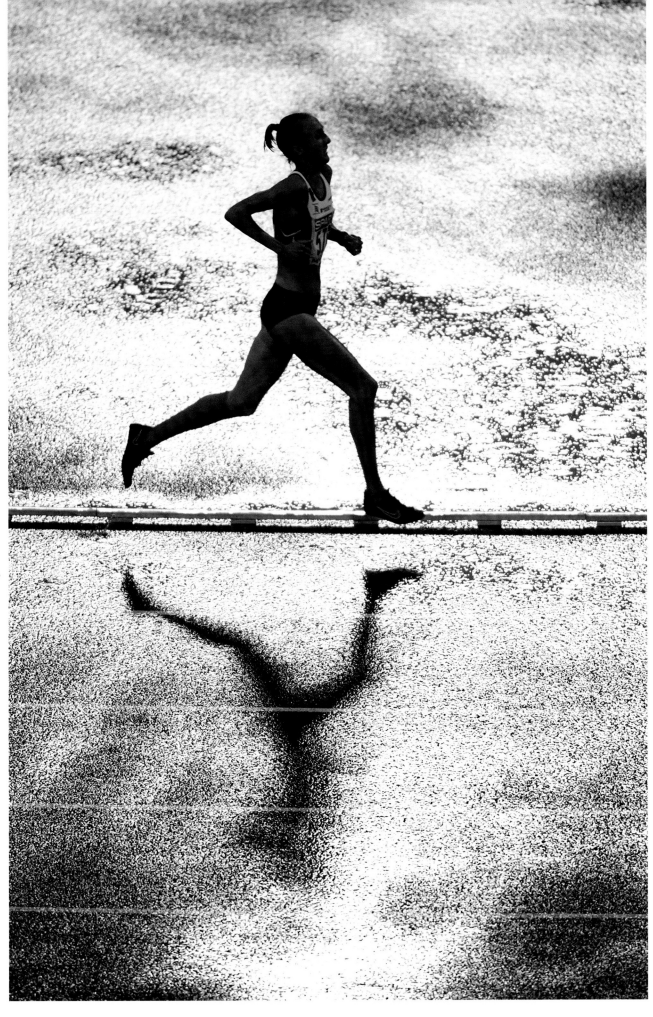

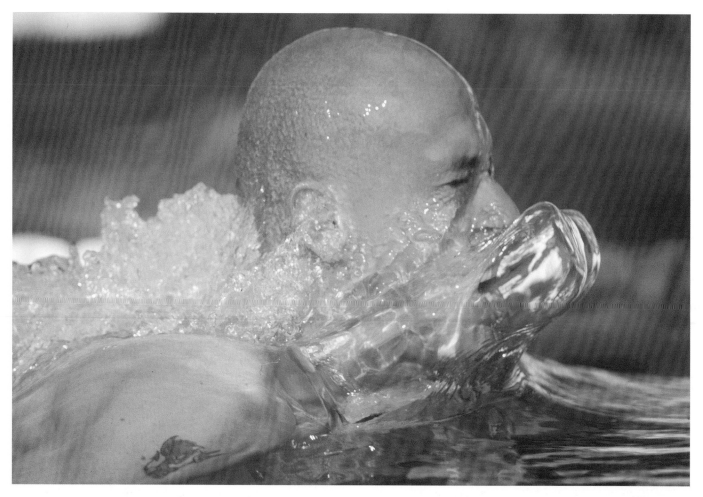

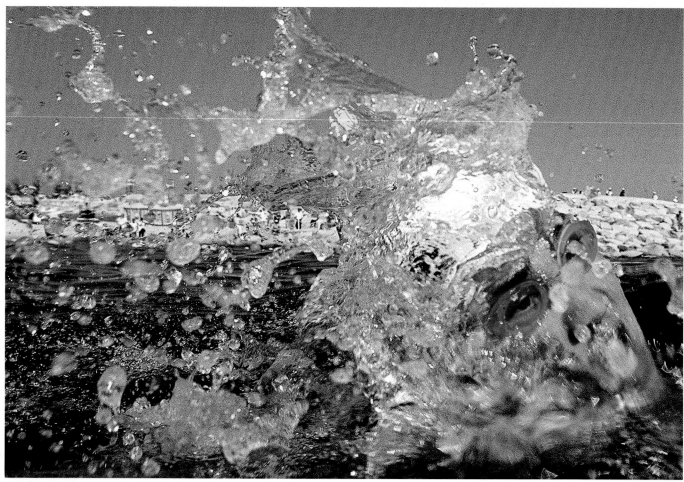

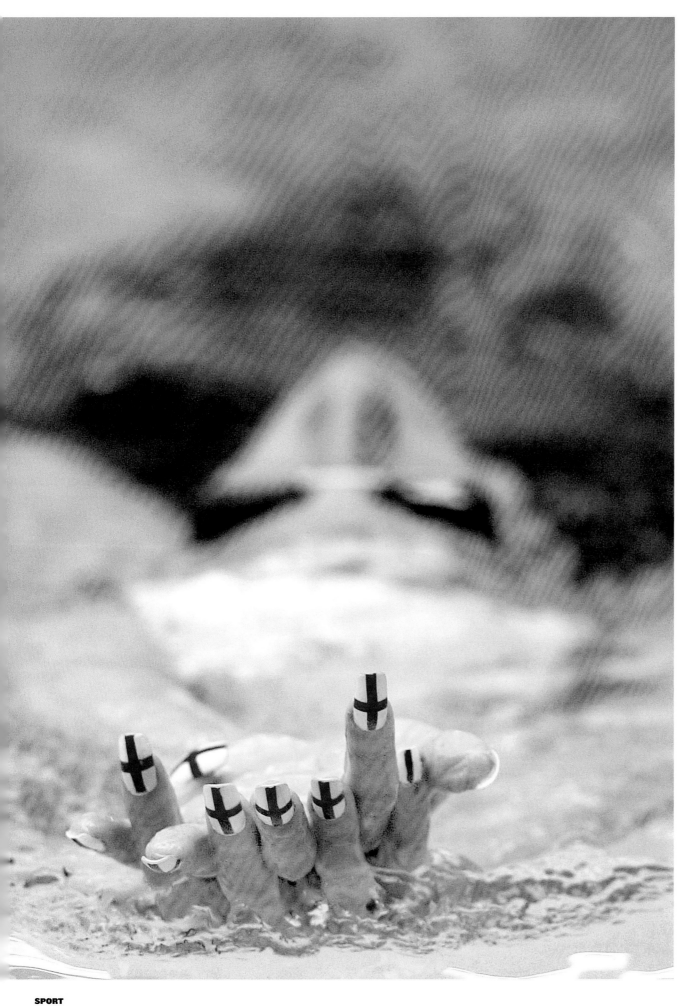

OPPOSITE PAGE
Shaun Botterill GETTY IMAGES

Frederick Deburghgraeve of Belgium in action during the European Swimming Championships in Vienna. August 1995.

Scott Barbour GETTY IMAGES

Competitors swim during the men's race of the 2001 ITU Triathlon World Cup held in Yamaguchi, Japan. 12 August 2001.

THIS PAGE
Scott Barbour GETTY IMAGES

English swimmer Sarah Price trains at the Grand Central Pools, Stockport before the 2002 Commonwealth Games in Manchester. 27 July 2002.

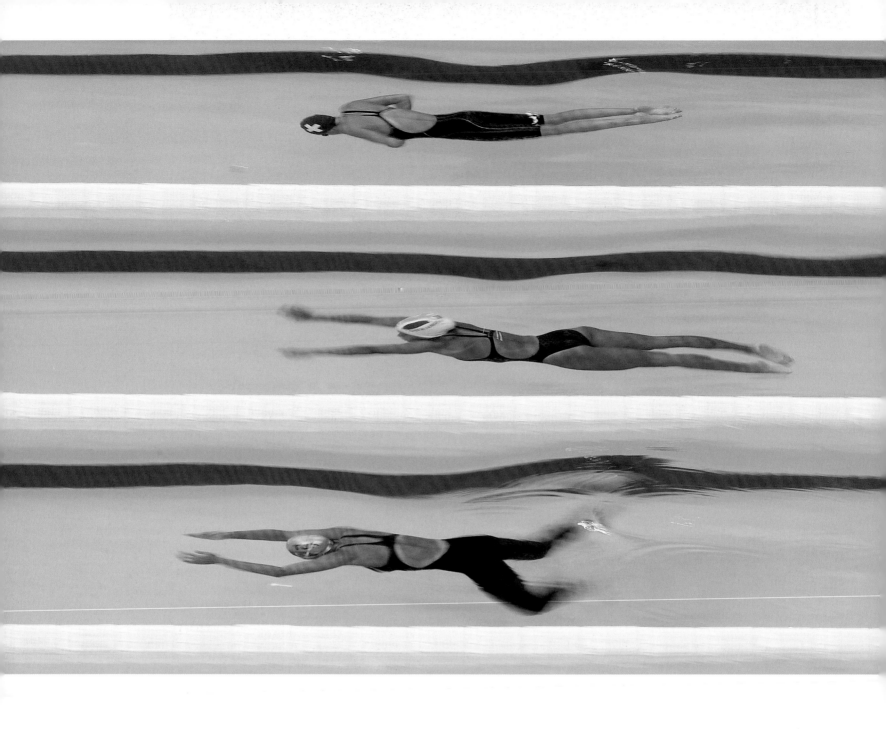

Ramona Pedretti of Switzerland (top)
with Ziada Jardine of South Africa
(middle) and Ilkay Dikmen of
Turkey (bottom) in action during
the Women's 100m Breaststroke
during the World Swimming

Championships at Palau Sant Jordi
in Barcelona. 20 July 2003.

Justin Dumais of the USA competes
in the men's 10m Synchronized
Diving event during the 2003 FINA
World Swimming Championships
at Piscina Municipal De Montjuic,
Barcelona. 19 July 2003.

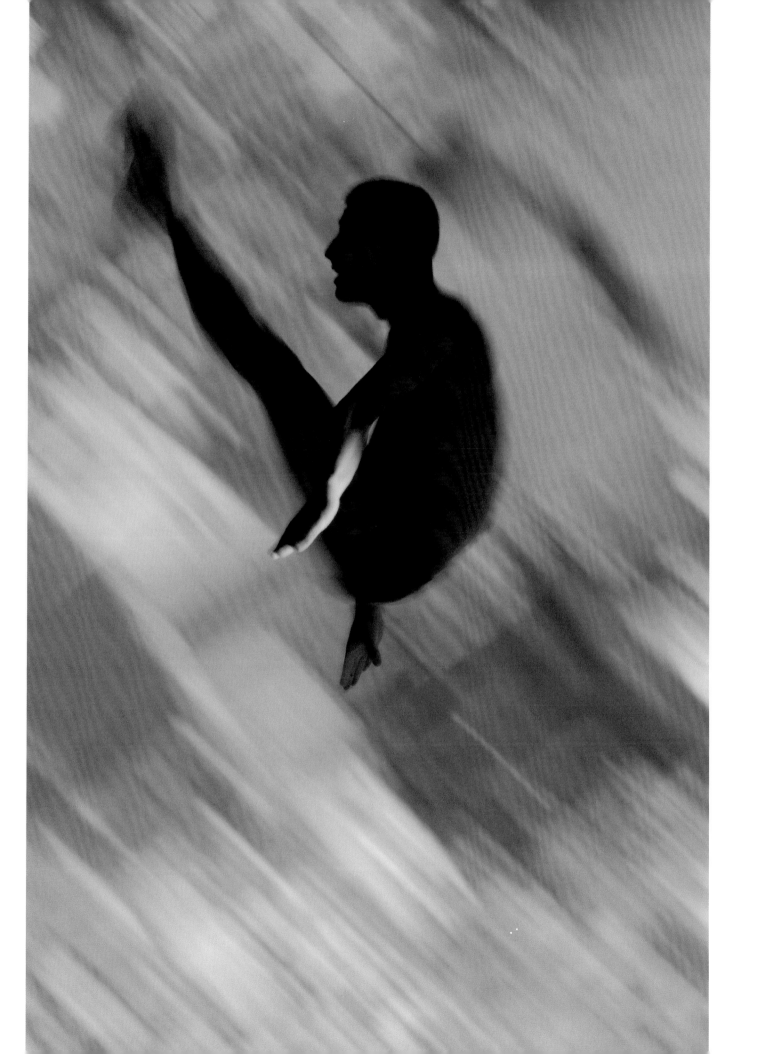

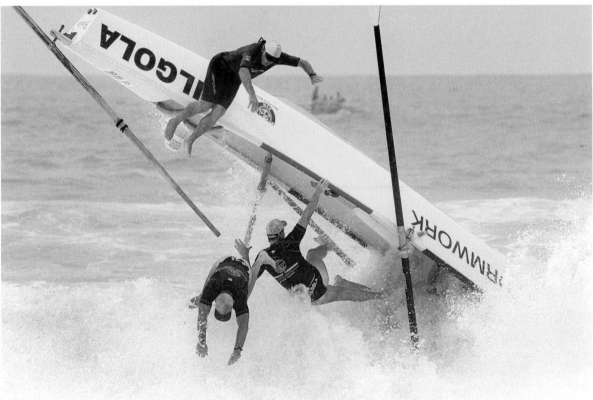

Clive Brunskill GETTY IMAGES

A slalom kayaker takes to the water during a training session at the Penrith Whitewater Stadium before the start of the 2000 Olympic Games in Sydney, Australia. 12 September 2000.

Scott Barbour GETTY IMAGES

The Bilgola crew wipeout during the Surf Boat competition at the 2001 New South Wales Surf Life Saving Championships held at South Maroubra beach, Sydney, Australia. 11 March 2001.

Toby Melville PRESS ASSOCIATION

Steve Redgrave is congratulated by fellow crew members, Matthew Pinsent (left) and James Cracknell (right) following the gold medal victory in the Coxless Fours at the Sydney Olympics. September 2000.

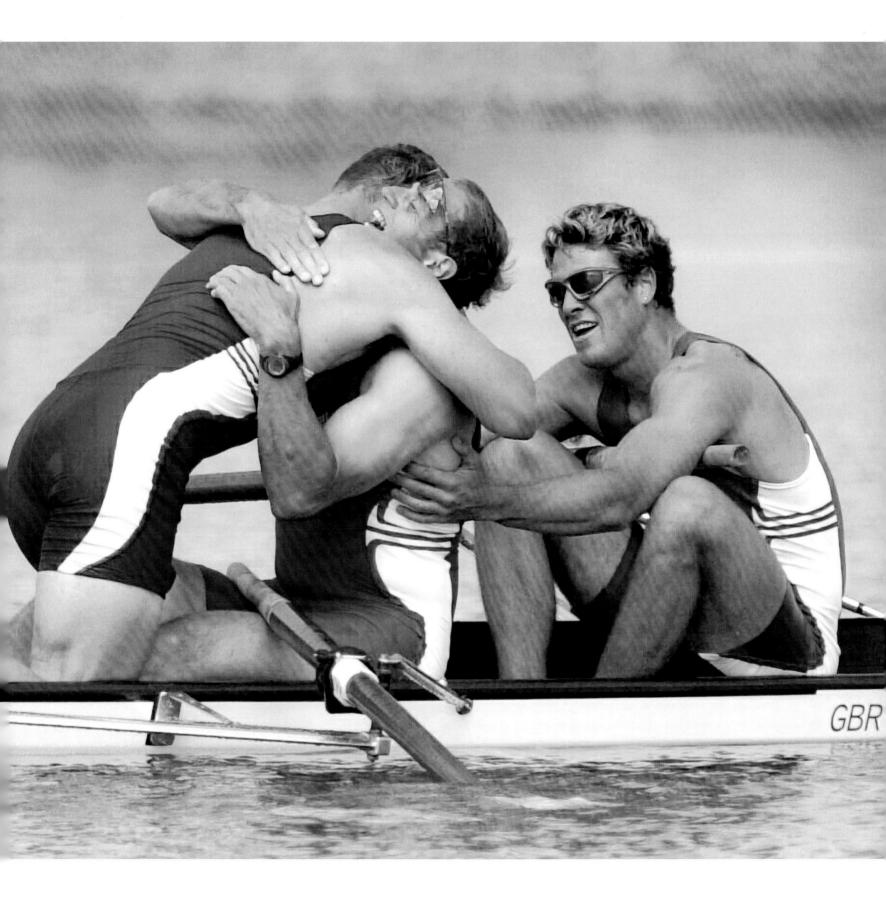

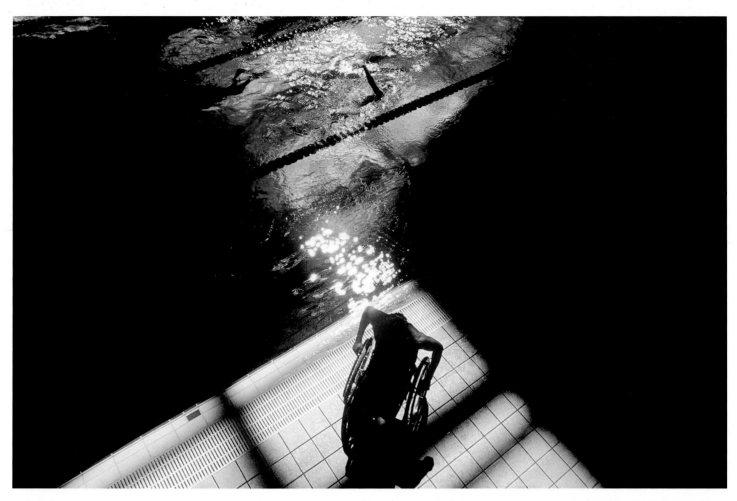

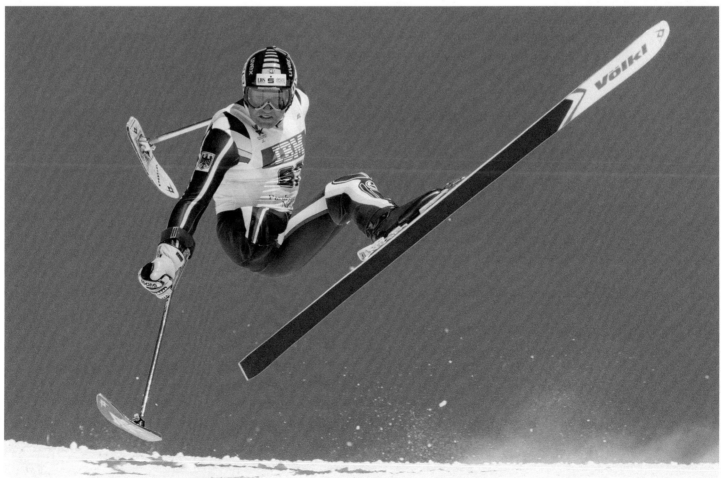

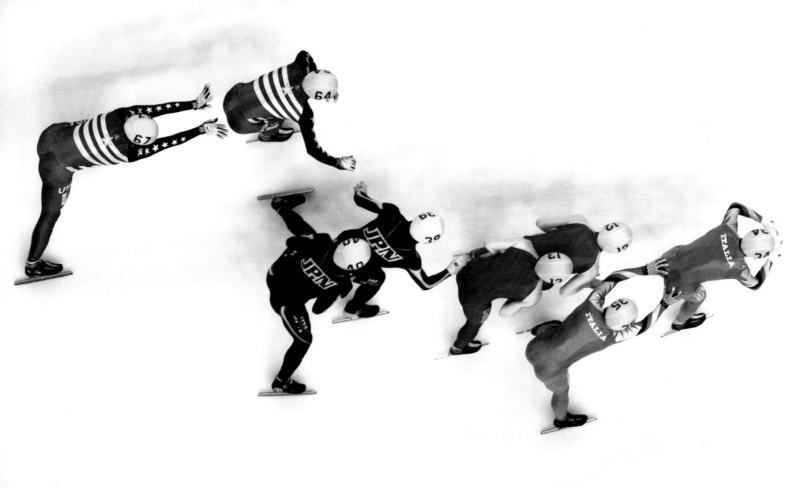

Stuart Emmeson FAOPL

The twin towers of Wembley Stadium
in London a few hours before they
were torn down to make way for
the new stadium. January 2003.

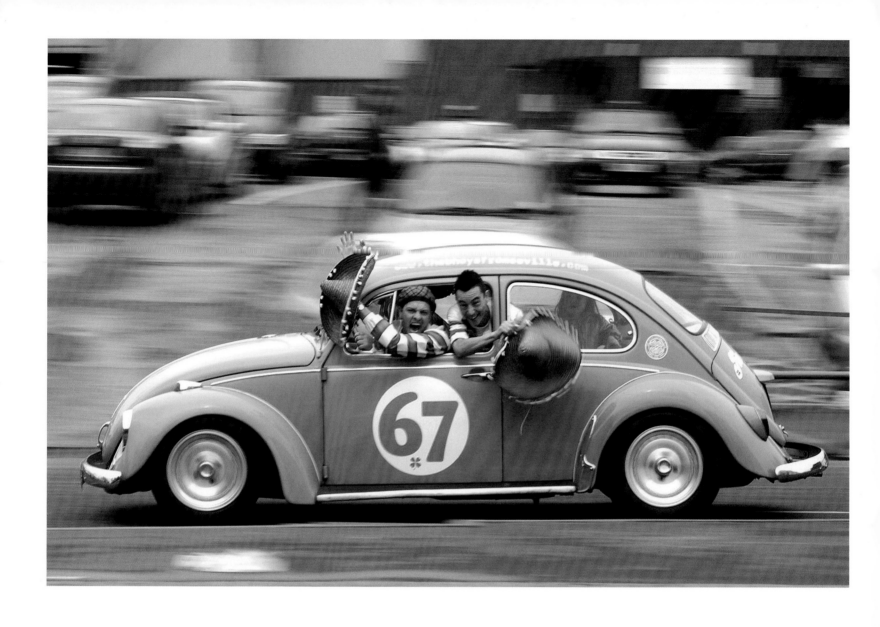

Graeme Hunter

Celtic supporters leave Glasgow
in their 1967 Volkswagon Beetle
for the UEFA Cup Final in Seville,
Spain. 16 May 2003.

Marc Aspland THE TIMES

A young Birmingham City fan at
St. Andrews stadium in Birmingham
reminds arch-rival Aston Villa
supporters of the 3-0 scoreline.
16 September 2002.

Marc Aspland THE TIMES

A fan (far left) slips past security
wearing his Manchester United
strip with 'Cantona' on his shirt
and, to the amazement of captain
Roy Keane (far right), joins the team
picture before the Champions

League quarter final match with
Bayern Munich, Olympic Stadium,
Munich. July 2001.

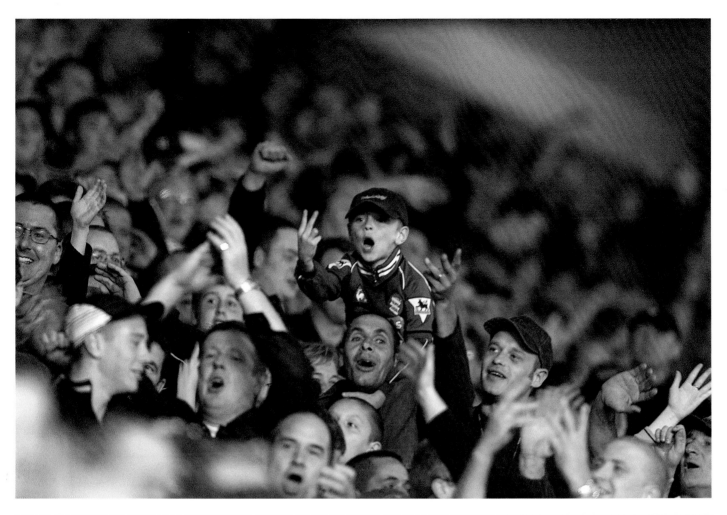

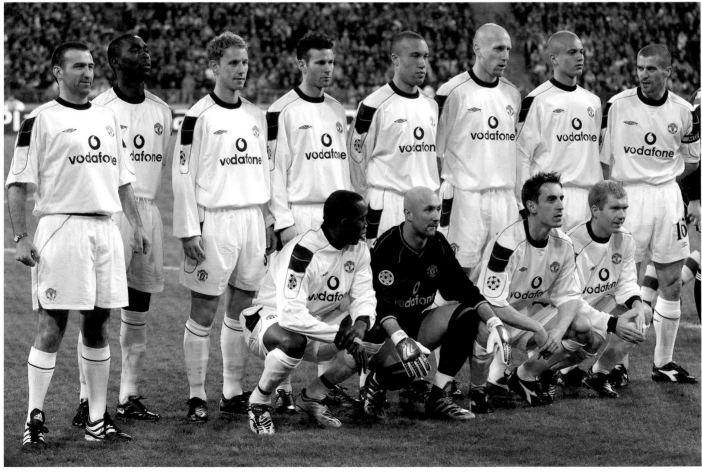

Dan Chung REUTERS

David Beckham gives a news
conference at the England training
base in Saitama during the World
Cup in Japan. 30 May 2002.

Robert Hallam THE INDEPENDENT

The Australian golfer Greg Norman
on the tee during a round at
Sunningdale, England. 10 July 1994.

Peter Nicholls THE TIMES

Boris Becker at the French Open,
Roland Garros, Paris. May 2002.
.

Clive Brunskill GETTY IMAGES

Andrew Ilie plays a forehand whilst
sitting on the ground during the
French Open at Roland Garros, Paris.
28 May 1999.

Scott Barbour GETTY IMAGES

André Agassi serves during his
match against Lleyton Hewitt during
the Tennis Masters Cup held at the
Sydney Superdome in Sydney,
Australia. 14 November 2001.

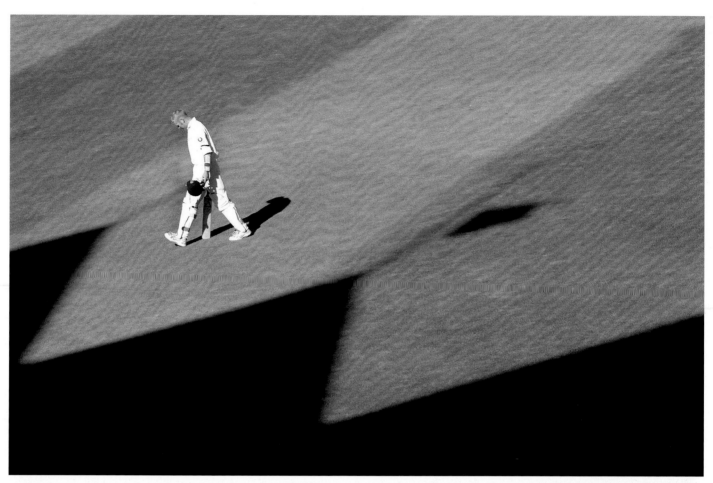

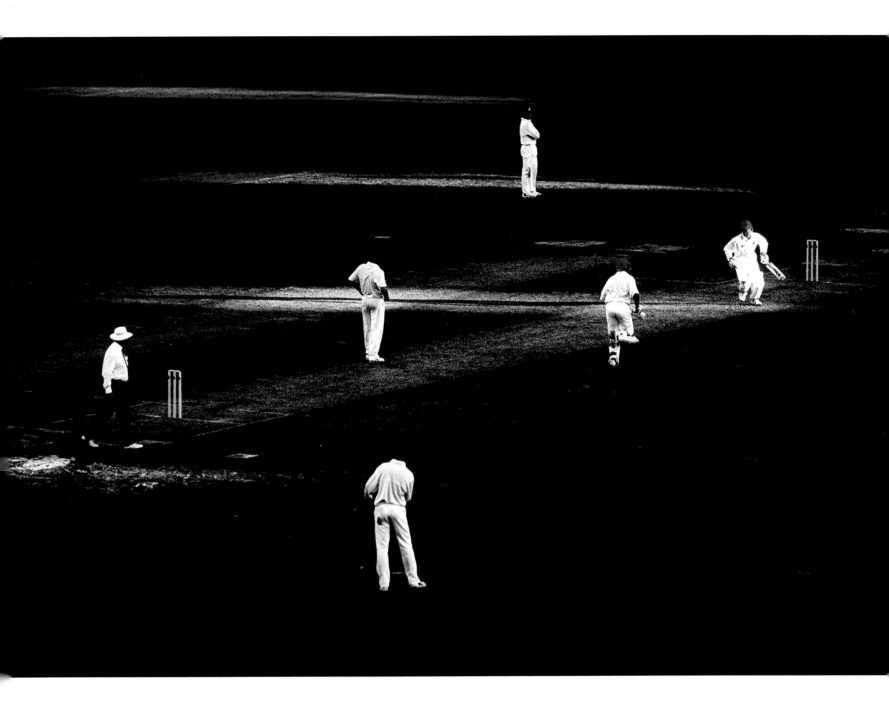

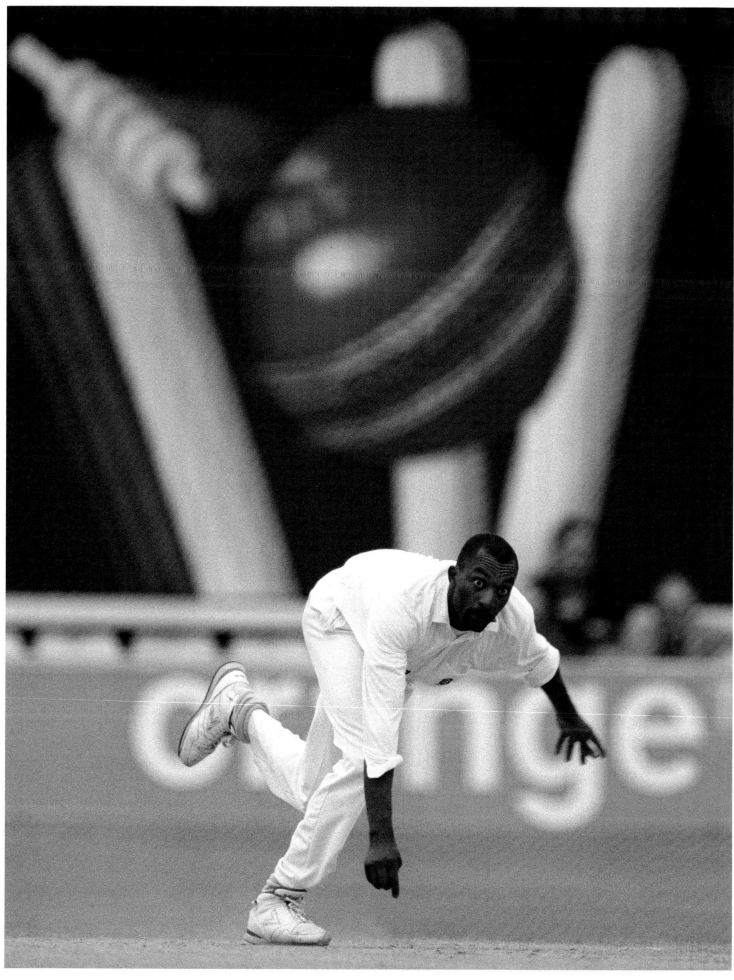

Philip Brown THE DAILY TELEGRAPH

Neil Williams of Essex bowls in front
of a giant advertisement during the
County Championship match against
Warwickshire at Edgbaston,
Birmingham. 6 September 1996.

Ian Rutherford THE SCOTSMAN

Tiger Woods casts a shadow as
he plays from a greenside bunker
during a practice round for the Open
Championship at Royal St. Georges,
Sandwich, Kent. 15 July 2003.

Michael Steele GETTY IMAGES

A competitor putting out during
the Drambuie World Ice Golf
Championships in Uummannaq,
Greenland. The event takes place on
a specially designed nine-hole course,
which offers a different challenge

each year as the course changes
dependant on the ice formation.
9 April 2001.

Robert Hallam THE INDEPENDENT

Desert Orchid exercises in the horse walker at Ab Kettleby Stud, Leicestershire, two years after his retirement from jump racing. He was due to head the parade of horses for the King George VI Chase at Kempton Park on Boxing Day, a race he won four times during his career. 23 December 1993.

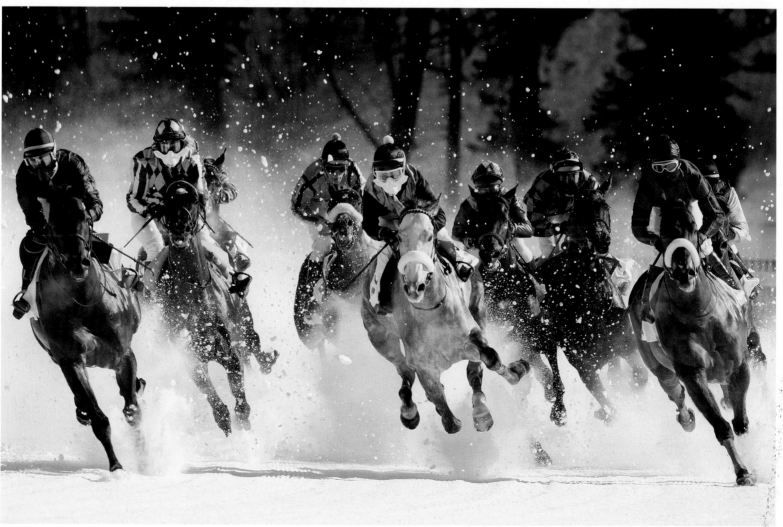

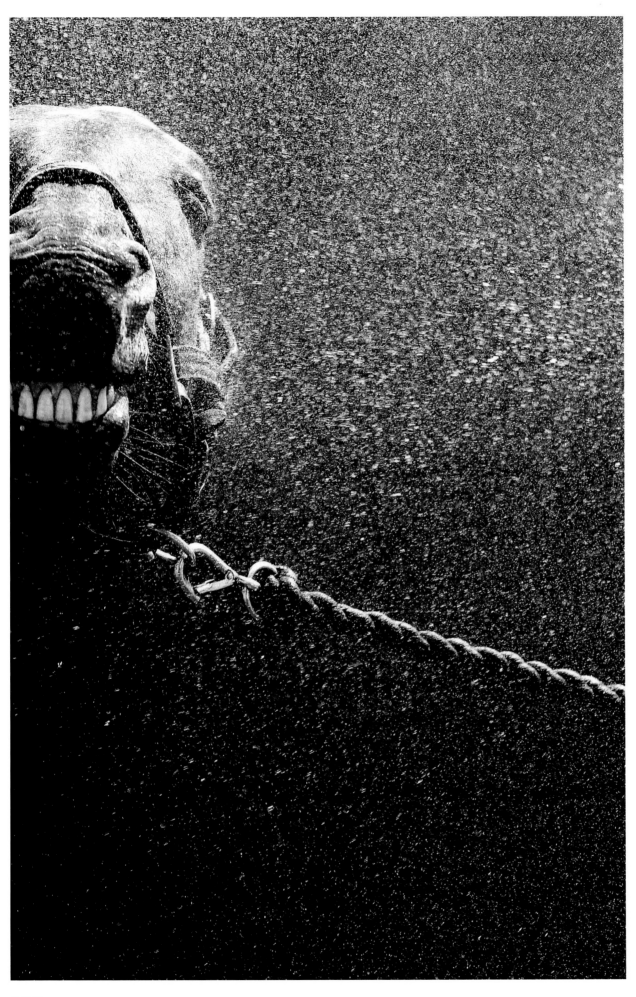

OPPOSITE PAGE
Edward Whitaker

A unique obstacle in jump racing in
Hamburg, Germany where the horses
and jockeys have to swim a lake.
2 July 2002.

Alex Livesey GETTY IMAGES

Horses take the first bend in the
sprint race at the White Turf horse
racing meet held annually on the
frozen lake in St. Moritz, Switzerland.
9 February 2003.

THIS PAGE
Mykel Nicolaou

A horse cooling down at a polo stable
in Berkshire. July 2003.

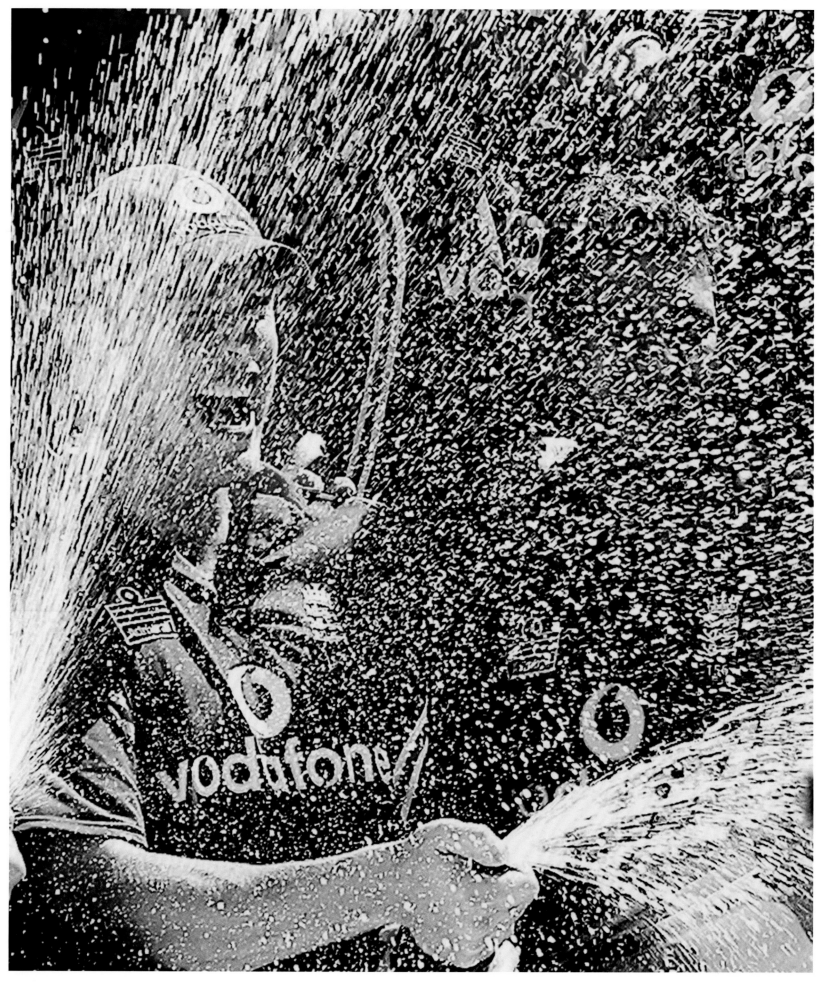

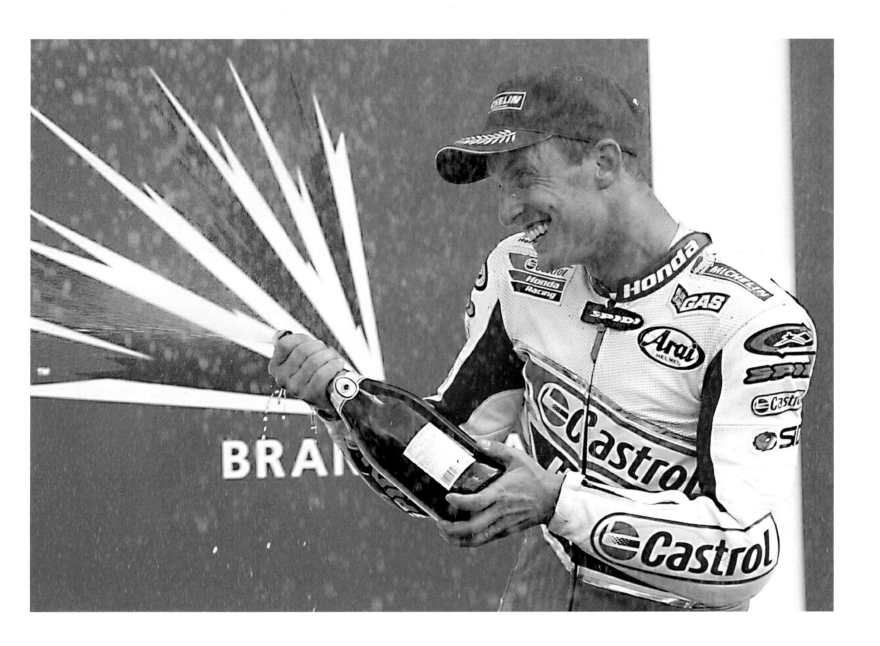

Max Nash ASSOCIATED PRESS

England's 'man of the series' Andrew
Flintoff sprays champagne over his
team mates after helping England
win the final of the Tri-Nations
NatWest One Day Series against
South Africa at Lord's. 12 July 2003.

Nicholas Asfouri AGENCE FRANCE PRESSE

Colin Edwards of the USA celebrates
on the podium after his second
consecutive victory in the World
Superbike Championship at Brands
Hatch circuit near London.
28 July 2002.

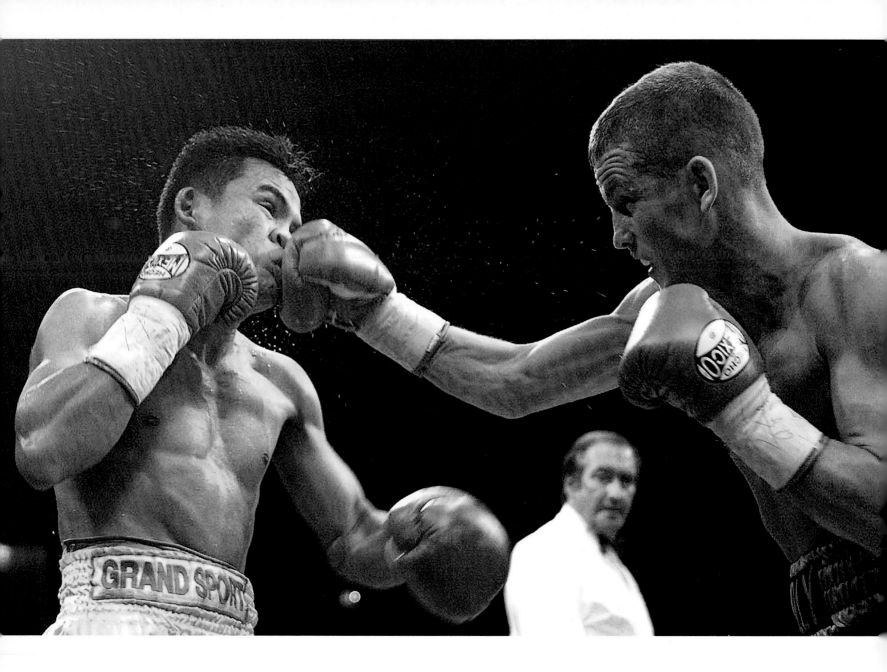

Sean Dempsey PRESS ASSOCIATION

Thailand's Wandee Chareon (left) and
Liverpool's Peter Culshaw in action
during their WBF Super Flyweight
title at the Wembley Conference
Centre in London. March 2003.

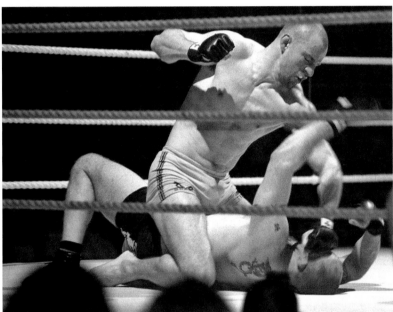

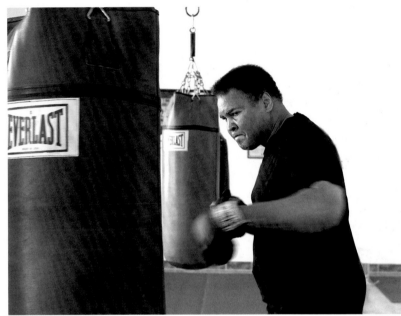

Marc Aspland THE TIMES

Mike Tyson during a training session at the Grosvener House Hotel in London before his fight with Julius Francis in Manchester. 25 January 2000.

Rosie Hallam

Members of the Wallsend Amateur Boxing Club in Newcastle-upon-Tyne which provides training and discipline for local lads of all ages. January 1995.

Anthony Upton

The first licenced 'no rules' fight to take place in the UK at The Mount, Milton Keynes. 12 March 2000.

Roger Allen THE DAILY MIRROR

Muhammad Ali in his gym at home in Berrien Springs, USA.
Despite having Parkinson's Disease, Ali still works out regularly. When he came into the ring, an assistant put on 'The Eye of the Tiger' from the film *Rocky III* and Ali went straight into punching the heavy bag. March 2001.

Adrian Dennis AGENCE FRANCE PRESSE

Petter Solberg of Norway drives his Subaru Impreza through the water splash during the Margam Park Special Stage 16 on the final day of the Network Q Rally near Port Talbot, Wales. 17 November 2002.

Shaun Botterill GETTY IMAGES

The Sydney International Regatta Centre on day four of the Sydney Olympic Games. 19 September 2000.

Howard Walker MANCHESTER EVENING NEWS

Members of the crowd wearing plastic capes during the closing ceremony of the Commonwealth Games at the City of Manchester Stadium. 23 July 2002

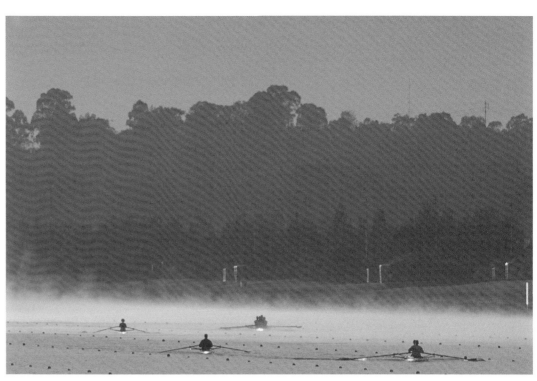

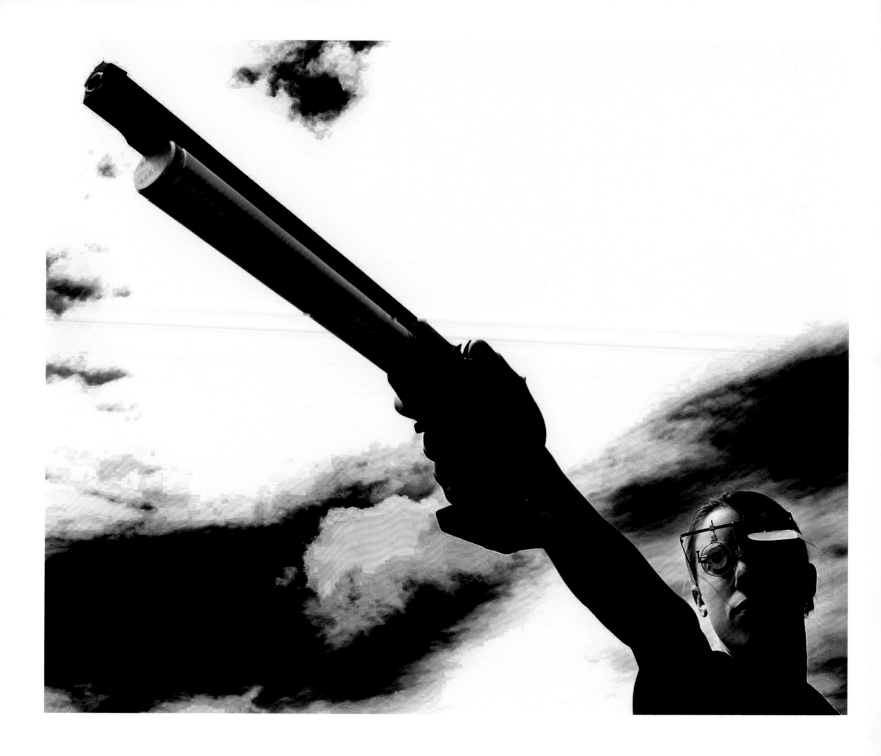

Peter Tarry SUNDAY TIMES

Georgina Hartland, member of the
Great Britain Modern Pentathlon
Team, training at Bath University.
12 July 2001.

Robert Hallam THE INDEPENDENT

One of the 350 competitors at the
British Skeet Championships at RAF
Lakenheath, Suffolk. 5 August 1994.

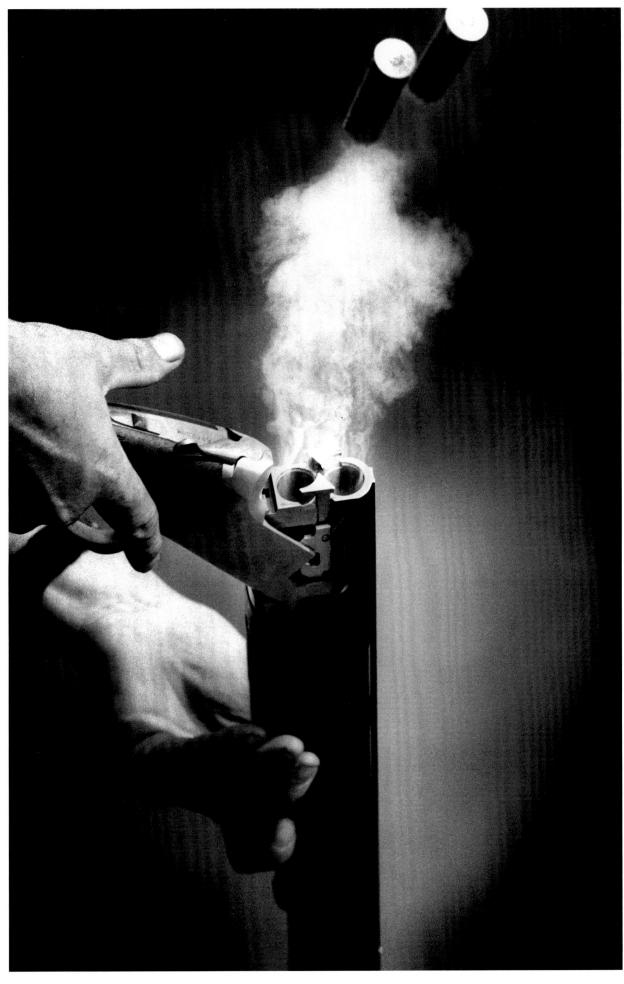

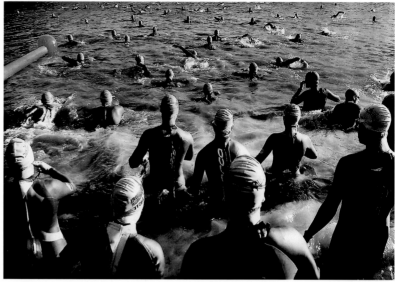

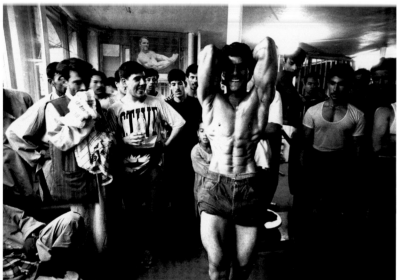

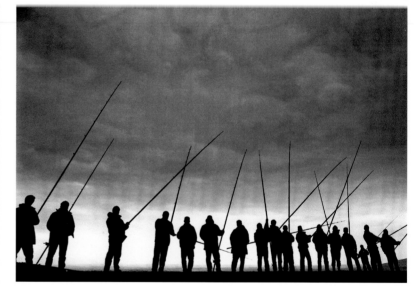

TOP
Dillon Bryden THE INDEPENDENT

The opening two moves of the World
Chess Championships between Nigel
Short and Gary Kasparov at the Savoy
Theatre in London. September 1993.

Mykel Nicolaou

The swimming section of the Ironman
competition at Sherborne Castle,
Dorset. August 2003.

BOTTOM
Sean Smith THE GUARDIAN

A man poses in a newly opened body-
building club in Mazar-e Sharif in
Afghanistan. Under the recent Taliban
government it was not possible for
these clubs to exist. August 2002.

Kirsty Wigglesworth BRIGHTON EVENING ARGUS

Long-distance casters practise their
sport inland on the South Downs in
Sussex. Casting has developed from
beach fishing to become a sport in its
own right, with records standing at
over 300 yards. 29 May 1996.

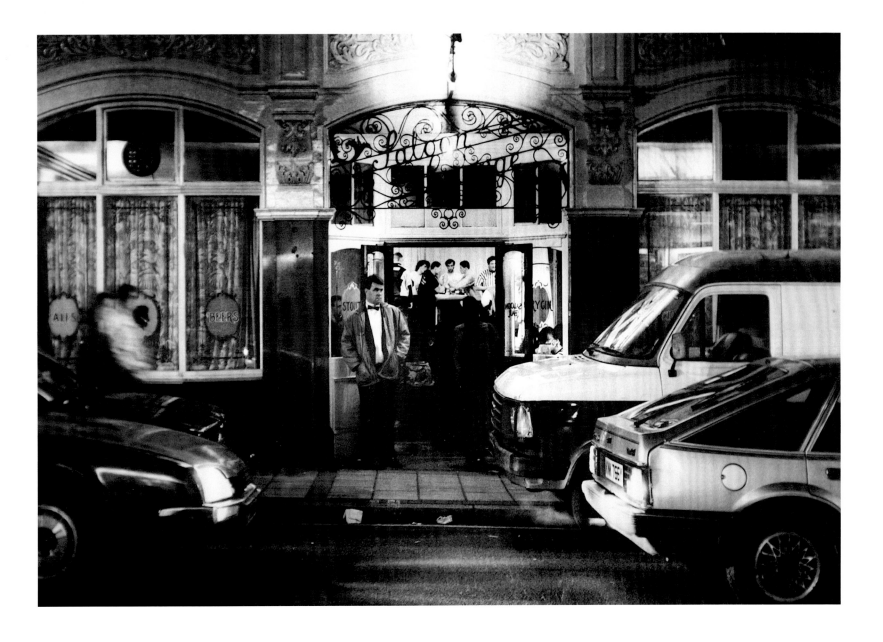

David Sandison THE INDEPENDENT

Competitors in the All London Arm
Wrestling Championship are framed
by the entrance to the Samuel Beckett
public house in Stoke Newington,
North London. September 1990.

SPORT

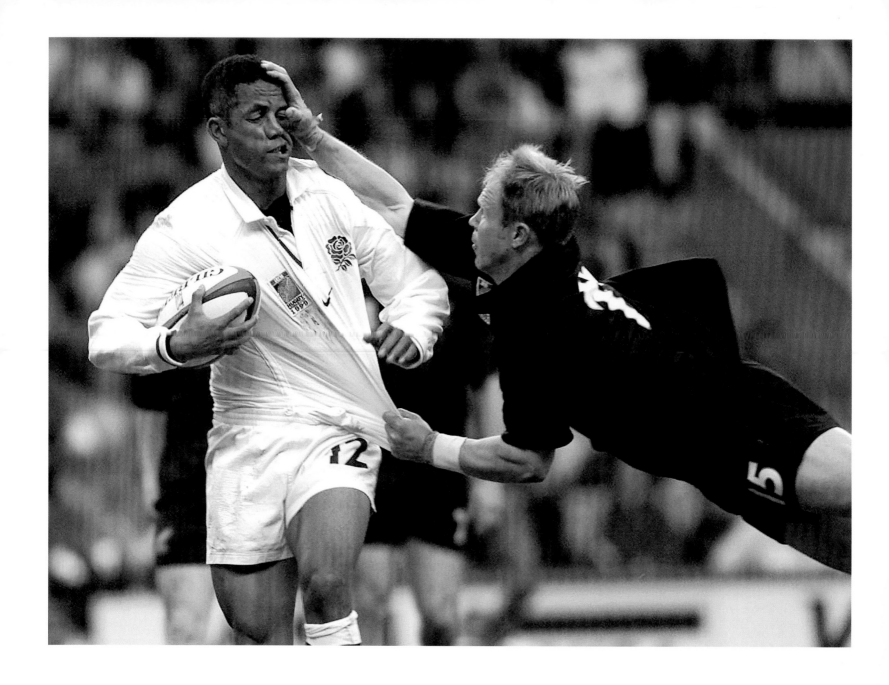

Adam Butler ASSOCIATED PRESS

Jeremy Guscott is tackled during
New Zealand's 15-12 World Cup
victory over England at Twickenham,
London. 9 October 1999.

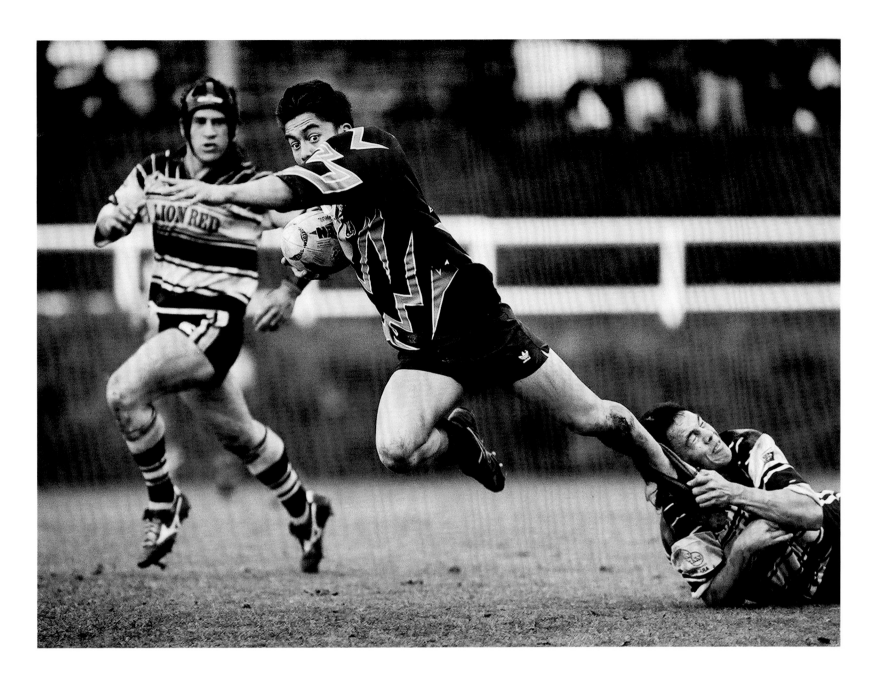

Dwayne Senior NEW ZEALAND DAILY NEWS

A desperate tackle during the
1994 Taranaki rugby league final,
New Zealand. 5 September 1994.

Jeff Morgan THE GUARDIAN

Trefil rugby players make their way to the pitch past rubbish and scrap before a game against Hafodrynys. 28 November 1998.

Philip Brown THE DAILY TELEGRAPH

Adelaide Crow Australian rules football player Wayne Weidemann fails to catch a kick whilst taking on the West Coast Eagles at the Oval in London. 16 October 1994.

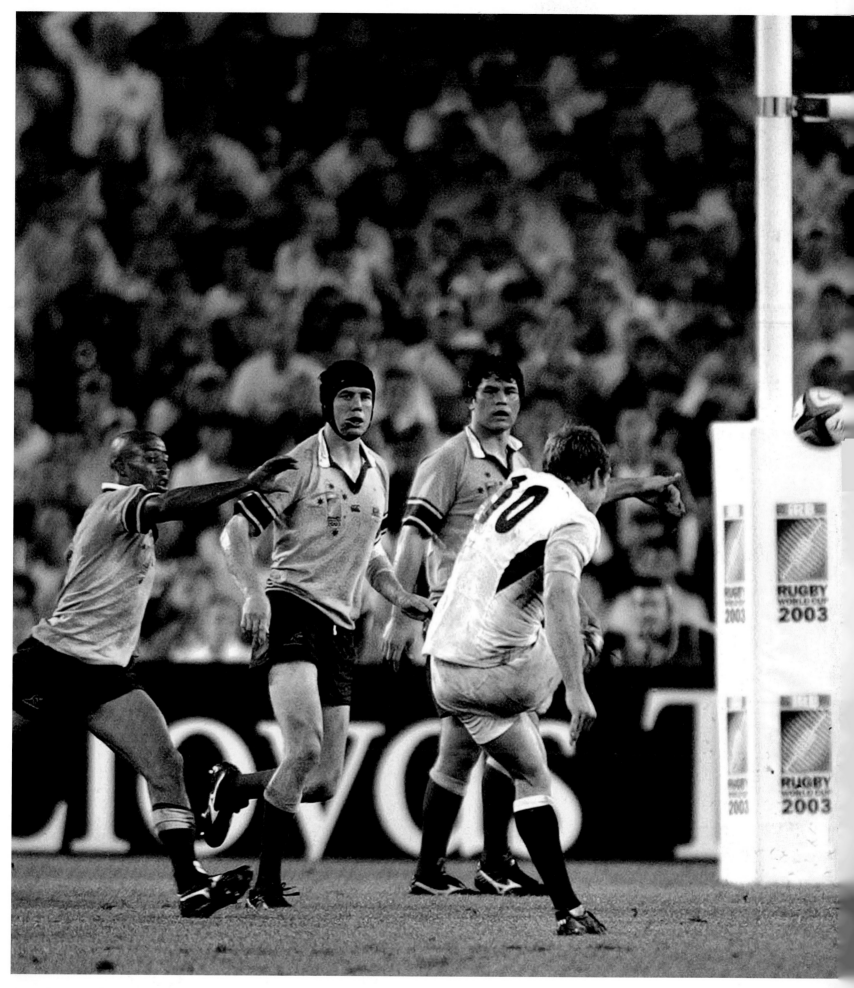

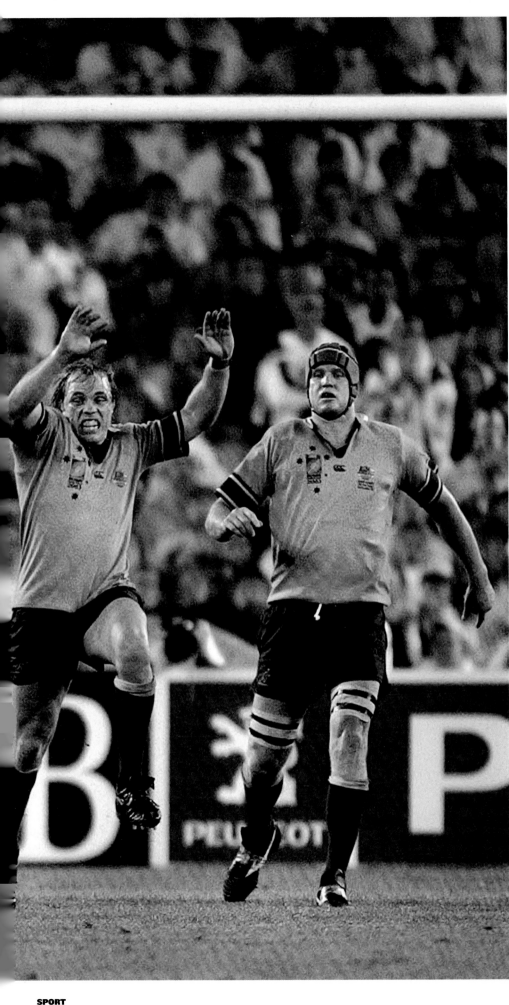

Kieran Doherty REUTERS

Jonny Wilkinson kicks the winning drop goal against Australia in the Rugby World Cup Final, Sydney, Australia.

After eight weeks of following England around Australia it became apparent two or three minutes before Wilkinson's kick that everything we had worked for was about to culminate in this one moment. It had been raining all night which made working conditions difficult and my main concern was making sure my camera batteries didn't die. I had my shortwave radio earplugs in, given to me by the organizers, and I could hear the referee in one ear and the commentator in the other. One of the commentator's said 'and Wilkinson is in the pocket' and I realised he was going for the drop goal. I moved my lens to Wilkinson and, as I did so, he received the ball and I had time for two frames.

At the time I didn't know what sort of image I had as the full time whistle was about to blow and there were all the celebration pictures to do. It was only about two hours after the match that I was able to see the picture. I knew every photographer in the stadium would have a version of it but was relieved that I had managed to get mine sharp. 22 November 2003.

The BPPA book committee would like to thank all the photographers who submitted photographs for *Five Thousand Days*, and to those who have kindly allowed the BPPA to reproduce them. The copyright for each of the photographs published in this book is held by the individual photographer with the exception of the following publications and agencies. The BPPA are very grateful to them for their permissions.

Associated Press
137, 160 top right, 304, 314
Brighton Evening Argus
312 bottom right
Camera Press
42, 160 top left, 175 bottom left, 176
Daily Mail
105
Daily Mirror
40 bottom, 74 top, 100 top, 107 bottom, 140, 171, 184 bottom, 307 bottom right
Evening Standard
80
Express Newspapers
123
Getty Images
84, 87 right, 163 top, 276, 277, 278-284, 286, 294 bottom, 295, 296 top, 297, 300 top, 309 top
The Guardian
21, 23, 46 left, 93, 98, 104 top, 107 top, 108, 264 left, 312 bottom left
The Independent
14, 19, 20, 28, 44 bottom, 50, 57, 116, 127, 135 bottom, 149 top, 170, 185 top, 186 top left, 190, 195, 200, 203 top right, 219 top, 236, 313
INS News Group
61 bottom
Lincolnshire Echo
209
Manchester Evening News
309 bottom
New Zealand Daily News
315
Northern Echo
269 bottom
Press Association
58 centre left, 58 centre right, 102, 132, 160, 178, 181, 269 top, 285, 306
The Racing Post
300 top
Reuters
58 top left, 59, 71, 96, 163 bottom, 184 top, 186 top right, 210, 213, 265 left, 292, 296 bottom, 318
Rex Features
162, 179, 198 bottom, 204, 240
The Scotsman
299
Splash News
81
South Wales Argus
217
The Sun
90, 91 left, 91 right, 101
The Times
100 bottom, 106, 220, 291, 294 top, 307 top left,
TSL Education
255

All the copyright holders have asserted their moral rights under Copyright Designs & Patents Act 1988.

We would like to thank the following people for their valuable support of the BPPA without whom, not only would the BPPA not have been possible, but *Five Thousand Days* would still be a dream.

FORMER MEMBERS

Steve Bent
Jane Bown
Jonathon Buckmaster
John Chapman
Stuart Clarke
Chris Cole
Bob Collier
Bryn Colton
Bill Cross
Stephen Daniels
Keith Dobney
Stephen Douglas
John Downing
Ros Drinkwater
Bob Gannon
Ben Gibson
David Harden
Chris Harris
Julian Herbert
Frank Hermann
Jon Hoffman
David Hogan
Mike Hollist
Clive Howes
Roger Hutchings
Dennis Jones
Martin Keane
Herbie Knott
Tony Larkin
Mike Lawn
Dave Levenson
Neil Libbert
Neville Marriner
Anthony Marshall
Frank Martin
Paul Massey
Eamonn McCabe
Hillary McCarthy
Tony McGrath
Denzil McNeelance
Don McPhee
Ilkhay Mehmet
Richard Mildenhall
Dod Miller
Dario Mitidieri
David Modell
Brendan Monks
Douglas Morrison
David Moxey
Stuart Nicol
Stuart Nicholls
Ian Parry
Judah Passow
Michael Pattison
Mark Pepper
Steve Poole
Tony Prime
John Reardon
Crispin Rodwell
John Rodgers
Nick Rogers
David Sillitoe
Sally Soames
Arthur Steel
Aidan Sullivan
Dennis Thorpe
Allan Titmuss
Ken Towner
Simon Townsley
Graham Turner
John Voos
Keith Waldegrave
Michael Ward
Gareth Watkins
Gary Weaser
Geoffrey White
John Wildgoose
Graham Wood
Richard Young
Sir Tom Hopkinson

THANKS TO

Julien Allen
Mike Allen
Neil Baber
Lucy Bull
Dave Beck
Lewis Birchon
Tom Braid
Mark Borkowski
Carole Butcher
Sav Chandray
Alan Clark
Bob Cox
Melissa DeWitt
Graeme Dimmock
Rosie Doggett
Sara Domville
Fraser Downie
Barry Edmonds
Michael Edwards
Sir Harold Evans
Victoria Forrest
George Freston
Adam Gahlin
Greg Garneau
Dirck Halstead
Colin Hayward
Christopher Kay
Allon Kaye
Lizzy Kremer
Roger Lane
John Langley
Paul Lubbock
Kath Macdiarmid
Barry Macloughlan
Fred Miranda
Jackie Moores
Jane Mulholland
Steve Newman
Bill Nuttall
Donal Ogilvie
Clare Owen
John Pemberton
Photo Zoom software
Alex Ray
Stephen Reid
Victoria Routledge
John Selby
Mike Selby
Graham Smith
Kelly Smith
Stuart Smith
Paula Stevens
Charles Taylor
Jo Turner
Anna Wells
Rob Willes
Donald R Winslow

THE BPPA MEMBERSHIP

Bruce Adams
Richard Addison
Sue Adler
Mark Allan
Roger Allen
Timothy Allen
Odd Andersen
John Angerson
Martin Argles
Nicolas Asfouri
Marc Aspland
Sam Atkins
Helen Atkinson
Andrew Baker
Lara Ball
Roger Bamber
Fraser Band
Scott Barbour
Graham Barclay
Sam Barcroft
Jane Barlow
Tony Bartholomew
David Bebber
Martin Beddall
Simon Bellis
Martin Bennett
Tim Bishop
Nat Bocking
Shaun Botterill
Stuart Boulton
Russell Boyce
Anna Branthwaite
Rob Bremner
Simon Brooke-Webb
Philip Brown
Val Reynolds Brown
Kelvin Bruce
Clive Brunskill
Dillon Bryden
Steve Burton
Adam Butler
Dan Callister
Andre Camara
Richard Cannon
Matt Cardy
Richard Chambury
Joel Chant
Jacky Chapman
David Cherkin
Wattie Cheung
Mark Chilvers
John Christopher
Dan Chung
Nobby Clark
John Cobb
Phil Coburn
Ray Collins
Stuart Conway
Stewart Cook
Kevin Coombs
Ian Cooper
Vicki Couchman
Jez Coulson
Christopher Cox
Michael Crabtree
Shaun Curry
Simon Dack
Colin Davey
Alan Davidson
Simon de Trey-White
Sean Dempsey
Neil Denham
Adrian Dennis
Matt Devine
Ken Dickinson
Kieran Doherty
Brian Duckett
Michael Dunlea
Nic Dunlop
Andrew Dunsmore
Arthur Edwards
Colin Edwards
Stuart Emmerson
Jonathan Evans
Matthew Fearn
John Ferguson
Michael Finn-Kelcey
Em Fitzgerald
Darren Fletcher
Steve Forrest
Stu Forster
Andrew Fox
Stuart Freedman
Sam Frost
Alistair Fuller
Martin Godwin
Anna Gordon
Tim Graham
Alastair Grant
Bob Greaves
Johnny Green
Simon Grosset
Paul Grover
Ben Gurr
Andy Hall
Robert Hallam
Rosie Hallam
Patrick Hannagan
Fiona Hanson
Richard Hanson
Brian Harris
John Harris
Phil Harris
Andrew Hasson
Sean Hernon
Neil Hickson
Andrew Higgins
Jack Hill
Ian Hodgson
Dave Hogan
Craig Holmes
Roland Hoskins
Nigel Howard
Joanna Hunt
Graeme Hunter
Jess Hurd
Gerard Jefferson-Lewis
James Jenkins
Tom Jenkins
Bob Johns
Anthony Jones
Christopher Jones
Jon Jones
Peter Jordan
Nils Jorgensen
Terry Kane
Suresh Karadia
David Katz
Findlay Kember
Clare Kendall
MJ Kim
Steve King
Rob Lacey
Mark Large
Richard Lea-Hair
Gary Lee
Sarah Lee
Justin Leighton
Amit Lennon
Alex Lentati
David Levene
Geraint Lewis
Laurie Lewis
Mark Lewis
Richard Lewis
Stephen Lewis
John Li
Alex Livesey
Mark Lloyd
Andrew Lopez-Calvete
Paul Lowe
Sinead Lynch
Peter Macdiarmid
Alex MacNaughton
Thomas Main
Paul Mattsson
James McCauley
David McHugh
John D McHugh
Ken McKay
Keith Meatheringham
Toby Melville
Richard Mills
Jon Mills
Pete Millson
Jeff J Mitchell
Chris Moore
Jeff Moore
Mike Moore
Jeff Morgan
Eddie Mulholland
Max Mumby
Max Nash
Leon Neal
Jeremy Nicholl
Pete Nicholls
Ian Nicholson
Mykel Nicolaou
Robin Nunn
Linda Nylind
Ellis O'Brien
Heathcliff O'Malley
Andy Paradise
Andrew Parsons
Cavan Pawson
Teri Pengilley
Matthew Phillips
Tom Pilston
Mark Pinder
Simon Pizzey
Jonathan Player
Richard Pohle
Stephen Pond
Michael Powell
Karl Prouse
Steven Prouse
Geoff Pugh
Robert Rathbone
David Rawcliffe
Nick Ray
Steve Reigate
Stefan Reimschussel
Jiri Rezac
Terry Richards
Gary Roberts
Graeme Robertson
Paul Rogers
Tim Rooke
David Rose
Stefan Rousseau
Jayne Russell
Ian Rutherford
Russell Sach
Paul Sanders
David Sandison
Susan Schulman
Doug Seeburg
Dwayne Senior
Andrew Shaw
Dave Shopland
Julian Simmonds
Sean Smith
Tim Smith
Matt Sprake
Michael Steele
Brian David Stevens
Mark Stewart
Paul Stewart
Vivien Stewart
Tom Stoddart
Richard Stonehouse
Andrew Stuart
Jon Super
Justin Sutcliffe
Sang Tan
Peter Tarry
John Taylor
Edmond Terakopian
Hugh Thompson
Sion Touhig
Abbie Trayler-Smith
Freia Turland
Neil Turner
Anthony Upton
Chris Valentine
James Vellacott
Ian Vogler
Ian Waldie
Howard Walker
Simon Walker
Malcolm Watson
Andy Weekes
Allan Weller
Edward Whitaker
David White
Lewis Whyld
Andrew Wiard
Kirsty Wigglesworth
Fergus Wilkie
Rob Wilkinson
Jay Williams
Les Wilson
Jim Winslet
Jamie Wiseman
Chris Young